HUDSON VALLEY RUINS

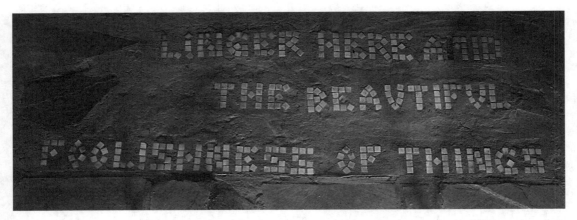

Fireplace inscription from a house undergoing restoration in the Catskill Mountains.

This book was published in association with the Center for American Places, Santa Fe, New Mexico, and Staunton, Virginia (www.americanplaces.org)

HUDSON VALLEY RUINS

Forgotten Landmarks of an American Landscape

Thomas E. Rinaldi ❧ Robert J. Yasinsac

University Press of New England
Hanover and London

Published by University Press of New England,
One Court Street, Lebanon, NH 03766
www.upne.com
© 2006 by University Press of New England
Printed in the United States of America

5 4 3 2 1

LIBRARY OF CONGRESS CATALOGING-IN-PUBLICATION DATA
Rinaldi, Thomas E.
Hudson Valley ruins : forgotten landmarks of an American landscape /
Thomas E. Rinaldi, Robert J. Yasinsac.
 p. cm.
Includes bibliographical references and index.
ISBN-13: 978–1–58465–598–5 (cloth : alk. paper)
ISBN-10: 1–58465–598–4 (cloth : alk. paper)
1. Hudson River Valley (N.Y. and N.J.)—Antiquities—Pictorial works.
2. Hudson River Valley (N.Y. and N.J.)—History, Local—Pictorial
works. 3. Historic buildings—Hudson River Valley (N.Y. and N.J.)—
Pictorial works. 4. Historic sites—Hudson River Valley (N.Y. and
N.J.)—Pictorial works. I. Yasinsac, Rob. II. Title.
F127.H8R56 2006
974.7′3440222—dc22 2006008076

This book was published with the generous support of Furthermore: a
program of the J. M. Kaplan Fund

 University Press of New England is a member of the Green Press
Initiative. The paper used in this book meets their minimum require-
ment for recycled paper.

for

Thom Johnson

Peter Oley

Allen E. Shifrin

CONTENTS

FOREWORD

Like so many others over the millennia I have been drawn to ruins. As a youngster it was the mystery and romance of a place once vibrant but now moribund, once cherished but now abandoned. Later, as an activist in historic preservation, it was the challenge to stabilize such relics of the past, to pull them back from the brink of oblivion and tell their story, perhaps even to restore the building's usefulness to society.

And so it was that at an early age I explored the "false ruins" John C. Cruger erected as a landscape folly on Cruger's Island in Red Hook; the partially standing walls of Chancellor Livingston's Arryl House at Clermont and Colonel Henry Beekman's house at Rhinecliff, both accidentally destroyed by fire a century ago (a portion of the latter replicated as Rhinebeck's Post Office in the 1930s, using the original fieldstone); the roofless and floorless plastered brick walls of the Shookville Methodist Chapel in Red Hook; and the extraordinary "Dick's Folly," the immense house of reinforced concrete modeled after Spain's Alcazar that Evans R. Dick began building on a Garrison bluff about 1900, only to be stopped midway by bankruptcy—eighty years were to pass before work on the house was resumed and completed in a different form by others, the place over the intervening decades having been a magnet for artists, photographers and impressionable children.

More recently, both as a private citizen and in my official capacity as New York's Deputy Commissioner for Historic Preservation, I have become deeply committed to numerous buildings and sites that were enroute to their demise but are vital to an understanding of and appreciation for our nation's cultural heritage. Prime among these are the former state mental hospitals at Buffalo, Utica and Poughkeepsie; Camp Santanoni in the central Adirondacks; the Harmony Mills in Cohoes; the Dutch Reformed Church in Newburgh; the Plumb-Bronson house in Hudson; and the Lydig Hoyt house and grounds in Staatsburg.

Many of these properties that I have known, early or late, are treated in this splendid book, and some of them, I am happy to report, are now enjoying the promise of a brighter future. A steadily growing interest in local and regional history combined with the public's strong support for protection of our natural and built environment, provide the context in which the writers have shrewdly selected their sites, made their evocative photographs, and meticulously researched and written marvelous brief histories that are ostensibly accounts of a building's rise and decline but also adroitly and lucidly impart the salient facts about an industry, an architectural style, or epochal economic and social change. Structures

not featured in the main narrative receive their due in short captions. It is hard to imagine there is a ruin or ruin-in-the-making that the writers have failed to locate and cite.

The diversity of subject matter encompassed in these engaging, fluent annals and the way in which they appear somehow to distil and make accessible the complex history of man's presence on the shorelands of the Hudson River, is truly admirable. From the economics of the nineteenth-century ice-harvesting industry to the founding of the Communist Party of America, from the treatment of prison inmates 150 years ago to Downing's notions about the picturesque in landscape and house design, from the workhorses of waterborne commerce to the fancies of a dealer in second-hand armaments, from the daunting engineering challenges of canal and railroad construction to the evolving forms of recreation, important and surprising stories are told here, with the photographs reinforcing the message at every turn.

We welcome this book as another important contribution to documenting, promoting and celebrating the heritage resources of the Hudson River Valley National Heritage Area. These pages bring to mind lines from a grand old Victorian hymn:

> Change and decay in all around I see;
> O Thou who changeth not, abide with me!

With the wide and energized readership that it deserves, this book should help ensure that many of these and other endangered structures abide with us, and enrich our lives for many years to come.

John Winthrop Aldrich
Advisor, Hudson River Valley
National Heritage Area

ACKNOWLEDGMENTS

The nature of this undertaking has led us as authors to delve into nearly every major theme in the incredibly complex history of the Hudson River Valley, and required us to gain an intimate familiarity with dozens of communities along the river's 150-mile course between Albany and New York City. In the process we've had the pleasure to become acquainted with some remarkable people, without whose help this project could never have come to be.

First and foremost, we owe an enormous debt of thanks to Allen Shifrin, who read through the manuscript and made corrections and observations that improved this work markedly. In addition to his splendid foreword, J. Winthrop Aldrich provided dozens of much welcomed suggestions that helped to clarify and correct detail information throughout the manuscript. Francis Kowsky and Kate Johnson were kind enough to proofread portions of the text dealing with picturesque landscape and architectural design. Ed Polk Douglas read through an early draft of the text and offered invaluable comments and advice.

We offer many, many thanks to Randall Jones at the Center for American Places and to Phyllis Deutsch at the University Press of New England, who shepherded this project into being. With great admiration and gratitude we recognize the brilliant work of Will Hively, who copyedited the manuscript. We are indebted also to Robert Arminio and Debra VanSteen at the Ossining Historical Society, Raymond Beecher, Greene County Historian, Mary Cardenas of the Orangetown Historical Museum and Archives, Michelle Figliomeni of the Orange County Historical Society, John Bonafide, William Krattinger and Peter Shaver at the New York State Historic Preservation Office, Stephen Burke and Kevin Noyes of Hudson Heritage Park, Neil Caplan of the Bannerman Castle Trust, Sarah Charlop and Warren Reiss at Scenic Hudson, John Curran at the Peekskill Museum, Peter Cutul and Dennis Haight of the Palisades Interstate Park Commission, Susan Czarnecki of The King's College, Pat Fenoss, City of Hudson Historian, Brian Fischer and André Varin of Sing Sing State Correctional Facility, Edwin Ford, City of Kingston Historian, Elizabeth Fuller, Katie Hite, and Chris Marinaro at the Westchester County Historical Society, Carol Haddad and John Manuelli at the Briarcliff Manor–Scarborough Historical Society, Eileen Hayden of the Dutchess County Historical Society, Joseph Hogan of the Clarksville Historical Society, Tom Hollowak and Robert Shindle of the University of Baltimore, Mary Howell, Columbia County Historian, Diane Hutchinson, Historian for the Town of Schodack, Suzanne Isaksen,

Town of Montgomery Historian, Ron Janick, Ken Lutters, and Dennis Wentworth of the Taconic Region of the New York State Office of Parks, Recreation and Historic Preservation, Charles Johnson at the National Archives, Emily Johnson and Georgia Herring-Trott, past and present Historians for the Town of LaGrange, Nancy Kelly and Nicholas McCausland of the Rhinebeck Historical Society, Karlyn Knaust-Elia, Ulster County Historian, Robert Knight, Clarkstown Historian, Juanita Knott, Historian for the Town of Stuyvesant, Penny Leonard, Kimberly Schantz, and Florence Yonke at the Historical Society of Rockland County, Alynne Lange, Curator of the Hudson River Maritime Museum, Betty Larson, Village of Catskill Historian, Patrick Martin of Michigan Technological University, Sara Mascia and Mary Ann Marshall of the Historical Society Serving Tarrytown and Sleepy Hollow, Donald McDonald, Putnam County Historian, Elizabeth McKean with the City of Newburgh, Shirley McGrath of the Greene County Historical Society, Helen McLallen, Curator of the Columbia County Historical Society, Bob Murphy of the Beacon Historical Society, Bob Parmenter, Town of New Scotland Historian, Kristine Paulus and her colleagues at the New-York Historical Society, Jeanne Reid and her colleagues at the Warner Library in Tarrytown, Florence Schetzel at Kingston's beautifully restored City Hall, Betsy Wilson, Doug Wilson, and Barbara Sciulli at the Irvington Historical Society, Michael Seneca of the Philadelphia Architects and Builders Project, Peter Sinclair and the Hudson Valley Vernacular Architecture Association, Denise Doring Van Buren of Central Hudson Energy Group, Joan Van Voorhis, City of Beacon Historian, Viola Williams, Historian for the Town of Stockport, Marvin Wolfe, Town of Coeymans Historian, Antje Wollenschläger with Holcim Deutschland in Hamburg, and to the staffs of the Field Library, the Hastings-on-Hudson Historical Society, and Ulster County Community College.

The invaluable assistance provided by every one of these people and institutions is manifest throughout this book. Driven by an unabridged passion for the history of the areas in which they live, some of these historians went well beyond the call of duty, not only steering us through myriad files and history books, but in some cases offering their time to guide us through the buildings that were the subject of our research.

We are especially grateful to those who offered their help simply out of a common personal interest in some aspect of this project. To Thom Johnson, whose loan of *Hudson River Villas* had fateful consequences, both authors offer their thanks. Peter Oley's field trips to the Old Croton Aqueduct and to the Hermit's Grave left a lasting impression. Kevin Dworak helped turn a pile of ideas into something more when this project was in its infancy. Richard Anderson pointed the way to some remarkable ruins in Rockland County. Jim Logan has been a help and inspiration in many ways. A unique debt is owed to Steve Blumling of Staten Island, who offered a day of his time and a first rate kayak to help us document the hulk of the ferryboat *Beacon*.

Ted Scull proffered invariably sound advice first on book proposals and then on books in general. Allen Shifrin provided a lifetime of inspiration, not to mention help deciphering both German and English. Christian Zapatka educated a lifelong interest in architectural history and took time out of an incomprehensibly busy schedule to help get this project on its feet. Olive Doty and George Greenwood oversaw the very beginnings of this undertaking before any of us knew where it would go. Norman Brouwer, Chuck and Cathy Crawford, Brian Cudahy, Bill Ewen, Jr., Bill Fox, Jr., Roger Mabie, Bill Rau, and Barry Thomas were a few of those who helped track down the graves of steamboats we feared had vanished entirely. Our colleagues at the Central Park Conservancy and Historic Hudson Valley, especially Lane Addonizio, Henri Corbacho, Catalina Hannan, Kate Johnson, Kathryn Pappacosma, Karen Sharman, and Nancy Struve, have been willing confidants and supportive friends as we've wrestled with some of the more daunting parts of this undertaking.

A lack of space holds us back from thanking by name all who have helped us along the way. To Rebecca Adams, Andrew Allen, Paul Barrett, Roderic Blackburn, Bill Burton, Keith Cramer, Walter Crump, Richard Cunningham, Irene Epstein, Gerta Freeman, Ned Foss, Elizabeth Granville, Stephanie Griffin, Henry Guendel, Peter Hertling, Deidre Hoare, George Hutton, Mark Jelley, Kathy Jolowicz, Mark Klonfas, Steve Knowlton, Mr. and Mrs. John Mann, Jeff Mayer, Paul Miller, Scott Nevin, Margaret Schram, Ilene Shifrin, Vladimir Pajkic, Tom Panettiere, Alison Pierce, Skip Randall, Lee Richey, Professor Adam Rothman, Benard Rudberg, Fred Schaeffer, David Sharps, Elizabeth Smith, Frederic Steele and Sandi Schneider, John Thorn, Stefanie Valenzky, Kurt Vincent, Holly Wahlberg, Duane Watson, Glen Wells, Karl Zimmerman, and many more, we offer our sincere thanks. And to our families, the Yasinsacs, the Rinaldis and Sonrickers, who sustained us through this project from start to finish, our gratitude is too great for words. We only hope this book justifies the faith and support you have shown us and our work.

INTRODUCTION

MUCH HAS BEEN WRITTEN of the many historic sites of New York's Hudson River Valley. From the American Revolution and before to the Industrial Revolution and after, the region has maintained a high profile in the story of America. Historic buildings related to the valley's colorful past are many. They are restored and celebrated, drawn, painted and photographed, written of, documented and talked about, visited by thousands of tourists annually. But beside this fortunate group of preserved old buildings there stands another group of historic structures that hasn't fared as well.

All but forgotten are the ruins of the Hudson Valley. While historians tend to concentrate on those sites that are restored or preserved, an array of less fortunate historic landmarks are left to waste away. In some cases these buildings are every bit as worthy of preservation as their more fortunate counterparts. But preservationists must choose their battles: resources are too limited to be gambled on lost causes.

Despite their historic merit, these forlorn old buildings are commonly labeled "eyesores," or at best "attractive nuisances." Though regional icons such as Thomas Cole decried the *absence* of ruins on the Hudson in the nineteenth century, in the twentieth century ruins here became identified with issues such as pollution and economic decline. As the century progressed, these trends became increasingly serious threats to the quality of life on the river. In this climate abandonment became the single most formidable threat to historic buildings and the contribution these places make to the culture and identities of the communities in which they stand.

In the twenty-first century, abandonment continues to directly and indirectly bring about the demise of important landmarks throughout the Hudson Valley. Left uncared for, they are vulnerable to vandalism,

arson, and decay. Condemned as eyesores by those who live around them, they make easy targets for developers interested more in the value of the land beneath them than in whatever cultural value they might have. Politicians eager to promote economic development often go along for the ride, in some cases endorsing the demolition of decayed landmarks while in the same breath emphasizing the importance of historic preservation to draw tourists and build pride in their communities.

The Hudson Valley is changing today. Rapid population growth has brought development pressures greater than any the region has ever known. This change is especially visible on the riverfront, where the demand for commercial and residential development together with the successful cleanup of serious pollution problems has brought new attention to properties long laid to waste. Often these areas are home to historic structures that have stood abandoned for years, buildings that now could be redeveloped, put to new use, and preserved. But in a region still accustomed to viewing such buildings as symbols of stagnation, and whose communities for a generation have had to take what they could get in terms of new development, these ruins have begun to disappear at an increasing rate.

Developers have only to label such buildings "unsalvageable" or "too far gone" in order to gain popular and political support to bulldoze them and clear the way for new construction. Though precedents for historic buildings successfully rehabilitated and adapted to new uses after years of abandonment are common throughout the nation, few politicians are willing to stake their reputation on defending an abandoned building for its historic merit. To do so is to risk being criticized for obstructing economic growth. And so it goes up and down the river, as the region pens brochures promoting its rich history with one hand yet dashes that history away with the other.

With historic properties threatened by decay in all corners of the Hudson Valley, this contradiction is inescapable on the river today. It is this paradox that perhaps more than anything else has led to the creation of this book on the Hudson Valley and its ruins. This project set out to take stock of what the valley is losing with the disappearance of these buildings, whose abandoned hulks have been a characteristic part of the river scenery for at least a generation. Alarmingly, the region is losing more than anyone seems to realize.

Hudson Valley Ruins provides a survey of about eighty-five historic sites found abandoned in this region at the turn of the twenty-first century. The geographic boundaries of the Hudson Valley have been subject to varying definitions over the years, and though there are all sorts of ruins lining the river nearly all the way up to its source in the Adirondack Mountains, lack of space limits the scope of this work to the predominantly rural and suburban part of the valley stretching 130 miles between the urban centers of Albany and New York City, bounded

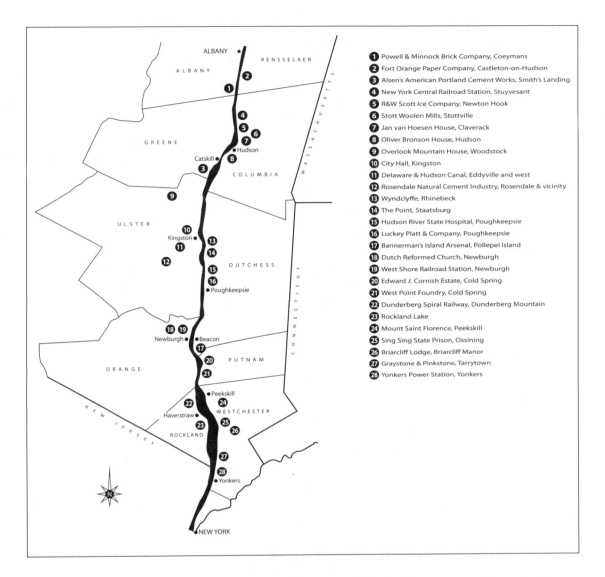

1. Powell & Minnock Brick Company, Coeymans
2. Fort Orange Paper Company, Castleton-on-Hudson
3. Alsen's American Portland Cement Works, Smith's Landing
4. New York Central Railroad Station, Stuyvesant
5. R&W Scott Ice Company, Newton Hook
6. Stott Woolen Mills, Stottville
7. Jan van Hoesen House, Claverack
8. Oliver Bronson House, Hudson
9. Overlook Mountain House, Woodstock
10. City Hall, Kingston
11. Delaware & Hudson Canal, Eddyville and west
12. Rosendale Natural Cement Industry, Rosendale & vicinity
13. Wyndclyffe, Rhinebeck
14. The Point, Staatsburg
15. Hudson River State Hospital, Poughkeepsie
16. Luckey Platt & Company, Poughkeepsie
17. Bannerman's Island Arsenal, Pollepel Island
18. Dutch Reformed Church, Newburgh
19. West Shore Railroad Station, Newburgh
20. Edward J. Cornish Estate, Cold Spring
21. West Point Foundry, Cold Spring
22. Dunderberg Spiral Railway, Dunderberg Mountain
23. Rockland Lake
24. Mount Saint Florence, Peekskill
25. Sing Sing State Prison, Ossining
26. Briarcliff Lodge, Briarcliff Manor
27. Graystone & Pinkstone, Tarrytown
28. Yonkers Power Station, Yonkers

approximately by the Taconic State Parkway to the east and by the New York State Thruway to the west.

The survey begins just below Albany and moves south with the flow of the river. The sites are arranged as one would encounter them moving from county to county down the Hudson toward New York. Limited in the number of sites that could be included, this book portrays a selection of places whose stories overlap minimally, and which are representative of the historical themes that brought such places into being and led them to their present state of decay. Expanded histories are provided for twenty-eight of the more significant sites, which together offer a travelogue of sorts, taking the reader on an uncommon journey down the river, stopping off at places that once played an important role in the

Map of the Hudson River Valley between Albany and New York City.

development of the region—and sometimes of the country as a whole—but that have now fallen into ruin.

Though abandoned buildings today are commonly dismissed as eyesores, the Hudson Valley's writers and artists in the nineteenth century—including figures such as Thomas Cole, Washington Irving, and Andrew Jackson Downing—promoted a popular understanding of ruins as romantic embodiments of a historical past. Looked at from this perspective, ruins are elevated from simple objects of blight to take on a new kind of beauty. In the context of today's Hudson Valley, keeping in mind themes such as setting, architecture, institution, and preservation, the picturesque decay of the region's old places takes on a greater significance.

In that context these buildings are indicative of the changes that took place in the Hudson Valley and across America over the last century and before. The picture they paint is one of a region that in many ways reached its peak at the end of the nineteenth century. It was a place of world-renowned beauty, a cultural mecca that fostered some of the country's best-known artists and writers, and a region that developed industrial and transportation infrastructures—built in many ways around the river itself—to support a thriving population.

In the twentieth century things changed. Income taxes and dwindling old-money fortunes brought an end to the great river estates. The settlement of the American West opened new realms of inspiration for artists and entrepreneurs alike, which de-emphasized the role of the Hudson Valley in the country's cultural and economic development. The coming of the automobile and related improvements to the nation's transportation network allowed more exotic places to eclipse the valley's popularity as a tourist destination, and at the same time diminished the importance of the river to the region's own transportation infrastructure and, in keeping with a nationwide trend, led to the development of suburban shopping malls that left downtown storefronts empty.

At the same time the valley's industrial framework began to collapse. Electric refrigeration put an end to ice harvesting, while increased use of concrete and steel in construction spelled the end for dozens of the region's brickyards. All up and down the river, small mills and factories that could not find their niche were put out of business by larger ones in other places. One by one, the river towns lost their respective industries. New businesses came—IBM to Kingston and Poughkeepsie, General Motors to Tarrytown. But by century's end, many of these had disappeared as well. The Hudson in these years was regarded as a hazard to public health, one of the most polluted rivers in the United States. Fish were inedible, the water in some places was unsuitable for swimming.

The tide of industrialization that had risen so steadily throughout the nineteenth century ebbed away in the twentieth. Still it left behind a residue, not only in the form of PCBs and Superfund sites, but also in the ruined shells of the buildings left empty in its wake. Life in the val-

ley did not wither away and die: it adapted to the changing times and shouldered on. Sometimes these old buildings were adapted for new use as well; sometimes they were torn down. And sometimes they sat empty, abandoned.

Hudson Valley Ruins and the Picturesque Ideal

Once there was a time when artists and writers seemed to draw more inspiration from a monument in ruins than one in good repair. In Western culture, the Renaissance brought a rediscovery of the art and architecture of antiquity. After a millennium of war, looting, neglect, and miscellaneous abuse, the models used by Renaissance architects as the basis for their work stood in varying states of decay. Beginning in the fourteenth century, it became common for artists and scholars to lavish attention on the ruins left behind by their Roman forebears, studying, salvaging, and excavating them, finding inspiration in their most minute details.

But there was something about these ruins that went beyond serving as a practical source from which artists and architects could reproduce classical design details. Even in ruins, the majesty of this earlier civilization was apparent. The story behind its downfall, the dramatic contrast between the glory of Imperial Rome and the crumbling ruins it left behind, struck a very definite chord with a growing number of artists and patrons, who could identify their own human frailty with the vulnerability of the architecture of empire, and indeed of empire itself.

By the seventeenth century the ruins themselves became a prime focus of Western art, as was demonstrated in the work of painters such as Nicolas Poussin (1594–1665), Claude Lorrain (c. 1604–1682), and Salvator Rosa (1615–1673). While these painters focused on the ruins of antiquity, in the north of Europe other artists turned to a very different kind of ruin, to what then could aptly have been called "modern ruins." Although they remain better known for their portrait painting, ruins became a favorite subject of the Dutch Masters. After decades of war with Spain, what the Netherlands may have lacked in ancient ruins it more than made up for in modern ones. Particularly after they had been left to weather for a few years, shattered castles and war ravaged homes seemed to offer the same appeal to artists such as Frans Hals (c. 1582–1666), Jakob van Ruysdael (c. 1629–1682), and Rembrandt van Rijn (1606–1669) as the crumbling remains of the Pax Romana did for the artists of France and Italy. At the very same time Dutch culture was beginning to manifest itself in the New World along the banks of what later became known as the Hudson River. Many of the ruined buildings depicted by the artists of the Dutch Golden Age were similar architecturally to buildings then being built in New Netherland.

In the meantime, the ruins of ancient Rome and Greece maintained their hold on Western art. This continued throughout the eighteenth century, as artists such as Giovanni Battista Piranesi (1720–1778) and Hubert Robert (1733–1808) carried on in the tradition of Salvator Rosa and Claude Lorrain. All the while the appeal of "picturesque decay" was spreading. In the later part of the century it found the perfect niche in the English Romantic movement, figuring not only into the work of the painters Robert Adam (1728–1792) and John Constable (1776–1837) but, more significantly, into a new realm of literary art as well. The groundwork had already been laid by earlier writers, such as Denis Diderot (1713–1784) and Constantin François de Chasseboeuf de Volney (1757–1820).

But it was the poets of the English Romantic movement—Wordsworth (1770–1850) and Coleridge (1772–1834), Byron (1788–1824) and Shelley (1792–1822)—whose fascination with ruin and decay seemed to eclipse that of all those before them. Like the Dutch painters of the previous century, the writers and artists of the Romantic period found inspiration not only in the ruins of Rome but also in those of later periods, whether they be crumbling castles over the Rhine or abandoned abbeys in England. By the beginning of the nineteenth century the work of the English Romantics had solidified the place of picturesque decay in the art and literature of Western civilization.

When a distinct culture of American art and literature began to emerge along the banks of the Hudson River in the 1820s, ruins—or rather the lack thereof—figured prominently here, too. It began with an English-born painter named Thomas Cole (1801–1848), who made a name for himself in New York by painting the pristine, spectacular wilderness he found in the mountains overlooking the Hudson. Here Americans had something no one else had, for unlike the sublime landscapes of Europe, this was a wilderness unaltered by the hand of man. It was a subject no one had depicted before, and in a new country struggling to step out from the shadow of European culture and establish an identity of its own, Cole was hugely successful. Soon others followed, and the county's first native art movement, the Hudson River School, was born.

Nonetheless, inasmuch as the "unspoiled" landscapes of the Hudson lacked any tangible relevance to the development of Western civilization, there was a certain self-consciousness manifest in even the most popular works of the Hudson River School, and in the work of American writers of the period. At the same time these artists and writers hailed the virgin splendor of the Hudson, they bemoaned its lack of ruins. Perhaps no one articulated this more clearly than Cole himself, in his 1836 "Essay on American Scenery":

> The Rhine has its castled crags, its vine-clad hills, and ancient villages; the Hudson has its wooded mountains, its rugged precipices, its green

undulating shores—a natural majesty, and an unbounded capacity for improvement by art. Its shores are not besprinkled with venerated ruins, or the palaces of princes; but there are flourishing towns, and neat villas, and the hand of taste has already been at work. Without any great stretch of the imagination we may anticipate the time when the ample waters shall reflect temple, and tower, and dome, in every variety of picturesqueness and magnificence.[1]

The same sentiment was shared by early American writers and poets, particularly those of the Knickerbocker School, which, led by Washington Irving (1783–1859), emerged concurrently as the literary counterpart to the Hudson River School. In an 1842 poem titled "Moonlight upon the Hudson," Charles Fenno Hoffman (1806–1884) paraphrased what Cole had written earlier:

> The storied Rhine, or far-famed Guadalquivir—
> Match they in beauty my own glorious river?
>
> What though no cloister gray nor ivied column
> Along these cliffs their somber ruins rear![2]

Writers of Hudson River travelogues almost invariably felt compelled to comment similarly. In these passages, defensive juxtapositions with European landscapes become even more frank, comparisons to the Rhine squarely clichéd, as evidenced in an 1852 Hudson River essay that appeared in the *New York Times*: "The Rhine, which every traveler feels derelict if he neglects to laud, certainly flows through no scenery comparable with the noble Hudson. Build a few old ruins on the Highland crests, and the supremacy in magnificence and beauty will universally be yielded to our native hills."[3] Fourteen years later, Benson Lossing's (1813–1891) definitive nineteenth-century history of the Hudson demonstrated that the same viewpoint was still alive and well more than three decades after Cole's "Essay":

Unlike the rivers of the elder world, famous in the history of men, the Hudson presents no grey and crumbling monuments of the ruder civilisations of the past, or even of the barbaric life so recently dwelling upon its borders. It can boast of no rude tower or mouldering wall, clustered with historical associations that have been gathering around them for centuries. It has no fine old castles, in glory or in ruins, with visions of romance pictured in their dim shadows. . . . The dead Past has left scarcely a record upon its shores. It is full of the living Present, illustrating by its general aspect the free thought and free action which are giving strength and solidity to the young and vigorous nation within whose bosom its bright waters flow.[4]

Steeped in the ruin lust of the English Romantics, Cole, Irving, and their respective courts went in search of ruins just as Adam and Words-worth did: in Rome and on the Rhine. The allure was heightened by a persistent American fascination with antiquity that was fueled by popular movements of political self-determination in Greece and Italy. This was further abetted by ongoing archeological work in these places, which was closely followed by the American press, and which at the same time perpetuated the Greek Revival movement in American architecture.

As they traveled Europe, ruins became a favorite subject among the painters of the Hudson River School, who trekked to the Foro Romano as though on a sacred pilgrimage (Cole in Rome went so far as to stay in the house where Claude Lorrain had lived two centuries before). In addition to Cole, Hudson River painters such as Jasper Cropsey (1823–1900) and Frederic Church (1826–1900) developed extensive bodies of work focused on the ruins of antiquity. Irving meanwhile summarized his own fascination with decay in the introduction to his *Sketch Book of Geoffrey Crayon*, published in 1819, the same work that included *The Legend of Sleepy Hollow* and *Rip van Winkle*: "My native country was full of youthful promise; Europe was rich in the accumulated treasures of age," he wrote. "Her very ruins told the history of the times gone by, and every mouldering stone was a chronicle. I longed to wander over the scenes of renowned achievement—to tread, as it were, in the footsteps of antiquity—to loiter about the ruined castle—to meditate on the falling tower—to escape, in short, from the commonplace realities of the present, and lose myself among the shadowy grandeurs of the past."[5]

Back on the Hudson, the preoccupation with ruins promoted by American painters and writers began to represent itself in American architectural theory. Succeeding the Greek Revival came a new movement, called the Picturesque, which took hold in the 1830s and '40s. At its forefront was the landscape designer Andrew Jackson Downing

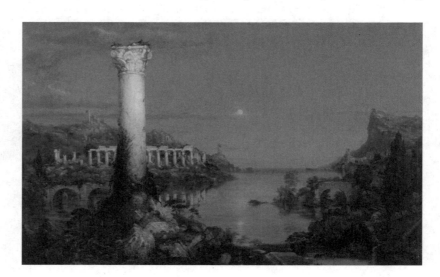

Thomas Cole, *The Course of Empire: Desolation*, 1836. Cole painted some ruins as he found them, and others from imagination. *Desolation* depicts what might be called Cole's "ideal ruin." Courtesy the New-York Historical Society.

(1815–1852), who lived and worked on the Hudson River at Newburgh. In his voluminous advocacy of the application of English Romanticism to landscape and architectural design, Downing promoted a distinction between what had been called the "Beautiful," under which he categorized the appeal of classical architecture and of buildings that sought to replicate its original character, and the "Picturesque," with which he identified the appeal of classical buildings not in their original form but as imperfect, timeworn ruins, worked by the hand of man and nature. "The Temple of Jupiter Olympus in all its perfect proportions was prized by the Greeks as a model of beauty," Downing wrote in his seminal *Treatise on the Theory and Practice of Landscape Gardening* in 1842: "we, who see only a few columns and broken architraves standing with all their exquisite mouldings obliterated by the violence of time and the elements, find them Picturesque."[6]

Perhaps the ultimate consummation of the thirst for picturesque decay came with the construction of ruin follies, purpose-built ornamental structures that replicated the crumbling relics depicted in the art and writing of the Romantic period. Nowhere were these faux ruins more popular than in England, where they became a common sight on estates by the end of the eighteenth century. In the United States, the popular acceptance of Downing's theories of the Picturesque joined forces with the frustrating lack of genuine ruins to inspire the construction of at

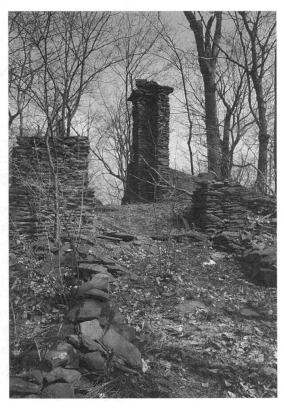

John Church Cruger's ruin folly has become a genuine ruin today.

least two ruin follies on the Hudson River. One of these, built in the early 1840s on the estate of John Church Cruger in northern Dutchess County, included Mayan sculptural ornament taken from Mexico by John Lloyd Stephens (1805–1852) and was identified in guidebooks of the river through the beginning of the twentieth century.[7]

But despite the ongoing lament for the Hudson's lack of ruins, there were indeed picturesque ruins to be found here, and the same writers and artists who decried their absence often acknowledged their presence. In the very same "Essay on American Scenery" in which Thomas Cole wrote of the lack of ruins on the Hudson, the artist seemed to contradict himself: "American scenes are not destitute of historical and legendary associations—the great struggle for freedom has sanctified many a spot, and many a mountain, stream, and rock, has its legend, worthy of poet's pen or the painter's pencil."[8]

Specifically Cole was writing of ruined fortification structures left over from the Revolutionary War. Of these the most significant and best known were the ruins of Fort Putnam, which overlooked

the Military Academy at West Point. Cole himself had painted the ruins in 1826, at the very beginning of his career, in a work called *View of Fort Putnam*. The painting, which shows the fort as a distant, almost incidental structure in a vast landscape, was purchased by the Hudson River painter Asher B. Durand (1796–1886). "It is a feature almost unique in American scenery," wrote Durand of the ruins of Fort Putnam in an 1830 essay, "reminding the traveler of the romantic ruined towers of defence in the gorges of the Pyrenees, or the feudal castles which still frown from the rocky banks of the Rhine."[9]

While Cole painted Fort Putnam, James Fenimore Cooper (1789–1851) wrote of similar ruins farther upriver, above Albany:

> This rude and neglected building was one of those deserted works, which, having been thrown up on an emergency, had been abandoned with the disappearance of danger, and was now quietly crumbling in the solitude of the forest, neglected and nearly forgotten, like the circumstances which had caused it to be reared. Such memorials of the passage and struggles of man are yet frequent throughout the broad barrier of wilderness which once separated the hostile provinces, and form a species of ruins that are intimately associated with the recollections of colonial history, and which are in appropriate keeping with the gloomy character of the surrounding scenery.[10]

The Hudson's abandoned fortification structures were noted as the exception to the rule, the precious few ruins America had to offer, and they became an essential stopping point on any thorough tour of the river. To the British actress Fanny Kemble (1809–1893), who visited the ruins of Fort Putnam in 1832, they offered all the appeal of the Parthenon: "The beauty and sublimity of what I beheld seemed almost to crush my faculties . . . I felt dizzy as though my senses were drowning—I felt as though I had been carried into the immediate presence of God. Though I were to live a thousand years, I never can forget it."[11] Later Fort Putnam appeared in Lossing's *The Hudson*, and later still in William Cullen Bryant's (1794–1878) *Picturesque America*, published in 1874: "The ruins of the fort are themselves picturesque, with that beauty of ruins that is so rare with us in America—the nameless charm that, even for the least sentimental, always surrounds an old, decaying structure that has played its part in the world, and seems resting and looking on dreamily, only an observer now, and not an actor."[12] For those who couldn't hang Cole's *Fort Putnam* in their parlor, views of these Hudson Valley ruins were reproduced in Currier & Ives–type prints, and in early stereoscope view cards.

Though less recognized, there were other, more ordinary ruins along the Hudson as well. Away from the remote mountain landscapes depicted in the paintings of the Hudson River School, industrial development had already left its mark on the river. By the middle of the nine-

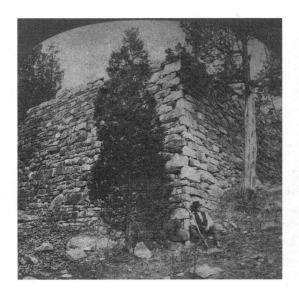

teenth century, the Hudson Valley could aptly be described as the cradle of American industrialization. As industrial advancements left older factories obsolete, many of the region's early industrial facilities, especially old iron furnaces and gristmills, were abandoned. As historian Judith Richardson has written, "With their slowly crumbling, Gothic-tower-like furnaces, in a period when some Hudson Valley residents were importing and even building ruins to fill a perceived gap in misty historical associations, abandoned iron works were ripe even in the first half of the nineteenth century for romantic interpretation."[13] A number of nineteenth-century writers used ruined iron furnaces as evocative backdrops for works of fiction and nonfiction: "the scene is lovely and to the last degree picturesque," wrote Elizabeth Oakes Smith (1806–1893) in an 1848 novella set at one such site in Rockland County. "One entire stone wall, with its low arch, is yet standing, covered with wild vines, together with many tottering vestiges, in the midst of which tall trees have sprung up, and now wave their luxuriant branches in melancholy beauty over the decay and the solitude of years."[14]

Abandoned mills from the valley's early settlement likewise received the attention of local ruin seekers. Writes Richardson, "the general rise of Hudson Valley industry in the nineteenth century inevitably produced further instances of industrial failure—adding to the landscape not only decaying furnaces but also dilapidated factories, abandoned quarries, and overgrown railroad tracks."[15] Along with ruined fortification structures associated with the War for Independence, these early industrial ruins were commonly illustrated in popular stereoscope view cards, with romanticized titles such as "Old Mill on the Hudson," and "The Old Mill at Tarrytown—a Relic of the Revolution." Bryant's *Picturesque America* included an etching of an often-illustrated mill ruin on the Hudson at Highland Falls. What appears to be a more anonymous abandoned

Stereoscope view cards illustrate the popular understanding of ruins as part of a picturesque ideal in the nineteenth century. *Left:* the ruins of Fort Putnam, which overlook the Military Academy at West Point. *Right:* a ruined mill at Highland Falls, a short distance downstream. Courtesy New York Public Library.

mill figured into an 1860 painting by the Hudson River painter Jervis McEntee (1828–1891), titled *Autumn, Mill Stream*. "The Autumnal view augurs the end or metaphorical death of the year," wrote a museum curator in describing the painting: "The abandoned structures (the wooden building whose peaked roof pierces the horizon and the stone hearth directly below it) also suggest the passing of time by introducing the motif of the ancient ruin in New World terms."[16]

While some of the valley's early industrial sites fell to ruin, a great migration of farmers left the hinterlands scattered with fallow fields, abandoned barns, and shuttered farmhouses. Beginning in the 1840s, the exhaustion of upland agricultural lands, the opening of the American West, and a migration to industrial jobs in mill towns and larger cities brought an agricultural exodus that left thousands of abandoned farmsteads in the Hudson Valley and New England. Census records reflect this widespread trend. The population of the town of Milan, an agricultural community in northern Dutchess County, fell from 1,725 in 1840 to only 622 in 1930.[17]

Many farms remained active on healthier soil. But much of the abandoned agricultural landscape would be left to the elements: soon the fields turned back to forests, the barns disappeared, and the abandoned houses fell in on themselves. Later much of the abandoned farmland, particularly in mountainous areas such as the Catskills, the Berkshires, and the Shawangunks was made part of state park land. Today old stone walls and foundation pits in the woods testify to this period in the history of Hudson Valley ruins.

Closer to civilization, grander ruins began to appear in the form of abandoned river estates. Especially in southern Westchester, the opening of the Hudson River Railroad in 1849 spurred the construction of dozens of riverfront mansions that served as weekend homes for wealthy New York City businessmen, some of whom used the railroad to commute to their offices in the city. Later in the century, economic downturns, personal financial crises, the increased popularity of places such

Jervis McEntee, *Autumn, Mill Stream*, 1860. This work is thought to depict a rural landscape in Ulster County, near McEntee's Calvert Vaux-designed studio at Rondout. "The abandoned structures . . . suggest the passing of time by introducing the motif of the ancient ruin in New World terms." Courtesy the New-York Historical Society.

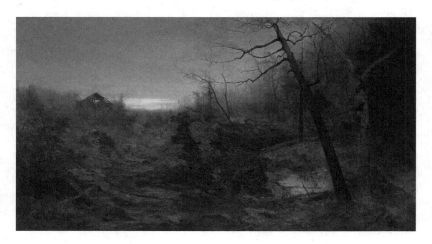

as Long Island for summer homes, and high maintenance costs associated with these lavishly built estates led many to abandonment. The phenomenon was recorded in a number of late-century travelogues, which offered wistful accounts of these newfound American ruins, penned in the spirit of the English Romantics. An 1882 article in the *New York Times* summarized the situation under the headline "Ruins along the Hudson": "A picture of desolation is to be seen on the top of Mount Pleasant," where an abandoned 218-acre estate near Dobbs Ferry, called Monte Rio, was one of several going to seed:

> For well nigh 15 years it has been tenantless. To-day naught but neglect is seen. . . . The foundations have settled, the piazzas are rotting away, the frame work is becoming distorted, and gradually the house is going to pieces. In one of the towers is a clock. On its weather-beaten face a single hand loosely hangs, seemingly ready to drop off at every gust. The spiders have curtained the windows with their webs, dust has settled thick upon the furniture within, and, peering through the broken slats, as dreary a sight is seen inside as out.[18]

At last it seemed the Hudson was beginning to rival the Rhine with ruins of its own—crumbling fortifications from the War for Independence, overgrown industrial sites, deserted farms, even ruined palaces—romantic vestiges of historical association that Claude Lorrain or Piranesi, Wordsworth or Coleridge, even Cole or Irving might have found nearly as enchanting as the temples of Paestum. An 1878 writer in the *New York Times* declared almost triumphantly:

> If . . . the Rhine must be granted superiority in legends and antiquities, the Hudson must not be entirely ignored in these regards. Indeed, the North River is extravagantly furnished with ruins of taste [though] the nature of these ruins is peculiar. A paradox can be made of their age and appearance, for most of these ruins are comparatively new. But in this they necessarily resemble all our monuments and institutions. Hence they lack the harmonious mellowness acquired only by age, and they also miss the veneration due them.[19]

"The Hudson's ruins may not be so complete as those of the Rhine," added the author of "Ruins along the Hudson," "but a quarter century hence there bids fair to be no end of shapeless piles and moss and ivy grown sculptures."[20]

A quarter century later it wouldn't matter. No sooner were ruins in the Hudson Valley accepted and understood in the terms of the Romantic tradition than the centuries-old charm of picturesque decay began to fade in popular appeal. In the twentieth century, the Romantic tradition grew ever more removed from the mainstream. As author Rochelle Gurstein has written in the *New Republic*, "Today, the picturesque is thought

of as the rather minor aesthetic key of the quaint or the pretty or it is associated with things old fashioned, even insipid or maudlin."[21] Especially in the second half of the new century, vast economic and social changes in the Hudson Valley would lead to a very different popular understanding of ruins.

The Forgotten Ideal: Hudson Valley Ruins in the Twentieth Century

Just as the Hudson Valley's lack of ruins created a sense of cultural inadequacy in the nineteenth century, the very presence of ruins gave rise to a new kind of self-consciousness in the twentieth. Swept by vast change, the valley became a repository of ruins after the 1950s. Economic and cultural shifts brought the abandonment of myriad industrial sites, farms, estates, transportation infrastructures, and civic and commercial institutions—and the profound decline of urban centers—along the river. In some cases historians or artists recognized these ruins for their cultural or picturesque value. But more often they were condemned as symbols of the region's economic stagnation and torn down.

In the early part of the twentieth century some ruins found a new niche with the rise of the preservation movement. If not depicted as places of picturesque allure, they gained attention as threatened historic sites in need of documentation. This view was not new: the pragmatic drive to document vanishing relics of antiquity had played a role in the study of ruins from the very beginning. This was particularly evident in the work of Piranesi, and of course it was demonstrated through the centuries in the rise of archeology as a field of study. As time went on, the documentary study of ruins expanded in scope to include Gothic buildings and, as early as the 1850s, more modern ruins such as those on the Hudson.

The brewing interest in preservation was perhaps best articulated in the nineteenth century by the English writer and critic John Ruskin (1819–1900), for whom ruins—especially Gothic ruins—struck a chord both picturesque and pragmatic. Ruskin promoted the idea that the process of aging and weathering was what perfected good architecture, that age was a building's "greatest glory." He wrote of "the mere sublimity of the rents, or fractures, or stains, or vegetation, which assimilate the architecture with the work of Nature, and bestow upon it those circumstances of colour and form which are universally beloved by the eye of man."[22]

Nonetheless, Ruskin recognized that this "superinduced and accidental beauty is most commonly inconsistent with the preservation of original character." Often, he found the decay that so enhanced his favorite buildings seemed also to foreshadow their impending doom. "I have . . .

suffered too much from the destruction or neglect of the architecture I best loved," he wrote in the preface to his *Seven Lamps of Architecture* in 1849.[23] Later, architect Russell Sturgis (1836–1909) wrote of Ruskin that his "indignation was roused by the wanton destruction of so many [Gothic buildings]. . . . His emotion grew to frantic impatience that he could not hope to preserve even an adequate set of illustrations of buildings that were perishing before his eyes by the two processes—demolition and restoration. Had photography been more advanced as a practical art . . . his feeling of distress . . . would have been a little tempered by the possibility of [putting] together a great collection of photographic reproductions."[24]

The link between ruins and preservation appeared on the Hudson at Fort Putnam. In a narrative evocative of the infamous quarrying of the Roman Colosseum, Benson Lossing wrote in the 1850s that Fort Putnam had been "speedily disappearing under the hands of industrious neighbours, who were carrying off the stone for building purposes, when the work of demolition was arrested by the Government. Its remains . . . are now carefully preserved . . . and we may reasonably hope that the ruins of Fort Putnam will remain, an object of interest to the passing traveller, for more than a century to come."[25] Preserved Fort Putnam would be—but not as a ruin. In 1909 the crumbling hulk was partly restored, and then in 1976 it was almost completely reconstructed to re-create its original condition.

After sites of Revolutionary importance, the first places to gain the attention of Hudson River preservationists were those associated with the period of Dutch settlement. This was especially true after the Dutch Colonial Revival movement that took root in the late nineteenth and early twentieth centuries, evidenced in architecture and in the formation of groups such as the Holland Society, which formed in 1885.

By the beginning of the twentieth century, many of these early colonial buildings had fallen into disrepair. "There are many which long ago passed from the original owners and are lived in now in squalor by laboring aliens," wrote the historian Helen Wilkinson Reynolds in a 1929 survey called *Dutch Houses in the Hudson Valley before 1776*.[26] Still others were left abandoned to fall into ruin, such as the Ulster County house of Coenradt Bevier, which Reynolds found "a pitiful wreck, abandoned by the fast vanishing native population in the period of the incoming alien and of the cheap, frame dwelling, equipped with modern conveniences."[27] The book's introduction, written by Franklin Delano Roosevelt (1882–1945), carried forth a Ruskinian sense of now-or-never urgency:

> The Genesis of my interest in *Dutch Houses in the Hudson Valley before 1776* lies in the destruction of a delightful old house in Dutchess County, New York, when I was a small boy; for, many years later, in searching vainly for some photograph or drawing of that house, I came to realize

that such dwellings of the colonial period in New York as had stood until the twentieth century were fast disappearing before the march of modern civilization and that soon most of them would be gone.[28]

Thus came a new, less romanticized attention to Hudson Valley ruins. Reynolds illustrated her book with high-quality plates by photographer Margaret Brown, one of several Hudson Valley photographers in this period, such as Waldron Polgreen, whose work sought to document these vanishing landmarks.

The preservation movement gained momentum as the century progressed, both in the Hudson Valley and elsewhere, and more recent buildings were eventually recognized as worth keeping around. As they did for Ruskin, ruins posed a challenge to preservationists. The right amount of neglect could actually be a good thing: poverty, it has often been said, can be the greatest agent of preservation, for without money it is difficult to tear a building down or to make alterations that change its character. If neglected for too long, however, a building becomes a ruin; and, in the Hudson Valley of the twentieth century, even the most historic ruins proved vulnerable to being labeled eyesores, attractive nuisances, and were targeted for demolition.

Especially after the 1950s, a growing number of ruins appeared along the length of the river, evidence of the region's shrinking industrial base, declining urban centers, and a variety of other fundamental changes. In the latter half of the twentieth century ruins represented job loss, economic stagnation, and poverty—social problems that began to affect a growing number of those who lived along the river. These conditions led the public's understanding of ruins to grow increasingly negative. With the notion of picturesque decay all but forgotten, there were no Irvings or Coles to promote a perception of these places in romantic terms: many came to view these ruins simply as obstacles to economic recovery.

Poverty served as an indirect agent of preservation in these decades. With little financial impetus to justify their redevelopment, many abandoned buildings were left undisturbed. What money there was to address the problem of these decaying buildings usually came from the state or federal government. As the state Conservation Department funded the destruction of ruins such as the Catskill Mountain House, local governments used federal urban renewal funding to bulldoze entire blocks of decaying buildings in cities such as Hudson, Kingston, Poughkeepsie, and especially Newburgh. By the mid-1970s, the self-imposed gross physical destruction that came with urban renewal left these towns with decimated streetscapes that evoked scenes of firebombed European cities in the aftermath of the Second World War. The irony was that while European cities spent the postwar period rebuilding, America spent the same period tearing its own cities apart.

Many other ruins sat untouched for the duration of the century. The

1960s and '70s brought a time of relative tranquillity on the Hudson. River industries declined. Though many parts of the valley experienced marked population growth in these years, that growth did not follow traditional patterns of development, thereby avoiding the riverfront (which was characterized by pollution problems and decaying industrial buildings) and old downtown areas alike. Development in this period concentrated instead on undeveloped, sometimes abandoned agricultural land. By the last decades of the century, this left the valley scattered with a large number of abandoned historic buildings that had survived years of neglect to become picturesque reminders of an earlier era. But an impending wave of new development stood poised to threaten their continued survival.

The Last Judgment: Ruins and Modern Development Pressures

Almost before anyone noticed, a new tide of economic prosperity arose at the end of the twentieth century, especially in the lower reaches of the Hudson Valley, as newcomers mostly moving north from the New York metropolitan area began filling the void left by the valley's fleeting industrial base. With this new era of prosperity has come a wave of construction to keep pace with the growing population. Although the region encourages tourism by promoting its rich history and numerous historic sites, pressure from this new development has resulted in the loss of many historic buildings in the Hudson Valley that had fallen on hard times in the lean years of the mid-to-late twentieth century. While neglect may have indirectly functioned as an agent of preservation in the 1960s and '70s, by the beginning of the twenty-first century it became perhaps the single greatest enemy of the region's historic buildings.

Of ninety-one National Historic Landmarks identified as endangered in a nationwide survey published by the National Park Service in 2004, sixty-two—fully two-thirds of those listed—were threatened by "deterioration."[29] Not coincidentally, only four years earlier the National Trust for Historic Preservation included the entire Hudson River Valley on its list of the country's "Eleven Most Endangered" historic places. At least seventeen of ninety historic properties on a government listing of National Heritage Sites within the Hudson River Valley National Heritage Area were once or are presently all or partly in ruin. With encroaching development threatening even well-preserved historic sites, abandoned landmarks that bear the stigma of "attractive nuisances" have become especially vulnerable.

Despite the region's economic resurgence, ruins continue to be generally characterized as "blight." In a region long accustomed to seeing these buildings simply as eyesores, such places continue to be dismissed

as being worthy only of the wrecking ball. There is little regard for their historic importance or the potential to restore them, much less for an understanding of ruins in terms of the long-forgotten Picturesque ideal of the nineteenth century.

This negative image is particularly problematic for abandoned industrial buildings, whose architectural significance—though well understood by many artists, designers, and historians—remains an abstract concept to some who live around them. This is despite the prominent and successful rehabilitation of several such buildings, most visibly the conversion of an abandoned box-printing factory in the city of Beacon into Dia:Beacon, a gallery of modern and contemporary art. It almost instantly became one of the preeminent cultural destinations in the region when it opened to international acclaim in May 2003. The project is regarded as an enormous leap forward for the revitalization of the city of Beacon.

Yet two years later, at Hastings-on-Hudson, many welcomed the demolition of a similar industrial ruin. "We're very excited," one local official said of the demolition of the Anaconda Wire and Cable plant there in the summer of 2005: "The fact that it's coming down is very symbolic for us that the waterfront redevelopment is really moving forward." Local newspaper coverage offered a window on public sentiment toward the plant's long-abandoned buildings: "Residents expressed satisfaction that the village will be rid of the buildings, which have fallen into disrepair. 'It would be nice to get that eyesore out of the way,' said Deborah G——, a 64-year-old yoga teacher, as she walked in downtown Hastings. 'It's ugly.'"[30] Much of the plant was demolished later that year, though the site remains unused as plans for redevelopment are still being formulated.

The same image problem plagues more quaint ruins as well. When a developer near the city of Poughkeepsie planned to demolish a derelict nineteenth-century cider mill, listed on the National Register of Historic Places, in order to build a subdivision of single-family homes called "Cider Mill Estates," local preservationists trying to save the building faced opposition from some residents who saw the mill as "an eyesore that decreases property values and should be torn down."[31] In northeastern Columbia County, the long-vacant Lebanon Springs Union Free School faced similar antipathy when it was cited for building code violations, though it too had been listed on the National Register: "The only viable option is to have it razed, school officials say . . . 'We have no real attachment to the building. It's an eyesore.'"[32] Historic sites not recognized on the National Register have an even harder go of it.

Developers looking to build strip malls, gas stations, or "townhouse style" condominiums to accommodate the valley's growing population have only to label such buildings "beyond repair" in order to gain popular and political support for their proposals. If a historic building hasn't yet deteriorated enough to be labeled an eyesore, it can be left to rot for

several years until it can be written off as "too far gone." In the mean-
time, left unsecured, these buildings are vulnerable to vandals and, not
uncommonly, destruction by fires found later to be "suspicious."

In fact it is unusual when such buildings actually are beyond salvage.
Not only are examples of landmarks brought back to life after decades
of abandonment common, they include some of the best-known historic
sites in the region. At least eight such buildings are included on the
federal government's list of ninety National Heritage Sites in the Hud-
son Valley. In addition to Dia:Beacon, these include Boscobel, a Federal-
style mansion near Cold Spring; the Van Wyck Homestead and Mount
Gulian, two colonial-era homes with Revolutionary War significance in
Fishkill; and the Burden Iron Works museum at Troy.

Other well-known landmarks rescued from advanced states of decay
include the small Greek Revival–style Chapel of Our Lady, overlooking
the river at Cold Spring, which stood decaying for sixty years before it
was restored in the 1970s; the frequently photographed Fitch Bluestone
Company office building at Kingston, now a residence; Union Station
at Albany, which has been adapted to house a bank; and the Saugerties
lighthouse, which remained abandoned for more than thirty-five years
until it was restored to house a bed-and-breakfast in 1990. Though once
in ruins, these buildings now appear in postcards and calendars celebrat-
ing the region's historic character, which in turn generates tax revenue
by making the region attractive to tourists and businesses alike. They
demonstrate the potential of buildings that remain neglected today.

One of the most confounding things about the loss of these ruins is
how unnecessary it is. As the demand for development increases, com-
munities in the region become ever more empowered to have a say in the
direction development takes. But conventional wisdom remains guided
by a notion formed during the hard years of the late twentieth century,
when it appeared that the river towns couldn't give away waterfront
property. During this period, government officials gave profit-driven
developers a great deal of liberty in shaping communities in the region.
Concerns for historic preservation were stifled for fear of antagonizing
developers and leading them to "walk away" from projects that promised
the potential of increased tax revenue. Gas stations and fast-food restau-
rants opened on the sites of historic buildings throughout the region. In
many cases, botched development schemes left empty lots where impor-
tant landmarks once stood.

Today things have changed. With demand for development high,
Hudson River communities can exercise greater say in what course this
growth takes. Local governments can enact and judiciously enforce pres-
ervation laws, channeling the rising demand for development toward
more frequent restoration of long-neglected landmarks, which will
enrich the communities in which they stand with something more than
tax revenues. For as this book will show, these buildings are an integral
part of the Hudson Valley's history and culture. Forlorn as they may be,

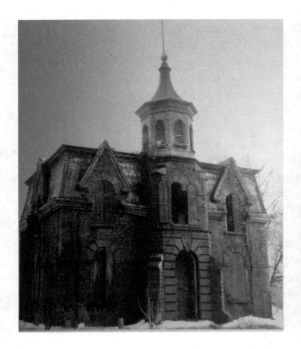
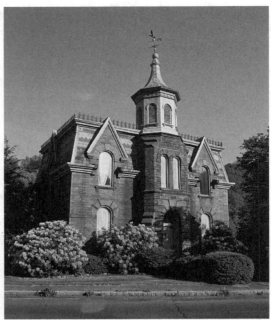

The S. & W.B. Fitch
Bluestone Company office
building stood abandoned
for decades (*left*) before it
was restored as a residence
(*right*) in the early 1970s.

these ruins collectively have an enormous value to the region's cultural identity. To write them off as eyesores is to underappraise that value, and to risk a great and irreversible loss.

In 2004, the New York State Department of State published a guidebook titled *Opportunities Waiting to Happen*, intended to encourage developers to further explore adaptive reuse options for abandoned buildings: "A growing number [of communities] have begun to look at abandoned buildings not as liabilities or useless relics, but as opportunities waiting to happen. These residential, commercial, industrial and institutional ghosts are part of the community's heritage and are being dramatically brought back to life, reinvigorating the community."[33]

But unfortunately it seems this assessment may have been somewhat optimistic. The pattern established in the twentieth century persists today, and these ruins continue to disappear. In the meantime, open space in the southern half of the valley is becoming scarce, as old agricultural land is being subdivided for the development of condominiums and single-family houses. This change is especially pronounced in the mid-Hudson counties of Orange, Ulster, and Dutchess, where some communities have felt compelled to enact moratoriums on new construction in an attempt to rein in almost out-of-control development. Together with the loss of historic landmarks, this onslaught of suburbanization is drastically altering the traditional character of the region.

In his book *The Geography of Nowhere*, the writer James Howard Kunstler speculated that a time will come when suburban development of the kind now sweeping the Hudson Valley and the rest of the country, which is entirely dependent on the automobile, will no longer be sus-

tainable, or even functional. "The Auto Age, as we have known it, will shortly come to an end," he wrote:

> Possibly only the rich will be able to own cars, as in the early days of motoring; the rest of us may rent one when we need it, for a day in the country or a vacation. This was how society managed with the horse and carriage . . . and this is how many Europeans still manage with cars. If we are lucky, and wise, and we can intelligently redesign our towns to eliminate the absolute need to drive everywhere for everything . . . we may possibly be able to adapt to the new realities without a lot of political trouble.[34]

What such a future may hold for the sidewalkless residential subdivisions sprawling their way up the Hudson leads one to view the built environment in a different light. Just as the river's business and political

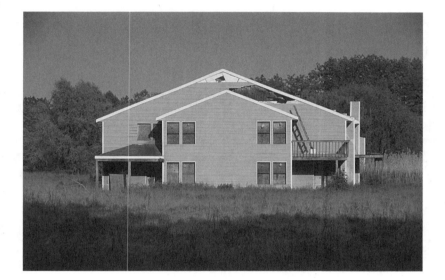

A glimpse of what is to come? Abandoned facade with vinyl siding near Rosendale, Ulster County. June 2005.

leaders a century ago could never have imagined the wholesale destruction of their cities that came with urban renewal, few developers today seem to anticipate how their buildings might sustain fundamental changes such as those the river saw in the twentieth century. Looking now at the ruins left in the wake of those changes, one is compelled to wonder whether age will be the "greatest glory" of the buildings rising over them, whether the elements "which assimilate architecture with the work of Nature" will bestow upon their vinyl-sided facades the "circumstances of colour and form which are universally beloved by the eye of man."

THE UPPER HUDSON

ALBANY AND
RENSSELAER COUNTIES

ONE HUNDRED FIFTY MILES below its source, the Hudson flows past the state capital at Albany. For 150 miles more it will continue its journey south, through the valley that bears its name, to New York City and to the sea. Already along its course the river has met places rich in history. But it is below the capital that the Hudson assumes the majestic character for which it is known around the world. Passing innumerable sites that once helped to steer the cultural, industrial, and political development of a nation, the river moves along with apparent indifference, though it seems there might be a thousand stories for every mile of riverbank between here and the Atlantic.

Flanking the Hudson as it makes its way past the capital are the counties of Albany and Rensselaer. It was here, just below the future city of Albany, that in 1609 Henry Hudson abandoned hopes that he had found a shortcut to the Far East and turned south to continue his search elsewhere. Five years later, the Dutch built a fortified trading post near the same spot, on an island in the river. After recurrent flooding they built a new post, called Fort Orange, on higher ground. By the 1650s two communities had emerged here: Beverwyck, administered by the Dutch West India Company, and Rensselaerwyck, part of a veritable fiefdom overseen by the patroon Killaen van Rensselaer. Collectively these represented one of the most important European settlements in North America.

With the British takeover in 1664 New Netherland became New York, and the settlement around Fort Orange was renamed Albany. In 1683 colonial governor Thomas Dongan divided New York into twelve

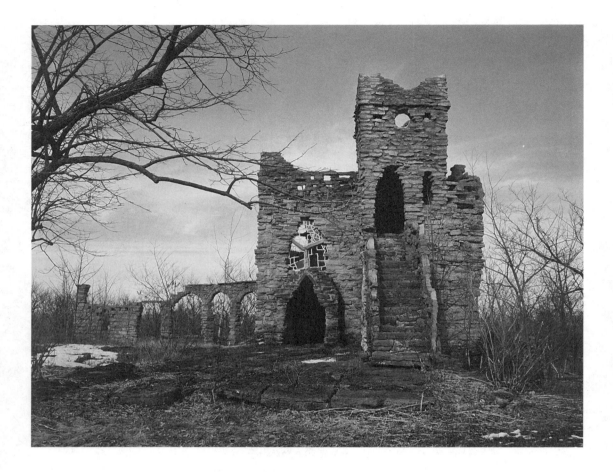

Federalberg, near New Scotland, Albany County

Perched on a rocky cliff of the Helderberg Escarpment overlooking Albany, fifteen miles to the north, are the ruins of the home and pottery studio of Bouck White (1874–1951) and his "Chapel of the American Dream," pictured here, a fieldstone structure resembling a Gothic Revival garden folly. In his obituary, the *New York Times* described White as a philosopher, onetime Socialist, pottery maker, and "hermit of the Helderbergs." Admired by Upton Sinclair, White was an active critic of industrialists including John D. Rockefeller, Sr., whom he blamed for various social ills.

White built his Albany County estate, which he called Federalberg, in 1933 after spending five years living in Paris. His house, Middlemight, also contained a studio where he produced "Bouckware," a nonfired pottery, using a technique he perfected in Paris. After a fire in the 1940s damaged the house and studio, a small part of the ruins was rebuilt as a residence; the new house is still a private home.

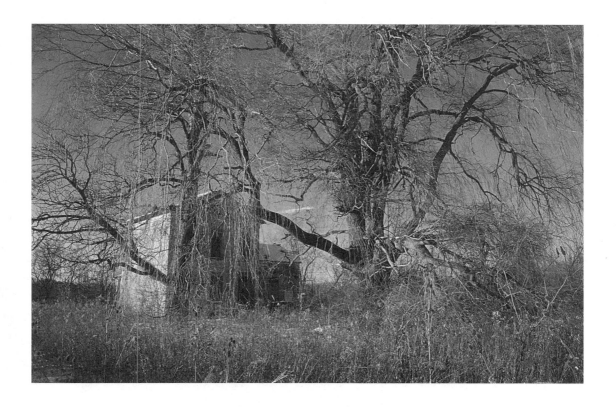

F. Sheffdecker House, Bethlehem Center, Albany County

Built c. 1850, this brick farmhouse represented a late example of Greek Revival residential architecture. Though the Greek Revival reached its peak in America during the 1830s and '40s, its popularity spanned thirty years, from the 1820s through the 1850s. Identified on early maps as the home of F. Sheffdecker, beginning around 1900 the property hosted a dairy farm run by the Mosher family. The business closed in the early 1960s, after which time the house and farm sat abandoned. Suburban development pushing out from Albany, just a few miles to the north, finally caught up with the old farm forty years later, when it was bulldozed c. 2001 to make way for a Wal-Mart shopping center. The destruction of local landmarks for big-box retail development is part of a nationwide trend that continues to erode the distinct character of communities throughout the Hudson Valley.

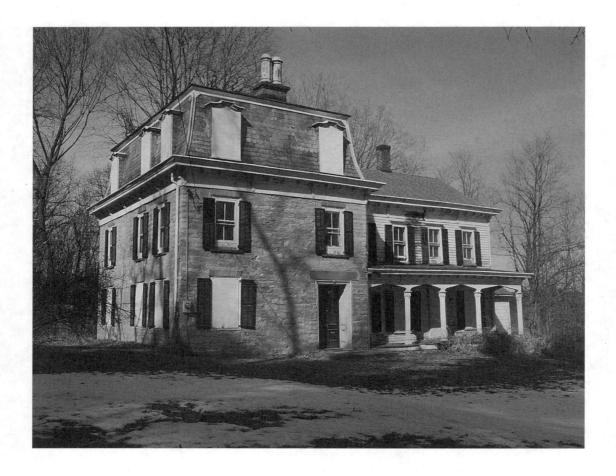

Tobias T. Waldron House, Coeymans, Albany County

The older, wood-frame portion of this house is thought to have been built for the Ten Eyck family in the middle part of the eighteenth century. The stone portion to the west probably dates from the early 1800s. Tobias T. Waldron purchased the home in 1819. Mid-nineteenth-century alterations include the bracketed cornice, mansard roof, and Gothic Revival veranda. In recent years the house has deteriorated under the ownership of the LaFarge Cement Corporation, which operates the nearby portland cement factory.

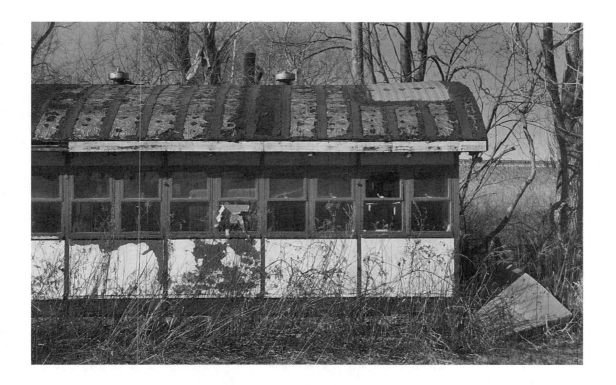

Bridge Diner, Selkirk, Albany County

Even in a state of abandonment, the Bridge Diner is believed to be the best-preserved New York State diner made by the Bixler Manufacturing Company. Built between 1931 and 1937, the diner served motorists traveling between Albany and river towns to the south. Bixler diners are noteworthy for their extreme width and high ceilings; diners of that period were usually very small and offered only counter service. Bixler diners also had a unique ventilation system consisting of small transom windows above each window and several small ventilating cupolas on the rooftop. Other surviving Bixler diners have been remodeled to the point where distinguishing details have been removed or covered by modern siding and faux-mansard roofs.

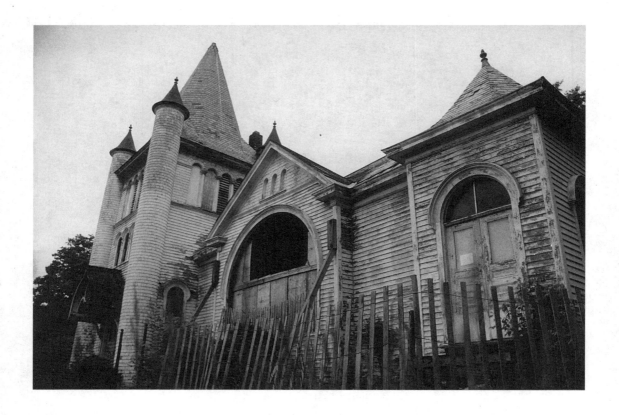

Dutch Reformed Church, Nassau, Rensselaer County

The Dutch Reformed Church may be the most visible living remnant of the Hudson Valley's Dutch roots. Nassau's Reformed congregation organized around the time the village was settled in the 1780s. In 1901 it hired architect Samuel Kingman to build a new church. Situated on Church Street, the building served the congregation until the late 1980s, when a new minister cited declining membership and the need for costly repairs as cause to abandon the old church and move services into an adjacent religious education building. Despite its listing on the National Register of Historic Places, the building was demolished in 2001 over the objections of local preservationists.

"shires," or counties. Most of these were named to honor James, the duke of Albany and York, who two years later ascended to the British throne as James II. Though his reign proved short-lived—with the Glorious Revolution in 1689 James II was deposed and forced to flee to France, where he died in exile in 1701—the counties of the Hudson River continued to bear witness to his legacy. To the south, the island of Manhattan belonged to New York County. Along the middle Hudson, there were Orange, Dutchess, and Ulster counties, named respectively for James's son-in-law, his wife, and his earldom in Ireland. Farther north, the lands along the upper Hudson fell under the dominion of the county called Albany.

The original boundaries of Albany County were immense, including not only present-day Rensselaer, Columbia, and part of Greene counties but all of northern New York, as well as what is now the state of Vermont. In time large portions of the county were separated off. In 1791 what remained of Albany's holdings east of the Hudson broke away to form Rensselaer County, named for the landowning family that had come to the area in 1629.

As the river flows south from the urban centers of the capital district, its banks quickly grow rural. These upper reaches of the tidal Hudson were once scattered with small islands, most of which were joined together and to the mainland when mud dredged from the river bottom was dumped in shallow waters away from the navigation channel. Along this stretch of the river three old landing towns, Coeymans, Castleton-on-Hudson, and Schodack Landing, have stood since the seventeenth century. In the short space of about fifteen miles, the shorelines of southern Albany and Rensselaer counties hold vestiges of Hudson River institutions now all but vanished from points farther south.

Powell and Minnock Brick Company, Coeymans

At the dawn of the twentieth century, more than 130 brickyards operated on the Hudson between New York City and Albany. By century's end only one remained, the Powell and Minnock Brick Company at Coeymans, some fifteen miles below Albany on the river's western shore. Its closure in 2001 brought an end to more than three centuries of brick making on the Hudson. Now, as its old buildings fall into ruin, this last of the Hudson River brickyards seems poised to go the way of its predecessors, and fade into memory.[1]

Before the Hudson became a gallery of American industrialization, before even there was a place called New York, brick making established itself as a mainstay of life on the river. As early as 1630 there existed a trade in brick on the Hudson at Fort Orange, today called Albany. By 1647 another *steenbakker*, as the Dutch called the makers of their brick,

It is much more difficult today to simply drive up, park your car, and take a walk along the shore. It was easier in the time of decaying waterfront industry, and I personally preferred it. The few people you met were friendly lovers of nature and of the Hudson, instead of scowling parking lot attendants and deputy law enforcement officers telling you to "move on."
—Arthur Adams, *The Hudson Through the Years,* 1996

◆

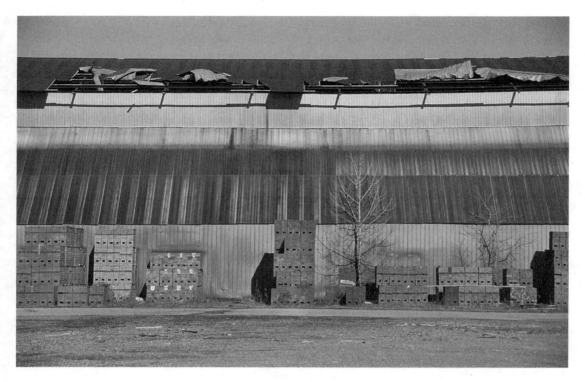

This broadside view of the kiln sheds captures the bold simplicity of brickyard architecture. Decay is already evident in damage to the roof. Leftover paletts of unsold brick remain where they were left when the yard closed in 2001.

had set up shop at Nieuw Amsterdam. Though brick was a common building material in Holland and the other European countries from which the settlers came, scarce supply in the New World limited its use to important public buildings and the homes of the very wealthy. While more brickyards opened throughout the seventeenth and eighteenth centuries, construction on the river remained reliant on stone and wood, with only minimal use of brick for fireplaces and chimneys.

In the nineteenth century brick came to dominate the streetscapes of towns and cities along the Hudson and across the country. In New York, devastating fires in the 1830s and '40s prompted legislation requiring masonry construction in much of the city. Lined by vast deposits of clay for nearly its entire length from New York to Albany, the Hudson was in an ideal position to supply the metropolis as it built itself into one of the greatest cities in the world. While the Hudson River brickyards supplied builders in all the river towns, it was the enormous New York market that drove the region to lead the nation in brick production by the latter half of the century.

Not surprisingly, most of the yards built to serve New York opened first on the lower Hudson, especially on Haverstraw Bay. In Westchester, Croton Point and Verplanck's Point became early centers of brick making by the 1840s, while across the river Haverstraw grew to become perhaps the largest brick producer in the world. By 1860 there were some sixty-five brickyards in Westchester and Rockland counties, and at one point more than forty yards operated at Haverstraw alone.

After the Civil War the upriver brickyards began to rival the production of the lower Hudson. In the last decades of the nineteenth century, accessible clay deposits around Haverstraw Bay dwindled, causing most of the Westchester brickyards to close. Improved bulk transportation meanwhile made it less expensive to transport vast quantities of brick to New York from farther up the river. Between 1860 and 1890 the number of yards above the Hudson Highlands rose from thirty to more than sixty, and after 1907 the upriver yards would outproduce the yards of the lower Hudson for the duration of the industry's tenure on the river.[2]

The highest concentration of upriver brick makers was in Ulster County, where at one time more than twenty yards operated on a sixteen-mile stretch above Kingston. Other important centers of brick production above the Hudson Highlands included Fishkill in Dutchess County, Roseton across the river near Newburgh, Stuyvesant in Columbia County, and Coeymans, where some ten yards, including Powell and Minnock, operated at the beginning of the twentieth century.

Settled by Barent Pieterse Coeymans in 1673, Coeymans (pronounced "queemans") was one of the oldest landings on the river. By the late 1800s ice harvesting became the dominant industry at Coeymans and other landing towns of the upper Hudson, and it was to enter the ice-harvesting business that A. T. Powell and Thomas Minnock formed Powell and Minnock in 1896. By this time a number of brickyards had already opened at Coeymans to serve markets in both New York and Albany. As the brick industry continued to grow, the Hudson River ice business began to show signs of falling off, and in 1906 Powell and Minnock entered the more lucrative brick trade themselves.

The largest of the yards at Coeymans belonged to a firm called Sutton and Suderly, situated just north of the village, which had formed in 1885 with the partnership of John H. Sutton and Conrad F. Suderly. In 1906 the Sutton and Suderly yard became the scene of one of the most dramatic episodes in the history of labor on the Hudson. Long before the brickyard workers unionized in the 1930s, strikes at the yards were a fairly regular occurrence. One such strike came in May 1906. Demanding higher wages and a ten-hour workday, thousands of men walked out of nearly every yard on the Hudson. While some of the companies shut down, others, including Sutton and Suderly, continued production with a contingency crew of migrant workers.

Early on the morning of May 16, an armed mob of strikers marched on the yards at Coeymans, intimidating the interim workforce and bringing production to a halt. By the time the mob reached the Sutton and Suderly yard, the company's management—including Conrad Suderly himself—had themselves taken up arms and vowed not to be intimidated. When Suderly refused to allow the strikers into the yard, the mob opened fire. Suderly's men fired back but, largely outnumbered, they were forced to retreat by boat from the company dock, and the strikers took the yard. To restore order, the state militia came in from Albany,

setting up camp with about 250 troops on the bluff overlooking the yard. For two days Coeymans remained under siege, until finally the mob disbanded and the ringleaders were arrested. Later an accord was reached and the men returned to work, but three more decades passed before the brickyard workers formally organized.[3]

Production methods at the brickyards evolved significantly through the middle 1800s, and with little exception nearly all Hudson River brick makers adhered to the same techniques for a century thereafter. Over the years many important innovations in brick making came from the banks of the Hudson River, and the brickyards also supported an entire industry in the manufacture of brick-making tools and machinery.

The making of a brick began in the clay pit, where workmen shoveled soft clay into horse-drawn carts for delivery to the brickyard. Once at the plant, the clay was mixed with sand and culm, or coal dust, and pressed into wooden molds, where it took the shape of a brick.[4] First done by hand, the molding process was later accomplished by steam-powered "brick machines." After molding, the newly formed brick came to the drying yard, where they were laid out to dry in the open air.

From there the brick were taken to the kiln sheds. The Hudson River brickyards made almost exclusive use of what was known as the scove kiln. Apart from a shed to protect the kiln from the elements, the scove kiln required no permanent structures. The kiln was formed by the unfired brick themselves, an average of one million per kiln, which were stacked to form a large structure usually fifteen feet high, thirty to forty feet wide, and several hundred feet in length. Small firing tunnels were left running the width of the kiln at its base, spaced about four feet apart for the kiln's full length. In the twentieth century, some brickyards built permanent side walls around the kilns, but otherwise their design

View east toward the river through one of the old kiln sheds. Daylight silhouettes the building's plank siding.

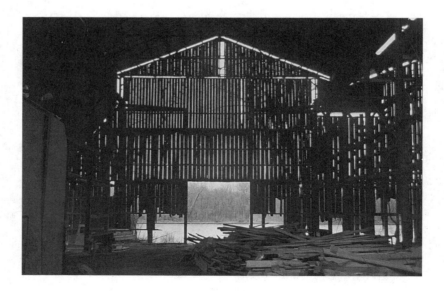

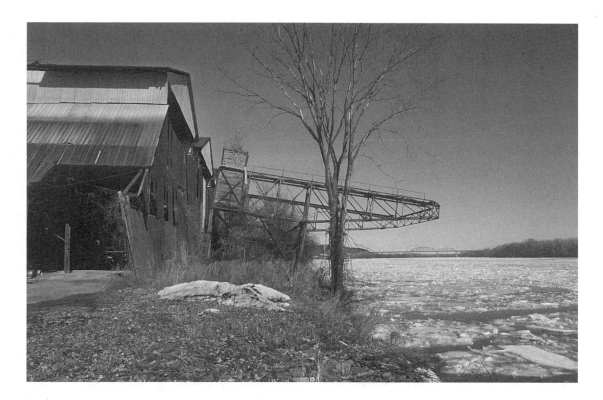

Twentieth-century improvements included gantry cranes and steel kiln sheds like those pictured here.

remained largely unchanged. After firing, the kilns were disassembled and the brick loaded onto barges for shipment.

The architecture of the brickyards was typically rather unsophisticated. The yards used readily available brick in the construction of stables, boiler rooms, chimneys, administration buildings, and machine shops, built in the industrial vernacular of the period. Ironically the yards built their most characteristic structures not of brick but of wood. Up and down the river the yards could be identified by crudely built wooden sheds that housed the brick machines and kilns, with unshingled plank roofs that could be opened in fair weather for ventilation. The long, low kiln sheds were usually built parallel to the river by the docks so that the fired brick could be easily loaded onto barges for shipment.

Until the 1920s Hudson River brickyards operated seasonally, with the plants closed during the winter months as cold temperatures froze clay pits and interfered with the outdoor drying process. This annual cycle encouraged some brickyards to venture into the ice-harvesting industry, and some ice harvesters, such as Powell and Minnock, to go into brick making.

Powell and Minnock entered the brick industry in 1906. Despite the strike, Hudson River brick production peaked that year, with 131 brickyards producing more than 1.3 billion brick. There would be ups and downs in the years to come, but never again would the Hudson River

brickyards produce so many bricks and sell them for such a high price. Overproduction soon became one of the biggest problems for the industry, causing brick prices to plummet by 1910 and forcing dozens of brickyards out of business. The 1910s proved disastrous for the brickyards, and by 1922 only about fifty yards survived in operation on the Hudson.[5]

Times got better in the 1920s, and the increased demand that accompanied the robust American economy brought a revival for Powell and Minnock and the other yards that had survived the downturn of the previous decade. But no sooner did prosperity return than the coming of the Great Depression brought unprecedented hardship. At the same time, increased use of other building materials, such as concrete and steel, further reduced demand for brick. The few remaining Haverstraw brick makers closed during this period. By the time Carl Carmer wrote his landmark history of the river in 1939, he found more brickyards in abandonment than in production, leaving the Hudson, he wrote, lined "on both sides with the picturesque weathered ruins of many yards, their chimneys standing lonely beside tumbled, weed-grown walls and staring, empty windows."[6]

Interior view of a modern kiln shed. This building housed tunnel kilns, which replaced the older scove kilns.

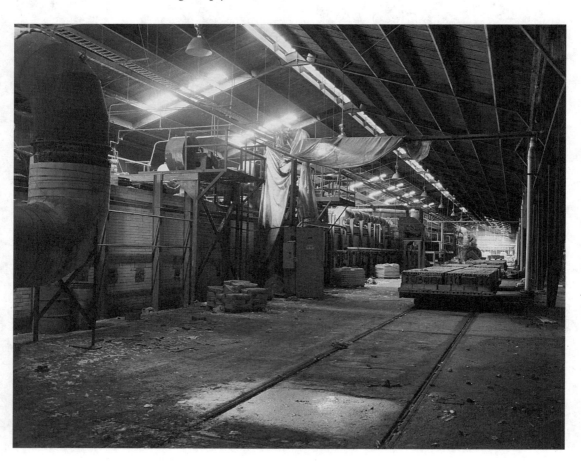

With brick production declared nonessential, the yards sat dormant for the duration of the Second World War. After the war only twelve plants reopened on the Hudson. These included both Powell and Minnock and Sutton and Suderly, which along with the other surviving brickyards enjoyed a resurgence in demand that came with the building boom of the postwar years.

The brief windows of prosperity that came during the 1920s and 1950s enabled the brick makers to modernize their facilities. By the early part of the twentieth century, most of the yards had installed narrow-gauge railways to haul clay in from the quarries. In the 1920s steam-heated drying houses replaced the old drying yards, enabling brick to be dried much more quickly and in any kind of weather. Later, some yards adapted their scove kilns to burn oil, while others experimented with altogether new types of kilns. The old wooden kiln sheds meanwhile gave way to large steel buildings, with gable roofs running perpendicular rather than parallel to the shoreline. Usually built in groups of three or more, by midcentury these new sheds became the most characteristic architectural feature of the remaining Hudson River brickyards, including those at Coeymans.

In the late 1950s the brick market slowed. For a variety of reasons other parts of the country, particularly the southeastern states, could produce brick at a lower cost than the Hudson River yards. Along with depleted clay banks and the need to make costly modernizations to stay competitive, these factors conspired to force the remaining Hudson River brickyards out of business beginning in the late 1950s.

But one yard persevered. By 1963 Powell and Minnock acquired and transferred its operations to the old Sutton and Suderly yard, which had closed after nearly eighty years in the business. After relocating, Powell and Minnock embarked on a campaign of improvements that enabled it to outlast every other yard on the river. Instead of clay from the adjacent quarry, the company would make brick using shale from a mine situated a few miles west of the plant.[7] The firm installed new machinery to produce what is known as extruded brick. New, more efficient tunnel kilns meanwhile replaced the old scove kilns. In this process the dried brick were fired after being loaded onto small flatcars that moved on rails through long superheated tunnels. While the firm built some new structures, some of the old Sutton and Suderly buildings survived the reconstruction and remained in use until the end.

In 1969 the descendants of its founders sold the company to the General Dynamics Corporation, a defense contractor known for aircraft and submarine building, which was then diversifying into the construction industry. Ten years later, with the closing of the Hutton yard at Kingston, Powell and Minnock became the last functioning brickyard on the Hudson River. General Dynamics ran the company until 1994, when the yard changed hands, eventually passing to a Turkish building materials conglomerate called Isiklar Holdings. Under the name of Powell

Nineteenth-century brickyard structures exemplify the industrial vernacular of their day. This building may date from the initial development of the Sutton and Suderly yard in 1885. Insurance maps from the 1930s identify it as a coal storage shed.

and Minnock the plant continued to operate until October 2001, when it closed during a restructuring of its Turkish parent company and a 350-year-old Hudson River tradition passed quietly into history.

Despite their important role in the river's history, only a handful of structures associated with the Hudson River brick industry have survived, and even these are nearly all in ruins. Many of the upriver brickyards have stood completely abandoned since the day they closed, their ruins now hidden amid dense vegetation. There are crumbling old chimneys at East Kingston and Stuyvesant, and overgrown scove kiln ruins at Malden. Former clay pits at Haverstraw have flooded and been made

into marinas for pleasure boats. At Kingston the old Hutton yard, closed since 1979, remains almost completely intact, though proposed new development would demolish many of its old buildings. Throughout the Hudson Valley, the sites of nearly every vanished brickyard remain marked by stretches of shoreline strewn with old broken brick bearing "frog marks," which identify their makers in bold capital letters.

And then there is Powell and Minnock. After it closed, the company's local management attempted to purchase the plant themselves and resume production. But the yard remained dormant, its old complex of industrial buildings slowly following the path of decay taken by so many brickyards before it. It is a path known well not only to the brickyards but to dozens of vanished Hudson River industries and institutions, once integral parts of life along the river, now extant only in crumbling ruins. With traditional industry no longer driving the region's economy and sprawling development encroaching, it remains unclear what the future holds for the scant remains of the Hudson River brickyards at Coeymans and elsewhere.

Fort Orange Paper Company, Castleton-on-Hudson

Within sight of the office towers at Albany lies the village of Castleton-on-Hudson, where fine old homes stand upon a ridge overlooking the Hudson and nineteenth-century storefronts line Main Street a stone's throw from the river. Though only a few miles from the urban centers of Albany and Troy, Castleton long had a significant industrial base of its own. As it has elsewhere on the river, industry here has declined, and Castleton today has become a bedroom community for the capital city ten miles away. Just north of the village, the abandoned buildings of the Fort Orange Paper Company stand as proof of the industrial decline that has challenged this and many other communities on the Hudson.

Settled by the 1630s, Castleton is one of the oldest landings on the Hudson. Today it is a village within the town of Schodack, which occupies the southwestern corner of Rensselaer County. There are varied accounts of how Castleton got its name: one holds that the native Mahicans had

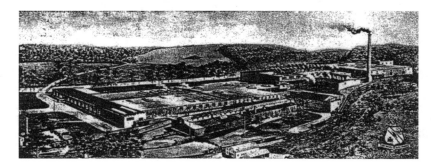

Aerial view from a company newspaper showing the extent of the plant in the 1920s. Collection of the Town of Schodack Historian.

a stronghold here before the arrival of the Dutch. Long after the colony fell to the English, the community remained predominantly Dutch in character, as is evidenced in the names of three creeks that meet the Hudson here—the Muitzes, the Vlockie, and the Moordener—which to this day are identified not as creeks but as kills, a derivation common in the Hudson Valley from an early Dutch word for rivulets such as these. Largest of the three is the Moordener Kill, literally the "Murderer's Creek," which tradition has it was named when the daughter of an early settler was tied to a horse and dragged to her death through the woods during a skirmish with neighboring Indians.[8]

The first documented mills at Castleton appeared by the middle of the eighteenth century, probably on the Muitzes or Vlockie kill just south of the landing. As elsewhere in the Hudson Valley, the first mills in Castleton were grist, saw, or woolen mills, built to supply settlers with the bare essentials. In the first years of the nineteenth century a fulling mill had been built on the Moordener Kill about two miles east of Castleton. The coming of several small brickyards helped build the old landing into a thriving community by the beginning of the nineteenth century. But it was not until the 1850s that any noted milling operations came to take advantage of the impressive falls of the Moordener Kill, situated at the north end of the village a short way up from where the creek meets the river.[9]

This was the Van Benthuysen print paper mill, established in 1856 by Charles van Benthuysen, the son of an Albany printer. By this time many of the small, primitive mills of the seventeenth and eighteenth centuries had given way to larger industrial concerns that manufactured everything from cotton cloth to cast-iron stoves. One of the earliest paper mills on the Hudson appeared at Stuyvesant Falls in neighboring Columbia County in 1801. By the 1850s a number of large paper mills had appeared in the valley, especially at Saugerties in Ulster County, where paper manufacturing became the town's principal industry.

Van Benthuysen's mill was typical of the large modern manufactories that appeared throughout New England and the Hudson Valley beginning in the 1790s. Built of stone, it was considerably larger than the old grist and woolen mills of the previous century. First driven by a traditional overshot waterwheel, the mill later derived its power from a more efficient hydraulic turbine, and later still from steam engines that could power the mill in times of low water or when the creek froze in winter. Eventually its machines ran on electric power. To serve the company's transportation needs a siding was built off the main line of the Hudson River Railroad, which had opened in 1851.

By 1881 the mill was in operation as the Fort Orange Paper Company, a name borrowed from that of the old Dutch trading post established in 1624 at the future site of Albany. The company produced a variety of products from blank ledgers to writing paper and envelopes. Later it ventured into box making, and during World War I it produced folding car-

tons for sugar companies such as Jack Frost and Domino. Despite ownership changes the firm grew quickly, and within a few years it employed about two hundred hands. The drive for continued expansion got the company into trouble later, when Fort Orange was one of thirty-nine firms found guilty of conspiring in a price-fixing scheme in 1910.[10]

A second paper mill opened on the Moordener Kill in 1888. Known as the Oak Grove Company, this firm specialized in bookbinding boards, and later trunk board for travel cases, album board for books, and a variety of products recycled from wastepaper. Eventually two businessmen named Calvin Woolworth and John Graham acquired interests in both Castleton paper mills, and in 1926 the mills were consolidated under the banner of the Fort Orange Company.

By the late 1800s other industries had come to Castleton, including a piano factory and a company that made metal screws. In the 1860s and '70s Castleton became perhaps the most important center of ice harvesting on the upper Hudson. These enterprises typically were owned by local industrialists who lived in the community, served on local boards, and supported local charities. Profits generated at the paper mills and other local industries stayed in Castleton, helping the village to develop as a thriving community with its own commercial and civic institutions shared by local blue-collar and white-collar families alike.

The 1920s and '30s were a peak period for Fort Orange. The company stayed in production through the Great Depression, employing 425 persons who turned out three million folding cartons per day under the direction of company president Colonel Peter Cummings Brashear. During the Second World War much of the mill's production went to the war effort. The company still maintained some commercial contracts, but it operated with a reduced staff of about 130 hands, some of whom worked eighty-hour weeks to meet continued demand.

From an early date, continued expansion led to the construction of more and more additions onto Van Benthuysen's old stone mill. Early additions came in the form of handsome brick industrial buildings typical of the late nineteenth century. Later construction obscured these older buildings with more utilitarian, flat-roofed structures that sprawled out from the original complex, eventually covering a massive footprint. Today the original mill buildings remain swallowed up in a sea of later additions that comprise an eclectic mix representing several eras of industrial architecture, from fieldstone to brick, concrete to steel.

In the twentieth century, the stark, utilitarian facades of modern industrial buildings such as those that took shape by the Moordener Kill at Castleton inspired a new generation of architects. The rise of modernism came first in Europe, where by the 1920s the Bauhaus school and figures such as Walter Gropius (1883–1969) and Ludwig Mies van der Rohe (1886–1969) applied machine-age functionality to architectural design. After the Second World War, modernism became the guiding force in American architecture. In the latter half of the century, Ameri-

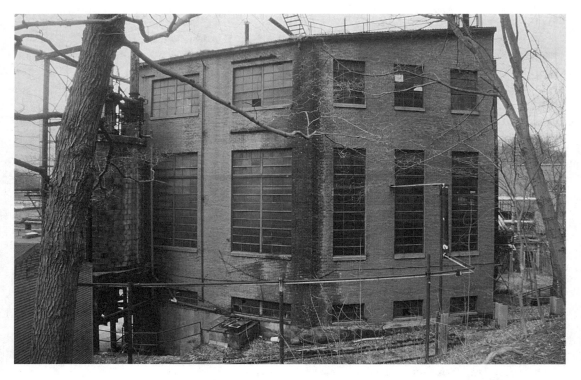

The straightforward, utilitarian character of industrial buildings such as these inspired artists and architects in the twentieth century.

cans such as Louis I. Kahn (1901–1974) continued to apply the industrial aesthetic to all forms of architecture, using materials such as reinforced concrete to form unadorned facades that evoked the straightforward simplicity of factory buildings. Artists also drew inspiration from industrial structures, as is seen in the work of Charles Sheeler (1883–1963), and Ralston Crawford (1906–1978), whose paintings depicted steel mills and oil tanks. Today, the work of artists such as the photographers Bernd and Hilla Becher demonstrates the ongoing fascination with industrial form.

The Fort Orange plant changed ownership several times in the mid–twentieth century while continuing to produce folding paper cartons and paperboard. It was at this time that the company, in keeping with a national trend, was acquired as a subsidiary of larger firms based outside Castleton. Eventually the plant came under the ownership of a firm called the Brown Paper Company, itself a subsidiary of Gulf and Western Industries.

In the late 1960s and early '70s, growing concerns about the environmental health of the Hudson River led to increased scrutiny of companies such as Fort Orange. Unregulated, these old mills had been allowed to discharge a variety of chemicals and pollutants that found their way into the river, eventually giving the Hudson a reputation for conditions of utter filth. In 1971 the newly formed Environmental Protection Agency cited Fort Orange Paper for dumping 1.5 million gallons of con-

taminated waste water into the Moordener Kill on a daily basis. The EPA required the company to develop a pollution control plan, which eventually meant the construction of the plant's own water treatment facility on the site.[11]

By the last quarter of the twentieth century, old nineteenth-century mills such as Fort Orange were a dying breed. Throughout the Hudson Valley and across the northeastern United States, small traditional manufacturing firms declined: many, including the paper mills at Saugerties and others at New Windsor in Orange County and Piermont in Rockland County, were abandoned in these years. Nearly all of Castleton's other industries had long since disappeared. In New York State alone, at least thirty-seven paper mills closed or curtailed operations in the 1980s and '90s.[12]

Fort Orange managed to hang on. By 1978 the mill was again in the hands of a small group of local investors, in a reversal of the national trend toward consolidation. The company found its niche supplying folding cardboard boxes for cereal and candy makers, often filling smaller orders from smaller companies. As other Hudson River industries continued to disappear, Fort Orange seemed immune to changing economic realities that plagued American manufacturers of all shapes and sizes.

But things were not as they appeared. As its workforce declined from about 220 in the late 1970s to roughly 80 in its last years, the com-

View to the northwest, March 2004. Vines creep over arched window openings of an industrial facade.

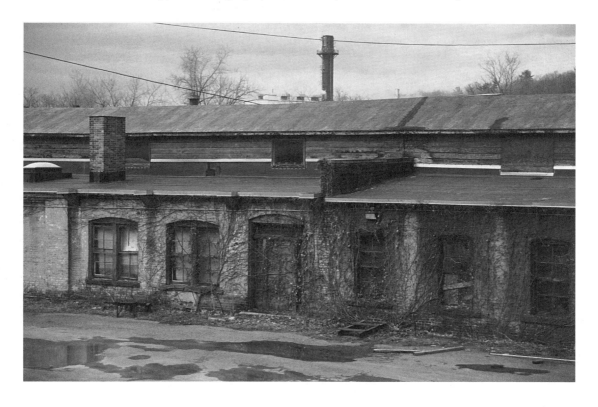

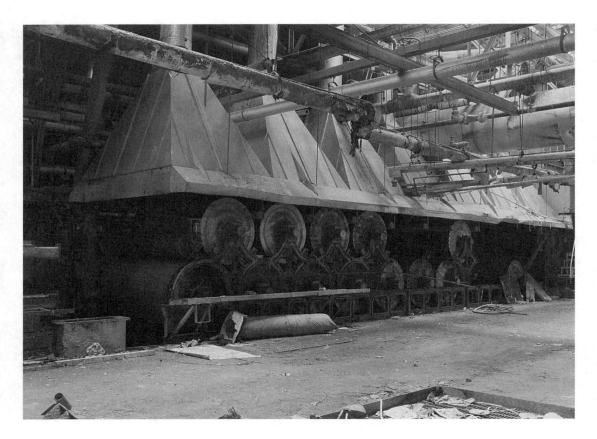

The dryer section of this paper machine is covered with a metal hood from which moisture is removed by exhaust fans as the paper passes through the rollers.

pany quietly began to fall into debt, eventually amassing $400,000 in unpaid bills. Despite a favorable arrangement with a neighboring power-generating plant, the firm's management was unable to pay its electric bills, and on February 28, 2002, its power was cut. Abruptly, after nearly 150 years of continuous operation, the company closed its doors, and eighty shocked employees found themselves unemployed.[13]

Once it was abandoned, vandals and the elements quickly took their toll on the old mill. Grass grew tall, vines crept up its old brick walls, windows were broken, roofs sagged and fell in. Citing the property as a public health threat because of the presence of hazardous chemicals left on the site, the U.S. Environmental Protection Agency and the state Department of Environmental Conservation undertook costly cleanups in the years following the mill's closure, which involved the remediation of two small mercury spills and the removal of vast quantities of miscellaneous hazardous materials.

Even before the Fort Orange Paper Company's sudden demise in 2002, the decline of Castleton's local industries had left the village beset with empty storefronts and boarded-up houses. In spite of its attractive streetscapes, its proximity to good jobs in the state capital, and its desirable location immediately on the river, this sort of economic and physical decline remains a persistent problem in Castleton, as it has in towns

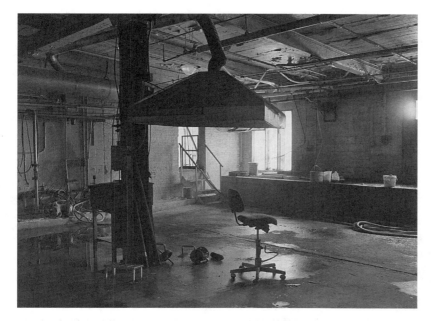

Laboratories like these once
contained equipment for
various steps in the paper-
making process including
mixing chemicals.

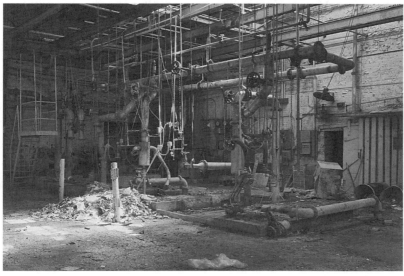

A machine-age ruin.

large and small throughout the Hudson Valley. While elected officials
have remained optimistic that new industrial activity can make renewed
use of Castleton's abandoned paper mill, in other communities success-
ful reuse of abandoned industrial sites has meant finding new com-
mercial or residential uses. But as its buildings slip further into decay,
the old Fort Orange Paper Company grows increasingly vulnerable to a
more ominous fate that in the twenty-first century continues to claim
the river's historic buildings and institutions with little discrimination.

GREENE COUNTY

WITH PUTNAM, Greene County is one of two Hudson River counties between New York City and Albany named for a hero of the Revolution. Formed in 1800 with land taken from Albany and Ulster counties, it owes its name to Nathanael Greene (1742–1786), a major general of the Continental Army, who presided over the espionage trial of John André on the Hudson at Tappan in 1780. After the war Greene was rewarded for his service with gifts of land, which included significant acreage in the Hudson Valley county that now bears his name.

Geographically Greene County is dominated by the eastern edge of the Catskill Mountains, which rise sharply ten miles west of the river. Many Dutch families settled here in the seventeenth and eighteenth centuries. The most important early settlement was Catskill, the county seat, situated where the Catskill Creek meets the Hudson River. To the north, other important early settlements included Athens and Coxsackie.

But Dutch settlement penetrated west through the Catskill Mountains as well. Perhaps because of the remote character of this land, Dutch influence lasted longer here than in other parts of the valley, as is evidenced in domestic architecture (such as the Bronck house near Coxsackie, built in 1663) and in place-names. Dutch-speaking communities are thought to have survived in Greene County well into the nineteenth century.

Clearly visible from the river, the Catskill Mountains captured the imagination of writers such as Washington Irving and James Fenimore Cooper, and of the painter Thomas Cole, founder of the Hudson River School, who made home and studio in Catskill. In the first decades of the nineteenth century these artists popularized the Greene County Catskills in story and on canvas, using their sublime landscapes to help shape a young country's formative national identity.

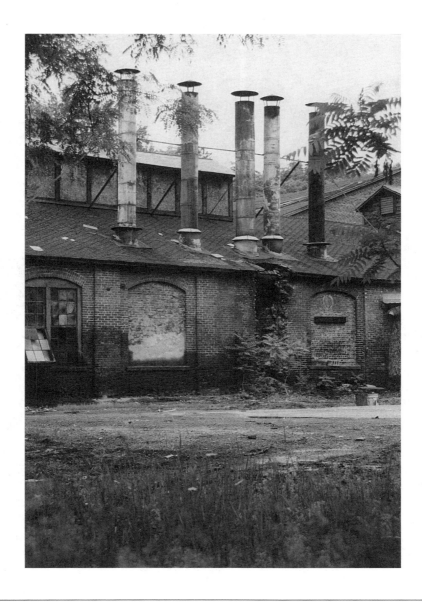

American Valve Company, Coxsackie

Coxsackie is one of the oldest and best-preserved landing towns on the Hudson River. An abundance of fine molding sand drew a number of iron and brass foundries here by the 1860s. By 1902 a firm called the American Valve Co. operated out of two buildings on South River Street near the landing. Within a few years the firm expanded, building a handsome complex of one- and two-story brick factory buildings. In 1920 American Valve sold the buildings to Leo M. Scully of Albany, who manufactured brass, bronze and aluminum castings here as late as the 1950s. During the Second World War the plant produced depth-bomb triggers. Later operated by M. G. Carter, the buildings stood abandoned by the 1990s. In the summer of 2002 a Catskill businessman purchased the former foundry, declared the buildings "unsalvageable" and demolished all but one of them with the intent of developing a marina on the site. "That building they're knocking down is shot," said Coxsackie's mayor at the time: "and it's a nice piece of property down by the river." Three years later the land remained vacant.

Capt. James Bogardus House, Catskill

Little is known of this Federal-style home on Water Street in the village of Catskill. Its construction probably dates to the first decade of the nineteenth century. Early maps identify it as the home of Captain James Bogardus. Bogardus may have been a relative of another James Bogardus of Catskill, who in the 1850s became well known as a pioneer in the development of cast-iron buildings in New York City.

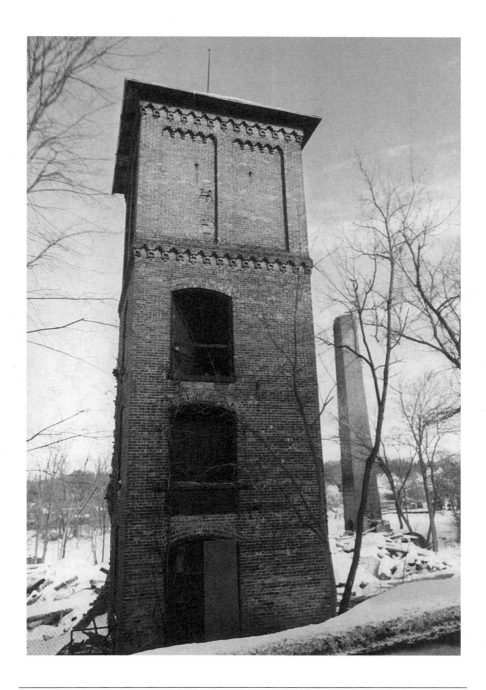

Hop-O-Nose Knitting Mill, Catskill

Built in 1881 on the Catskill Creek, the mill was recognized as the one of the last intact remnants of Catskill's industrial heritage. In 1995, the Hop-O-Nose Knitting Mill was deemed worthy of listing on the National Register of Historic Places as "one of the village's most prominent local landmarks," yet the brick building was demolished by the end of the decade. Only the mill's stair tower and chimney survived.

1939 Buick Sedan, near Catskill

One of 208,259 Buicks produced during model year 1939 lies abandoned off Route 9W below Catskill. Fine examples of Art Deco industrial design, their styling was overseen by Harley Earl (1893–1969), later credited for the design of Cadillac's trademark airplane-inspired tail fins of the 1940s and '50s. The year 1939 was the first in which Buick offered no models with rumble seats. The company also provided the Official Pace Car for that year's Indianapolis 500. In a nation that more than any other has been shaped by the automobile, and where shiny new cars are recognized as symbols of personal success, these machine-age ruins have a particular ability to convey the same sense of fleeting fortune that drew the English Romantics to the Roman Forum. Americans know few greater sources of pride than a new car. Yet they age quickly. A few are preserved as collector's items. Most are melted down for scrap, and some, like this one, are simply left to rust.

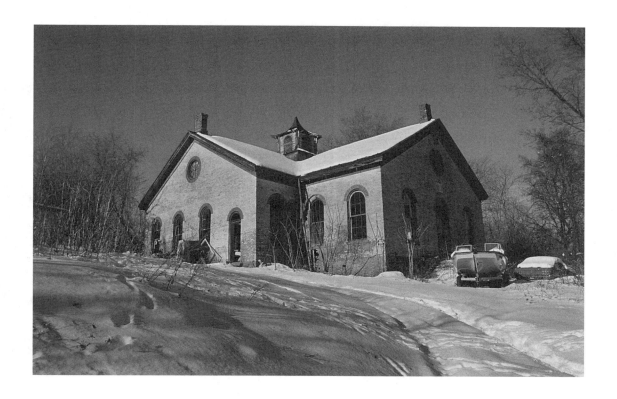

District No. 1 Public School, Athens

Built c. 1875, this four-room school house looks out across the river from the village of Athens, opposite the city of Hudson. The building served until a larger, centralized school opened in the 1950s. It remained vacant for the remainder of the twentieth century. As village officials discussed having the building condemned for code violations in 2004, a new owner began work to restore the former school as a residence.

Subsequently, the eastern Catskills became a favored vacation spot, and great hotels or "mountain houses" appeared perched on steep cliffs overlooking the river. The first and most famous of these resorts, the Catskill Mountain House, stood due east of the county seat of Catskill; its fortunes and decline mirrored national trends of wealth and society.

Though the county remained known for its rugged natural landscape, industrial development came along the riverfront here as it did elsewhere on the Hudson. Mills and foundries appeared early on; modern textile factories were built at Catskill and Leeds in the nineteenth century, and by the dawn of the twentieth the large gray towers of the portland cement industry came to dominate the riverfront south of Catskill. Though these industries have declined, at the beginning of the twenty-first century a regionwide debate over the future of industry on the river zeroed in on this stretch of the Hudson. Today Greene County's historic mountain resorts have all but disappeared, leaving only a few foundation ruins behind. The decline of the county's industrial base meanwhile has left the abandoned Alsen Cement Works south of Catskill one of the most fascinating ruins in the valley. Though the ancient towns of Catskill, Athens, and Coxsackie have each lost wonderful examples of nineteenth century industrial buildings in recent decades, these communities preserve the traditional character of the old river landings perhaps better than any other towns on the Hudson River.

Alsen's American Portland Cement Works, Smith's Landing

The name said it all: Cementon. A ramshackle sort of a place, it had been called Smith's Landing until the beginning of the twentieth century, when the cement factories came, rearing their giant heads over the humble frame houses of the village like grim leviathans. Eventually three plants were built here, their tall smokestacks standing sentinel above the town day and night. Production fell off in the latter part of the century, and today the village again calls itself Smith's Landing. But the factories still stand. While two remain in use, one—the former Alsen's Cement Works—lies a massive, sprawling industrial ruin, an ominous reminder of bygone prosperity.

Truth be told, there wasn't much here before the coming of the cement plants. Throughout the seventeenth and eighteenth centuries, the land that was to become Smith's Landing remained sparsely settled. The town takes its name from Rufus Smith, who purchased a vast tract of land here in 1822. Around Smith's dock a small river landing took hold, on a low expanse of gently rolling farmland that lay about midway between the old towns of Catskill and Saugerties. To the west, a high limestone escarpment called the Kalkberg rose abruptly out of the earth, and beyond it the Catskill Mountains.

Throughout the nineteenth century the docks at Smith's Landing served the farmers who worked the land beneath the Kalkberg. Sloops and later steamers brought goods for sale at the store by the landing, and they carried local harvests off to market. For a time a vibrant fishing trade thrived here. While ice harvesting, brick making, and quarrying of the Kalkberg were conducted on a limited basis, the town remained agrarian in character. A post office opened in 1872, but it was the coming of the West Shore Railroad ten years later that foreshadowed the industrial development to come.

As Hudson River industries go, portland cement was a relative latecomer. In the nineteenth century, Rosendale, about twenty-five miles away in Ulster County, had led the nation in the production of natural cement. Unlike the natural cement produced at Rosendale, portland is an engineered composition made primarily from limestone and clay. Joseph Aspdin, a bricklayer, first patented it in England in 1824. Aspdin marketed his product as "Portland Cement" for its likeness to a popular building stone quarried on the Isle of Portland in the English Channel.

The portland process took hold first in Europe, and was not patented in the United States until 1871. Though not as strong as natural cement, it could set much more quickly, and by the 1890s portland was available at a lower price than natural cement. At the turn of the century it swept the construction industry almost overnight, leaving the once-mighty Rosendale cement district an empty, decimated shell, whose ruins still dot the Ulster County landscape today.

New portland plants appeared on the Hudson even before the demise of the natural cement industry. James C. Kittrell, an engineer building waterworks across the river in Columbia County, discovered the limestone deposits of the Kalkberg in the late 1890s. Kittrell quickly assembled a group of investors and organized the Catskill Cement Company. The firm bought five farms at Smith's Landing and in the years 1899 and 1900 built the first large portland cement factory on the Hudson River.

In 1902 a German firm known as the Alsen'sche Portland Cement

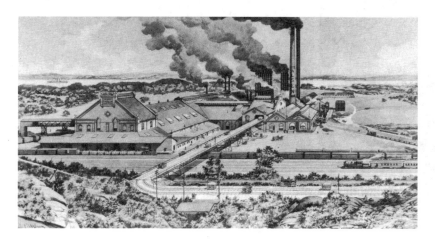

This illustration shows the plant as it appeared from the Kalkberg at the time of its completion in 1902. The large gabled building at left center is the packing house, still in existence. Dense smoke obscures the river in the background. Courtesy Holcim Deutschland AG

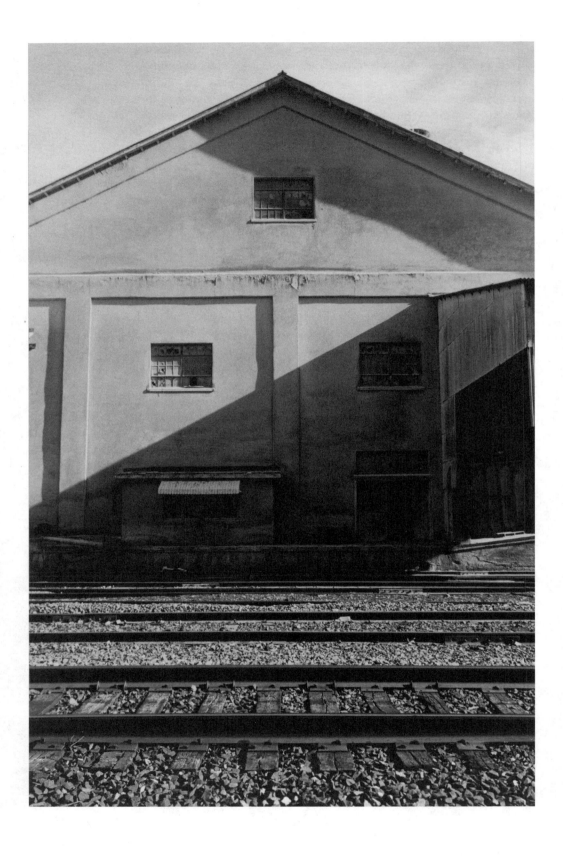

Fabriken built a second factory nearby. Founded in 1863 near Hamburg, Germany, by Otto Friedrich Alsen, by the turn of the century the company was looking to establish itself in the United States, where the market for portland cement was growing exponentially. The Germans incorporated a firm called Alsen's American Portland Cement Works and built a new factory one mile north of Smith's Landing. They set a new precedent by building not on the river but about a half mile inland, on the tracks of the West Shore Railroad.

The Alsen's plant functioned like most modern cement works of the period. Limestone came down from quarries in the Kalkberg by cable railroad to the factory. There it was crushed and mixed with clay taken from quarries near the river. The mixture was dried and combined with other additives to form a composite material called slurry. This was then fed into coal-fired horizontal rotary kilns, which tumbled the mixture rather like laundry in a slow-motion dryer, until it was reduced to a loamy substance called clinker. Once cooled, the clinker was mixed with gypsum and taken to the ball mills, where it was pulverized and ground into cement.

To house the machinery, the company built a rambling complex of large gable-roofed brick buildings with tall arched windows and clerestory monitors. High over the plant stood no fewer than sixteen tall smokestacks, which loomed over the village, belching out plumes of dark smoke that rose skyward over the river.

A third cement plant appeared at Smith's Landing in 1916. In the meantime two other plants had appeared near Hudson in Columbia County. Although the Hudson Valley would no longer lead the nation in cement production as it had in the 1800s, these five plants, all in operation by 1916, would make a significant contribution to the nation's annual production of portland cement for much of the twentieth century.

With portland cement came the arrival of modern, multinational heavy industry on the Hudson River. Despite their pastoral settings, these were gargantuan facilities, comparable in size and appearance to the steel mills of Pennsylvania. They all but dwarfed anything hitherto seen on the Hudson, making even the brickyards seem quaint by comparison. And whereas the Hudson River brickyards and most of the old Rosendale cement factories had been owned locally, by 1920 all five of the valley's portland cement plants were run by

(Opposite) packing house, west elevation, January 2002. Constructed during the initial development of the plant in 1902, this building owes its present appearance to alterations made in the 1920s.

The oldest part of the Alsen's Portland Cement Works is located near the western end of the complex by the West Shore Railroad tracks.

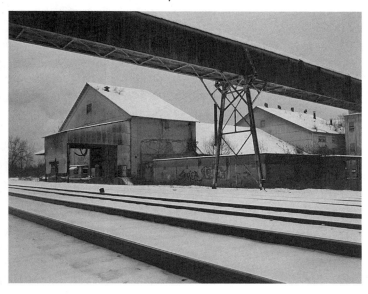

large syndicates that were based out of state or, in the case of Alsen's, across the Atlantic.

Within a few years, Smith's Landing grew from a quiet village into a bustling factory town. In 1906 the village changed its name to Cementon. To man the big factories came a stream of immigrants, many from eastern Europe, and especially Croatia, bringing with them such names as Krstovish, Yelovich, and Grbavac. The first to arrive were usually single men, who found very rudimentary lodging in dormitories built by the cement companies. The town quickly earned a reputation among the old Dutch families of Greene County for being a rough and unsavory place. By 1910 it could boast fourteen saloons. Brawls and gunfights now and then erupted between feuding workers, leading to headlines in the local press such as "War Again in Cementon."[1]

Skilled laborers from Germany staffed the Alsen's plant in its first years. The area in the immediate vicinity of the factory became known as Alsen. Like the other portland plants on the Hudson, the Alsen's works encountered numerous technical and financial difficulties as the new industry struggled to get off the ground. While other plants went through frequent ownership changes, Alsen's had the benefit of an established parent company, and after a few years the plant was able to operate successfully.

But the Great War soon intervened. After the outbreak of hostilities in 1914, Alsen's main office in Hamburg could no longer oversee operations of its American holdings. Under local management the factory continued to operate until March of 1918, by which time America's entry into the conflict forced the company to suspend its operations in Cementon. Declared enemy owned, the plant was seized by A. Mitchell Palmer, the Wilson-appointed alien property custodian who later, as attorney general, became known for the infamous Palmer raids during the first Red Scare.

By the end of the war the dormant factory had deteriorated considerably. Over the next few years it changed hands repeatedly, passing from the government to a holding company and then, in 1920, to a local shipbuilder named M. H. Reiss. Reiss made repairs and the plant resumed production, but only for a short time before the operation found itself in receivership. By 1923 a new firm had been organized, called the Hudson Valley Portland Cement Corporation, but this too failed, and the factory again went quiet.

As the buildings sat in limbo, a New York City building contractor known as "Subway Sam" Rossoff quietly began buying up the company's stock. A rags-to-riches caricature in the truest Horatio Alger tradition, Rosoff had risen from poverty to make a fortune from subway-building contracts in New York. Although he owned quarrying operations elsewhere on the Hudson, his interest in the former Alsen's plant turned out to be speculative, and in 1925 he made a deal to sell the facility to the Lehigh Portland Cement Company of Allentown, Pennsylvania.[2]

Founded in 1897, Lehigh had grown by the 1920s to operate nearly twenty factories throughout the United States. Upon buying the former Alsen's plant the company launched a program of improvements to put the factory back in working order. True to the architecture of the industry, it constructed new buildings of reinforced concrete, and refaced existing brick structures to match. Lehigh later acquired Kittrell's Catskill Cement Company as well, giving it control over two of the three plants at Cementon.

The arrival of the Great Depression forced the plants to close for a period in the early 1930s, but production soon resumed. By 1939 the cement workers had unionized, and the increased demand that came as America prepared for another armed conflict sustained the industry through the Second World War. In the postwar years demand surged, and the industry scrambled to supply the construction of new highways and houses for GIs returning from the front. The building boom continued into the next decade, and by the mid-1950s cement shortages resulted as the industry simply could not keep pace with demand.[3]

To catch up, the cement companies built new plants and upgraded existing ones. All three factories at Cementon underwent marked expansions in these years. By the late 1950s demand leveled off, but with plans for further expansion already in place, the industry continued to increase capacity.[4] New factories appeared on the Hudson at East Kingston in 1958, and at Ravena (just below Albany) four years later. As the shortage of the 1950s became a surplus in the 1960s, the cement companies looked for ways to scale back. Obsolescence spelled the end for many older plants, and by the mid-1980s the number of portland cement factories on the Hudson below Albany fell from seven to three.

Lehigh closed the old Alsen's plant in 1982, in the midst of an economic recession. Three years later there came a proposal to use the old factory as a coal distribution facility. But residents across the river in Germantown mounted a legal campaign to stop the project, complaining that the facility would create visual blight on the river, and the proposal was dropped.[5] Environmental and conservation groups had formed in the Hudson Valley during the early and middle parts of the twentieth century, primarily in response to quarrying and

Unused machinery rusts in a midcentury addition.

This massive rotary kiln from a midcentury expansion has been partly dismantled.

power plant construction on the lower Hudson, but the large cement factories farther upriver had largely evaded scrutiny.

This began to change in the 1970s as the towns of the upper Hudson became divided over the place of heavy industry on the river. The issue came to a head two decades later with the proposal for a new cement plant to be built near Hudson, in Columbia County. The proposed plant was to have been built for St. Lawrence Cement of Canada, which by 1984 owned two Hudson River cement factories. One, the former Universal Atlas plant near Hudson, had been closed since 1977. The other was the last of the three plants built at Cementon, and was still in production. In 1998 St. Lawrence proposed shutting down its Greene County plant and building a massive new cement factory across the river at the unused Universal Atlas property.

The proposed plant became a flash point in the histories of environmentalism and industry on the river. Environmental organizations immediately mobilized in opposition to it. For seven years the battle dragged on. Finally in 2005 the New York State Department of State, whose approval was requisite for the plant's construction, determined that the new factory would violate policies requiring waterfront development to stimulate local economies without compromising nearby environmental or cultural resources, and without impeding public access to the water. St. Lawrence relented, and the plant was dropped.

The implications of the St. Lawrence decision seemed to toll the end for the Hudson River's long-held place in the American industrial economy. Whereas previous campaigns against industrial development on the river had succeeded by citing threats to the environment or scenic landscapes, the defeat of St. Lawrence was based primarily the plant's potentially negative impact on the regional economy. "Tourism is the leading industry in the Valley," said the Department of State. The Hudson River waterfront, the agency added, had moved "from industrial uses and brownfields to mixed use redevelopment, recreation, cultural activities, and, increasingly, high-tech businesses." St. Lawrence's proposal was denied because it would counteract this trend: "industrial operations . . . will not encourage future retail and tourism-focused investment," the department stated. Heavy industry no longer had a place in the river towns.[6]

With traditional industrial use effectively ruled out, the problem of what to do with the river's former industrial sites remains unsolved. At East Kingston, fourteen miles south of Smith's Landing, a Westchester-based developer has proposed 2,200 condominiums and 300,000 square feet of commercial buildings for the riverfront site of the abandoned Hudson Cement Company. The new housing alone could accommodate as much as 20 percent of the population of the nearby city of Kingston. Though the proposal calls for residential rather than industrial development, the enormous environmental, visual, and economic impacts of

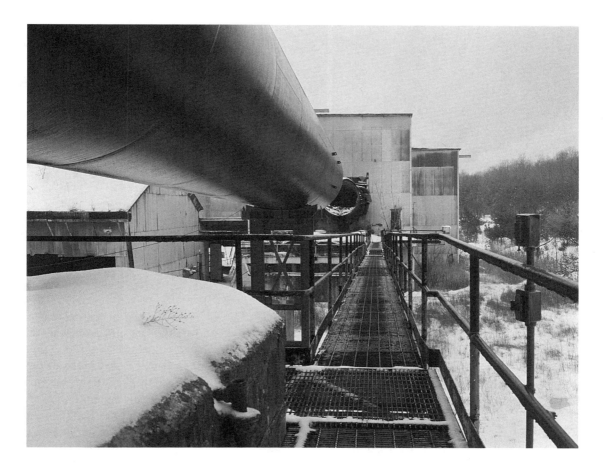

such a project are comparable to those that would have accompanied the new St. Lawrence plant, and have stirred controversy in Kingston and elsewhere on the Hudson.[7]

The old Alsen's plant meanwhile remains abandoned. As time went on, modernization enabled the cement factories to operate with fewer employees, and the once-rowdy factory town of Cementon began to simmer down. By the time Lehigh closed the old Alsen's plant in 1982, the village looked decidedly past its prime. Sensing the regional shift away from industry, in 1993 the community decided to change its name back to Smith's Landing. The following year Lehigh scaled back operations at its active Smith's Landing factory, leaving the St. Lawrence and Ravena plants as the last remaining active cement producers on the Hudson between New York City and Albany. As proposals for other abandoned cement factories continue to spark debate, one can only speculate as to what the future may hold for the century-old ruins of Alsen's American Cement Works. While it seems unlikely that the facility will ever return to industrial use, the river has seen many things change. Few towns know this better than the one that used to be called Cementon.

Newer rotating cement kilns like the one shown here were built in the mid–twentieth century and could produce a more consistent quality of cement at lower cost than older kilns.

COLUMBIA COUNTY

THE HUDSON'S EAST BANK between Rensselaer and Dutchess belongs to Columbia County. European settlement began here in the seventeenth century, when Killaen van Rensselaer purchased much of the land from the Mahican Indians and added it to his enormous patroonship. A significant Dutch presence existed here by the time the English took over in 1664. In 1683, with the division of the colony into counties, the land that later became Columbia fell under the vast domain of Albany County. Not until after the American Revolution did Columbia break off from Albany to form its own county in 1786.

By the early 1700s, much of the future Columbia County belonged to two manorial estates. While the Van Rensselaers owned nearly all of the northern part of the area, a second manor, belonging to Robert Livingston, occupied much of the southern part. In an almost feudal arrangement that survived into the nineteenth century, the Van Rensselaers and the Livingstons leased tracts of land to tenant farmers, whose families in many cases remained on the manors for generations without ever having the opportunity to buy their farms outright. The persistence of this system discouraged development here, as settlers gravitated to other parts of the valley that were open to freeholding.

Nonetheless, there were pockets of available acreage to be had. One such area occupied a point of land near the middle of the Columbia County shoreline, part of a large freehold bought from the Mahicans at the end of the Dutch period by Jan Franse van Hoesen. By the 1780s a small town had been established on the point, called Claverack Landing. In the years 1784 and 1785, a party of whaling families arrived here from Nantucket, seeking to relocate to a more sheltered port. Within a year the whalers had built a city, which was incorporated as Hudson in 1785.

The eastern part of the county meanwhile received families migrat-

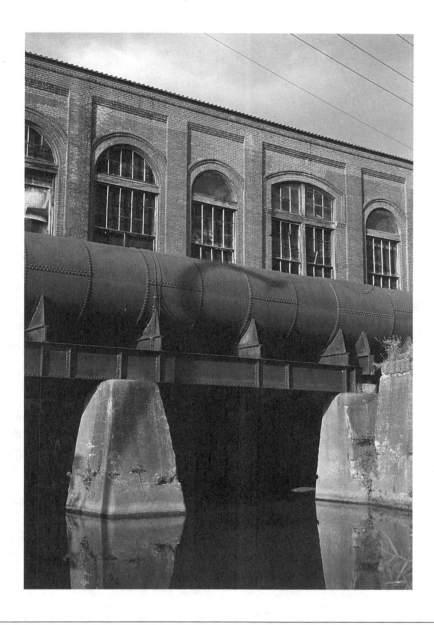

Albany & Hudson Railroad Company Power Station, Stuyvesant Falls

The Albany & Hudson Railroad organized in 1899 with the consolidation of several existing railroads to connect inland farm towns between the cities of Hudson and Rensselaer. Its thirty-seven mile route ran parallel to the river a few miles east of the tracks of the New York Central Railroad, and served towns including Kinderhook, Valatie, and Nassau. After its formation the company electrified its entire route, using a then nascent technology through which it supplied power to electric trolley cars by means of a "third rail." To generate its own electricity, in 1900 the company built a combination hydraulic and steam power station on the Kinderhook Creek at Stuyvesant Falls. After the railroad ceased operations in 1929 the plant continued to generate power for public and private use under the Niagara Mohawk Company. Long disused, the power station has been listed on the National Register of Historic Places since 1976.

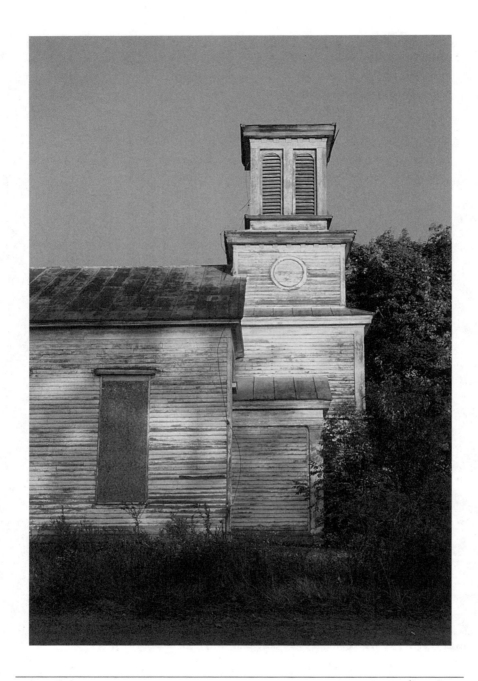

Methodist Episcopal Church, Columbiaville

The Methodist Episcopal Church of Stockport formed in 1828 and built this church the following year at a cost of $1,200. Subsequently enlarged, in 1866 it was moved to its present site in Columbiaville, near the Stockport Creek.

Porter's Store, Ancram

Built in the 1840s, this building originally housed a hotel and general store. Later its upper floors were converted to apartments. The Ancram Post Office occupied the building until 1995. It has stood vacant since then.

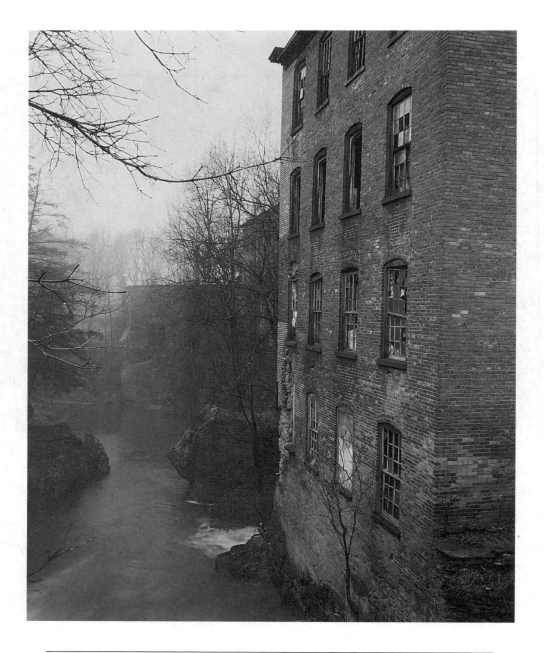

Summit Mills, Philmont

A series of brick mills developed in the nineteenth century at Philmont, located on the Ockawamick Creek, the east branch of the Claverack Creek, which falls 250 feet in a span of one-half mile. The first modern mills here were built around 1845 by George P. Philip, whose surname presumably gave the village its name. In the twentieth century the mills closed. Today only one, the Summit Mills, survives. It was built near the outlet of the dam above the village center, after an earlier satinet and carpet factory burned in 1876. The mill's last commercial tenant moved out in 1989. It was purchased in 2004 and restoration began soon thereafter for conversion of the brick building into artists lofts.

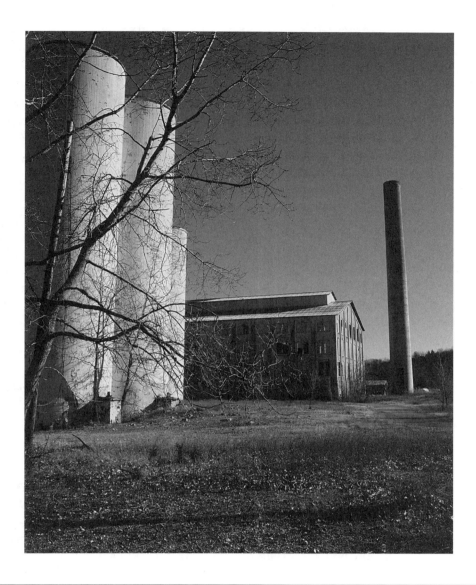

Universal Atlas Cement Company Storage Silos and Powerhouse, Greenport

A proposal to revive cement production near the site of this abandoned plant sparked controversy throughout the Hudson Valley at the beginning of the twenty-first century. First opened in 1903 as the Hudson Portland Cement Company, the original plant stood along the river in the nearby city of Hudson. In 1909 the New England Lime and Cement Company purchased the plant and moved operations about one mile east, which required the construction of a new factory. The Universal Atlas Cement Company ran the plant from c. 1930 until it closed in 1977. Most of the factory buildings have since been demolished. The storage silos, shown at left in the photograph, date to 1931. The powerhouse, at right, survives from the plant's 1909 reconstruction, making it one of the most significant remaining buildings associated with the early development of the portland cement industry on the Hudson River. St. Lawrence Cement of Canada proposed to restore the powerhouse as part of its plans for a new plant to be located nearby. The building remained vacant after the proposed plant was dropped in 2005.

ing west from an increasingly crowded New England, lending the towns of central and eastern Columbia County characteristics typical of communities in neighboring Massachusetts. In the middle eighteenth century, these families arrived in an area where industrial development was already well under way, with mills and foundries built to take advantage of the waterpower afforded by dozens of creeks tumbling their way to the Hudson. By the 1870s, Columbia County became one of the country's most important centers of ice harvesting. Later came brickyards, and later still large portland cement factories. Today these industries have vanished almost entirely; they are manifest in the form of crumbling ruins throughout the county.

Below the city of Hudson, the Columbia County riverfront became lined with the mansions of the heirs of Livingston Manor. Best known is Clermont, namesake for Robert Fulton's first commercially successful steamboat, developed with financial backing from Robert R. Livingston, Jr., in 1807. While other Livingston estates remain in the family today, Clermont is now a State Historic Site open for public tours. Also open to the public are Olana, home of the painter Frederic Church, which overlooks the river near Hudson, and Lindenwald at Kinderhook, home of Martin Van Buren, the eighth American president.

In the latter part of the twentieth century, a distinct social dichotomy emerged in Columbia County with the arrival of the "weekenders." Columbia lies too far from New York City to have attracted a significant commuter population. But the easy two- or three-hour drive has made it exceedingly popular among New Yorkers as a place for weekend country homes. The coming of the weekenders has brought high-end restaurants, art galleries, and antique shops to Hudson and elsewhere. The weekender homes are often readily identifiable as the most beautifully restored old houses of the county, painted in carefully selected, historically appropriate colors with expensive brass porch lights and door knockers. Old farmhouses belonging to longtime Columbia County natives meanwhile are often found clad in aluminum siding and fake shutters that detract from their historic charm. The juxtaposition of these two kinds of historic houses, which convey their authenticity in very different ways, prompts one to contemplate what it is that makes the traditional character of this region so appealing.

As available properties have grown scarce, some full-time residents of Columbia County have expressed concerns over cost-of-living increases. This is particulary true in Hudson, where property values rose nearly 18 percent between 1998 and 2003. But the weekender phenomenon seems otherwise generally accepted as a good thing for local economies. For better or for worse its visible impact has been minimal, allowing Columbia to maintain its traditional character perhaps better than any county in the valley. From the Hudson River shoreline east to the Berkshire Mountains, the unspoiled landscape of the county remains predominantly agricultural. A few mills still run by the creeks that drain

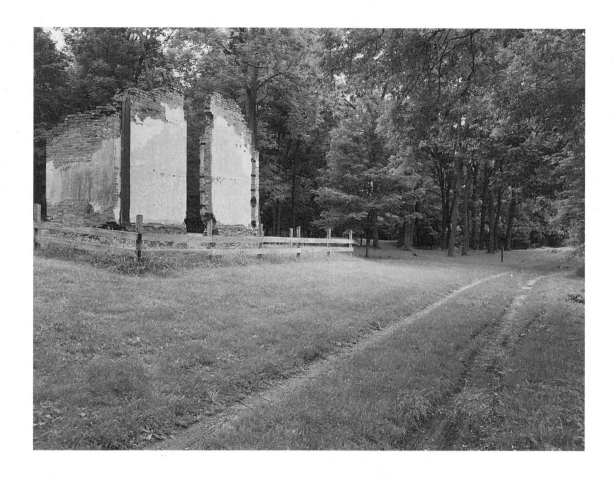

Arryl House, Clermont

Robert Livingston, Jr., established Clermont, the country seat of one of New York's most politically and socially prominent families, in 1728. In 1792, his grandson Chancellor Robert Livingston, drafter of the Declaration of Independence, administrator of the presidential oath to George Washington, and developer of steamboat technology with Robert Fulton, built Arryl House, also known as New Clermont. Arryl House burned in November 1909, allegedly due to a fire caused by embers from a passing locomotive tossed eastward on that windy night. The Livingston family preserved the ruin as a memorial to its builder, although substantial sections of the house were later taken down. The first Clermont survives as a historic house museum open to the public by New York State.

the forests and fields, and the river still collects their waters and carries them down to the sea.

New York Central Railroad Station, Stuyvesant

The trains tear up and down the river past Stuyvesant at breakneck speed, rattling the empty windows of a forlorn old building by the tracks that used to be this town's railroad station. Trains called here for more than a century. Then in the late 1950s Stuyvesant became one of many towns on the river to lose rail service, as America's network of railroads began to fall apart. Today Stuyvesant's abandoned station is an elegy to a transportation infrastructure and an entire way of life now all but forgotten.

Of all man's interventions on the Hudson River, perhaps none left a more profound impact than the railroads that line its shores from New York City to Albany. The Hudson River Railroad came first, running up the river's more populous eastern shore.[1] The line's construction was first proposed in the early 1830s, but the difficulties of engineering it and the river's existing network of waterborne transportation forestalled its planning. Throughout the 1830s and early 1840s, as more and more railroads began to link the far corners of the Republic, the river towns remained maritime.

But the reliable service afforded by the Hudson's sloops and steamers halted each year with the coming of winter. All through the winter the icebound river towns sat at a disadvantage while other communities continued to prosper. In 1841 a group of Poughkeepsie merchants (including the brewer Matthew Vassar) commissioned a preliminary survey to determine the feasibility of building a railroad that would serve the river's eastern shore, running from New York City to Greenbush, just opposite the capital at Albany.

Stuyvesant, c. 1915. The northbound *Empire State Express* approaches from the south. Note riverfront industrial and commercial buildings at right, now vanished. Courtesy Mary Howell

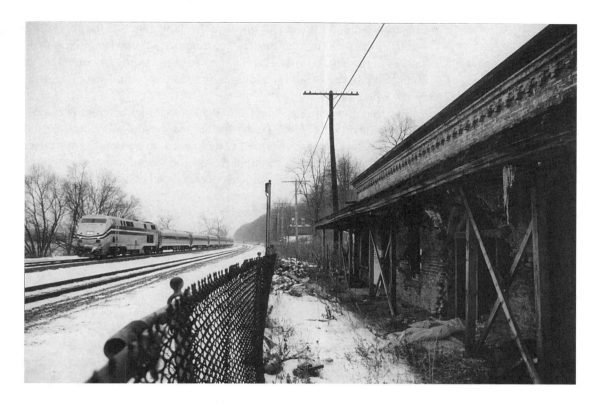

Interest in the plan came slowly. The construction of the New York and Harlem Railroad along the Connecticut border finally lent the cause a sense of urgency, and in 1845 its backers tried again. This time the project captured the interest of John Bloomfield Jervis (1795–1885), prolific engineer of America's early industrialization, who had already built the Delaware and Hudson Canal and the Croton Aqueduct to supply New York with coal to burn and water to drink.

By 1846 Jervis was helping gain financial and political support for the proposed railroad. But there remained fierce opposition, not only from the Hudson River merchant marine, but also from the residents of estates clustered along the river's eastern shore from Manhattan to Columbia County. For months the two sides lobbied aggressively for and against the railroad's charter. But in the end Jervis stood triumphant. The Hudson River Railrod was chartered on May 12, 1846. Jervis stayed on as chief engineer, a position he held for the company's first three years.

Work began in Manhattan and moved north toward Westchester. Across creeks, bays, and inlets Jervis piled stone rights-of-way, blasting and tunneling his way up through the Hudson Highlands. This was the landscape made famous by the painters of the Hudson River School, and early devotees of the river's scenic beauty voiced concerns that the railroad might mar the views immortalized by Cole, Durand, and Church. But Jervis seemed always to have an answer: "To a very great extent the

construction of the Road will improve the appearance of the shore," he wrote in 1848. "Rough points will be smoothed off, the irregular indentations of the bays be hidden and a regularity and symmetry imparted to the outline of the shore . . . adding to the interest, grandeur and beauty of the whole."[2]

By December 31, 1849, service was open to Poughkeepsie. The company spent much of 1850 restructuring and raising additional funds, and the following year resumed construction on the route's northern half. Work commenced at Poughkeepsie and Greenbush, and the railroad finally inaugurated through service on October 8, 1851.

Just eighteen miles below the capital, the village of Stuyvesant had been an important river landing for nearly two centuries before the coming of the railroad. It was settled at the very twilight of New Netherland, in 1664. First called Kinderhook Landing, its docks served the busy community for which the landing was named, situated about five miles inland. Not until 1823 did the landing town break away on its own, naming itself for Peter Stuyvesant (1612–1672), the colonial governor of New Netherland who had authorized its purchase from the Indians just weeks before surrendering his colony to the English.

The waiting room, January 1999. Four decades since the last train departed.

As an independent town Stuyvesant continued to grow. After the arrival of the Hudson River Railroad in 1851 it went on to become an important center of the river's burgeoning ice-harvesting industry. Sec-

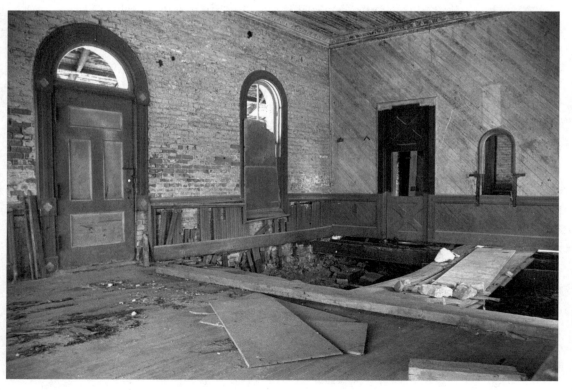

ond only to the city of Hudson, its docks were the busiest in Columbia County, serving farms, shops, and factories locally and east to the Berkshire Mountains at the Massachusetts border.

The railroad brought swift changes to the way business was done in the river towns. Most directly affected were the sloop captains and steamboat companies, who struggled to stay competitive. But because the railroad followed the shore of the river, the center of trade in Stuyvesant and elsewhere remained at the waterfront, for it was there, usually in close proximity to existing docks and ferry landings, that the railroad built its station houses.

The Hudson River Railroad built its first stations in the so-called Carpenter Gothic style, in the vein of the Picturesque mode then promoted in the Hudson Valley by architects such as Davis, Downing, and Vaux. Though attractive, these buildings proved too small, and within a few decades the railroad replaced most of them with larger and more permanent buildings (today only one of these original wood frame stations is thought to remain, at Garrison in Putnam County; twice outmoded by newer facilities, it now houses a used book shop).

The first station at Stuyvesant is thought to have been similar in design and construction to the others built up and down the line. It had served for nearly thirty years when the landing was swept by a devastating fire on May 13, 1880. The fire destroyed icehouses, mills and factories, hotels, homes and shops, the town post office, and the railroad station, more than thirty buildings in all, leaving the village a smoldering ash heap.

But Stuyvesant quickly rebuilt. Less than two weeks after the fire, the railroad hired contractors to build a new station, and by 1881 the building was up and running. The reconstructed station was built of brick, with round-arched windows and doors sheltered beneath a distinctive concave overhang, a corbeled brick cornice and squat hip roof atop the whole. The interior was divided into a baggage room and waiting room, separated by a central ticket and telegraph office. Wood trim and beadboard paneling set in opposing vertical, horizontal, and diagonal patterns finished the walls and ceiling. The building's architect is unknown, but its design appears to have been based on a standard company plan that the railroad employed for a number of second-generation stations built at about the same time, including those still standing at Peekskill, Cold Spring, and Hudson.

In 1869 the Hudson River Railroad merged with the Vanderbilt-controlled New York Central, which had formed in the 1853 consolidation of a number of railroads running between Albany and Buffalo. As the New York Central and Hudson River Railroad, it grew to become one of the largest and most powerful railroads in the country, by 1870 linking New York with Chicago. Eventually it controlled a network of railroads from Boston to St. Louis, including the West Shore Railroad, built from 1882

to 1884 along the river's opposite bank. The company dropped "Hudson River" from its name during a reorganization in 1914, and operated thereafter simply as the New York Central.

Running up the Hudson and Mohawk rivers and then along the Great Lakes, the Central's main line between New York and Chicago became known as the "Water Level Route." Its trains were famous across the country: the Pacemaker, the Commodore Vanderbilt, the Empire State Express. None was better known than the Twentieth Century Limited, which for sixty-five years ran between New York and Chicago. "It was a happy thought to build the Hudson river railroad right along the shore," wrote Walt Whitman in 1882: "I see, hear, the locomotives and cars, rumbling, roaring, flaming, smoking, constantly, away off there, night and day—less than a mile distant, and in full view by day. I like both sight and sound."[3]

Of course the railroad's fast express trains never made scheduled stops at Stuyvesant. While the Century hurled past at full speed, the little brick station kept busy as a local stop, serving passengers headed for Hudson or Albany, and bringing others to connecting trains bound for destinations farther off. In the early 1900s, with steamboat traffic waning and the automobile not yet a practical reality, rail travel became the country's default means of transportation. With communities centralized, most Americans lived, worked, worshipped, and shopped within walking distance of train stations like the one at Stuyvesant, from which they could travel to other towns, big or small, near or far, whose people lived the same way.

In addition to the two lines built on the river's shores, the Hudson Valley was served by a number of other railroads, such as the Erie, the New York, Ontario and Western, and the Delaware and Hudson. A network of smaller lines reached up into the hills to the east and west of the river. These included the Ulster and Delaware, the Poughkeepsie and Eastern, and the Wallkill Valley. Usually these railroads offered connections to the New York Central and to the West Shore at towns like Poughkeepsie or Kingston. In the first years of the twentieth century nearly every farm town in the valley was served by at least one railroad.

The automobile changed that. The United States emerged from the First World War strong and economically robust. Americans had the resources to build and buy new cars and to fuel them. The Great Depression stemmed the tide somewhat, but by 1929 car culture had already taken root. In the Hudson Valley, the short lines connecting the farm towns in the hills suffered first: most vanished during the Depression. By necessity the railroads enjoyed a reprieve during World War II. But in the prosperous years after the war, the automobile was king. While state and federal governments began building a system of interstate highways, the auto manufacturers took aim at the country's mass transportation infrastructure. Improved aircraft meanwhile began to take passengers away from long-distance trains such as the Twentieth Century Limited.

Like many railroads, the Central began to cut service in an attempt to save money. On the Hudson River this meant the end of rail service to smaller towns north of the commuter district. Stations such as Hyde Park, Tivoli, Germantown, and Castleton were all dropped from the timetables. The railroad eliminated service to Stuyvesant in 1958. Passenger service on the West Shore stopped the following year. While the railroad had allowed the river towns to maintain their traditional commercial centers by the waterfront, the Hudson Valley's main north-south highways—U.S. Route 9 and the Taconic State Parkway on the east bank, Route 9W and the New York State Thruway on the west—ran some distance inland. With their railroad stations closed and steamboat service a distant memory, the old river landings now found themselves bypassed and forgotten.

The New York Central meanwhile didn't fare much better. In a last-ditch effort to remain solvent, the company in 1967 scaled service back to the most basic level the Interstate Commerce Commission would allow. On February 1, 1968, the company merged with its archrival, the Pennsylvania Railroad, to form the Penn Central, which struggled unsuccessfully to regain financial viability. In 1971, the Penn Central gave over its long-distance passenger service to Amtrak. The state-administered Metropolitan Transportation Authority took over commuter service in 1983. The Penn Central itself eventually consolidated with other railroads to form the government-controlled Conrail Corporation. Conrail was later purchased jointly by the Norfolk Southern and the CSX Corporation, which today manage the freight operations of the former New York Central and Hudson River Railroad.

After the old station at Stuyvesant closed, the railroad sold it to a local man who used it for storage. Already in poor repair after years of deferred maintenance, the building quickly deteriorated. As its abandoned counterparts began to disappear, Stuyvesant's station fell further into decay. By the end of the century it was one of only five stations left on the east bank of the Hudson between Poughkeepsie and Rensselaer. By the 1980s, the building's deterioration was growing increasingly evident. Water infiltration damaged the original wood paneling inside and led to the partial collapse of its north facade. Windows were broken and doors left unsecured, exposing the building to vandals and the elements.

Fearing the worst, a group of proactive townspeople formed the Stuyvesant Railroad Station Resto-

Exterior detail, January 1999. The station wore the same shade of "Century Green" used by the railroad for everything from office furniture to rolling stock. A stenciled marking dates the building's last paint job to September 1946.

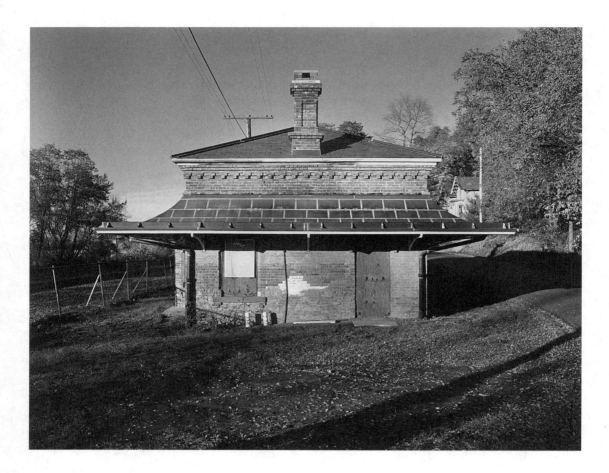

Stuyvesant Station, south elevation, after initial restoration work began.

ration Committee. In 1996 the station was purchased by the town of Stuyvesant. The committee helped secure more than $200,000 in state and federal grant money for the building's restoration, and by the time work began in 1999 the station had been placed on the National Register of Historic Places.[4] The collapsed north facade was repaired, the station's masonry walls were repointed, a new roof was installed, and the building was made structurally sound before funds ran out. Additional grant money has since been awarded to help complete the restoration, and although the old station remains empty in 2005, the repairs undertaken by the Restoration Committee have paved the way for this ruin's path to recovery.

Like many river landings, Stuyvesant is quiet now. Many of the stations abandoned with the demise of America's rail network eventually disappeared, leaving only empty lots behind. Visiting these places, one cannot help but sense a particularly stark contrast between the intense activity they once knew and the desolate picture they present today. Even those stations that remain active on the commuter line between New York City and Poughkeepsie now pose problems for preservationists, as the Metropolitan Transportation Authority has put many up for sale in

an effort to cut costs. Happily, it seems the station at Stuyvesant will soon fill a new role in service to its community, thanks to the work of concerned citizens and an involved town government who saw potential in a building that other communities might have left for dead.

R&W Scott Ice Company, Newton Hook

A few miles below Stuyvesant on the Hudson's east bank once stood a small but busy river landing called Newton Hook. The first Europeans to arrive here were Dutch settlers, who called it Nutten Hoek. The town later prospered as a center of brick making and ice harvesting. With a ferry connection to Coxsackie on the opposite shore, it was already an established river landing when the railroad came in 1851. But in the twentieth century the icehouses vanished, the brickyards closed, the ferry stopped running, and the town was bypassed by river, rail, and highway traffic. Today Newton Hook is one of several landing towns that have all but vanished from the map. But on the river, the ruins of the R&W Scott Ice Company still stand, vestiges of a town and an industry long lost.

The banks of the upper Hudson were once characterized by a chain of massive, windowless buildings that stored ice harvested from the river in winter to be sold for refrigeration throughout the year. Commercial ice harvesting in the United States began at Boston in 1805. Within a few decades, the growing demand for ice in New York City brought the trade to the Hudson Valley. But the river's salt content south of Poughkeepsie restricted ice harvesting on the lower Hudson to freshwater bodies in the hills above tidewater, such as Rockland Lake, opposite Ossining.

The need for ice in New York quickly outgrew supply from nearby freshwater sources. To keep pace, the industry began to push farther north. By the 1850s it had come to the upper reaches of the tidal Hudson, which loses its brackishness above Poughkeepsie. For the remainder of the nineteenth century the Hudson Valley led the country in ice harvesting, producing as much as 2,750,000 tons annually at the industry's peak in the 1880s and '90s.[5]

The first large icehouses on the riverfront appeared at Castleton-on-Hudson, in Rensselaer County. By the 1880s there were 135 ice-harvesting operations on the river.[6] Enormous in size, the icehouses were of wood-frame construction, some equal in height to a six-story building, with very low-pitched roofs. Painted white or beige to deflect heat, their exterior walls were typically double-layered for insulation. Often the names of their owners were painted on their sides in large letters visible from the river's opposite shore. So large were these buildings that river pilots stuck in a dense night fog were known to find their way by blowing their steam whistles and listening for echoes off the broad icehouse facades.[7] Giant inclined elevators carried cakes of ice cut from the river

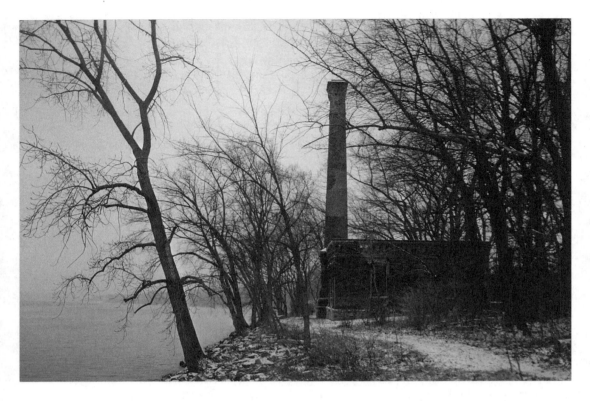

Ruins of the R&W Scott Ice Company, view north, January 2002. Trees have completely overtaken the site of the icehouse at far right.

up to the house for storage. These were driven by steam engines, which were usually housed in separate powerhouses with tall smokestacks.

The harvest usually took place in January and February, when the river lay locked beneath a layer of ice ten to twelve inches thick. While the ice companies employed a few men year-round, extra hands were brought on during the winter months. Many of these seasonal workers came from farms along the river or from neighboring brickyards, which shut down for the winter. After being cut free, blocks of ice called "cakes" were drawn through open channels cut into the ice to the inclined, endless-chain elevators that carried them to the house, where they were stacked and insulated in hay or sawdust for storage.

Packed to the rafters, the house was sealed until spring, when the river reopened to navigation and specially built ice barges tied up at the company dock to take the harvest to market. Once a common sight on the river, ice barges were built of wood and, like other barges and scows, were equipped with living quarters for the barge master and his family. Though they resembled typical covered barges, they functioned essentially as floating icehouses. They could be told apart by a series of mastlike spars used to hoist ice cakes aboard and ashore. Most distinctively, they were fitted with small, canvas-sailed windmills that pumped out water from their melting cargo. Once loaded the barges would be picked up by a passing towboat and lashed together with other barges and scows, likewise bound for market.

After the ice harvest, most hands went back to work on nearby farms or brickyards, while a few men stayed on to load the ice for shipment over the spring and summer. Roughly three-quarters of Hudson River ice went downstream, to New York City. The remaining 25 percent was shipped to the river towns along the way, and north to Albany and Troy. Any ice left over at the end of the season would be kept in the icehouses to help buffer potential shortages if the next winter proved less productive.

The brothers Robert and William Scott formed the R&W Scott Ice Company at the height of the industry. In 1880 the Scott brothers purchased a tract of riverfront land at Newton Hook and built what was then a relatively small icehouse with a capacity for fifteen thousand tons. These were boom years, and the Scotts did well. In 1885 they decided to expand, undertaking the construction of one of the largest icehouses ever built on the river. With a footprint three hundred feet long by two hundred feet wide, the new building stood large enough to enclose a football field, and could store as much as fifty-two thousand tons of ice at any one time.[8] Architecturally it was somewhat more sophisticated than many of its neighbors, topped with a mansard roof with six functional dormers on its west facade, which served as loft doorways to allow for the passage of ice in and out of the upper levels of the house.

On the small strip of land between the icehouse and the dock, the company built a handsome brick powerhouse to drive the six conveyors that brought ice up from the river. Dwarfed by the massive icehouse that rose behind it, what the building lacked in scale it more than made up for in detail. Large arched windows with detailed surrounds lit the building's interior, above which a delicately corbeled cornice supported a mansard roof built to match that of the icehouse. A tall, tapered chimney stood at the building's northwest corner, with well-articulated corbeling and diamond-shaped details that to this day demonstrate the Scott brothers' choice of highly skilled masons to erect a landmark that would long outlast the industry it was built to serve.

Ice harvesting on the Hudson continued to boom until the turn of the century, when sanitary concerns over ice from increasingly polluted rivers quickly led to the industry's decline. Especially after outbreaks of typhoid fever were blamed on contaminated river ice, mechanically produced ice became an appealing and successful alterna-

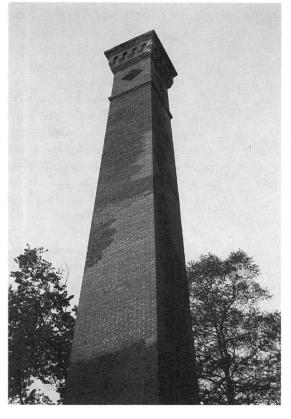

The powerhouse chimney. Stabilization work has ensured this ruin's survival.

tive that quickly led to the demise of ice harvesting in the Hudson Valley and elsewhere. The development of artificial refrigeration in the 1920s sealed the industry's fate, and by the 1930s what was once one of the dominant river trades had vanished completely.

Almost overnight, the great icehouses of the upper Hudson were left empty. Such mammoth structures proved poorly adaptable for other uses: some were quickly demolished. Others were revived for mushroom growing, their vast and dark interior spaces taken over to serve as man-made caves. But in this too the old buildings proved of limited usefulness, and soon even those that had found new uses were again abandoned. Their wood construction made them especially vulnerable to fire, and it was this that brought most—including the huge Scott icehouse at Newton Hook—to their ultimate fate.

In 1900 the Scott brothers sold their Newton Hook property to the Merchant Union Ice Company, a large firm that ran numerous ice-harvesting operations throughout the northeastern United States. In 1922 Merchant Union was bought out by the Knickerbocker Ice Company of New York, one of the oldest and most powerful companies in the business. Founded in the Hudson Valley at Rockland Lake in 1855, by the 1890s Knickerbocker dominated the industry, with holdings up and down the eastern seaboard. Knickerbocker became one of the only ice companies to survive these years by diversifying into mechanically produced ice. With little hope for traditional ice harvesting the company ceased operations at Newton Hook in the early 1920s, leaving the property abandoned. On July 16, 1934, the icehouse burned to the ground, leaving only its stone foundation and the gutted shell of the powerhouse behind.

Little has changed since then. Situated on an isolated point of land west of the railroad tracks, the site gradually returned to nature. The elaborate masonry walls and chimney of the old powerhouse remain there today, along with the stone foundation of the icehouse itself. A row of rotted pilings in the river is all that is left of the icehouse dock. Elsewhere in the valley, powerhouse chimneys remain to mark the sites of at least two other Hudson River icehouses, one at Malden-on-Hudson in Ulster County, another on Schodack-Houghtaling Island opposite Coeymans. But of the rest, all that can be seen is an occasional foundation ruin, or a decaying old bulkhead. Many icehouses were built on fill, and today these flat, rectangular projections of overgrown land are the most common visible remnants of an industry whose presence once characterized this part of the river.

Unlike the Hudson River brickyards or cement factories, whose legacies can be seen in buildings that have long outlasted the trades themselves, the product of the Hudson River ice industry literally melted away. Today the ruins at Newton Hook are perhaps the best-preserved reminders of this vanished industry. In 1985 they were recognized by the Interior Department as "the most intact icehouse site of the period

in the region," and included on the National Register of Historic Places.[9] Five years later the land was acquired by the New York State Department of Environmental Conservation and opened to the public as part of a small, undeveloped park called the Nutten Hook State Unique Area. In the fall of 2001, the state undertook much-needed conservation work to stabilize the deteriorating powerhouse ruins.

Today only a few houses stand along Route 9J where the busy little landing of Newton Hook once occupied the river's shore. After the icehouse closed and the ferry stopped running, the townspeople quickly scattered to the winds, and their buildings faded back into the landscape. A short distance from the icehouse ruins stands another lonely old brick chimney, a remnant of the old Cary Brickyard. Together these two ruins tell the story of a town whose reliance on the river proved both its making and its downfall. Without conservation, the Cary chimney will continue to crumble until it vanishes altogether, leaving the ruins of the R&W Scott Ice Company alone to mark the spot where a town and a trade have come and gone.

Stott Woolen Mills, Stottville

In the eastern part of Columbia County the journey begins. The streams and brooks wander through hilly countryside, moving ever downward toward the Hudson. Flowing into one another, they form the Claverack Creek. As it nears the river, the Claverack turns abruptly and in one short stretch falls more than fifty feet, winding around past the old village of Stottville and the ruins of four mills that were built here to capitalize on the power of the falling water. In a short distance the Claverack and Kinderhook creeks join and form the Stockport Creek. Four miles above the city of Hudson the Stockport meets the Hudson River, which will carry its waters on toward the sea.

The Dutch arrived in New Netherland to find the course of the Hudson punctuated by what they called *kils*, or creeks, flowing into the river from its eastern and western shores. On these creeks in the early part of the seventeenth century the settlers built mills to grind wheat from farms nearby. In addition to gristmills, they built weaving mills and sawmills to supply the colony with textiles and lumber. The first of these were usually built on the falls closest to tidewater. As time went on, the mills followed the pattern of settlement up the tributaries of the Hudson farther into the hinterlands.

Lords and patroons of the great river manors and estates built many of the first Hudson Valley mills. Tenant farmers on the manors were obliged to bring their harvests to the mills of their respective landlords, who profited in selling the finished goods. In Westchester the Philipse and Van Cortlandt families built mills on the Nepperhan, Pocantico, and

If water enlivens the scene, we shall hear the murmur of the noisy brook, or the cool dashing of the cascade, as it leaps over the rocky barrier. Let the stream turn the ancient and well-worn wheel of the old mill in the middle ground, and we shall have an illustration of the picturesque, not the less striking from its familiarity to every one.
—Andrew Jackson Downing, *Treatise on the Theory and Practice of Landscape Gardening*, 1842

Croton rivers by the 1680s. Farther north, the Van Rensselaers erected mills on both sides of the river as early as the 1630s. The immense holdings of the Van Rensselaer family eventually grew to include the land surrounding the present-day Stockport, Kinderhook, and Claverack creeks.

Once there stood so many mills on the Stockport and its tributaries that for a while it was known as Factory Creek. Earlier it had been called Major Abram's Kill, for Abram Staats, who established a trading post at the mouth of the creek in the 1650s. In the middle of the eighteenth century, Hendrick van Rensselaer erected a saw- and gristmill a few miles up the Claverack Creek, on the great falls by the future village of Stottville. Sometime later a woolen mill was also built. With three mills in operation a small hamlet was soon established, called Springville for a cluster of mineral springs that rose nearby. In 1828 the Van Rensselaers sold the water privileges and at least one of the mills at Springville to Jonathan Stott (1793–1863), a miller in the city of Hudson.

Stott, the son of a silk manufacturer, was born in England near Manchester in 1793. Reluctant to take his place in the family business, at age sixteen he enlisted in the British army. With the War of 1812 Stott found himself sailing for America to join in the attack on Fort Niagara. There in 1814 he was captured by the Americans and taken to a military prison at Pittsfield, Massachusetts. The industrialization that had already swept England was then just arriving in the United States, and in the years before the war American manufacturers had looked to England for advanced machinery, improved production methods, and skilled labor. The mill owners of Pittsfield came to the military prison looking for men with experience in the British textile factories. With his knowledge of the textile industry Stott gained his release to help train workers at a nearby mill. After the war he avoided being sent back to England and managed to make his way to Hudson, where an uncle had settled sometime before.

Within a few years Stott wed the daughter of a local hatmaker, and, apparently having had a change of heart toward the textile business, he opened a small hand-powered weaving factory in the city of Hudson. The mill was destroyed in a fire that swept the city in 1826, but Stott rebuilt. The business grew considerably, and by the late 1820s the next logical step in the company's growth required access to waterpower. In 1828 Stott bought the old Van Rensselaer mills at Springville, two and a half miles north of Hudson, and moved his business there.

By the 1820s the industrialization of New England had moved west, making very visible changes to the mills of the Hudson Valley. Earlier mills had been relatively small structures, often two or three stories in height, built of wood or stone and employing perhaps a dozen hands at most. At the beginning of the nineteenth century, improved machinery

such as the power loom began to arrive from England. These machines required more space and were often installed in great numbers, and the pastoral mills of the previous century began to give way to much larger, modern factories.

The first modern, mechanized textile mill to open in the United States came in 1793, with the Samuel Slater mills near Providence. So efficiently could these mills process cotton into cloth that the raw product was shipped all the way north from plantations in the South. In 1811, James Wild opened two modern cotton mills on the Stockport Creek, a few miles downstream of Springville. Wild built his mills of brick, four and six stories in height. They employed some two hundred people.[10] The phenomenon repeated itself all along the river as large, modern factories that produced textiles and other products appeared at Wappingers Falls and Fishkill, Catskill and Castleton, and at tiny Springville in Columbia County.

Stott's new mill specialized in making flannel from wool. An 1835 gazeteer of New York State found at Springville "a flannel factory, grist and plaster mills, 2 stores and about 15 dwellings."[11] Within a few years Stott acquired the other mills at Springville, and in 1846 he built the first of four large brick factories, just east of the old wooden bridge that spanned the falls. The new building was called "Mill No. 1," and the more recently acquired factory across the creek "Mill No. 2." By 1848 the vil-

Franklin Ellis's 1880 *History of Columbia County* provided this full-page illustration showing the "Residences and Mills of C. H. & F. H. Stott." Courtesy Mary Howell.

lage became known as Stottsville.[12] The firm continued to grow, and by 1859 it operated as J. Stott and Sons. That year the company built its own finishing mill, which it called Mill No. 3, a short distance downstream.

The Civil War proved a fateful time for the Stott mills. The elder Stott retired in 1860 and left the business to his sons, who reorganized under the name of C. H. and F. H. Stott. The firm had gone through good times and bad in the preceding decades, but during the war the Stotts won lucrative contracts to supply uniforms for the Union army, ushering in a thirty-year period of prosperity. In January of 1861 Mill No. 1 burned, but the company rebuilt it that same year. By the time Jonathan Stott died in 1863 Stottsville had blossomed into a flourishing village, home to several hundred men, women, and children who ran the mills.

In 1865 the Stotts replaced the No. 2 mill with a new building, and a third large brick mill rose up over the falls. A few hundred yards downstream, around a bend in the creek, Mill No. 4 appeared in 1876. With a tall central stair tower topped by an ornate octagonal cupola, this was to be the most elaborate of the mills at Stottville (the name of the town lost its second *s* by the end of the century). The roar of the falls now echoed off the towering facades of four big factories, which dominated the village and the pastoral landscape around it. All were built of brick, all were five stories in height. To augment the power of the falls three dams were built, and the company installed large steam engines with tall brick

Stott Mill No. 4, west facade, January 2002. Center tower and cupola date from 1876; more modern industrial facades to the left and right were added later, probably in the 1920s.

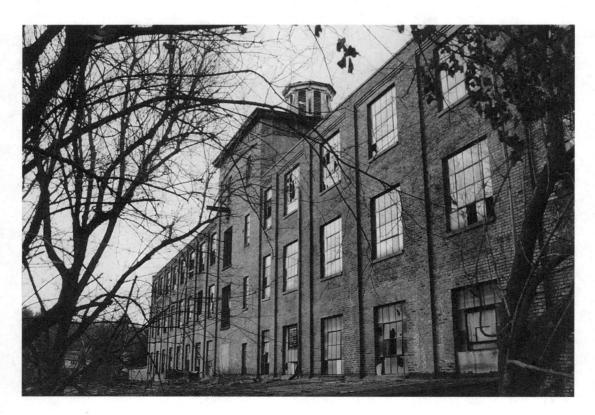

smokestacks to keep the mills running during periods of drought or when ice interfered with their hydraulic turbines in winter.

The company flourished throughout the 1800s, and the town continued to grow around the mills and the big Italianate mansions of the Stotts until its population reached just over one thousand. But business turned sour with the panic of 1893. Management issues that arose with the deaths of C. H. and F. H. Stott didn't help matters, and in 1901, having amassed debts in excess of $1.5 million, the company abruptly went into receivership. Francis H. Stott's personal debt alone amounted to nearly $80,000, and the company's creditors were able to recoup only forty cents for every dollar lost. It was a scandalous end to a company that had lasted more than eighty years to become one of the oldest textile firms in the state.[13]

When the dust settled, the mills had been acquired by Augustus D. Juilliard, a prominent textile manufacturer who later endowed the famous music conservatory in New York. Juilliard's company assigned the factories at Stottville to a subsidiary known as Atlantic Mills. Over the next fifty years Juilliard built significant additions onto each of the four mills and added more housing for workers. But the character of the town and its factories remained largely unchanged until Juilliard went out of business and the mills closed in the fall of 1953.

By the 1950s the face of heavy industry in America had changed drastically. Compared with modern chemical factories, oil refineries, and steel mills, the textile factories of the Northeast seemed almost as quaint as the early gristmills they had supplanted in the previous century. In the face of increased competition from textile plants in the South and later from outside the country altogether, the northeastern mills began to close en masse by the middle of the twentieth century. Especially in the

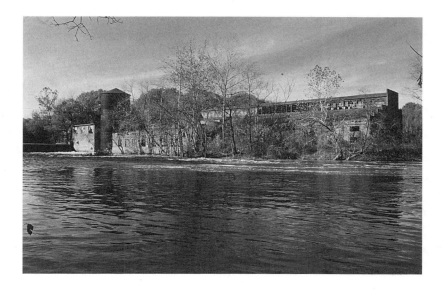

Mill No. 3, from across the Stockport Creek. The last tenant to occupy this building was a printing company.

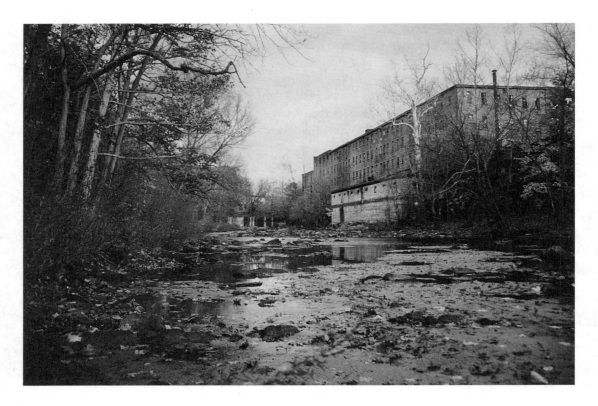

Mill No. 4, view to the
southeast, fall 2001.

Hudson Valley and New England, this great shift left a legacy of abandoned mills and factories, and of broken old mill towns struggling to deal with problems of unemployment, searching to find their place in a changed American economy.

In Stottville the former textile mills found a number of makeshift uses after the collapse of Juilliard's company. In 1955, a Brooklyn company called L&B Products acquired Mill No. 3 to make furniture for restaurants. L&B transferred its operations to Stottville and later expanded to occupy Mill No. 4. Mills No. 1 and 2 meanwhile were sold to a local poultry farmer in 1958, presumably to serve as chicken coops. But the enterprise failed, and the mills sat empty. In 1970 a local man purchased Mill No. 2 for $10 in a tax auction, with the intent of tearing it down to resell its brick. But even this plan never got off the ground. Finally in 1978 the county government demolished the building itself. In 1982 L&B Products moved to nearby Hudson, and the last of the mills went dormant forever.

The closing of the mills left Stottville high and dry. A factory town in the truest sense, it was to the mills that the village owed its very existence. When they closed, its residents had to find work elsewhere, which wasn't always easy to do. Soon many of its old houses began to appear run down, and the place assumed an air of desolation and decay. Situated well off the main highways, time seemed to have left Stottville behind.

Elsewhere in the Hudson Valley, other mill towns experienced similar

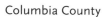

Mill No. 4, office door.

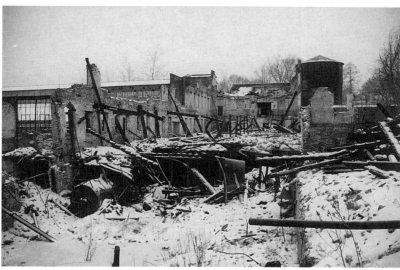

Snow covers the fire-ravaged
ruins of Stott Mill No. 3,
January 1999.

problems. While many old mills have vanished and others remain aban-
doned, some towns have found new uses for old industrial buildings. In
Saugerties a developer converted a long-abandoned paper mill into apart-
ments. A portion of the old bleachery at Wappingers Falls now serves as
a small business incubator. At Garnerville in Rockland County a large
complex of old mills has become studio space for artists. In putting the
old mills back to work, these communities have preserved an important
part of the valley's industrial, cultural, and architectural heritage. Where
they survive, the factories stand as monuments to the industrial develop-
ment that often spurred the creation of the towns in which they stand.

Sadly, the mills at Stottville would never enjoy such recognition. Mill
No. 1 was razed shortly after Mill No. 2. The oldest of the mills, No. 3,

Interior view of Mill No. 4. Floor beams and brick walls were dismantled for salvage and reused elsewhere.

was destroyed in a dramatic fire on the night of August 4, 1994. Its ruins were partly demolished in the years that followed, but more than a decade after the fire much of the mill still stands. Mill No. 4 was stripped of its valuable timber floors and then slowly demolished over the course of several years beginning in 2002. Besides the abandoned shell of Mill No. 3, all that remains to mark the sites of the mills at Stottville are crumbling stone and brick foundation ruins that lie here by falls of the Claverack Creek, its waters still making their way inexorably toward the Hudson.

Jan van Hoesen House, Claverack

For nearly three hundred years, the home of Jan van Hoesen has stood overlooking the Claverack Creek, about two miles in from the river's eastern shore. Today the house is empty. Though historians recognize this as being one of the oldest and most important examples of residential architecture in the Hudson Valley, decades of neglect have left the house a desolate ruin. Once it was common to find the Hudson's old Dutch houses in varying states of disrepair. In recent years many homes from this early period have been carefully restored or even made into museums, but this old mansion remains a landmark forgotten by most.

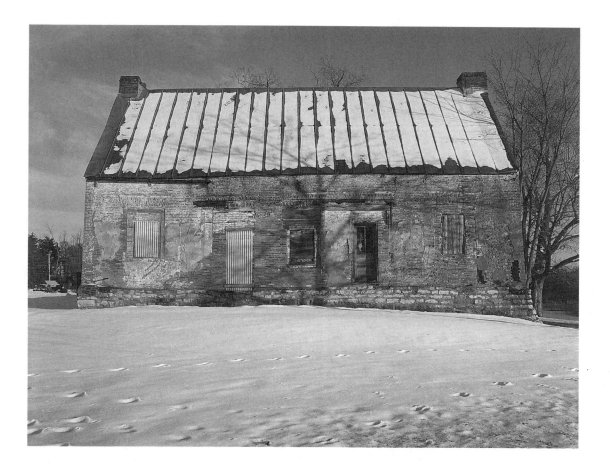

Though small by today's standards, the Van Hoesen house was one of the grandest on the Hudson when built, around the year 1720. It stands on a tract of land purchased by Jan Franse van Hoesen, the grandfather of its builder, who came to New Netherland via Amsterdam from Husum, near Hamburg on Germany's North Sea coast. A seafarer by trade, Van Hoesen arrived at New Amsterdam in 1639 and eventually made his way up the river to Beverwyck (now Albany), where he settled with his family. In 1662 he negotiated the purchase of a large tract of land south of Beverwyck from the native Mahicans, at the site of the future city of Hudson.

Van Hoesen's land lay some thirty miles downstream of Beverwyck, near Claverack (literally "Clover Reach"), at the southern end of the vast patroonship of the Van Rensselaer family. The property included a large, flat point of land that jutted out into the Hudson, where a village called Claverack Landing emerged by the eighteenth century. In a drawn-out legal battle that went on for generations, the powerful Van Rensselaers challenged Van Hoesen's title to this land, claiming to have purchased it for themselves in the 1640s.

But Van Hoesen fought back, and he passed the land to his heirs

The original main facade of the Jan van Hoesen house has been altered, but its symmetrical arrangement can still be discerned.

upon his death in 1665. With the creation of Livingston Manor to the south in 1686, the Van Hoesen property became one of very few freeholds for miles along the Hudson's eastern shore. The feud persisted for more than a century, until 1784, when most of the contested land was sold to a group of Quaker whaling families from Nantucket. In the wake of the Revolutionary War, these families had come up the Hudson in search of a more sheltered place to make their homes. They found that place at Claverack Landing, which they renamed Hudson and which in 1785 became the third city incorporated in the state of New York.

Just east of the newly established city stood a graceful brick mansion that could already have been called "old" by the time the Quakers arrived from New England. This was the house built for Jan van Hoesen (1687–1745), a grandson of Jan Franse van Hoesen, who had inherited a portion of his family's land in the early part of the eighteenth century. Though there is speculation that the inheritance may have occurred around the time of this grandson's marriage in 1711, historians believe the house to have been built sometime between 1715 and 1725, based on the probable time of Jan van Hoesen's inheritance and on known construction dates of similar houses built in what was then still part of Albany County.[14]

Van Hoesen built his home in a style developed in the medieval period and used commonly throughout northern Europe for centuries afterward. While early American builders typically borrowed from European precedents, few did so as literally as the builders of Dutch-era

West elevation, January 2002.

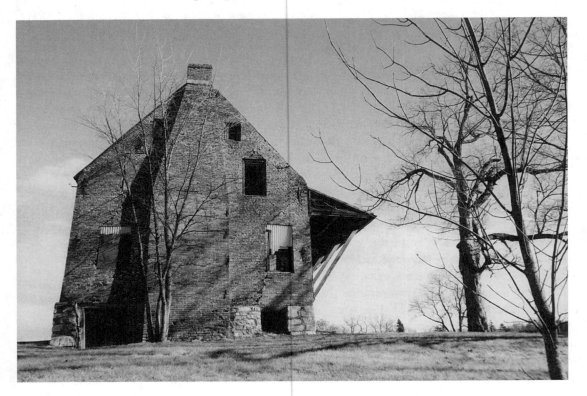

mansions in old Albany County, such as that of Jan van Hoesen. Unlike more modest homes in New Netherland, which were usually built of stone or wood, these larger homes were constructed with brick facades built around a timber frame set atop a fieldstone foundation. It has been speculated that this unique structural system was held over from a Dutch technique designed to reduce the weight of load-bearing walls in an attempt to prevent settling, which was a common problem on the soft soil of the Netherlands.[15]

Like his grandfather, Jan van Hoesen is thought to have been a mariner, which would have afforded his family the resources necessary to build so impressive a house.[16] He situated his home where the road from the landing to the village of Claverack forded the Claverack Creek. The house occupies a rectangular footprint forty-eight feet long by twenty-four feet wide, and was oriented to face the road and the creek below. Over a stone foundation the wood frame was erected first. A skilled builder then laid its brick exterior walls in the Dutch Cross bond, a hallmark of Dutch masonry on both sides of the Atlantic, in which courses of headers alternate over courses of stretchers. Two doorways and three windows were arranged sym-

Detail of west elevation, showing Dutch Cross bond.

Detail view of tumbled brickwork and handmade iron fleur-de-lis anchor, both typical details of Dutch mansions built on the Hudson River in the first part of the eighteenth century.

metrically in the main facade, topped by flat arches in which alternating red and black brick provide subtle architectural detail. Iron fleur-de-lis anchors tie the brick facade to the wood frame beneath. A steep-pitched roof tops the whole, with gable ends forming shallow parapets at either end. Chimneys built into each of the gable ends vented fireplaces used for cooking and heating. Set into the north gable, blackened bricks called *klinkers* mark the initials of Jan van Hoesen and his wife, Tanneke.

In each gable end, brick laid in stepped triangular patterns set at right angles to the slanting roofline form what is perhaps the building's most distinctive architectural detail. The Dutch called this technique *vlechtegen*, and employed it to help create a smooth, weatherproof edge along the roofline of the gable parapet walls. In English it is known as braiding or tumbling (it is often incorrectly identified as another technique called *muizetanden* or "mouse toothing"). A common feature in northern Europe and in England, it was a

definitive detail of the finest homes of old Albany County, and surviving examples today are exceedingly rare.

Three rooms occupied the main floor, which probably made up the extent of the family's living space when the house was built, as Dutch houses typically used basement and garret space for storage. Elegant turned balusters and paneling—an interior detail common only in the finest homes of the period—adorn a central staircase leading to the garret. Almost certainly the builder fitted the house with hinged casement windows and with jambless, open fireplaces, though these have not survived (by the nineteenth century both features were typically replaced by English sash windows and enclosed fireplaces).

While the house itself stands as a fine specimen of the region's early architectural heritage, it is also a reminder of an important, often forgotten theme in the social history of New Netherland. Jan Franse van Hoesen had his origins not in Holland but on Germany's Jutland Peninsula, in an area that was then part of Denmark. Although Dutch character prevailed in the colony, from the very beginning New Netherland was among the most cosmopolitan places in the New World, with early settlers including considerable populations of Dutch, Danes, Germans, Swedes, Norwegians, and French, among others.

Like the Van Hoesens, many of these families came to New Netherland by way of Amsterdam, where their assimilation into Dutch society began even before they left Europe. They adopted the Dutch language and took Dutch spellings for their names (as in "Hoesen," derived from Jan Franse's native Husum). Once in the New World, they often employed Dutch builders to give their houses characteristics like those of the Dutch establishment that administered the communities in which they lived. Long after the English assumed control of the colony in 1664, these families continued to identify with their adopted Dutch culture. Built some six decades after the British takeover, the home of Jan van Hoesen is indicative of this persistent cultural identity.

Although the family house bears a heavy Dutch influence, Jan van Hoesen and his wife remained active in the Lutheran Church—which meant a journey across the river to Lunenburg (today Athens) to participate in church services. The Lutheran community was something of an isolated group in New Netherland, and local histories written in the nineteenth century tended to rely on records of the Dutch Reformed Church, thereby neglecting to document non-Dutch families such as the Van Hoesens. Some have attributed this early oversight to the Van Hoesen house's eventual obscurity.[17] After the death of Jan van Hoesen in 1745, his descendants handed the house down through several generations before it eventually passed out of family ownership. The realignment of the roadway led subsequent owners to build a new main entrance and porch onto what had been the building's rear facade, while further alterations obscured the handsome fenestration and masonry details of the home's intended front elevation.

Insensitive alterations were the least of the problems that faced the Hudson Valley's early Dutch houses in the nineteenth and twentieth centuries. Despite a growing appreciation for the region's early colonial history, many of that era's houses disappeared during this period, while others fell into ruin. As their owners built newer, modern homes on adjacent lots, many of the old houses were converted into barns, used for storage, leased to poor immigrant families, or simply demolished. None of these uses required particularly attentive maintenance, and it became common to find the old homes in various stages of decay. An Albany reporter writing in 1906 found that one such house, the c. 1716 home of Ariaantje Coeymans in Albany County, "despite its former glory," had "deteriorated into a second rate Italian boarding house," but still retained "some of its pristine beauty."[18]

By the end of the nineteenth century an increased interest in New York's Dutch roots led to a greater appreciation for the architecture of New Netherland. Evidence of this resurgence manifested itself in the advent of organizations such as the Holland Society, formed in 1885, and the Society of Daughters of Holland Dames, founded ten years later. At the same time there appeared a revival of Dutch Colonial architecture, a movement that had an especially strong hold on Franklin Roosevelt, who was himself of Dutch ancestry, and who as president saw to it that the style was faithfully adhered to by WPA architects working in the Hudson Valley.

Historians meanwhile set out to document surviving Dutch houses before they disappeared. Books appeared on the subject by the 1920s, of which Helen Wilkinson Reynolds's *Dutch Houses in the Hudson Valley before 1776* is probably the best known. In surveying what remained of the region's Dutch Colonial architecture, Reynolds found the Abraham de Peyster house at Beacon "rented to Italian and Slavic tenants," the Bethlehem home of Hendrick van Wie in "a state of decay" where "occupation in recent years by tenants of the laboring class has altered the house in many details," and the Coenradt Bevier home in Ulster County "a pitiful wreck, abandoned by the fast vanishing native population in the period of the incoming alien and the cheap, frame dwelling, equipped with modern conveniences."[19]

Remarkably, Reynolds and other historians neglected even to mention the Van Hoesen house in their surveys. Its provenance was confused in local histories, which attributed its construction to other Van Hoesen descendants. Writing of the house in 1961, a local newspaper reporter found living there a "Mrs. Minnie McKittrick, an alert little lady of 82 years, who has resided in the handsome old home since 1923."[20] After her death the house was left empty. On the fields behind the house, which Mrs. McKittrick had leased for many years to neighboring farmers, a later owner developed a trailer park called the "Dutch Village" in an apparent, somewhat ironic tribute to the decaying landmark next door.

By the 1960s, a greater appreciation for such early homes prompted

the restoration of many, including the old Ariaantje Coeymans house in Albany County. In nearby Kinderhook another Dutch mansion, the Luykas van Alen house, had also suffered prolonged neglect. Architecturally the Van Alen and Van Hoesen homes were extremely similar. Yet while the Van Hoesen house slipped further into disrepair, the Van Alan house was acquired by the Columbia County Historical Society, restored to its original appearance, opened to the public as a museum, and declared a National Historic Landmark in 1968. Today the Van Alen house is celebrated as one of the best-preserved examples of its kind. The Van Hoesen house meanwhile remains in the shadows. The presence of the adjacent mobile homes has deterred vandalism, and the house is kept securely boarded up. Local historians succeeded in placing it on the National Register of Historic Places in 1979. But twenty-five years later the home of Jan van Hoesen remains empty, still awaiting the recognition that has come to the rescue of its more fortunate contemporaries.

Oliver Bronson House, Hudson

Just south of the city of Hudson, one of the Hudson Valley's most distinguished homes stands vacant and forlorn on the grounds of a state prison. Built in 1812, the Oliver Bronson house later underwent extensive alterations at the hand of Alexander Jackson Davis (1803–1892), one of the most prolific and talented American architects of the nineteenth century. While other Davis buildings in the Hudson Valley have been opened as museums and are published regularly in surveys of the river's most important homes, the Bronson house remains largely overlooked. Only at the beginning of the twenty-first century has a group of dedicated preservationists begun to gain this house the overdue recognition it deserves.

Samuel Plumb, a Hudson businessman, began development of the estate in the second decade of the nineteenth century. In 1811 he acquired 263 acres at the south end of the city of Hudson, which had been established by New England Quakers just twenty-five years before. Plumb's estate stretched from the river up to the old turnpike road leading south from the city (today U.S. Route 9). The following year he erected a large Federal-style mansion, situated near the turnpike road some distance in from the river. The architect of the original house is unknown, though similarities have been noted to the James Vanderpoel house in Kinderhook, which suggests that both houses may have been the work of a local architect named Barnabas Waterman.[21]

In 1835 the estate passed to Robert Frary, who three years later sold the house with eighty acres to Dr. Oliver Bronson (1799–1875), heir to a wealthy Connecticut financier, banker, and real estate speculator. Two years earlier Bronson had married Joanna Donaldson in New York City,

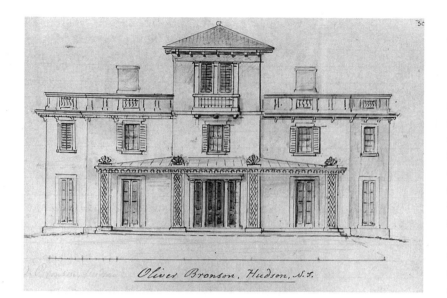

Oliver Bronson, Hudson, N.Y.

Davis' design for the mansion's west elevation, commissioned in 1849, featured an Italianate tower and a broad verandah that offered views west toward the Hudson River. Detail of A. J. Davis, *Oliver Bronson, Hudson, N. Y.*, c. 1849. Pen and ink; graphite image: 13.5 x 20 cm; sheet: 30.7 x 20.1 cm. Courtesy Metropolitan Museum of Art.

whose brother, Robert Donaldson, is known to architectural historians as perhaps the greatest patron of architect Alexander Jackson Davis. In 1831 Robert Donaldson commissioned Davis to design his home on State Street in New York. Five years later Davis designed Donaldson's river estate, Blithewood, at Annandale-on-Hudson, less than twenty miles south of Hudson. Almost certainly it was through his brother-in-law that Oliver Bronson was introduced to Davis, and in 1839 Bronson hired Davis to redesign and expand his home at Hudson.

One of America's first great architects, Alexander Jackson Davis may be the figure most closely associated with the early development of grand estates and country seats on the Hudson River.[22] Born in New York City, he began his career as a draftsman and in 1826 joined the New York firm of Ithiel Town and Martin Thompson. Three years later Davis formed a partnership with Town. The new firm emerged as one of the nation's leading practitioners of the Greek Revival, gaining ever greater commissions and recognition. Early works included the temple-like Federal Customs House (1833–1842) and a row of townhouses known as LaGrange Terrace (1830–1833), both in New York. Gaining prominence outside New York, the firm participated in the design of several state capitols, including those of Indiana, North Carolina, Illinois, and Ohio. In 1835 Davis established his own practice. His Dutch Reformed church built the following year at Newburgh today remains one of the greatest Greek Revival buildings in the Hudson Valley.

Davis's work underwent an important change in the mid-1830s as he set off in the vein of a new design aesthetic based on English theories of the Picturesque. This movement had its origins in the writings of English landscape designers such as William Gilpin (1724–1804), who

drew a distinction between the "Beautiful," into which could be grouped neat and orderly structures such as the Greco-Roman temples built by Davis in his early career, and the "Picturesque," which called for rambling, asymmetrical buildings whose facades were complemented by the effects of age and by wild, untamed landscapes. Beginning in the mid-1830s Davis became an early champion of the Picturesque in American architecture. Soon he moved away from the Greek Revival in favor of a variety of styles, including the Tuscan, Italianate, Egyptian, Swiss, Gothic, and Italian Villa. Elements of these he adapted to create his own distinct style, which, employed prolifically on the banks of the Hudson, eventually became known as the Hudson River Bracketed. The designs Davis provided for Donaldson and Bronson were among the first major works executed in this uniquely American style.

Davis's work at the Bronson house came in two phases, the first in 1839 and the second in 1849, representing an evolutionary trajectory in American rural architecture. In 1839 Davis remodeled the home's exterior, building an ornate veranda along its east facade and adding wooden brackets under the eaves. This latter device typified what became known as the "Bracketed Mode," and though Davis did not employ it in many of his best-known works from this period, it remains one of the design elements most commonly associated with Davis's romantic architecture. Quickly copied by other architects, the Bracketed Mode eventually worked its way into the architectural vernacular, and by midcentury prefabricated cornice brackets were commonly available through catalogues to any amateur house remodeler.

The 1839 work also included landscape improvements to transform the grounds along the same lines as Davis's alterations to the house itself. This brought what may have been the first collaboration between Davis and the landscape designer Andrew Jackson Downing (1815–1852). Although there is no documentation to confirm that Downing was hired to consult on landscape work at the Bronson property, records from 1839 show that Downing's Newburgh nursery did supply plantings for the estate, and the two designers are known to have collaborated frequently thereafter.[23] Within the next two years Downing's own career quickly took off, and his informal association with Davis continued throughout the following decade, until the Newburgh nurseryman partnered with an English-born architect named Calvert Vaux.

Both Davis and Downing continued to gain prominence in the 1840s, promoting their work through publications such as Downing's *Treatise on the Theory and Practice of Landscape Gardening* (1841), and his *Cottage Residences* (1842), which showed estates such as Blithewood as examples for others to follow, and put the English romantic design theories in terms Americans could understand. In *The Architecture of Country Houses* (1850), Downing defined the Picturesque as "seen in the ideas of beauty manifested with something of rudeness, violence or difficulty. The effect of the whole is spirited and pleasing, but parts are not bal-

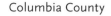

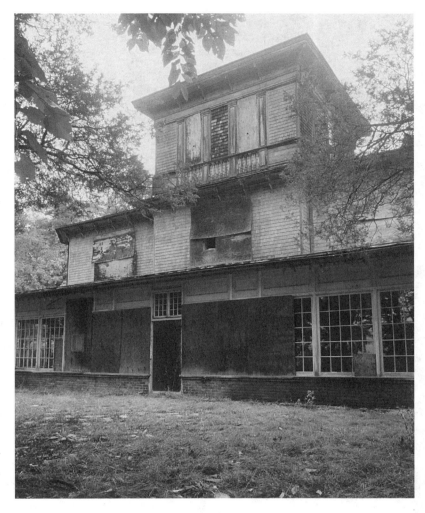

View of the boarded-up west facade in 2005. The veranda has been enclosed, but otherwise the house remains unaltered.

anced, proportions are not perfect, and details are rude."[24] At the same time, Thomas Cole and Washington Irving painted and wrote of the untamed natural setting of the Hudson River and Catskill Mountains, romanticizing the natural landscape and promoting in art and literature the romantic momentum that Davis and Downing promoted in design.

In 1849 Bronson commissioned Davis to undertake more substantial alterations that brought the mansion fully into line with the romantic ideal. Davis reoriented the house so that its main facade faced west toward the river and the Catskill Mountains. To the west facade Davis added additional living space, a new veranda, and a three-story Italian Villa–style central tower that became the house's defining feature. Semi-octagonal additions were built onto the north and south ends of the house. But it is the west elevation that most clearly bears the stamp of Davis. Its symmetrical arrangement is similar to that of Locust Grove, the Poughkeepsie estate of Samuel F. B. Morse, which Davis redesigned in 1851.

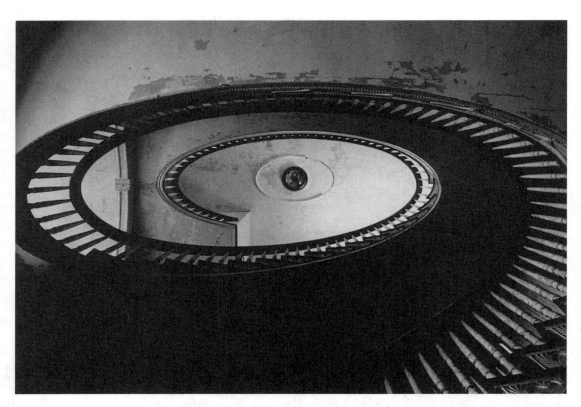

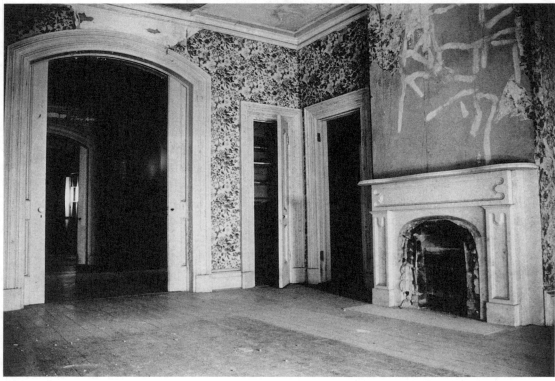

Interior details survive to reflect both the Federal period and the Davis alterations. The overwhelming feature is a three-story elliptical staircase, which dates to the home's initial construction in 1812, though its turned balusters and newel post are likely the work of Davis. Windows and doors to the west opened the house to the 1849 veranda and to views of the river and the Catskill Mountains. Today both interior and exterior details survive intact, having changed little despite a century of institutional ownership and thirty years of abandonment.

Bronson sold his estate in 1853 and returned to Connecticut. Apart from the addition of a Gothic Revival gatehouse in the 1870s, his estate remained without substantial alteration. The house changed hands among private owners until 1904, when it was sold to the New York State Training School for Girls, which had opened in 1887 on an adjacent property. The training school served as a reformatory for girls between the ages of twelve and fifteen who were convicted of petty misdemeanors. Later it became a women's juvenile detention center. The Bronson house served as a residence for the school superintendent until 1972, when it was vacated in favor of more manageable quarters. In 1976, the property became a medium- and minimum-security adult correctional facility. The lawn below the mansion's west facade is now used as a firing range, and Davis's carriage house remains in use for storage. But the prison complex is situated well out of sight of the house itself, and the surrounding acreage retains a pastoral character.

(*Opposite, top*) an elliptical staircase dating from the mansion's original construction remains the most prominent interior feature.

(*Opposite, bottom*) high ceilings, double pocket doors and marble fireplace mantels characterize the mansion's interior.

Second-floor landing, looking east, January 2002.

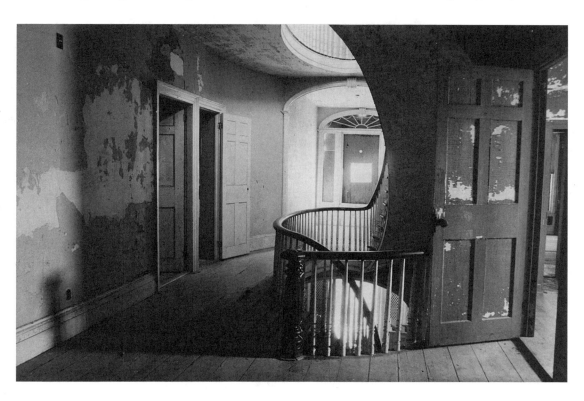

In the years following the Civil War, Davis's career declined. Though he continued to practice into old age, writes historian William Krattinger, his "presence on the American architectural scene had all but faded."[25] Downing lost his life in a tragic steamboat disaster on the Hudson in 1852, but he and Davis had already helped give rise to a movement that prevailed across the country for much of the nineteenth century. By the 1860s, Davis had beautified the Hudson Valley with more of his works than perhaps any other region in America. Robert Donaldson's Blithewood was demolished sometime around 1900, but the estate's Davis-designed gatehouse remains on land now part of Bard College. Other survivals include the Dutch Reformed church at Newburgh (1836); Lyndhurst, the Tarrytown estate of Jay Gould (1838, additions 1865); Montgomery Place, near Blithewood in northern Dutchess County (alterations, 1842, 1863); Locust Grove, home of Samuel Morse at Poughkeepsie (alterations, 1851); the Delamater house at Rhinebeck (1844); and Edgewater, another mansion built for Robert Donaldson and later the home of Gore Vidal, at Barrytown (alterations, 1854). The demolition of Blithewood left the Bronson house the oldest known example of Davis's work in the Bracketed Mode.

After his death, Davis's work continued to languish in obscurity through much of the twentieth century. Edith Wharton crystallized (if not coined) the term "Hudson River Bracketed" in her 1929 novel of the same name: it came to be used as a catchall for a variety of styles used by numerous romantic architects of the nineteenth century. It was a style much out of fashion by then, and the term was not always used flatteringly. Early written works on the region's historic residential architecture tended to gloss over or indeed to scorn "Victorian" interventions on old homes such as Bronson's. Typical of these, Harold Eberlein and Cortlandt Hubbard's *Historic Houses of the Hudson Valley*, first published in 1942, included just two works by Davis (the Bronson house was not one of them), and mentioned the architect only once in passing. Writing in reference to architect Richard Upjohn's 1849 alterations to Martin van Buren's home at Kinderhook (about twelve miles north of the Bronson home), the authors espoused utter disdain for "the Victorian 'beautifier' who wrought such atrocities at Lindenwald."[26]

Gradually there came a greater appreciation among historians for Davis, Downing, Upjohn, and their contemporaries, and today all three figures are revered as icons of American architectural history. The federal government designated Locust Grove a National Historic Landmark in 1964, and Lyndhurst gained the same distinction two years later. In 1973, shortly after the Bronson house was last used as a residence, it was listed on the National Register of Historic Places. However, it took another thirty years for plans to restore the house to be set in motion. In 2003 it joined the ranks of other Davis houses as a National Historic Landmark, and the state Office of General Services reached an agreement to lease the house to Historic Hudson, Inc., a volunteer organi-

zation dedicated to promoting the architectural heritage of the city of Hudson. Historic Hudson hopes to use the opportunity for a public-private partnership to open the house as a museum. The Bronson house has already been opened to the public on a handful of special occasions, including the two-hundredth birthday of Alexander Jackson Davis in July of 2003. Though the building remains empty, stabilization work has already begun, and there is hope that this long-overlooked Hudson Valley landmark may soon be restored after more than thirty years in limbo.

II

THE MIDDLE HUDSON

ULSTER COUNTY

ULSTER IS THE largest county on the Hudson between New York City and Albany. Along with Albany, Dutchess, Orange, and Westchester it is one of the twelve original counties of New York established in 1683. It took its name from the duke of York's earldom in the north of Ireland. Initially it covered even more land than it does today, until its northernmost part was ceded to form part of Greene County in 1800. Today Ulster remains home to some of the most dramatic landscapes along the river, including much of the Catskill Forest Preserve.

As early as 1614, the Dutch had established an active trading post here, near the mouth of the Rondout Creek. Thereafter settlement was sporadic. Not until 1652 did a distinct community take shape by the trading post, eventually known as Wiltwyck, literally "Wild Town," named for frequent clashes between the European settlers and the Esopus Indians with whom they shared the land. Today called Kingston, this was the third town established in New Netherland. Later, it became the seat of Ulster County. For a number of years during the Revolution, Kingston served also as the state capital.

Other settlements followed toward the end of the seventeenth century. These included Saugerties in the northern part of the county and New Paltz, founded by French Huguenots in the late 1670s. Long after the colony fell to the English in 1664, the towns and villages of Ulster retained the character of the Dutch colonial period. The early architecture of the county is dominated by the distinctive fieldstone houses of the Hudson River Dutch, which seem to have proliferated here more than anywhere else on the river.

The nineteenth and twentieth centuries saw the rise and fall of industrial Ulster. Here as elsewhere mills had been built beginning in the 1600s, where creeks from the hinterlands fell dramatically down to tide-

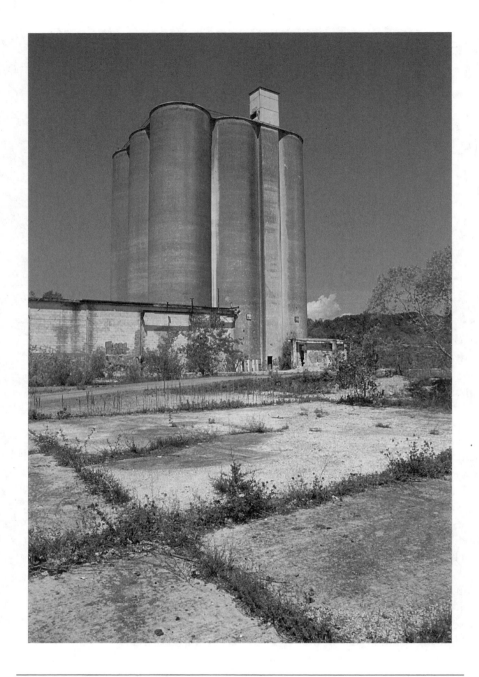

Hudson Cement Company, East Kingston

The Hudson Cement Company, which was formed in 1957, built a factory and three-hundred-foot-tall storage silo near the Steep Rocks area along the Hudson River. Previously this was the site of several brickyards. A boiler flue from the Schultz brickyard survives nearby along with a brick office building. The cement plant closed in the early 1980s. In 2005 a developer announced plans to build 2,200 condominiums and 300,000 square feet of retail space on this former industrial site.

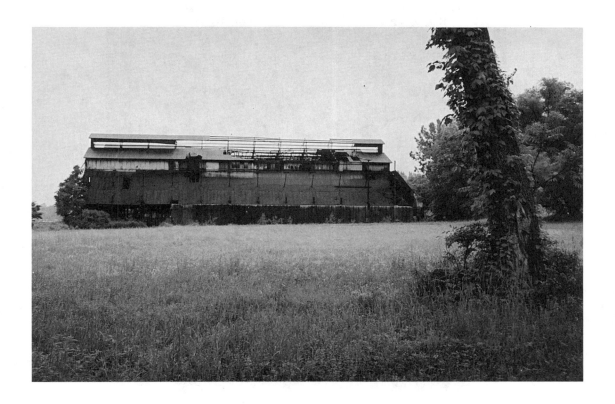

Hutton Company Brick Works, Kingston

Situated north of Kingston Point, the Hutton Company operated continuously from 1865 until 1980, making it the longest-running brickyard on the Hudson River. Its ruins remain much as they were when the plant closed. Pictured is the northernmost of three kiln sheds originally erected in 1928 for the Excelsior brickyard at Haverstraw. After the Excelsior plant closed, the Hutton Company purchased the sheds and had them brought to Kingston, where they were re-erected in 1940. Ownership of the Hutton yard passed to the Jova brick works in 1965, and then in 1970 to the Staples family, both longtime Hudson River brick manufacturers. In 1979, new environmental regulations required the brickyard to replace its antiquated scove kilns with modern kilns that produced fewer emissions. Unable to afford the upgrade, the plant closed instead. A proposed condominium development may lead to the demolition of some of the brickyard buildings.

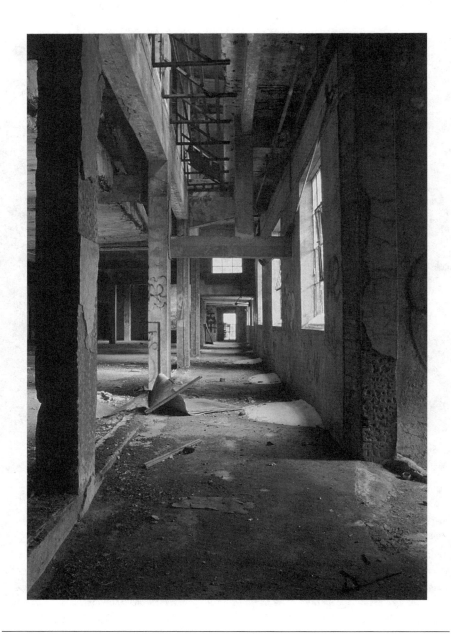

Jacob Forst Packing Company, Kingston

German-born Jacob Forst established a meatpacking business in Rondout in 1873, and for a time was employed as an agent in the firm of Armour and Company, selling meat throughout the Hudson Valley. Forst incorporated his company on January 4, 1922. The packing building (shown above) and garage were built on Abeel Street, across from the company office. Cattle pens, a slaughterhouse, and a distributing warehouse lined West Strand. Forst smoked delicacies were shipped worldwide, and Forst frankfurters were famously served to King George VI and Queen Elizabeth during their visit to the Roosevelt estate at Hyde Park in 1939. After years of planning, demolition of the plant began in September 2005 for development of a hotel.

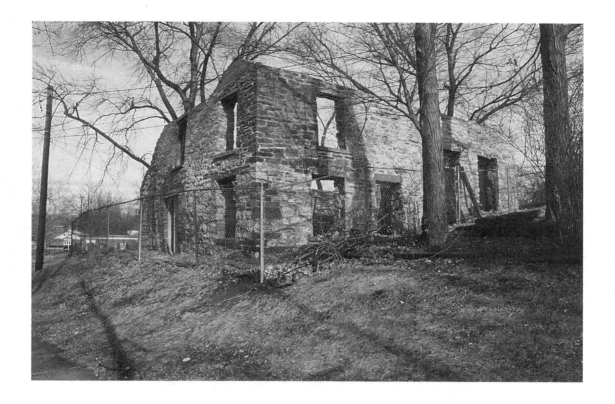

Pieter Corneliessen Louw House, Kingston

This stone house, also known as the Louw-Bogardus house, may be the oldest substantial ruin in the Hudson Valley. The eastern section of the house was likely built around 1676, while the western section was probably added in the eighteenth century. Helen Wilkinson Reynolds, in her book *Dutch Houses in the Hudson Valley before 1776*, described the crude masonry as typical of early regional domestic architecture. The house burned in the 1960s and was subsequently threatened with demolition by the Kingston Urban Renewal Agency. The Friends of Historic Kingston acquired the property and stabilized the ruin. The Louw house is a Kingston City Landmark and is included in the Kingston Stockade Historic District on the National Register of Historic Places.

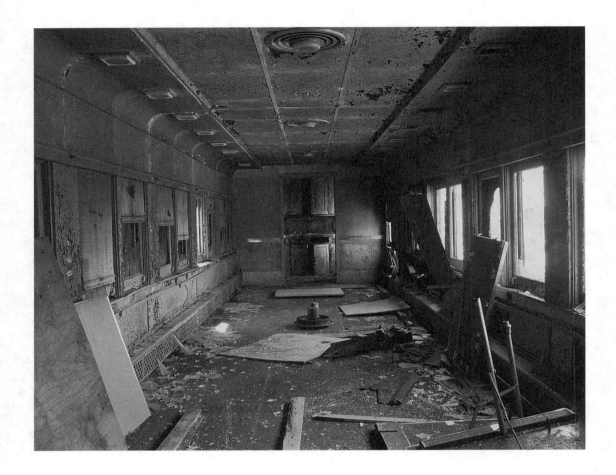

"Lion Gardiner," Kingston

Pullman Standard built this dining car for the New York Central Railroad in 1930, which operated it as no. 66, the "Lion Gardiner." Later it ran as Delaware and Hudson no. 154. In the 1970s it had an active retirement, running for an excursion railroad called the Connecticut Valley. Sold in the 1980s to become part of a railway museum near Kingston, it now lies abandoned along with other early-twenti-eth-century rail equipment on an unused stretch of track west of the city.

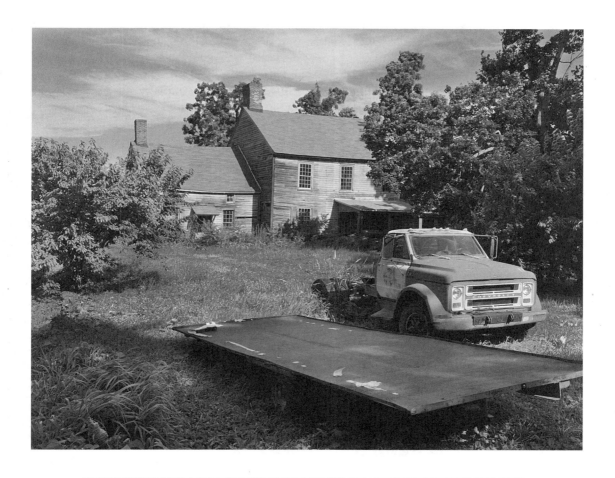

Samuel Halleck House, Milton

This remarkable house overlooks the Hudson from an apple orchard just north of the village of Milton. Its main portion was built c. 1760 by Samuel Halleck, a Quaker, and appears to have gone largely unaltered since its construction. The smaller wing to the north may be older still. Tradition holds that during the Revolution, British ships fired on the house while en route to their assault on Kingston in 1777.

water. The opening of the Delaware and Hudson Canal in 1828 catapulted this county to industrial preeminence. Where the canal met the river, the port town of Rondout took shape almost overnight. Soon Ulster County led the nation in cement production. Bluestone shipped from Ulster quarries paved sidewalks throughout the Northeast. By the end of the century, icehouses and brickyards lined its shoreline for miles.

Despite the presence of so much heavy industry, the Ulster County landscape remained predominantly agricultural. Especially below Kingston, much of the land near the river supported vast orchards and vineyards. Where the Catskill Mountains rose in the eastern and northern part of the county, resort hotels appeared by the score in the late 1800s. The same scenery that in the early nineteenth century inspired the painters of the Hudson River School later brought art colonies, such as Byrdcliffe near Woodstock, and fostered some of the country's foremost writers and artists, including the painter Jervis McEntee (1828–1891) and the outspoken naturalist John Burroughs (1837–1921), who lived here until his death in 1921.

As railroads forced their way up from the river landings into the Catskills, there arose increasing concern, voiced by Burroughs and others, that encroaching development threatened to spoil the mountains forever. In 1885, the state legislature responded by creating the Catskill Forest Preserve, thirty-five thousand acres in Ulster and its neighboring counties to be "forever kept as wild forest lands." Later the Forest Preserve became part of the Catskill Park, which was designated in 1904. Thus protected from development, the stage was set for the construction of reservoirs to serve New York City. Opened in 1915, the Ashokan Reservoir in the central part of Ulster County became the first of many built throughout the Catskill region in the twentieth century.

Today the Catskill Park encompasses some 700,000 acres, more of which lie in Ulster than in any other county. By the middle 1900s, changing trends in tourism led to the demise of nearly all of the Catskill Mountain resorts, while in the foothills by the river the industrial onslaught that had so worried the likes of Burroughs gradually died away. As vines crept over the ruins left behind by the ebbing tide of commercial development, the county's bucolic appeal continued to attract some the nation's foremost writers, artists, and actors, such as Bob Dylan and Robert DeNiro. In recent years, it has also drawn a growing number of commuters from the New York metropolitan area, who have sustained the local economy in the wake of massive layoffs by International Business Machines, the county's largest employer in the latter half of the twentieth century. As the suburban frontier works its way north, the Ulster County landscape faces an onslaught of development pressures unthinkable in Burroughs's time.

Overlook Mountain House, Woodstock

High in the mountains west of the Hudson River one finds a massive ruin that belongs to the era of grand mountain houses. Like its more famous predecessor, the Catskill Mountain House, the Overlook Mountain House stood perched high on a rock ledge, from which the Hudson River was only a small blue sliver in the distance. Panoramas from its long porches offered sweeping views of mountain scenery made famous by the artists of the Hudson River School. In the twentieth century, declining popularity led hotels like the Overlook to close. Fire had claimed most of them by the 1960s. Built of concrete, the Overlook Mountain House has managed to achieve a permanence—if only in ruins—that the other grand resorts of the eastern Catskills have not.

The origins of the Catskill Mountain resorts date to the 1820s. The work of painters such as Thomas Cole (1801–1848) and of writers such as Washington Irving (1783–1859) and James Fenimore Cooper (1789–1851) helped popularize the Catskills as a tourist attraction at a time when tourism was something known only to the wealthiest Americans. In a young nation yearning to stand out from the shadow of European culture, the work of these painters and writers quickly took hold, and gave the rugged Catskill landscapes a special significance. Through the work of Cole, Irving, and others, Americans began to discover a national identity of their own in undeveloped mountain landscapes such as those of the Catskill Mountains. Here America had something Europe did not: wild, untamed natural splendor, lands that unlike the Alps or the Apennines were innocent of man's intervention.

No resort of the eastern Catskills enjoyed greater fame than the Catskill Mountain House, begun in 1827 and expanded over time as its popularity increased and improved transportation made the mountains more accessible. In addition to spectacular scenery, high elevations offered clean mountain air that many believed could cure ailments bred in the ever more crowded streets of New York City. The Catskill Mountain House retained fame and grandeur, even when it was surpassed in size later. Its columned facade stood over a precipice ten miles due west of the Hudson at a place called Pine Orchard, a shining example of American wealth and culture in the midst of a sublime wilderness.

Near the village of Woodstock, just eight miles south of Pine Orchard, the first attempt at building a resort on Overlook Mountain began in 1833.

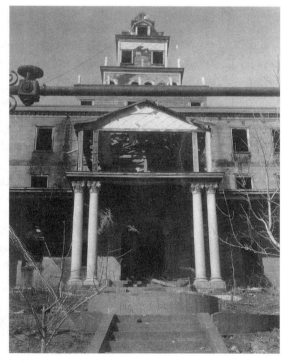

Although the Overlook Mountain House had been abandoned since the early 1940s, the columned entrance at this door survived for two decades, as did the towered roof, seen in this image from c. 1961 to 1962. Photograph by Henry Wm. Guendel.

At that time the mountain was still known as South Peak or Woodstock Mountain. James Booth entertained investors at a "temporary Mountain House" while trying to raise funds for a permanent structure that was to have been called the Woodstock Blue Mountain House.[1] But Booth picked a bad time to attempt competition with the Catskill Mountain House, then itself losing money during a national economic downturn, and the plan went nowhere.

In the years following Booth's failure, South Peak was popularized in the travel writings of Charles Lanman. But it is a better-remembered artist whose imprint the mountain bears to this day. From here in October 1847, Thomas Cole had what may have been his last view of the Hudson from on high: he died a few months later. But his name for the mountain—The Overlook—soon after became the peak's permanent appellation.[2]

Lewis B. Van Wagonen of nearby Kingston constructed the first successful hotel atop the Overlook from 1870 to 1871, for the investors of the Woodstock Overlook Mountain House Company. John Lasher, of an old Woodstock family, leased the management of the hotel, which officially opened on June 15, 1871.[3] At an elevation of three thousand feet it was literally a hotel above the clouds—guests who left Woodstock for the summit in a rainy fog sometimes found themselves bathed in sunlight upon reaching the top. The two-and-a-half-story, mansard-roofed structure faced almost directly south and offered large guest rooms, a well-appointed parlor and dining salon, and a broad piazza, which afforded some of the most magnificent views in the valley.

The Mountain House could accommodate three hundred guests, some of whom stayed for a full season, which usually lasted from June through September. But business was slow in the first years, owing to bad weather and relative isolation. Nonetheless Overlook managed to attract some of the very wealthy and the very famous. In July of 1873 Ulysses S. Grant, then serving his first term as president, paid a visit as a guest of General George H. Sharpe.[4] Though brief—Grant's stay lasted less than twenty-four hours—the president's visit gave the Overlook Mountain House the kind of status investors hoped would draw throngs of visitors.

But misfortune struck, not for the last time, and the first Overlook Mountain House was destroyed by fire on April 1, 1875. Early cries for help were dismissed as an April Fools' Day prank, and once the fire got out of control there was little that could have been done to stop it. Struggling to make the hotel turn a profit, Lasher had allowed insurance policies to lapse. With the hotel now gone, he came down from the mountain for good.

The Kiersted brothers, John and James of Saugerties, later acquired the site and commenced reconstruction of the hotel late in 1877. The new Overlook Mountain House opened on June 25 of the following year.

Architecturally the reincarnated hotel resembled its predecessor, with white clapboard siding and long verandas looking out on the mountains and river below. Business remained sluggish, but the determined Kiersteds made improvements through the early 1880s, which included the addition of a bowling alley and an observatory tower. Though it was sometimes half empty, the Mountain House was still able to attract distinguished guests including Chester A. Arthur, who came for lunch near the end of his term as president.

The 1880s saw the beginning of the peak years for the resorts of the eastern Catskills. The Ulster and Delaware Railroad and the Catskill Mountain Railroad, both up and running by then, made the hotels easier to reach from the steamboat landings at Rondout and Catskill. The opening of the West Shore Railroad in 1882 only helped. In addition to the Overlook Mountain House, there was the Laurel House, built in 1852, and the Hotel Kaaterskill, which opened in 1881, both situated near the famous Catskill Mountain House. To the west at Highmount stood the Grand Hotel, built by the Ulster and Delaware Railroad in 1881. These hotels provided fierce competition for each other, and one factor that hurt the Overlook was the lengthy stagecoach ride from the nearest station of the Ulster and Delaware Railroad, located ten miles away at West Hurley. The Catskill Mountain House was able to overcome this problem with the construction of the Otis Elevating Railway between 1892 and 1893. Ten years later the construction of the Kaaterskill Branch of the Ulster and Delaware, which brought guests practically to the front doors of the Laurel House and the Hotel Kaaterskill, left the Kiersteds at a major disadvantage.

The second Overlook Mountain House opened amid a growing resistance to accommodate Jewish guests.[5] In the twentieth century, the stated and unstated anti-Semitic policies of many hotel owners in the eastern Catskills gave rise to a whole new chapter in the history of Catskill Mountain resort hotels, as Jewish families built their own summer resorts farther away from the Hudson in the southern and western Catskills. Eventually so many of these resorts opened that the area became known as the Borscht Belt, or the Jewish Alps. While some long outlasted the old hotels of the eastern Catskills, by the 1990s many had closed, leaving abandoned old resorts scattered throughout Sullivan and western Ulster counties.

Egbert Kiersted, son of James Kiersted, assumed ownership of the Overlook Mountain House by 1891, as his father and uncle had both passed away. After the younger Kiersted took his own life in 1897, B. F. Bruce, secretary to former president Grover Cleveland, became manager for the 1898 season. Further improvements were made to the property, but the hotel did not reopen in 1899. Thereafter the Mountain House operated only intermittently. Henry Allen Tupper, a writer, lecturer, and clergyman, bought the hotel and reopened it in 1906. The coming of the

automobile initially brought hopes that the Overlook might finally overcome the transportation issues that had left it at such a disadvantage. But within a few decades the automobile had a damning effect on all the resorts of the eastern Catskill Mountains, as it increased accessibility to other parts of the country previously too isolated to succeed as tourist destinations.

New York hotelier Morris Newgold purchased the hotel in 1917 and leased it to the Unity Club, a recreational organization of the International Ladies' Garment Workers' Union. The club's membership included large numbers of Russian and eastern European immigrants, many of whom sympathized with the Bolshevik overthrow of Czar Nicholas II in 1917. The group moved out of the Mountain House when its lease expired, but its relationship with the site later had fateful consequences.

The success of the Bolshevik Revolution led to an anticommunist backlash in the United States known as the first Red Scare. America's two communist political organizations, the Communist Party and the United Communist Party, were forced underground and by 1921 had become disorganized. The parties recognized the need to unify, but with their activities closely monitored they needed a place where they could collaborate in secret. The Overlook Mountain House, by this time fallen from fashion, fit the bill perfectly. In strict secrecy the leaders of the two parties made their way up to the old hotel, and there, on May 28, 1921, the Communist Party of America was born. Historian Alf Evers has suggested that these attendees might have been the last paying guests of the hotel.[6]

In September 1923, the United Mine Workers, a vocal champion of anticommunist sentiment, published a widely distributed series of articles that exposed the Overlook Mountain House as the scene of the party's organization. The hotel had come a long way from the time when presidents and millionaires were entertained in its grand public rooms. Photographs from the late 1910s show its white facade tarnished, its piazza looking worn. On October 31, 1923, less than two months after the United Mine Workers report, the second incarnation of the Overlook Mountain House mysteriously burned to the ground.

By this time the region had gained increased popularity as a place for more modest hotels, camps, and bungalow communities that catered to the working classes who for the first time were able to be tourists themselves. This detracted even more from the exclusive cachet promoted by the old Catskill resorts, thus further diminishing the appeal of these places to the wealthy clientele for whom they were built. Around the same time that the second Overlook Mountain House burned in 1923, fire also destroyed the Hotel Kaaterskill. It was not rebuilt. Business at the Laurel House and Catskill Mountain House also ebbed, and both establishments began to struggle for survival in these years.

On Overlook Mountain, Morris Newgold sought to stay in business

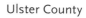
Ulster County

Overlook Mountain House,
main entrance. The process
of decay from a nearly fin-
ished hotel to an empty ruin
became complete when the
towered roof fell in c. 1963
and a fire consumed the
remains in 1965.

Overlook Mountain House
in silhouette, as viewed from
the northwest corner.

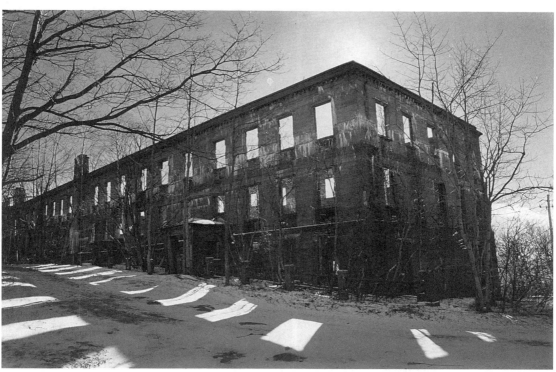

Woodstock artist Sarah Greer Mecklem produced an exhibit in the mid-1990s of biodegradable reproductions of photographs and newspaper articles that are glued to the interior walls of the Overlook Mountain House.

by appealing to the working-class families he astutely recognized held the future of Catskill tourism. After the fire he ambitiously hired architect-builder Frank P. Amato to build a third Overlook Mountain House, located a few hundred feet south of the earlier hotel. The exterior walls of the new building were built of reinforced concrete. A lodge, chapel, power station, stable, and an underground icehouse and cistern were also constructed. In the village of Woodstock, Newgold's stepson built and opened the Colony Hotel, intended to serve as a stopover for guests bound for the Mountain House above. But the third Mountain House never opened, as the elder Newgold encountered financial difficulties and was unable to complete its construction. Left empty, it was eventually boarded up and abandoned. Around 1940 the state Conservation Department acquired the property and joined it to the Catskill Forest Preserve. One year later, the third incarnation of the Overlook Mountain House began its course into ruin after a fire. A more devastating blaze some two decades later left the hotel in its present state of ruin.

Decay and deliberate acts of man led to the disappearance of the other eastern Catskill resort hotels. The most infamous case involved the destruction of the Catskill Mountain House. Closed in 1942, it eventually became a ruin some found as evocative as any in the Old World. Sadly forlorn and neglected, the ruins of the Catskill Mountain House became a common subject for amateur and professional photographers in the 1950s. Seemingly the Catskill Mountain landscape had come full

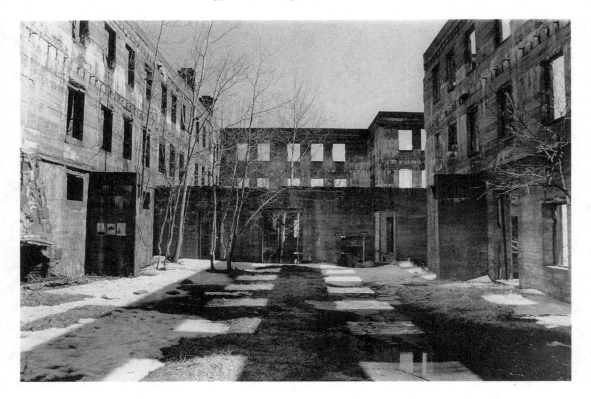

circle from the time when its untouched natural magnificence first made it a symbol of an emerging American identity. Historian Roland Van Zandt described the scene as "disturbingly, hauntingly American, full of pathos and loneliness."[7] Eventually the Conservation Department acquired the property, and in 1963 the agency supervised a controlled fire that destroyed what remained of the ruins. The nearby Laurel House met a similar fate after it too was acquired by the state a few years later.

Today the empty walls of the Overlook Mountain House stand in memoriam to the vanished flagship resorts of the eastern Catskills. Its concrete construction has allowed it to survive fire and decades of abandonment, which the other old hotels, built of wood, could not. In addition to the hotel ruins, the concrete shell of Newgold's lodge and the foundations of several other structures can also be found here. Meanwhile in the village of Woodstock, the Colony Hotel has reopened as a popular performing arts center called the Colony Café. Built at the same time as the third Mountain House, it bears a notable resemblance to the larger hotel on the mountain, and may echo design elements lost when the Mountain House burned.

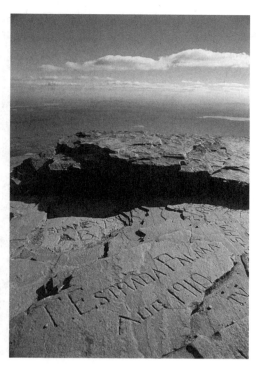

Etchings in the rock lodge at Overlook Mountain can be traced back to the early nineteenth century.

Discussions at the state Department of Environmental Conservation (as the conservation department is now known) over what to do with the ruins have led to concerns for their future. A 1998 agency report identified the ruins as "a potential hazard which must be dealt with," and explored the possibility of destroying the remaining structures or fencing them off to keep people out.[8] But as yet no action has been taken. The Overlook Mountain House remains an unyielding vestige of a time gone by, and at least for now a wander within its walls is a unique and inviting experience. From the mountaintop, one can easily visualize why Americans once flocked to the Catskills—for fresh air, fine scenery, and to connect with an evolving cultural identity.

City Hall, Kingston

Lording over the city of Kingston for the past 130 years, the great tower of City Hall has seen the best and worst of times for this third-oldest of the river towns. A symbol when built, of a thriving center of river commerce, in abandonment it symbolized the troubled times that befell this and other river towns during the twentieth century. In 2000, the restored building reopened to the public after nearly three decades of

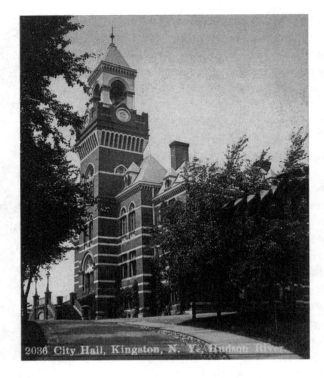

Kingston City Hall's original exterior elevations epitomized the High Victorian.
Courtesy New York Public Library.

2036 City Hall, Kingston, N. Y. Hudson River

decay. Twice ruined and twice rebuilt, it is emblematic now of Kingston's recent revival, proving that where there is a will there is often a way to reclaim a building even after years of abandonment.

Kingston's story can be traced to the very beginnings of New Netherland, when the Dutch established a trading post here in 1614, though settlement did not begin in earnest until 1652. Persistent violent conflicts with the neighboring Esopus Indians earned the town a reputation for being one of the most dangerous settlements on the Dutch colonial frontier. In midcentury it became known as Wiltwyck, or "Wild Town," and the village was walled in behind a wooden stockade. This failed, however, to prevent a devastating attack in 1663 during which much of the village was burned to the ground.

The following year the British assumed control of the colony, and the growing settlement was renamed Kingston, reputedly for the family home in England of Francis Lovelace, colonial governor of New York from 1668 to 1673. In the eighteenth century tensions with the Indians cooled, and after the Declaration of Independence Kingston served as New York's first state capital. But soon the town again found itself under siege, this time at the hands of the British, who attacked and burned it in 1777.

Today's city of Kingston is actually made up of three distinct centers. In addition to the old stockade district, which stands some distance inland from the river, there is also Rondout, situated on the creek of the same name that joins the Hudson here. Between these older settlements

a third center, now called Midtown, arose in the nineteenth century. First established as a small landing town to serve Kingston, Rondout's waterfront location became particularly important after the completion of the Delaware and Hudson Canal in 1828. The canal was built principally to transport coal from the mines of northeastern Pennsylvania to the Hudson for distribution throughout New York and New England. With its eastern terminus at Rondout, the canal transformed this small landing into one of the busiest and most important communities on the river.

The union of Kingston and Rondout in 1872 brought the need for a new city hall. City fathers situated the building in the Midtown district, on a small hill above Union Avenue, now Broadway, the main thoroughfare linking the city's two commercial hubs. In June of 1873 the city council commissioned English-born architect Arthur Crooks (c. 1837–1888) to design the building. Construction began in April 1874 and was completed the following May.

Crooks, who had come to the United States just prior to the Civil War, worked for a time under the architect Richard Upjohn (1803–1878) before starting his own practice at New York City in the 1860s. Like Upjohn, Arthur Crooks became well known for his ecclesiastical buildings. In addition to Kingston's City Hall, important commissions included St. Peter's Church at nearby Rosendale (1876), St. Joseph's Roman Catholic Church at Middletown, New York (c. 1880), and in New York City the Catholic Church of St. John the Evangelist (1881–1887), a rectory building for the Church of the Sacred Heart of Jesus (1881), the reconstruction of St. Joseph's Roman Catholic Church (alterations, 1885), and the Church of St. Anthony of Padua (1888).

Crooks's design for Kingston's City Hall was in keeping with the High Victorian taste of the day, which had evolved out of romantic precedents set earlier in the century by figures such as Alexander Jackson Davis (1803–1892) and Andrew Jackson Downing (1815–1852). Plans called for a symmetrical but still somewhat rambling brick building, three stories in height, whose polychromatic facade was dominated by an enormous central tower thought to have been based on that of the Palazzo

City Hall's main facade faces south to Broadway. Exterior details represent two eras in popular taste.

Publico at Siena, Italy. Rich woodwork characterized City Hall's interior, which housed administrative offices, a law library, and a meeting hall for the Common Council.

When finished, the building exemplified the romantic spirit in which it was designed, clearly bearing the influence of English architectural theorist John Ruskin (1819–1900), whose 1849 work *The Seven Lamps of Architecture* promoted a revival of the Italian Gothic, which had been particularly popular in Crooks's native England. Crooks was one of several English expatriates who imported this style to America in the latter half of the nineteenth century. Of these perhaps the best known was Calvert Vaux (1824–1895), who had come to America to work with Andrew Jackson Downing at Newburgh before moving his office to New York City, and who now lies buried in his wife's family plot in Kingston's Montrepose Cemetery, just a short distance from City Hall.

After the building's completion, Kingston continued to develop through the remainder of the nineteenth century, and the area called Midtown gradually filled in with houses, churches, schools, and shops. The canal had by this time lost much of its importance to the local economy, but Rondout had already become a thriving river town in its own right, the busiest port on the Hudson River between New York City and Albany. In addition to facilitating the largest shipbuilding center in the Hudson Valley, it was home to the fleet of the Cornell Steamboat Company, which at one time claimed to be the largest marine towing company in the world.

Fire swept City Hall on June 4, 1927, leaving the building's upper stories gutted and its great tower destroyed. A commission appointed to assess the damage eventually concluded that the structure was beyond economic repair, and recommended building anew. But when initial cost estimates showed that starting from scratch would cost more than restoring the building's fire-ravaged remains, city fathers reconsidered. Public opinion sided with cost efficiency, and within a few months of the fire the city hired local architects Myron Teller, Gerard Betz, and George Lowe to oversee the building's reconstruction. Two years and nearly $300,000 later, in May 1929, a restored and significantly changed City Hall reopened to the public.

Outside, the building lost some of its High Victorian eccentricity, reflecting a transition away from the romanticism of the nineteenth century. The steep, hipped roof yielded to a lower mansard replacement. Belt courses of white brick, which had given the facade its polychromatic character, were reduced from nine to six. The reconstructed tower emerged as a restrained version of the original. Interior changes were more substantial. Wooden floors, joists, and trim were replaced using steel beams and reinforced concrete, with marble, terrazzo, and plaster employed in the finishes. The new Common Council chamber moved from the second floor to the third, and featured a grand vaulted ceiling, five chandeliers, and a series of bas-relief lunettes depicting scenes

from Kingston's history. Though altered and subdued, the reconstructed City Hall managed to retain much of its original character, making it an eclectic architectural hybrid representing two distinct periods of popular taste. Restored, reinforced, and renewed, City Hall was ready to see Kingston through a new era of growth and development.

But the city's glory days were already behind it. Hardly had officials moved into their rebuilt offices when the country found itself plunged headlong into the Great Depression. Already the diminishing importance of the river in the region's transportation infrastructure had been felt in the Rondout section. The American economy eventually recovered, but boat traffic on the Hudson did not. A river town through and through, Rondout soon found itself one of the communities hardest hit by the changing face of Hudson Valley commerce.

Midtown and the historic stockade district began to suffer the same kind of urban decay seen throughout the valley and across the country. The local economy revived in the 1950s with the arrival of new industries, such as International Business Machines. But Kingston's old commercial districts faced new problems: by the 1970s the mass exodus to auto-based commercial and residential development on the outskirts had taken their toll. The state of City Hall reflected the deteriorating health of the town around it. An Interior Department survey conducted in 1972 listed the building's condition as "fair" but noted that "deterioration is proceeding rapidly due to neglectful maintenance."[9]

Beginning in the late 1960s, Kingston took advantage of federal urban renewal grants in its first concerted attempts at revival. In a chronic slash-and-burn response to fading urban centers, the city bulldozed entire blocks of historic buildings in Rondout. On one of the empty lots the Common Council voted to build a new City Hall, which it was hoped might symbolize the rebirth of this troubled part of town. Construction began in 1971—the same year old City Hall was listed on the National Register of Historic Places—and the building was ready for occupancy the following year, just in time for its predecessor's centennial.

For the next twenty-five years, old City Hall sat abandoned. With no heat or maintenance, decay began in earnest. Water damage wreaked havoc with the building's plaster reliefs, trim, and wall finishes, which began to flake off and then, as winter temperatures dropped below freezing, to fall in large pieces onto the marble floors.

In the 1990s Kingston began finally to rebound. In Rondout, postmodern faux-Victorian townhouses had appeared on lots left vacant since urban renewal, and those historic storefronts that had escaped the wrecking ball were brought back to life as restaurants and shops. A similar revival took place in uptown Kingston, where

Detail of east elevation, December 1998.

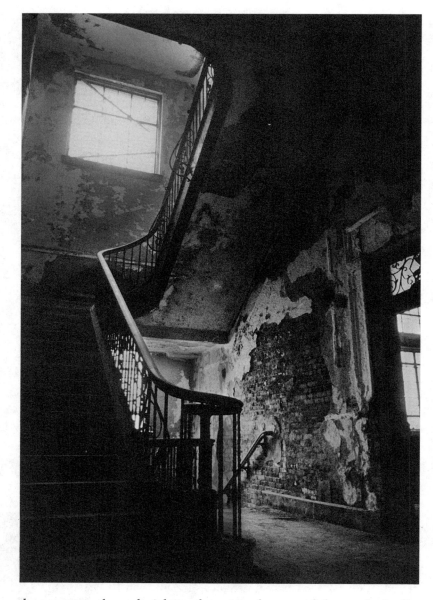

West stair, December 1998.
Plaster wall finishes have
fallen away to reveal the
brick beneath.

the seventeenth- and eighteenth-century houses of the stockade district gained increased recognition as some of the Hudson Valley's most important historic resources.

But old City Hall and much of Midtown continued to languish. The systematic departure of IBM meanwhile meant the loss of seven thousand jobs, posing new challenges to a city that had just begun to rebound. In an atmosphere of self-consciousness and uncertainty, the tarnished walls and boarded-up windows of such a prominent landmark flew in the face of all Kingston had managed to achieve. To T. R. Gallo, elected mayor in 1994, the irony was too much to ignore. "It sits directly across from Kingston High School and sends the wrong message to our

The postrestoration City Hall stands proud opposite Kingston's public high school.

youth that we can't take care of our own city," Gallo said of old City Hall. "I wanted that changed."[10]

In 1998 Gallo spearheaded a campaign to bring City Hall back. Twenty-five years after it had moved out, the Common Council unanimously voted to restore City Hall for a second time. Over $2 million in state and federal grant money was secured. But the project's $6.8 million price tag was still daunting, and probably would have been enough to dissuade most cities. Nonetheless work got under way in the fall of 1998, and two years later, in April 2000, City Hall was back in business.

Kingston's City Hall is now living proof that years of abandonment don't necessarily mean a lost cause. Developers and politicians often label even comparatively well-preserved buildings as "too far gone," not worth the trouble of bringing back. It would have been easier to let City Hall continue to rot away, cheaper just to tear it down. While his opponents criticized Gallo for focusing on what they called superficial projects like the restoration of City Hall and ignoring more fundamental problems of economic development, others saw the reopening of City Hall as a bold statement that the beleaguered heart of this ancient town was still beating. Public approval for the project was overwhelming, and when the energetic Mayor Gallo died unexpectedly in January of 2002, his constituency was left stunned. "It seems somehow fitting," wrote the *New York Times* after his death, "that Mayor Gallo will be laid in state Thursday inside City Hall, amid the marble staircases and wrought-iron details that bear witness to his legacy."[11]

Delaware and Hudson Canal, Eddyville and West

So radically has the world changed in the past two centuries that the very existence of the Delaware and Hudson Canal seems to belong not only to another age or era but to another planet entirely. Yet there is proof of its existence in the ruins of its locks and other miscellaneous structures, still to be found all along its 108-mile route between Honesdale, Pennsylvania, and Eddyville, near the Hudson River in Ulster County.[12]

At the dawn of the nineteenth century, transportation had developed little since the invention of the wheel. Ships and boats still provided the easiest way to move anything even remotely heavy. In Europe as in United States, industrialization meant an ever-increasing need to move larger, heavier cargoes across greater distances. With rail transport in America still decades from commercial viability, the steam engine was adapted first to propel floating cargoes, an innovation that came on the Hudson River with Fulton's *North River Steamboat*, better known as the *Clermont*, in 1807. So much more efficient was it to float goods than to haul them overland that artificial bodies of water were built where no natural ones existed.

Of the many canals that opened in America by 1850 the Erie Canal, built between 1817 and 1825 to link the Hudson with the Great Lakes, remains the best known. Although the D&H accomplished a greater change in elevation—1,075 feet versus the Erie's 675—the Erie was built first, stretched nearly twice as far, and had a far greater impact on the country's development. The Erie carried passengers and freight between the East and what was then the western frontier. The Delaware and Hudson carried mainly one product in one direction. But its impact on the Hudson River, if not as profound as that of the Erie Canal, would nonetheless be vast and long lasting.

The D&H Canal began as the initiative of two Philadelphia merchants, the brothers Maurice and William Wurts. At the outset of the nineteenth century the Wurts brothers found themselves in possession of tens of thousands of acres in the mountains of northeastern Pennsylvania, land rife with natural deposits of anthracite coal. The brothers realized the huge dividends this coal could bring. But with no access to market, their land was virtually worthless. Other merchants had already opened Philadelphia to coalfields closer by; Maurice and William Wurts set their sights on the New York market.

To reach New York, the Wurts brothers in 1823 proposed building a canal. After commissioning a survey, they found that the most feasible route would run from Honesdale, Pennsylvania, northeast to Rondout and the Hudson River. By April the brothers enlisted a small group of New York investors to join them in forming the Delaware and Hudson

High Falls, October 2004. Precision-hewn masonry of the old canal locks remains impressive even a century after the canal's abandonment.

Canal Company. On January 7, 1825, in a showy display at New York's famous Tontine Coffee House, the new company staged a burning of Pennsylvania anthracite and opened the sale of its stock. It sold out in a matter of hours.

In the year 1825, the construction of a 108-mile artificial river could only be described as a Herculean undertaking. The company broke ground in July of that year. To oversee construction the company hired John Bloomfield Jervis (1795–1885), later recognized as one of the most talented and prolific American engineers of the nineteenth century and whose career also produced the Hudson River Railroad and the Croton Aqueduct. A newspaper account from the following spring reported 2,500 men, mostly Irish immigrants, working to construct the fifty-mile section east of Cuddebackville, in Orange County.[13]

In the first months of construction, the canal builders made an accidental discovery that would have almost as profound an impact as the canal itself. In blasting rock from the canal bed near Rosendale, eight miles up from the Hudson, workmen uncovered a peculiar sort of stone that turned out to be natural cement. Used first in the construction of the canal, production of what came to be called Rosendale natural cement continued for over a century after the canal's completion, spawning an industry that would be tied to the D&H in its life and in its death.

By the fall of 1826, Jervis had completed work on the eastern section of the canal. Two more years passed before the canal was ready to carry its first boat, the *Orange*, on a trial run over its entire length. Finally, on December 5, 1828, the first load of coal arrived at Rondout. Instantly, Rondout became a boomtown, growing from a sleepy landing that served the larger village of Kingston to a thriving community in its own right.

Much of the canal was built to parallel existing rivers and creeks, which in addition to providing a right-of-way also fed water into the canal bed. From Honesdale the route followed the Lackawaxen and Delaware rivers to Port Jervis, where it crossed the state line into New York and adopted the course of the Neversink River to Cuddebackville. There the canal went off on its own, forcing its way through the hills of Sullivan and Ulster counties until it met the Rondout Creek near Kerhonkson, which it followed the remaining twenty-five miles to the Hudson. Once at tidewater the coal was transferred to larger vessels and delivered to New York City and other points up and down the river.

Horses and later mules towed the barges in both directions, following a narrow towpath alongside the waterway. The change in grade was accomplished through 108 locks. In addition to coal, canal boats also hauled produce, manufactured goods, and Rosendale cement to market. Passenger service was tried—Washington Irving made the trip in 1841—but never met with much success.[14] In addition to the canal, the company built a seventeen-mile gravity railroad to bring coal from the mines to the docks at Honesdale.

For all the confidence of investors on that winter day in 1825, the canal company struggled to turn a profit in its first decade. From the day it opened, the company enacted a series of innovations and improvements both to the canal and to the gravity railway in Pennsylvania. In 1829 it had a steam locomotive—the *Stourbridge Lion*—brought from England to haul empty coal cars back to the mines from Honesdale. There, for the first time in America, a steam engine pulled a train of wheeled carts along a stretch of rails. The experiment was a success, but the company felt the idea was impractical and, for the time being, pursued the matter no further.

Improvement campaigns widened and deepened the canal bed over the years to accommodate bigger and heavier barges. The company built larger locks, and the canal bed was realigned repeatedly. The most notable improvements came in the late 1840s with the construction of four new aqueducts, designed by an engineer named John Augustus Roebling (1806–1869). Carried by suspension cables, these structures were prototypes of the larger suspension bridge Roebling designed two decades later to link Manhattan with Brooklyn. Much of the cement used in the construction of this later bridge came down from Rosendale via the D&H Canal; both in its design and its construction, the Brooklyn Bridge owed much to the old canal upstate.

Even before the completion of Roebling's aqueducts, the D&H Canal had been fine-tuned to a point where it could begin to fulfill its great potential. Its builders expected the canal to carry 180,000 tons of coal and other freight annually. But in its first years, the canal managed less than a quarter of that figure, and only in the 1840s did it even begin to approach the capacity forecast by the Wurts brothers.[15] The peak years came in the 1860s and early 1870s. But such good fortune did not last long.

In the years following the Delaware and Hudson Canal Company's experiment with the *Stourbridge Lion*, other companies made more successful ventures into railroading. By midcentury, railroads had proved themselves as the most efficient means of overland transportation, able to move people and bulk cargoes for less money and, even early on, much faster than the canals ever could. As the D&H Canal entered its steady decline in the late 1870s, its owners began to invest more heavily in a number of railroads. In 1899, when the canal officially closed, the company did not cease operations. Rather it divested itself of the old canal, dropped the word "Canal" from its name, and continued to operate as a railroad for nearly a century, until it was finally bought out by the Canadian Pacific Railway in 1991.

Already by its peak years in the early 1870s, outmoded by the iron horse, the D&H Canal had assumed a quaint and pastoral character. After the last barge traversed its length in November 1898, the eastern

end of the canal was purchased by none other than the Consolidated Rosendale Cement Company, whose very existence stemmed from the construction of the canal some seventy-five years before. But like the D&H Canal, newer technology had already rendered natural cement obsolete, and by 1913, with Rosendale's cement industry nearly extinct, the canal closed once and for all.[16]

After the canal's closure, its right-of-way was sold off piecemeal. Left unmaintained, its shallow, stagnant waters quickly silted in. As its condition worsened, the old canal came to be seen at best as a waste of useful land. At worst it was regarded as a garbage dump and a breeding ground for mosquitoes. Where it didn't fill in by itself, its new owners often took the job upon themselves. Some communities used its old right-of-way to build roads. Only two small sections of canal retain water today. While Roebling's incredible Delaware River aqueduct was adapted for vehicular traffic and remains in use, others at Neversink and at High Falls have disappeared, leaving only their stone abutments behind. Lock tenders' homes, stores and taverns, small factories built along the canal's towpaths, even entire communities were left abandoned in its wake. Manville Wakefield's biography of the canal, titled *Coal Boats to Tidewater* and published in 1965, presents a veritable catalogue of canal-related ruins.

Today most of the ruins shown in Wakefield's book have disappeared altogether. Some have been restored. In 1968, the federal government designated the ruined locks and aqueducts of the canal itself a National Historic Landmark. Sadly, much of the canal had vanished by then. Elsewhere, better-preserved canals offer the visitor a glimpse of what life along the D&H once was like. In New Jersey it is possible to walk along a thirty-six-mile stretch of the former Delaware and Raritan Canal, completed in 1834 and closed a century later. Farther south, the well preserved Chesapeake and Ohio Canal offers hikers and bikers the opportunity to trace its course for 185 miles from Washington, D.C., to Cumberland, Maryland. Both canals approximate the historic appearance of the D&H, which today survives in little more than old photographs. Visiting these other canals, one can't help but feel a sense of loss for what might have survived had the D&H not been so hastily dismantled in the first decades of the twentieth century.

Eyebars that once anchored suspension cables remain in place at the site of Roebling's High Falls aqueduct.

In recent years, efforts have been made improve public access to what remains of the D&H Canal. At High Falls, not far from Kingston in Ulster County, the D&H Canal Museum maintains a trail that follows the old towpath, going from stone abutments left over from one of Roebling's

aqueducts past the ruins of five locks. Farther west, at Cuddebackville in Orange County, the longest remaining water-filled section of canal is part of the D&H Canal Park, which also includes a small museum and the ruins of Roebling's Neversink Aqueduct.

Despite the heavy toll of man and time, remnants of the D&H Canal are not hard to find. They can be found on maps in the names of towns such as Philipsport, Port Orange, Port Jervis, Creek Locks, and Wurtsboro. And, more tangibly, they can be found in the ruins of locks and aqueducts that lie overgrown in quiet woods, where once passed untold millions of tons of coal, the very lifeblood of America's industrialization. In the hills west of the Hudson River these ruins stand alongside those of the Rosendale cement industry, with which the canal shared both cradle and coffin.

Rosendale Natural Cement Industry, Rosendale and Vicinity

Across the Ulster County landscape near Rosendale they stand by the dozen. Long forlorn, these massive stone ruins are a familiar site to anyone who has lived here. Like the ancient *nuraghi* of Sardinia, they offer few apparent clues as to who built them and why. To many who live among them, their exact purpose is a mystery. Yet their place in history is an important one: these are the ruined kilns of Rosendale's vanished natural cement industry, which once furnished nearly half of America's annual cement production. Today they are a subtle reminder of this area's once essential role in the American industrial economy.

The discovery of natural cement in Ulster County came early and by chance. Previously there had been only one known source of cement in the United States, in Madison County, New York, near Syracuse. There in 1818 was discovered a kind of rock that when burned, ground, and mixed with water would harden into cement. This discovery proved crucial for the construction of the Erie Canal, which required a kind of mortar that would not dissolve underwater.

Ten years later another canal opened, linking the coalfields of Pennsylvania with the Hudson River and the markets of New York. The builders of the Delaware and Hudson Canal initially planned to utilize existing cement deposits of western New York. But in the summer of 1825, engineers excavating the canal bed near Rosendale made a discovery of their own: a massive deposit of the stone used for natural cement.[17] This not only facilitated the building of the canal; the industry that grew up around it later provided regular customers for lock tenders throughout the canal's existence.

Immediately upon its discovery, a quarry was opened, kilns were built, and the production of cement commenced under contract for the

D&H Canal Company. After the canal's completion a new cement company formed in 1827, under the direction of one Watson E. Lawrence. Based just west of Rosendale, Lawrence's cement factory enjoyed direct frontage on the canal, which meant easy access to the New York market. His position was further enhanced by the presence of the Rondout Creek, whose course the canal followed, and which powered mills where the "cement-stone" could be ground. By 1830 Lawrence had developed an improved type of kiln that burned coal instead of wood, taking further advantage of his proximity to the canal. Typically forty feet in height, these large stone "draw kilns" were built with wide, arched openings for the removal of burned stone; they quickly became the industry standard.

Recognizing the advantages of direct access to raw materials, a reliable source of waterpower, and an insatiable market, other investors quickly followed Lawrence's lead. In the 1830s cement kilns appeared all along the canal and the Rondout Creek from the Hudson River to High Falls, in an area that became known as the Rosendale district. Almost as quickly, the district's tiny agricultural communities became rough-and-tumble boomtowns. Lawrence himself enjoyed early success when he gained lucrative government contracts, supplying cement for the construction of the Croton Aqueduct and for a new dry dock at the Brooklyn Navy Yard in the 1840s. Though Lawrence encountered difficulties during the panic of 1837, he had already managed to raise a fledgling industry to early maturity, clearing the way for Ulster County to lead the nation in cement production throughout the nineteenth century.

From the 1830s onward, cement production in the Rosendale district grew rapidly. The process began in the quarries, which were dug into mountainsides and under farm fields to mine the raw cement stone. These were not cramped tunnels but vast, high, and labyrinthine underground spaces that eventually undermined the better part of the Rosendale district. Local legend held that through these mines one could walk all the way from Rosendale to the Hudson River at Rondout without ever seeing the light of day. To support the stone above, large stone "pillars" were left behind as the quarries were excavated, lending the mines a sort of grand architectural character.

Once mined, the stone was brought in horse-drawn carts and later small tramways to the draw kilns, which were monumental structures, similar in appearance to the iron furnaces or lime kilns with which they are now sometimes confused. Typically the cement companies built

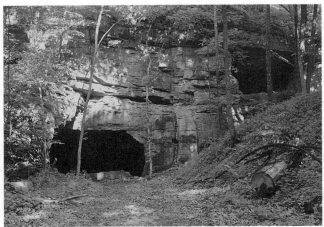

Entrances to the Lawrence Mine for cement stone on the Snyder Estate at Rosendale. Last used in 1970, the mine is believed to have been opened in 1830.

(*Opposite, top*) the "Widow Jane" mine on the Snyder estate at Rosendale is open to the public as part of the Century House Museum. Part of the abandoned mine is used today as an amphitheater in warm-weather months.

(*Opposite, bottom*) cement kilns overlook the Rondout Creek on Abeel Street in the Rondout section of Kingston.

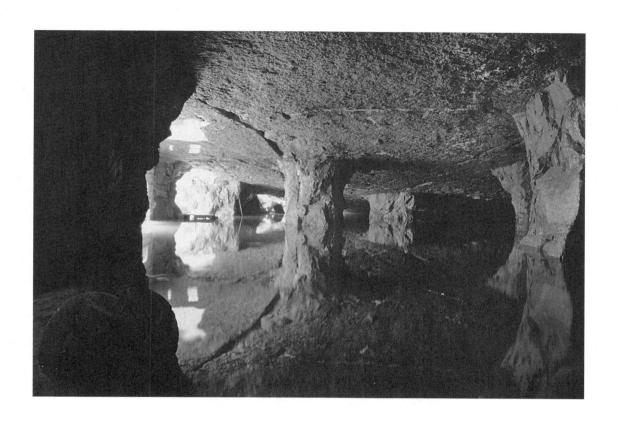

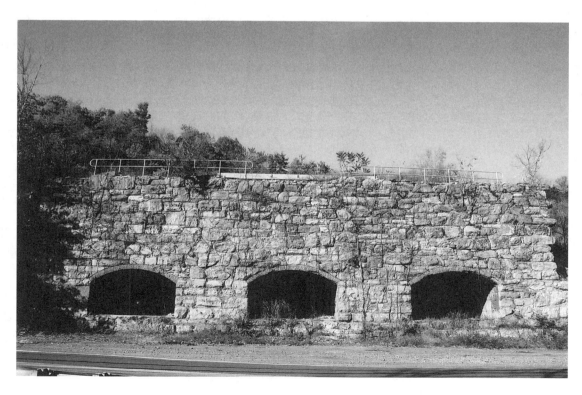

their kilns into hillsides, which enabled them to be more easily loaded or "charged" from above. Some were built freestanding, others in batteries of ten or more adjoined to each other. Workmen piled stone and coal into the kilns in alternating horizontal layers. Usually the stone required four days of continuous burning before it was ready to be ground. Over the course of that time it worked its way down from the top of the kiln to the bottom, where it fell through small openings into an arched space at the base of the kiln from which it was removed and taken for grinding. As each layer fell from the bottom a new layer was added to the top, and the kilns burned perpetually. From the time of their development in 1830 through the decline of the natural cement industry these draw kilns changed little in design; later examples were executed in cement rather than stone but matched the earlier kilns in shape and dimension.

From the kilns the stone went to be broken down in machines called "crackers," before being ground into powder. The first grinding mills were often converted from existing gristmills or textile mills on the Rondout Creek, which provided waterpower to turn grinding stones that functioned just as millstones used for grinding grain. Some companies were specialized, operating only a quarry or a grinding mill. Others did it all, running their own quarries, kilns, and mills, and in some cases even the barges that carried their product downriver. Often the grinding mills could be situated to front both the creek and the canal, allowing barrels of finished cement to be loaded directly from the mill onto barges. This enabled the entire production cycle to take place in one centralized area, and it is for this reason that today the cement industry ruins can be found alongside ruins associated with the canal.

For most of the nineteenth century, nearly half of the cement produced in the United States came from Ulster County. Rosendale cement went into the United States Capitol, the Brooklyn Bridge, the base for the Statue of Liberty. Annual production more than quadrupled from 103,000 barrels in 1850 to 428,000 barrels in 1870. By the industry's peak years in 1898 and 1899 the Rosendale district was producing some 4 million barrels of cement annually and employed more than five thousand workers in thirty factories.[18]

The end came faster than anyone could have imagined. As the Rosendale quarrymen were busy hollowing out the hills of Ulster County, engineers elsewhere were working to beat them at their game. Eventually an engineered product known as portland cement gained prominence in the building materials market for its ability to harden much more quickly than natural cement. Portland cement was first manufactured in England in 1824, just one year before the discovery of natural cement at Rosendale, but the process was not patented in the United States until 1871. By the turn of the century portland cement was available at lower cost than natural cement. Production of natural cement plummeted

from 10 million barrels in 1900 to only 1 million in 1910. In that same year production of portland cement reached 76 million barrels.[19]

In desperation, Rosendale's cement manufacturers scrambled to convert their factories to the production of portland. All their attempts failed. Already in dire straits financially, Rosendale's cement factories could neither justify nor afford to make the conversion. And so in the first years of the twentieth century, as large and modern portland plants began to appear elsewhere on the Hudson, the old factories of Rosendale began to disappear. By 1907 most of the remaining plants in the Rosendale district had been brought under the control of the Consolidated Rosendale Cement Company, a conglomerate owned by Kingston transportation baron Samuel D. Coykendall. In addition to the Cornell Steamboat Company and the Ulster and Delaware Railroad, Coykendall by this time also operated the remaining eastern section of the Delaware and Hudson Canal, which he had purchased in 1898 to serve the cement companies.

By 1915 Coykendall saw the writing on the wall and ceased operation of both the canal and the Consolidated Rosendale Cement Company. Born together, these two venerable Hudson River institutions would now pass into history together as well. The collapse of the Rosendale cement industry left thousands without jobs. As the quarrymen and "cement burners" moved on in search of work, villages such as Creek Locks, LeFever Falls, Whiteport, and Rosendale became ghost towns. Between 1900 and 1920, Rosendale's population fell from 6,278 to 1,959.[20] Empty factories, houses, shops, and stores left behind quickly fell into ruin.

Following the demise of the Coykendall cement conglomerate there remained only one manufacturer of natural cement in all of the old Rosendale district. This was the firm of Andrew J. Snyder and Sons, situated just west of Rosendale in a hamlet that had come to be called Lawrenceville. Before the company was organized in 1860, the Snyder family had leased its farm to cement manufacturers (including Watson Lawrence) from the earliest days of the industry. Under the guidance of A. J. Snyder II, grandson of its founder, the firm now scaled back and streamlined its operations. Though slower to set, natural cement proved somewhat stronger than portland, and some types of construction required the additional strength. In the 1910s and '20s, Snyder remained profitable by supplying the niche market that remained for natural cement.

Beginning in the 1930s, a newly developed concrete product that mixed portland with natural cement created a revived demand for Rosendale cement. The federal government and four states, including New York, adopted this hybrid as their standard specified material for some large-scale construction projects. For the Snyder firm, by this time known as the Century Cement Manufacturing Company, this brought a

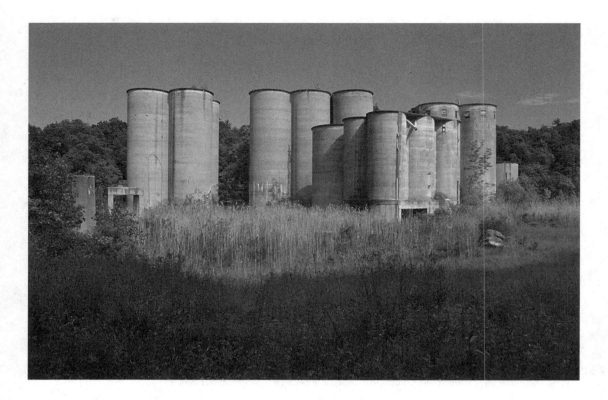

A. J. Snyder II, who owned the Century Cement Manufacturing Company, built this series of cement storage silos at the Snyder estate in 1929, 1938, and 1953.

kind of life after death. Once again Rosendale cement was specified for high-profile government contracts, such as the New York State Thruway. To meet demand, Snyder worked in cooperation with some of the new portland plants on the river at Kingston and Catskill, and his own plant expanded repeatedly into the early 1960s.

But the revival was not to last. In the late 1950s, a chemical additive that obviated the need for natural cement made the Rosendale-portland hybrid obsolete. Snyder persevered until 1970, when at age eighty-one, with no one willing to take the reins of his struggling company, he retired and the factory closed. Nearly six decades had passed since the collapse of the Coykendall conglomerate left Snyder the lone survivor in the industry. With the closing of his factory came a quiet end for one of the Hudson Valley's oldest enterprises.

In 1992 the Interior Department added the Snyder company lands to the National Register of Historic Places as part of a 275-acre historic district. The district also includes the old Snyder family estate, a number of abandoned quarries, cement kilns, and a variety of other ruined structures associated with several other cement companies that operated on the property over a span of more than 150 years. In October of 2004, a Connecticut firm called Edison Coatings reactivated one of the old Rosendale quarries to produce what it bills as "authentic Rosendale Cement." Produced on a limited basis, the product is marketed primar-

ily for use in repair and restoration work on historic structures whose builders used natural cement in their original construction.

Today Rosendale cement can still be found binding together the stones of America's most recognized buildings and structures. In the Rosendale district itself, however, many of the houses and shops abandoned with the industry's collapse in the early 1900s have disappeared. During the twentieth century, some of the abandoned cement mines found other uses, serving, like the Hudson River's out-of-work icehouses, as mushroom farms. While many have now flooded, one former mine is still used today as a document storage facility. Still others remain abandoned, in summer sending out blasts of cold air that can be felt by motorists in passing cars. Near the abandoned cement silos of the Century Cement works, the Century House Historical Society maintains a small museum dedicated to this lost industry, housed in outbuildings of the old Snyder estate. And throughout the area, the ruined cement kilns of the Rosendale district remain, crumbling memorials to the builders and the built.

DUTCHESS COUNTY

ABOUT MIDWAY BETWEEN Albany and New York City on the Hudson's eastern shore lies Dutchess County. In the seventeenth century, while settlement grew more dense to the north, south, east, and west, the land that would become Dutchess remained the domain of the Mahican and Esopus Indians. Not until the 1680s did European settlement take place here to any significant degree. In 1683 Dutchess became one of the first twelve counties designated in New York, bound by the Hudson River to the west, by Connecticut to the east, and by Albany and Westchester counties to the north and south. Its spelling derives not from the early presence of Dutch families here—though there were many—but from the title of its namesake, Mary of Modena (1658–1718), wife of James, the duke of Albany and York.

Towns began to emerge in the 1680s. To the south, Fishkill-on-Hudson, now called Beacon, was among the earliest. Farther upriver Rhinebeck was established in 1686. Between these, Poughkeepsie, the county seat, was settled at about the same time. Many of the first Europeans to arrive were Dutch or English families who had previously settled in other parts of the colony. Crowded conditions in Connecticut meanwhile drove many New Englanders into the eastern part of Dutchess County by the 1730s. In 1812 Dutchess ceded its southernmost portion to form Putnam County.

Although some tenant farms stood on large land patents, especially in the area of Fishkill, this feudal type of arrangement did not exist in Dutchess on so large a scale as it did under the Van Rensselaers and Livingstons farther upriver. Indeed, many early landowners seem to have acquired their holdings with the intention of selling them off piecemeal to profit from the settlement of the land.

Particularly north of Poughkeepsie, the Dutchess County riverfront

Sipperly-Lown Dutch Barn, Rhinebeck

Once ubiquitous along the Hudson River, New World Dutch barns are fast disappearing. A tangible link to preindustrial agriculture, these buildings are also a distinct regional architectural form derived from European antecedents. They can be recognized by their interior "H Frames" and resulting exterior appearance characterized by broad gables and low side walls. Built mainly for storage and threshing of grain, New World Dutch barns also accommodated cattle, wagons, and other farm equipment. The Sipperly-Lown barn was built c. 1800, making it a late example of this style. The barn was listed with the main house across Route 9 on the National Register of Historic Places in 1987. More recently it has been left untended while the property is advertised for sale.

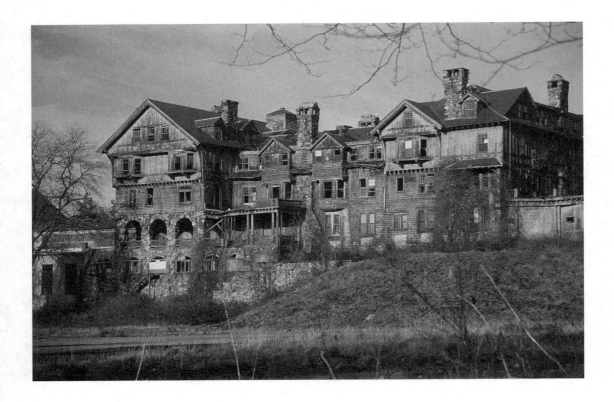

Bennett School for Girls, Millbrook

The rambling assemblage of buildings of the Bennett School for Girls is centered on a three- and four-story stone-and-wood-frame structure known as Halcyon Hall, which synthesizes elements of Shingle, English Tudor Revival, and Queen Anne architecture. Halcyon Hall was built c. 1891–1893 by Henry J. Davison, Jr., as a midsize resort situated outside the village center of Millbrook. Its architect was the well-known James E. Ware (1846–1918), who also designed additions for a more successful Hudson Valley resort, the Lake Mohonk Mountain House. The Millbrook hotel was not profitable and closed after 1902. Five years later, the buildings became home to the Bennett School for Girls. The school expanded through most of the twentieth century but closed in 1977. Halcyon Hall has sat vacant since. Development plans for the site and the preservation of Halcyon Hall are uncertain in 2005.

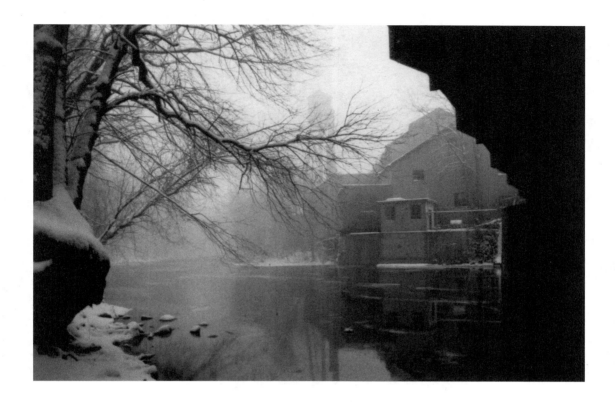

Pleasant Valley Finishing Company, Pleasant Valley

Pleasant Valley is situated about five miles east of the Hudson, where U.S. highway 44 crosses the Wappingers Creek, one of the river's main tributaries. By 1757 a mill was operating where the turnpike crossed the creek. The mill changed hands and expanded repeatedly. In 1809 Robert Abbatt built a mechanized cotton factory here. After a fire destroyed Abbatt's mill in 1815, John DeLaVergne and Luther Thwing built a new, three-story stone cotton mill crowned by an octagonal belfry. Later the factory was operated by Thomas Garner & Company, which owned textile mills throughout the Hudson Valley. In the 1930s the mill became a dye works known as the Pleasant Valley Finishing Company, which operated here until it moved to Poughkeepsie in 1985. For the next ten years the factory stood abandoned. Hidden behind vast modern additions, the 1815 mill was gutted by fire on July 21, 1994. The entire complex was razed the following year, save for its administration building, originally built c. 1763 to operate as a store in conjunction with the mill. This building and an ersatz ruin of the 1815 mill have since been incorporated into a new town green.

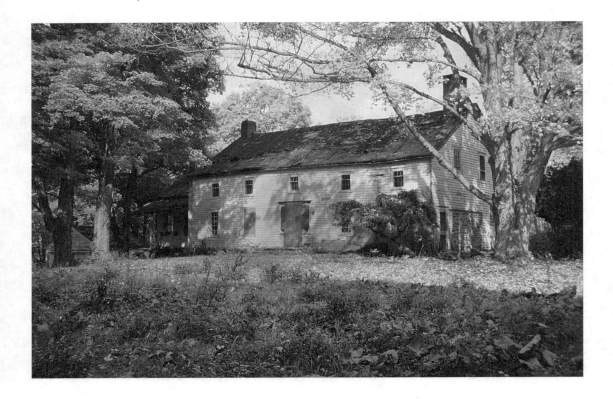

James Baird House, near Freedom Plains

Parts of this early farmhouse may date as far back as 1766. Later altered and expanded, the house and farm were purchased c. 1933 by James Baird (1873–1953), a well known building contractor whose projects included the Lincoln Memorial (1914–1922) in Washington, D.C. In 1939 Baird donated the house and 590 acres to the Taconic State Park Commission. In the 1940s and '50s the commission developed the property with a golf course designed by Robert Trent Jones, and a public swimming pool and bathhouse designed by Skidmore, Owings and Merrill. Used for many years as a residence for park staff, the Baird house has sat vacant and unused since the mid-1970s. Despite an awareness for the home's historic significance, the state Office of Parks, Recreation and Historic Preservation has recently mulled its demolition.

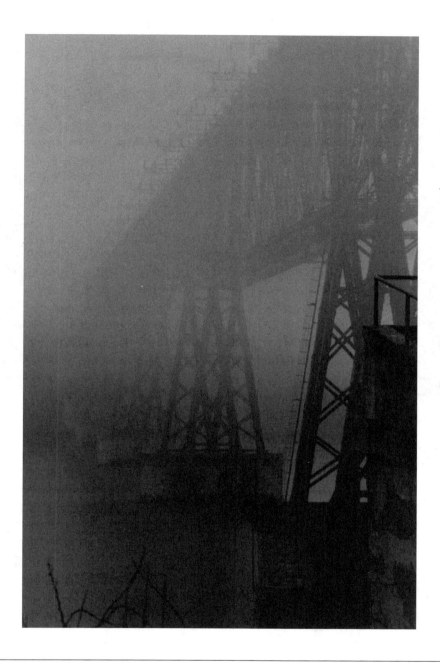

Poughkeepsie Railroad Bridge, Poughkeepsie

Once an engineering marvel, the railroad bridge at Poughkeepsie is now the largest and most visible ruin on the Hudson River. Intended to link Pennsylvania coal mines with New England factories, it was the first bridge to cross the Hudson below Albany. Financial backers included local investors, such as Matthew Vassar, and nationally known industrialists including Andrew Carnegie. Construction began in 1873, but economic downturns stifled progress, and not until December 29, 1888, did the first train cross its 6,767-foot span. After first being operated by the Philadelphia and Reading Railroad, its control passed to the New York, New Haven and Hartford Railroad in 1906, and then to the Penn Central following a consolidation in 1968. The bridge has been unused since a fire on May 8, 1974, destroyed a section of track. Today, a citizens group called Walkway Over the Hudson has formed with the intent of building a public walkway over the bridge, which was listed on the National Register of Historic Places in 1979.

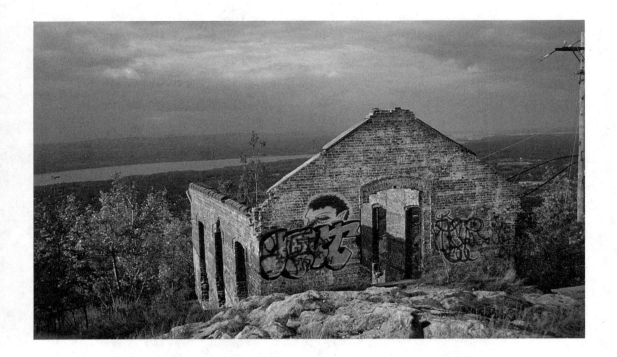

Mount Beacon Incline Railway Powerhouse, Beacon

The Mount Beacon Incline was a funicular railway opened in 1902 to bring passengers to the 1,500-foot summit of Mount Beacon, at the east end of the city of Beacon (then known as Fishkill Landing). Upon reaching the top, visitors could dine at the Mount Beacon Casino or stay at the Beaconcrest Hotel, a midsize resort whose guests included Gloria Swanson. The incline operated intermittently in its last years before making its final run in 1978, by which time it had served an estimated three million passengers. The casino was destroyed by fire in 1981. A second fire gutted the brick powerhouse two years later, shortly after the building was listed on the National Register of Historic Places. Today visitors can scale the mountain on a trail maintained by the Scenic Hudson Land Trust. A group called the Mount Beacon Incline Railway Restoration Society formed in 1996 with the aim of restoring service on the incline.

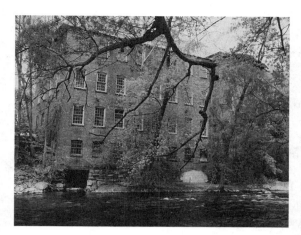

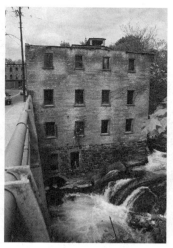

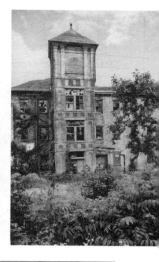

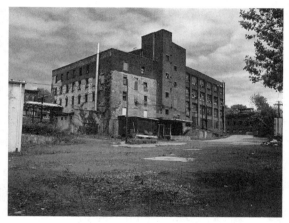

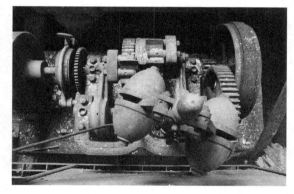

Beacon Mills

At Beacon, a number of nineteenth-century textile mills and factories survive along the Fishkill Creek. Challenges to pollution from one of these mills led to an important early success for environmentalists on the Hudson River. In 1974, Tuck Industries, which manufactured adhesive tape at a mill formerly owned by the New York Rubber Company, was indicted for excessive discharges of pollutants. The company pled guilty to the first charges filed under the Water Pollution Control Act of 1972. A number of these abandoned mills served as backdrops for the 1996 film *Nobody's Fool*, which starred Paul Newman. (*Clockwise from bottom right*) Tioronda Hat Works; industrial scale, Tioronda Hat Works; spinning governor, Tioronda Hat Works; Mattaewan Manufacturing Company, c. 1811 and additions; Ellroot & Lynch Company, Silk Mill; Horatio N. Swift Machine Shop; New York Rubber Company, later Tuck Industries (burned 2005).

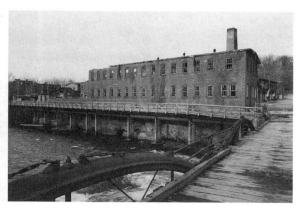

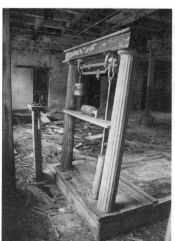

became characterized in the eighteenth and nineteenth centuries by the magnificent country seats of the landed aristocracy. Here lived some of the richest and most powerful families in the country, including Astors, Livingstons, Vanderbilts, and of course Roosevelts, whose proudest son, Franklin Delano, was born on his family's estate at Hyde Park in 1882.

Industrial development came here as elsewhere on the Hudson. Mills and iron furnaces appeared in the eighteenth century. Later came brick-yards, quarries, and a limited number of icehouses, but for the most part riverfront industry was confined to the areas near Poughkeepsie, Beacon, and Wappingers Falls.

Until recently the rolling hills of the Dutchess County landscape remained agrarian in character. While few of the grand river estates remain intact, today Dutchess is still a favorite place for weekend and country homes. The proximity to New York City of such fine views has drawn the likes of Mary Tyler Moore, James Cagney, Lewis Mumford, and Gore Vidal to live here. It has also brought a growing number of commuters whose work lies in the New York metropolitan area. Taxes and the cost of real estate are lower in Dutchess than they are nearer the city, adding to the allure. By the tens of thousands, the commuters travel as much as three hours each way to and from the city, every morning and every evening.

At the beginning of the twenty-first century the county experienced the fifth-highest rate of population growth in New York State, and the character of rural Dutchess grew decidedly more suburban. The cities of Beacon and Poughkeepsie meanwhile enjoyed some rejuvenation after decades of decline. Vibrant Hispanic populations appeared in the last decades of the twentieth century, and limited gentrification brought antique shops and art galleries to once-empty storefronts. Still, with the brunt of new construction focused on suburban subdivisions and strip malls, there remain dozens of abandoned buildings and empty lots in these urban centers. While the wave of new construction has pressured historic buildings in outlying parts of the county, the traditional centers of population remain in need of further stimulation if their revival is to become complete.

Wyndclyffe, Rhinebeck

The south and west facades of Wyndclyffe overlook Vanderburgh Cove and the Hudson River; the house is visible from Amtrak trains passing below.

There is perhaps no place in the Hudson Valley that lives up to the idyllic image of the proverbial small town better than Rhinebeck, in northern Dutchess County. Its tree-lined streets are home to textbook examples of eighteenth- and nineteenth-century architecture. In the village center stands the Beekman Arms, which opened its doors in 1766 and is billed today as the oldest continuously operating hostelry in the United States. A few miles south of town, on a hill above the river, stands a ruin every

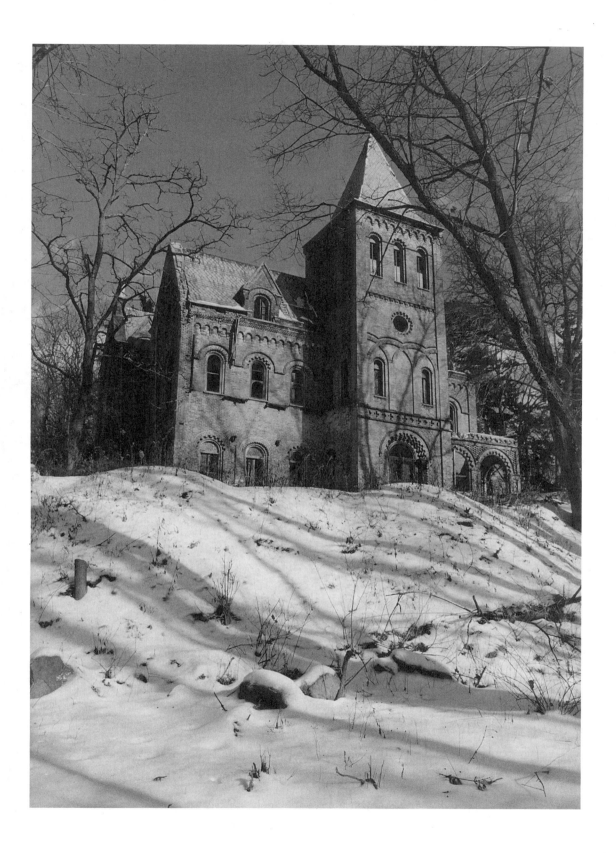

bit as perfect as the village itself. This is Wyndclyffe, a lavish home built in 1853 for a wealthy New Yorker named Elizabeth Schermerhorn Jones. Though this was one of the grandest estates on the river when completed, the contrast between wealth and penury now seems poignantly acute here, where decades of abandonment have left the future of this house in ever greater peril.

The town traces its beginnings to 1686, when Dutch settlers from Kingston, across the river, purchased the land from its native inhabitants. By 1700 a village had grown by the river, called Kipsbergen. In the first years of the eighteenth century another settlement appeared farther inland with the arrival of German Palatine families, whose European homeland along the river Rhine was then caught in the throes of the War of the Spanish Succession. This became known as Rhinebeck, a name thought to have been derived from the words *Rhine* and an old Dutch word, *beck*, meaning brook. With Rhinebeck situated on the post road to Albany several miles east of the Hudson, Kipsbergen developed as a landing town, later taking the name Rhinecliff. From here a ferry crossed to Rondout and Kingston on the west shore for 250 years until the opening of the Kingston-Rhinecliff bridge in 1957.

Until the 1800s, most riverfront acreage in Rhinebeck and throughout the valley supported active farmland. If only for the practical advantage of providing access to boat traffic, riverfront land traditionally comprised the region's most sought-after real estate. But eventually, a wealthier class began to acquire agricultural land along the river for reasons more aesthetic than practical. In the nineteenth century, its proximity to New York City and its internationally known scenery endeared the Hudson Valley to a growing population of successful capitalists who had built fortunes in everything from real estate to railroads. J. P. Morgan established his country seat, Cragston, in Highland Falls. Frederick Vanderbilt eventually built the most magnificent of Hudson River villas at Hyde Park, just a few miles upriver from Springwood, the estate where Franklin Roosevelt was born in 1882.

For a variety of reasons estate development in the early part of the nineteenth century was more pronounced on the river's eastern shore. The owners of these homes voiced opposition to the coming of the Hudson River Railroad in the late 1840s. But after the railroad's completion in 1851, it proved a stimulus for further mansion building along the east bank by providing easy access to business interests in New York City. To be sure, riverfront estates were common on both sides of the Hudson for almost its entire length between New York City and Albany. But by 1860 two distinct "estate districts" emerged on the river's eastern shore where these mansions stood in greatest concentration. To the south a gauntlet of estates came to occupy the riverfront in southern Westchester County, many of them built for New York businessmen who could now use the railroad to commute to and from offices in the city on a daily basis.

The upper estate district took hold in northern Dutchess and southern

Columbia counties, in the area between the cities of Poughkeepsie and Hudson. It could be said that estate development in this region began in 1686, with the establishment of the manor of Robert Livingston at what is now the boundary between Dutchess and Columbia counties. For centuries thereafter, successive generations of Livingston descendants divided the land they inherited and acquired other riverfront properties nearby, developing more estates as they married into some of the wealthiest families of New York society, taking surnames such as Astor, Chanler, Delafield, and Roosevelt. Wealth begot wealth, and after the opening of the railroad other moneyed families came to the area to build more country seats on whatever available land they could find, until eventually almost every parcel of riverfront land in the region had been taken for estate development.

More than a dozen families established country seats at Rhinebeck. In December of 1852 Elizabeth Schermerhorn Jones (1810–1876), heiress to two prominent New York families, purchased eighty acres that had formerly been farmed by the Van Etten family. There she erected a large mansion on a bluff overlooking the river. Jones was a cousin by marriage of William Backhouse Astor, Jr., a Livingston descendant who also lived at Rhinebeck. She named her eighty-acre estate Wyndclyffe. Though Elizabeth Jones shared the home with her brother Edward and his family, the estate was recognized as hers. After Edward Jones passed away in December of 1869, "Miss Jones," as she was known, continued to live at Wyndclyffe until her own death six years later. She had no children and never married.

Arguably the grandest house on the river when built, Wyndclyffe raised the bar for builders of river estates throughout the Hudson Valley. With its twenty-three rooms, its boat and carriage houses, its sweeping lawns and tennis courts, this was one of the most impressive estates in the country at the time of its construction. So ostentatious was the mansion that, as neighboring houses were subsequently expanded and remodeled, it is said to have inspired the phrase "keeping up with the Joneses."

Architecturally Wyndclyffe was designed in the Norman Romanesque, a style developed during the tenth and eleventh centuries in northern France and practiced commonly in England through the twelfth century. Characteristic design elements include round arches and pronounced towers, both of which were boldly employed at Wyndclyffe. The home's asymmetrical plan and elevations took their cues from the principles of Picturesque design promoted in the Hudson Valley by Davis, Downing, and others. From its beginnings in the 1830s, the Picturesque steadily gained momentum throughout the 1840s and was in full bloom by the time Elizabeth Jones commissioned Wyndclyffe in 1853.

The origin of Wyndclyffe's design remains unknown. While one source attributes it to an architect by the name of Gardiner,[1] it has also been credited to a local architect named George Veitch, whose commis-

sions included Rhinebeck's Episcopal Church of the Messiah, built one year before Wyndclyffe.[2] Both Elizabeth Jones and her brother were active members of this congregation and supported the church's construction, which would have introduced them to Veitch's work. Other Veitch buildings include St. Joseph's Roman Catholic Church (1863) and the District No. 2 School House (1878), both in the village of Rhinecliff.[3]

Finely articulated walls of brick make up the mansion's exterior, built over a faceted, irregular plan. The main block of the house stands two stories in height, with additional living space for servants in the basement and attic. Ornate terra-cotta chimney pots rise above a steeply pitched roof clad in patterned slate shingles. A high tower topped by a pyramidal roof projects from the main elevation, which is one of two facades oriented to face the river. Inside, rooms with high ceilings and rich wood paneling opened onto a central, three-story main hall, lit from above by a skylight. Outbuildings included a wood-framed carriage house and barns. The ruins of a frame boathouse remain near the water, though this structure appears to postdate the construction of the mansion above.

Guests at Wyndclyffe included Henry and William James (whose uncle Augustus James resided at a neighboring estate called Linwood) as well as Elizabeth Jones's niece, the writer Edith Wharton (1862–1937). Born Edith Jones in 1862, Wharton is best remembered today as a writer of fiction, though she also wrote extensively on architecture and design. Her 1897 work *The Decoration of Houses*, which Wharton coauthored with the interior designer Ogden Codman, Jr. (1863–1951), established her as a respected design critic. Wharton later helped promote the reputation of her own niece, the talented landscape architect Beatrix Jones Farrand (1872–1959), whose commissions included work at several Hudson River estates.

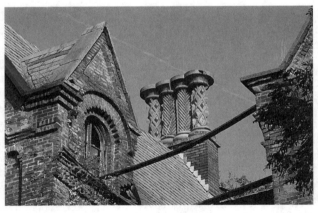

Despite decay, fine architectural details survive, including terra-cotta chimney pots.

Written later about her time at Wyndclyffe, Wharton's generally negative critique of the house reflected early-twentieth-century attitudes toward some of the more eccentric products of nineteenth-century romanticism. Almost certainly Wyndclyffe served as the basis for "The Willows," a setting for part of Wharton's 1929 novel *Hudson River Bracketed*. Later she described the house as "Rhinecliff" in her 1934 autobiographical work titled *A Backward Glance*:

But no memories of those years survive, save those I have mentioned, and one other, a good deal dimmer, of going to stay one summer with my Aunt Elizabeth, my father's unmarried sister, who had a house at Rhinebeck-

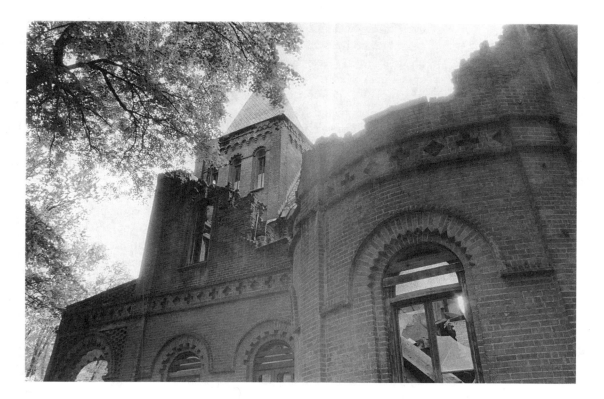

on-the-Hudson. . . . My aunt's house, called Rhinecliff, afterward became a vivid picture in the gallery of my little girlhood; but among those earliest impressions only one is connected with it; that of a night when, as I was ready to affirm, there was a wolf under my bed. . . .

. . . The effect of terror produced by the house at Rhinecliff was no doubt partly due to what seemed to me its intolerable ugliness. My visual sensibility must always have been too keen for middling pleasures; my photographic memory of rooms and houses—even those seen but briefly, or at long intervals—was from my earliest years a source of inarticulate misery. . . . I can still remember hating everything at Rhinecliff, which, as I saw, on rediscovering it some years later, was an expensive but dour specimen of Hudson River Gothic; and from the first I was obscurely conscious of a queer resemblance between the granite exterior of Aunt Elizabeth and her grimly comfortable home, between her battlemented caps and the turrets of Rhinecliff. But all this is merged in a blur, for by the time I was four years old I was playing in the Roman Forum instead of on the lawns of Rhinecliff.[4]

The turret, which survives in part at right, collapsed inward on March 26, 1998.

Other commentaries on Wyndclyffe's design both before and after Wharton's have had much nicer things to say, and the house was well received in its day. The landscape designer Henry Winthrop Sargent (1810–1882) provided a more positive and perhaps more objective appraisal in his 1859 supplement to Downing's *Treatise on the Theory*

and Practice of Landscape Gardening, originally published in 1841. "In the neighborhood of Rhinebeck," he wrote, "is 'Wyndclyffe,' the residence of Miss Jones, a very successful and distinctive house, with much the appearance of some of the smaller Scotch castles. This place is still quite new, but the situation is one of great beauty, upon a bold, projecting point of land, in admirable harmony with the style of the house and with the most extensive and superb view."[5]

Elizabeth Jones died in 1876, and the estate then passed to the only son of her late brother Edward. Andrew Finck of New York purchased the property in 1886 and subsequently renamed the estate Linden Hall. Finck, who made his fortune as a brewer, is said to have installed underground pipes that brought cold beer to the tennis courts. After Finck's death in 1901 the mansion passed to his heirs, who kept the house until 1936. Thereafter it changed hands several times until it was eventually abandoned in the early 1950s. Later owners subdivided the property until the house itself was left standing on a two-and-a-half-acre parcel.

Plans for rehabilitation have come and gone. While the old carriage house has been restored as a residence and the barns demolished, the mansion itself has been left to rot. A fragmented allée of gnarled linden trees remains along the old drives, but most of the historic designed landscape has been obscured by time, and the great sweeping lawns are almost unimaginable now beneath layers of secondary growth. The proximity of newer houses built on the subdivided property has discouraged vandalism, but the ravages of time have continued unabated. The mansion's east wing has fallen in upon itself, leaving only its brick shell

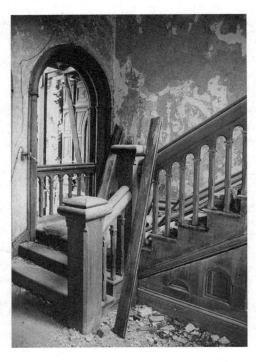

First-floor landing, summer 2000. The stair has since collapsed into the basement.

behind. Yet the rest of the house still stands relatively intact—a remarkable feat indeed after a half century of abandonment.

The fate of Rhinebeck's river estates spans the gamut. By the middle of the twentieth century, income taxes, dwindling family fortunes, and the increasing costs of maintaining such estates led many to be converted for institutional use, demolished, or abandoned. Ferncliff, one of the Astor homes, was demolished in the 1940s. Part of the estate later became a nursing home. The nearby Leacote estate stood abandoned for years before finally being destroyed by fire in 1977. Foxhollow, just south of Wyndclyffe, became a private school. The neighboring Linwood estate is now a convent. Ellerslie, built for Levi P. Morton, who served as vice president under Benjamin Harrison, became a Catholic school. Another estate, Wilderstein, is now open to the public. All the surviving mansions, including Wyndclyffe, today are listed as part of a National Historic Landmark district.

Today Wyndclyffe remains suspended in time. To

Although left to the elements for many years, the house was fenced off and its windows were boarded up after it was sold in 2003, after this image was taken.

restore or demolish the house would cost significantly more than the appraised value of the land on which it stands. With town officials mulling an order to have the structure secured or demolished, a new owner appeared in 2003 with plans to bring the house back to life, though little progress seems to have been made toward that end, and the house has remained empty. Once among the finest homes on the Hudson, Wyndclyffe is today one of its most dramatic ruins, seemingly more in keeping now with the Picturesque spirit in which it was built than when it was new. Abandoned for more than five decades, it is a Charles Addams caricature, the quintessential haunted mansion—though the only ghost at Wyndclyffe seems to be the house itself.

The Point, Staatsburg

In an isolated clearing above the river at Staatsburg stands a large, old, empty house on an estate called simply The Point. Calvert Vaux, the English-born protégé of Andrew Jackson Downing, designed the house and grounds in 1855 for Lydig Monson Hoyt, on land that had been handed down by Hoyt's Livingston in-laws. The Hoyt family maintained the estate for more than a century. After narrowly escaping destruction in the 1960s, the property later gained recognition for its significance as perhaps the last remaining estate with both house and grounds by Vaux. Yet today it remains all but unknown to the general public, and despite ownership by the state Office of Parks, Recreation and Historic Preservation, its future is jeopardized by continuing decay.

The Hoyt mansion as illustrated in Vaux's book *Villas and Cottages*, with wood trim and porches in place.

Staatsburg is a village in the town of Hyde Park. It takes its name from Dr. Samuel Staats, who purchased and settled the area in the middle of the eighteenth century. Later a number of river estates appeared here. Of these perhaps most prominent was that of Morgan Lewis, third governor of the state of New York, who like Hoyt also married into the Livingstons of Clermont. In 1895 Ruth Livingston Mills (Lewis's great-granddaughter) and her husband, Ogden, hired the architects McKim, Mead, and White to expand the former governor's house. Some might have called it another effort to keep up with the Joneses, but the resulting sixty-five-room mansion remains one of the grandest ever built on the Hudson. Now as then, Staatsburg is best known for this estate, which today is open to the public as a State Historic Site.

The story of The Point's creation exemplifies many of the prevailing themes that led to the emergence of the upper Hudson River estate district in northern Dutchess and southern Columbia counties. The home was built on a ninety-one-acre estate put together in the early 1850s by Lydig Monson Hoyt (1821–1868) and his wife, Geraldine Livingston Hoyt (1822–1897). A granddaughter of Morgan Lewis, Mrs. Hoyt acquired the northern part of the property as a gift of land ceded from her family's ancestral estate. To this Lydig Hoyt added sixty-two acres of former farmland. Shortly after the Hudson River Railroad extended service to Albany in 1851, the Hoyts moved forward with plans to develop the property as their country seat.

To design the house they commissioned the architect Calvert Vaux (1824–1895), whose remarkable career was then just beginning. Born in England, Vaux began working as a draftsman in London before coming to the United States to work with Andrew Jackson Downing (1815–1852) in 1850. It was a bold move for Vaux, but the young architect rightly saw this as an opportunity to go into partnership with a man recognized as one of the most influential figures in American landscape and architectural design.[6]

Downing's own career had begun on the Hudson at Newburgh, where with his father and older brother he ran a successful nursery and greenhouse business. While still in his early twenties, the younger Downing took an interest in theories of romantic landscape design developed in England by figures such as William Gilpin (1724–1804) and John Claudius Loudon (1783–1843). Downing developed a particular affinity for the style known as the Picturesque. Well established in England, the Picturesque began to take hold in the United States in the 1830s. It was based on an understanding of perfection in the imperfect, an appreciation for rugged, wild, and mysterious landscapes, and a call for architecture well seasoned by elements of time and age to fit harmoniously into its natural surroundings. At a time when American designers remained under the spell of the Greek Revival movement, which called for strict, stark symmetry firmly grounded in classical and Renaissance precedent, the romantic spirit of the Picturesque seemed almost revolutionary.

No topiary here. Left untended, the house and landscape seem to consummate the romantic spirit that guided their design. This view bears a notable resemblance to images used by Downing to illustrate his concept of the Picturesque.

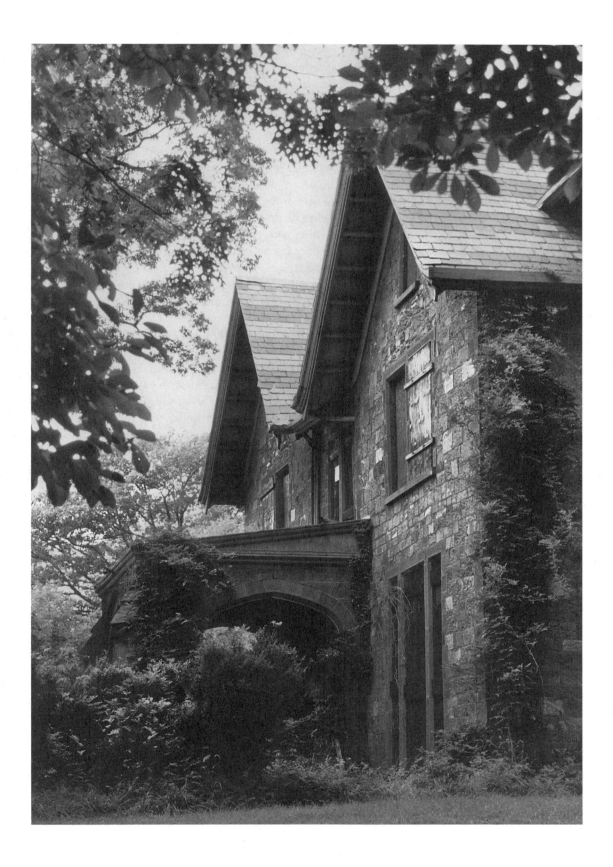

Ardently promoting the tenets of the Picturesque to his clients, Downing soon became one of the earliest proponents of this nascent movement in America. His work soon brought him into contact with the architect Alexander Jackson Davis (1803–1892), arguably the movement's greatest American progenitor. Beginning in the late 1830s, Davis and Downing collaborated on numerous projects, including Downing's books, such as *Cottage Residences* (1842). Along with his popular journal the *Horticulturalist*, these publications helped to establish the Picturesque as the dominant movement in American architectural and landscape design by the end of the 1840s.

It was into this climate that Vaux arrived at Newburgh in 1850. Vaux would provide Downing with the skills of a trained architect at just the right moment. The 1850s promised unprecedented demand for professional guidance in the development of designed landscapes, beginning with a boom in estate building on the Hudson River spurred by the coming of the railroad between 1849 and 1851, and culminating with the creation of Central Park in New York, opened in 1859. As business grew, in 1852 the firm brought on another English émigré, the architect Frederick Clarke Withers (1828–1901).

But the promise of the 1850s had only begun to be fulfilled when Downing lost his life in the wreck of the steamboat *Henry Clay* in 1852. Their mentor and employer suddenly gone, Vaux and Withers kept the office open to complete projects already under way. But their own reputations were already well established, and new projects continued to come in. Lydig Hoyt's Staatsburg estate was one of the most important commissions to come in the aftermath of Downing's death. Though construction on The Point probably did not begin until 1855, historian Francis Kowsky speculates that Lydig Hoyt may have contacted Vaux to begin planning the estate as early as 1853.[7]

Vaux chronicled his early work with Withers in a book titled *Villas and Cottages*, first published in 1857. Intended as a follow-up to earlier publications by Downing, the book offered detailed, illustrated descriptions of selected designs that were intended to serve as patterns to be imitated by other builders. The Point was included as "Design No. 31":

> This house is built of blue stone taken from a quarry a few hundred yards from the building site. . . . In ten or twelve years this blue stone will begin to change its hue, and then every month will add new beauty to its color. This kind of stone is undoubtedly most harsh and monotonous in appearance when first taken from the quarry, but after fifteen years of exposure it assumes a delicate luminous grey tint, each stone differing just so much from the next one as to give life and brilliancy to the general effect in the sunlight. When this point is once arrived at, it is unrivaled as a building material being as durable as granite, and, in connection with the landscape, far more beautiful in color than any brown stone, marble or brick.[8]

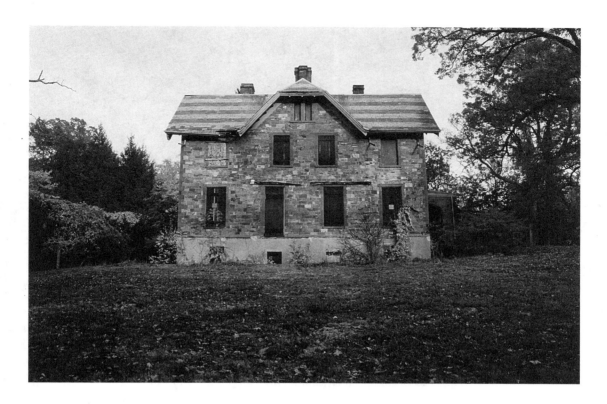

A serpentine entry drive nearly one mile in length worked its way west from the post road, providing glimpses of landscapes pastoral and picturesque before arriving at the mansion, which Vaux situated on a high point of land looking out onto the river. Vaux's plan for the house called for a simple, almost square footprint. The home's four facades, however, varied significantly from one to the next. Two were symmetrical, two were not. Bluestone set in an ashlar pattern surfaced the mansion's exterior elevations, which were enlivened by concave window hoods and delicate porches, and surmounted by an irregular roofline with gables, dormers, and chimneys of varied size. It is interesting to note that Vaux planned for and indeed intended the exterior facades to weather over time. Vergeboards, finials, and slate shingles laid in alternating dark and light bands provided further detail. Vaux also designed outbuildings including a farm cottage, though these have not survived.

West front of the house, showing clipped gable and polychrome roof details.

"In ten or twelve years this blue stone will begin to change its hue, and then every month will add new beauty to its color." Vaux specified mortar to match the mansion's brownstone trim.

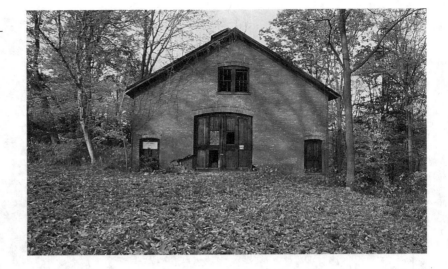

Brick barn, south front.

Vaux's reputation continued to grow after his design for The Point. In 1856 he moved his office to New York City. By the time the Hoyt house was ready for occupancy the following year he had already partnered with Frederick Law Olmsted (1822–1903) in the design of Central Park in Manhattan. With Jacob Wrey Mould (1825–1886), Vaux is credited for the design of nearly all architectural features built during the park's initial construction (1858–1873), including the Bethesda Terrace and some thirty bridges and arches. Vaux's partnership with Olmsted later produced Prospect Park in Brooklyn (1866–1872), as well as Morningside and Riverside parks in Manhattan (both initially planned in 1873). Other commissions in New York included the original buildings—both still extant—of the Metropolitan Museum of Art (1869–1874) and the American Museum of Natural History (1876–1877). In addition to The Point, Vaux also had a hand in the design of many other Hudson River estates, including Idlewild (1852), near Newburgh, home of the writer Nathaniel Parker Willis; Wilderstein (1888) at Rhinebeck; and most notably Olana (1870), the home of the painter Frederic Edwin Church, near Hudson. His renewed partnership with Frederick Withers produced the Hudson River State Hospital at Poughkeepsie (1867) and the Jefferson Market Courthouse (1874) at New York.

Upon the death of Geraldine Livingston Hoyt in 1897, The Point went to her son, Gerald, whose cousin Ruth Livingston Mills had earlier inherited the former Morgan Lewis estate to the north. Around the year 1905 Gerald Hoyt commissioned the architect Robert Palmer Huntington (1869–1949) to redecorate the mansion's first floor. Huntington, who later built his own riverfront estate just a short distance to the north, is thought to have practiced for a time with the New York firm of Hoppin and Koen,[9] probably best known for the Old Police Headquarters building in New York City (1909). (In 1915 Franklin Roosevelt hired

Hoppin and Koen to undertake alterations to his own Hyde Park estate, called Springwood.) Huntington's alterations at The Point included the removal of Vaux's first-floor interior details to make way for a tastefully executed neoclassical scheme, which was in keeping with (if not inspired by) McKim, Mead, and White's Beaux Arts reconfiguration of the neighboring Lewis-Mills mansion, undertaken for Gerald Hoyt's cousin just a few years before.

In 1927 the estate passed to Lydig Hoyt, grandson of Lydig Monson Hoyt, and his wife, Helen, who quickly did away with many of the mansion's vergeboards, finials, and window hoods in an effort update its nineteenth-century appearance. These modernizations were indicative of a general distaste for the work of Picturesque architects such as Vaux, a distaste that began with the increased popularity of more restrained neoclassicism and Colonial Revival designs at the end of the nineteenth century. Even Downing's own home at Newburgh fell into ruin and was demolished in the 1920s. First manifested at The Point in the form of alterations to the home's interior and then with the "modernization" of its exterior, the shift away from nineteenth-century romanticism grew more pronounced with the acceptance of modernism, and in the 1960s nearly led to the home's destruction.

As the twentieth century progressed, a variety of factors made the great river estates increasingly difficult to sustain. By the early 1960s, the Taconic State Park Commission had acquired both the former Lewis-Mills estate (which it opened to the public as Mills Mansion State Historic Site) and two former estates immediately to the south of The Point, which formed the Margaret Lewis Norrie State Park. In 1962, under the direction of Robert Moses, then finishing a twenty-eight-year stint as chairman of the New York State Council of Parks, the Taconic State Park Commission sought to unite the Mills and Norrie state parks by acquiring The Point. When Mrs. Hoyt declined to sell, the state took possession of the property by eminent domain. Turning down the Park Commission's offer to allow her to remain on the property for five more years, in October of 1963 Mrs. Hoyt packed up, auctioned many of the home's furnishings, and left.

In the 1960s the Taconic State Park Commission drew up plans for a heavily developed park to be built over the former Hoyt Estate. The proposal called for demolition of the mansion and for construction of a large public swimming pool and bathhouse, with parking to accommodate 960 cars and twenty-two buses.[10] Thankfully a lack of funding put the project on hold long enough for historians to recognize the estate's historic significance, and eventually the state scrapped the entire proposal. Instead the house sat vacant. In the 1980s the state invited private-sector proposals for the mansion's restoration, but despite its inclusion as part of a National Historic Landmark district in 1990, the house has remained empty. Estimates place the cost of its restoration between $2 million and $5 million.

Today The Point is at the same time a symbol of foolishness and foresight, for as regrettable as the state's decision to evict its occupants may have been, the property remains intact and has been protected from the development pressures that have destroyed so many others. In 2005 the same agency that once proposed its destruction nominated The Point for independent designation as a National Historic Landmark. With the price tag for its restoration growing steadily larger, one can only hope the agency will act sooner rather than later to secure the future of this definitive statement of the Hudson Valley's cultural identity.

"I did not want to come here at all," said one of the patients while descanting on the lovely, bright prospect from the windows of the parlor in his ward; "but I am glad now, for I can sit at the window all day and enjoy the fresh air and beautiful scenery. It does me good and I never tire of it. And I like to watch the steamers and schooners and barges as they pass up and down the river."
New York Times,
December 26, 1872

Hudson River State Hospital, Poughkeepsie

In the fall of 2001, the Hudson River Psychiatric Center at Poughkeepsie moved its last patients off the riverside campus it had occupied for more than 130 years. The place began its decline in the 1950s, and its old main buildings had already stood vacant for decades. Once known as the Hudson River State Hospital for the Insane, at the time of its completion it was among the most advanced institutions of its kind in the country. Hired for its design were three of the most preeminent figures in American design: Frederick Law Olmsted, Calvert Vaux, and Frederick Clarke Withers. Today, despite considerable decay, plans are afoot to breathe new life into these old buildings by adapting them for residential use.

In 1866 the New York State legislature authorized the construction of a large, modern facility to provide care and treatment for the mentally ill, to be situated at an undetermined location in the Hudson River Valley. The opportunity to host such an institution brought with it obvious economic advantages, and immediately the river towns began lobbying, jockeying, and finagling to get the prize. The legislature had nearly given the hospital to Newburgh when at the last minute another property became available in Dutchess County, just north of Poughkeepsie. This was a river estate called Mount Hope, the ancestral home of its owner, James Roosevelt. After a fire had destroyed the estate's main house earlier in 1866, Roosevelt put the property up for sale and moved his family a few miles upriver to Hyde Park, where his second son, Franklin Delano Roosevelt, was born sixteen years later.

In December of 1866 the state legislature selected Mount Hope as the site for the new hospital. Construction began in the spring of 1868. The Hudson River State Hospital for the Insane admitted its first patients four years later, in 1871. Only a few years before, government-sponsored assistance for the mentally ill was known only in larger cities, and was virtually nonexistent in rural areas. In smaller towns and cities the "insane poor" either went without treatment, were thrown into jail, or at best were relegated to charitable almshouses, where conditions were notoriously inadequate.

Beginning in the 1840s the public began to take a greater interest in the plight of the mentally ill. Perhaps no one did more for their cause than the reformer Dorothea Dix (1802–1887), who tirelessly promoted the recognition of insanity as a treatable illness, and campaigned across the country for the construction of hospitals and asylums to care for the mentally ill. By the 1850s numerous state-administered "hospitals for the insane" appeared primarily in New England, most of them a direct result of lobbying efforts by Dix.

By the end of the Civil War, population growth along the Hudson River had brought an increasingly urban character to towns such as Pough-keepsie. The coming of the railroad, the move from agricultural commu-nities to industrial centers, and waves of immigration had introduced social issues previously unseen in these communities. Poughkeepsie was incorporated as a city in 1854, Newburgh in 1865, and Kingston seven years later. The new Hudson River Hospital would address an ongoing problem that was growing more formidable every day.

As if to make up for lost time, the state legislature lavished enormous funds on the Hudson River State Hospital's initial construction. It speci-fied that the hospital's design follow what was known as the Kirkbride Plan, called "the first scientific response in America to the challenge of treating insanity as a disease."[11] Developed by Dr. Thomas S. Kirkbride (1809–1883), director of the Pennsylvania Hospital for the Insane, the plan called for living quarters broken into wings and arranged to allow adequate light and ventilation while at the same time providing patients a sense of privacy. In addition to the popularly accepted belief in the curative powers of fresh air and bucolic natural environs, both Kirkbride and Dix promoted the idea that well-designed hospital buildings were an essential part of the healing process.

When finished, the hospital represented a collaborative effort between Frederick Law Olmsted (1822–1903), Calvert Vaux (1824–1895), and Frederick Clarke Withers (1828–1901). The firm of Olmsted and Vaux took charge of laying out the grounds. Olmsted and Vaux had begun their partnership ten years earlier for the design of Central Park in New York City, a project in which both partners were still active at the time of their commission for the hospital at Poughkeepsie. At the same time, the firm was also busy overseeing construction of Prospect Park in Brooklyn. Both partners enjoyed a reputation in these years as America's chief practitioners of romantic landscape design theories developed in England in the eighteenth century and established in America by Vaux's late mentor, Andrew Jackson Downing (1815–1852). Their design for the three-hundred-acre grounds surrounding the hospital included a wind-ing entry drive that provided carefully planned distant views of the main hospital buildings, as well as sweeping, pastoral lawns, and a series of walks and carriage drives. Within three years Vaux took on the design of another Hudson River landscape at Olana, the home of Frederic Church,

General view of the Hudson River State Hospital showing lawn and west facade.

about forty miles to the north. (Olmsted oddly enough later spent his last years at the McLean Asylum, in Belmont, Massachusetts, which like the Hudson River State Hospital also stood on grounds he himself had designed.)

The buildings themselves are attributed primarily to Withers, who like Vaux came to America from England to work under Andrew Jackson Downing at Newburgh. After Vaux moved his practice from Newburgh to New York City in 1856, Withers stayed behind for several more years, gaining important high-end residential commissions and other projects in Newburgh and elsewhere. Later he too established himself at New York. Though he earned a reputation for ecclesiastical architecture, his commissions included a wide variety of projects, many of which—including the Hudson River State Hospital—he designed in partnership with Vaux. Among Withers's best-known buildings are several designed for Gallaudet College (1868) at Washington, D.C., and the Jefferson Market Courthouse (1874) at New York.

Twin diamond-shape date stones typify the hospital's elaborate masonry detail.

As prescribed, Withers laid out the hospital according to the Kirkbride Plan, with separate, tiered wings flanking a central administration building. Stylistically Withers executed the buildings in the High Victorian

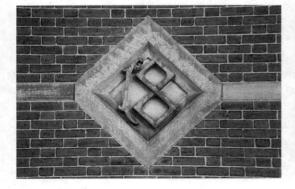

Gothic, an eccentric culmination of the Picturesque movement. Influenced by the seminal writings of the English theorist and critic John Ruskin (1819–1900), buildings of this period typically included highly detailed masonry elements and rich, polychromatic facades usually based on Italian Gothic precedents. These architects intended their work to last: specifically influenced by Ruskin, many of them anticipated the effects of weather and age in their designs, and saw these as elements that would continue to perfect a building's appearance for decades, even centuries, after its completion.

Decorative cast-iron staircase of a service building.

Withers's design for the Hudson River State Hospital brought the first application of the High Victorian to an American psychiatric hospital.[12] His drawings called for exterior walls of brick enlivened by stone stringcourses and a rich variety of polychromatic stone trim. A mansard roof capped the building's long brick facades, which were punctuated by a series of spires and towers. Behind the main buildings a complex of less elaborate structures housed service facilities for laundry and maintenance, as well as workshops in which patients were trained in cooking, metalworking, mattress making, shoemaking, sewing, and other trades. Other carefully situated buildings dotted the grounds, including greenhouses, a power plant, a railroad station (the hospital had its own spur from the Hudson River Railroad), and cottages for hospital staff.

As built, the hospital could accommodate two hundred male and two hundred female patients, housed in separate wings that provided living quarters and numerous parlors, billiard rooms, libraries, and semienclosed "ombras" for outdoor relaxation. Continual expansion through the early 1900s brought new buildings, including a library, separate Catholic and Protestant chapels, a recreation hall, and additional housing for patients and staff. The architecture of these structures reflected changing popular tastes, bringing to the site classically inspired buildings that were far more restrained than their Gothic predecessors. The hospital also added land, eventually growing to encompass about 1,700 acres at its peak in the 1950s.

Sculptural ornament included finely carved column capitals such as this at the administration building.

From an early patient population of about four hundred the hospital expanded to house some nine hundred patients by 1890.[13] In 1943 the hospital cared for 5,178 patients and had a staff of 884.[14] Mid-twentieth-century expansion de-emphasized the architectural treatment of the facility itself, and new buildings grew increasingly drab, a pattern that climaxed with the construction of the austere, nine-story Cheney Building, opened in 1952.

The hospital's combined patient and staff population eventually peaked at nearly 8,000 in the 1950s. With its own dock, railroad station, power plant, farm, dairy, and reservoir, it functioned almost as a city unto itself, and much of its staff could live on the grounds without ever having to leave.

Beginning in the late 1950s, new approaches to treatment led to a precipitous drop in the number of patients. Advances such as antipsychotic medications, which could be prescribed for home use, enabled many patients to receive treatment without the need for lengthy hospital stays. Later, many patients were placed in off-site group homes in a movement toward "deinstitutionalization," which was intended to allow them a more normalized lifestyle as enfranchised members of the community. Once lauded as a panacea that would once and for all solve the problem of treating the mentally ill, reduced funding in the late twentieth century caused facilities such as the Hudson River State Hospital to themselves suffer from overcrowding, and as their ability to provide adequate care suffered, their reputations were discredited. Even words such as "asylum" and "institution" became stigmatized: by 1976 the Hudson River State Hospital changed its name to the Hudson River Psychiatric Center.

But the problems facing these facilities went beyond anything that could be fixed with a simple rechristening. In the spring of 1975, the hospital closed much of Withers's original main building. While the central administration building remained in use, the wings that flanked it to the north and south were sealed and boarded up. As the number of inpatients continued to decline, other buildings followed suit.

In the late 1980s the state Office of Mental Health began to explore the possibility of demolishing the closed wings of the original building. A feasibility study in 1990 estimated the cost of mothballing the structure at nearly $3 million. Demolition, however, would cost less than half that amount.[15] In 1989 a coalition of concerned citizens helped to get the building added to the federal government's list of National Historic Landmarks, which prevented the expenditure of government funds on any action that could damage the property's historic value. The state dropped demolition plans.

Though protected from demolition, the building continued to decay. As vines crept up the hospital's elaborate facades, sections of roof began to give way. By century's end the number of patients had declined to fewer than 300. Scores of buildings stood abandoned on the old hospital's grounds. Finally the Hudson River Psychiatric Center announced that it would move its administration and all remaining patients to a satellite facility located about a mile to the east, where it continues to serve about 150 inpatients in 2006. In 1999 the National Trust for Historic Preservation named the hospital one of America's "Eleven Most Endangered" historic sites, along with other threatened New York asylums at Binghamton, Buffalo, and Utica.

Hudson River State Hospital, December, 2001. The advance of decay seems in a way to heighten the effect of Withers's High Victorian facades.

The Psychiatric Center completed its move by October of 2001 and offered the old hospital for sale. In abandonment, the Picturesque ambitions of its builders seemed to reach full maturity: with natural decay part of its original design intent, each passing day of neglect only heightened the intended effect of its architecture. It was a frustrating irony, for neglect became perhaps the single greatest threat to the continued survival of these buildings and many others like them. A similar fate befell dozens of old asylums across the country in the last quarter of the twentieth century. Like Hudson River, many of these old hospitals represent important examples of period architecture. But their vast size, use-specific configuration, and often lingering negative public image has made them difficult to adapt for new uses, and their prolonged abandonment stands as a daunting problem for preservationists.

Fortunately, today there is hope for the Hudson River State Hospital. In March of 2005 the state sold 156 acres including nearly all of the historic hospital buildings to a development group called Hudson Heritage. Their proposal includes the rehabilitation of Withers's original main buildings and many other historic structures on the site, which are to be adapted for use as residential and retail space and to house a hotel and convention center. Important elements of Vaux and Olmsted's designed landscape are to be preserved. The plan also calls for much of the property to be developed for new townhouse-type condominiums; this has raised eyebrows among those concerned about open-space preservation and traffic congestion. But with many other asylums continuing to languish and developers generally indifferent toward issues of historic preservation, there is good reason for optimism that the reclamation of the Hudson River State Hospital may soon set a new precedent for the adaptive reuse of other neglected historic sites in the Hudson Valley and elsewhere.

Luckey Platt & Company, Poughkeepsie

Poughkeepsie, the seat of Dutchess County, marks the halfway point on the Hudson between New York City and Albany. It is a small city, population thirty thousand, and with Newburgh, Beacon, and Kingston it is one of the principal river towns of the middle Hudson. As in these other towns, one need not spend much time here to see that Poughkeepsie has known better days. In the very heart of the city stands the former Luckey Platt & Company Department Store, by far the most prominent commercial building on Main Street. This is one of many buildings that survived urban renewal only to spend years empty and abandoned. In the year 2004, as some began to question the building's future, work began on its restoration, bringing to Main Street a sense that things might finally be looking up after decades of decline.

From humble beginnings Luckey Platt rose to become perhaps the largest department store on the Hudson River between New York City and Albany. Its tenure spanned nearly 150 years, during which time it established itself as a defining institution of a town that called itself the Queen City of the Hudson. Poughkeepsie traces its origins to the arrival of European settlers in 1687. The construction of a courthouse in 1717 secured the town's place as the political and commercial center of Dutchess County. During the American Revolution Poughkeepsie served briefly as the state capital. In 1799 it was incorporated as a village, and in 1854 as a city.

The writer Benson Lossing counted forty-two documented spellings for its name, the origins of which were lost until the 1930s, when historian Helen Wilkinson Reynolds traced its etymology to "Uppuqui-ip-ising," a phrase in the local Mahican Indian dialect, which she translated as meaning "reed-covered lodge by the water place." Franklin Roosevelt's father, James, was born and raised here: his friends called him "Poughkeepsie Jimmy." To the south of the city lived Samuel Finley Breese Morse, as in Morse code, inventor of the telegraph. From 1895 to 1949 Poughkeepsie gained fame as the scene of the Intercollegiate Rowing Association's annual regatta, then the largest event of its kind in the world. Today probably best known as the home of Vassar College, it is the end of the line for commuter trains from New York City.

Like other cities Poughkeepsie had its own commercial institutions,

The corner of Main and Adacemy streets, December 1998. Temporary fencing keeps passersby at a safe distance from downtown Poughkeepsie's most prominent commercial building.

which formed a bustling downtown business district. Of these, perhaps the greatest were the Nelson House, Poughkeepsie's leading hostelry, and Luckey Platt, its largest department store. Both had roots that pre-dated Poughkeepsie's incorporation as a city, and both stood abandoned by the 1990s. Situated on Market Street, the Nelson House opened in 1876 as the successor of two earlier hotels that had operated on the site since 1775. A series of expansions culminated with the construction of a six-story neoclassical building in 1925. In a career that spanned nearly two hundred years, the Nelson House and its predecessors hosted guests from the Marquis de Lafayette to Henry Ford. Members of Franklin Roosevelt's White House staff moved into the hotel's second floor whenever the president came north to visit his home at nearby Hyde Park.

If the Nelson House was Poughkeepsie's Waldorf-Astoria, Luckey Platt was its Macy's.[16] The company could trace its roots to the 1840s, to the dry goods store of Isaac Dibble. In the 1850s Dibble sold the business to partner Robert Slee, who hired Charles P. Luckey as an assistant. Luckey assumed an ownership position by 1866. In 1869 he formed a partnership with Edmund Platt (of an old Dutchess family, which gave its name also to Plattsburgh in Clinton County, New York), and Luckey Platt was born.[17]

In the 1870s the company began buying up buildings at the intersection of Main and Academy streets, and by the turn of the century Luckey Platt evolved (in the words of its advertising slogan) to become "the leading store of the Hudson Valley." In 1910 it hired Poughkeepsie architect Percival M. Lloyd to design a new building, which was to house its furniture department. Lloyd was prolific in Poughkeepsie, and his work included some of the most prominent buildings in the city.[18] His new building for Luckey Platt rose three stories in height and faced out onto Academy Street. Elaborate terra-cotta tiles clad its main facade to form six Corinthian columns surmounted by a denticulated cornice. Inside, a grand staircase led to a third-floor landing overlooked by a tripartite stained glass window depicting Henry Hudson's voyage past the future city of Poughkeepsie in 1609.

Continued growth brought a final phase of expansion in 1924 with the construction of a new building at the corner of Main and Academy streets. Designed by local architect Edward C. Smith, the enormous, classically inspired building stood five stories in height and tied the furniture department on Academy Street to an existing building on Main Street that the store had occu-

A grand staircase with an ornate iron handrail served as the focal point for Luckey Platt's furniture department, opened in 1910.

pied since the 1870s. Exterior walls were composed of off-white brick, with classical details of stone and terra-cotta. Inside, plaster ceiling cornices and other ornaments repeated Smith's neoclassical scheme throughout the building's well-lit, airy floor space. In character if not in scale Luckey Platt intended this building to match the finest department stores in the country, from Woodward and Lothrop in Washington, D.C., to Wanamaker's in Philadelphia, from Macy's or Gimbel's in New York to Marshall Field's in Chicago. This it did beautifully even after the store closed nearly six decades later.

For well over a century Luckey Platt served customers from all walks of life. The curtains that still hang in the library of FDR's Hyde Park home were purchased here in the 1930s. As at Macy's in New York, Christmas brought Santa to Luckey's, and for a few years in the 1950s the store also sponsored its own Thanksgiving Day parades. Eventually the company grew to employ some four hundred people in forty-three sales departments. There was also a cafeteria and beauty parlor. With four and a half acres of floor space and sixteen show windows, the store dwarfed every other business in town. Other department stores opened—Montgomery Ward around the corner, and Wallace's directly across Main Street in 1906—but neither of these were owned locally, and neither could rival Luckey Platt as one of Poughkeepsie's foremost institutions.

Much has changed since the days when elevators shuttled busy shoppers from floor to floor.

Today Poughkeepsie's downtown business district is but a shadow of its former self. Here, as in cities up and down the Hudson Valley and all across America, the automobile, the migration from urban to suburban, and shopping malls on the outskirts began in the 1950s to unbuild communities that had taken centuries to develop. By the 1960s city planners saw the writing on the wall. To keep the cars rolling they built the Arterial, a series of highways that bypassed the downtown business district. At the same time the city government used urban renewal money to raze entire blocks and pave them for parking. In a valiant effort to combat suburban shopping malls such as the Poughkeepsie Plaza, which opened about a mile south of town in 1958, the city closed off three blocks of Main Street to create the "Main Mall," an open-air pedestrian shopping plaza complete with fountains, pavilions, and honey locusts, which was dedicated in 1974.

But the fashionable shops of Main Street continued to fail. Some, such as the jewelry shop Zimmer Brothers, moved out of downtown and survived. Others closed as their owners retired and left vacancies no

Old advertising lies discarded in Luckey Platt's print room.

one wanted to fill. Drugstores, bakeries, and shoe stores, Woolworth's and Newberry's, Shwartz's men's clothes, Sherman's furniture, Haber's toys—all are gone. On Market Street, the old Nelson House closed in 1969. The county government later converted the former hotel for use as an administrative annex, but today this too lies abandoned.

Of the department stores not one is left. Montgomery Ward headed for the outskirts in the 1960s and survived until the chain declared bankruptcy. Wallace's closed in 1975 just one year after the opening of the Main Mall. Luckey Platt managed to hang on for a few years more. In response to declining sales in the 1960s, the company's management opened a number of satellite stores in suburban shopping malls. Operations at the downtown store meanwhile were scaled back until eventually only part of the first floor remained in use, staffed by fifteen employees. To draw additional revenue, the store leased empty space on upper floors to the Dutchess County Department of Social Services beginning in 1977.

But none of this stemmed the tide. In 1981 the company announced that it would close its downtown Poughkeepsie store on July 3 of that year. Three of its satellite locations would remain open, and no going-out-of-business sale was advertised. The end came even sooner than expected. On July 2, shortly before lunchtime, with most remaining merchandise moved to other stores and few customers coming around even for a last look, the clerks were sent home, the doors closed and locked. "With no particular notice, fanfare or funeral," reported the *Poughkeepsie Journal* on page 5 of the next day's paper, "Luckey, Platt and Co. quietly closed its Main Mall retail store Thursday after 112 years of doing business in downtown Poughkeepsie. . . . One rack of clothes was still sitting in the store, toward the rear, but most merchandise seemed to be gone."[19] In the window a hand-printed sign read simply "STORE CLOSED." So ended

more than a century of continuous operation. Within a few years the company's satellite stores also disappeared. The county moved its offices out in 1987, after which time the building sat empty.

A number of ideas for the building's reuse came and went. The federal government listed the building on the National Register of Historic Places in 1982. In 1987 a New York City developer purchased the property with plans to lease the former department store as office space. But nothing came to pass, and by 1998 its owners owed $643,000 in unpaid taxes. The following year a Minneapolis-based group called Artspace Projects Incorporated explored the idea of restoring the building to house studios, galleries, and residential space for artists, but this too fell by the wayside. Three years later a similar proposal by artist Peter Max came and went almost as quickly.

In the late 1990s, after a rash of arsons destroyed several other vacant downtown buildings, city officials voted to raze nearly an entire city block of empty Victorian storefronts farther up Main Street. Poughkeepsie's population had fallen from a peak of 41,023 in 1950 to 28,844 in 1990.[20] By this time the Main Mall presented a dismal scene. The only signs of life came during weekday lunch hours. At other times cheerful music played over loudspeakers with almost no one around to hear it.

Building at 413–415 Main Street, Poughkeepsie, December 2000. This and several neighboring buildings were demolished c. 2002 to make way for mixed-income housing designed to replicate the character of traditional downtown commercial and residential buildings.

Luckey Platt & Co., rear elevation. Painted sign is now obscured by new construction.

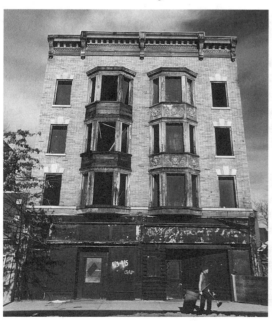

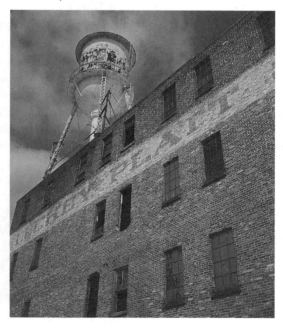

The Nelson House sits empty on Market Street.

Beginning in the late 1950s, similar pedestrian malls had been tried in as many as two hundred cities across the country in response to chronic problems of urban decay.[21] By the 1990s many were seen as failures. After heralding it as Poughkeepsie's ticket to salvation, many now blamed the mall for having perpetuated the very problems it was created to solve.

At the beginning of the twenty-first century things began to improve. In 2001 the Main Mall was reopened to traffic. The following year the city used federal grant money to restore, stabilize, and reface vacant Main Street properties to entice new tenants. But with no plans for Luckey Platt, the keystone of downtown's revitalization remained missing. Signs of neglect became more evident. Windows on upper floors remained open to the elements. Floors and roofs began to collapse in the fall of 2003 and spring of 2004, prompting serious doubts about the building's future. City officials, faced with a choice between investing in the building's stabilization or risking ultimately having to fund its demolition, voted to spend $1 million on bare-bones repairs in hopes a developer might soon be found to bring the empty building back to life.

The investment paid off. The city took possession of the building and in November of 2004 sold it to a Queens developer with plans to install apartments on its upper floors and retail space at the street level. Work began quickly. Unfortunately the building's advanced deterioration resulted in the loss of nearly all of its original interior details (though the

grand staircase has been preserved). But the building itself survives, and today the corner of Main and Academy looks much as it did in 1924.

Each of the river towns has suffered more or less the same fate. Fortunately most have begun to bounce back. Though Newburgh continues to struggle, in Hudson and Beacon ritzy antique shops have taken over empty storefronts, while once-blighted parts of Kingston have become outright tourist destinations. In Poughkeepsie life is slowly returning to Main Street. Coffee shops and art galleries have moved into historic buildings that survived urban renewal demolition. And while the county government has shamefully left the great Nelson House empty and decaying directly across from the Bardavon Theater—one of downtown's greatest attractions—the resurrection of Luckey Platt has demonstrated the potential of what some might have written off as just another lost cause.

Bannerman's Island Arsenal, Pollepel Island

Nineteenth-century writers often referred to the Hudson as the "American Rhine," for in sheer natural beauty it seemed every bit the equal of its European counterpart. But there was one thing the Rhine had that the Hudson did not: throughout the nineteenth century, writers felt compelled to make excuses for the Hudson's lack of castles and ruins. Despite attempts to romanticize the river's Revolutionary-era fortification structures, only in the 1850s did anything even remotely resembling the Rhine's baronial fortresses begin to sprout from the Hudson's hilly shores. But in time the Hudson would lay claim to its own castle-like ruins, and of these none have captured the popular imagination more than those of Bannerman's Island Arsenal.

Located near the east shore of the Hudson, just three miles below Beacon, Bannerman's Island Arsenal stands on Pollepel Island. It is the creation of Francis Bannerman VI (1851–1918), a Scottish immigrant, who built these buildings over an eighteen-year period at the beginning of the twentieth century. Before Bannerman's arrival the island was largely uninhabited. Over the years it has been known variously as Polopel, Pollopell's, and Pollepel Island. One of several accounts for the origins of its name holds that it derived from an old Dutch word for "pot ladle." During the Revolutionary War, the Americans used the island as the eastern terminus of an underwater chevaux-de-frise, a series of iron-tipped poles sunk in the river designed to prevent the passage of British warships. Owned for many years by the Van Wyck family, in 1888 the island was sold to Mary G. Taft.

Twelve years later Taft sold the island to Francis Bannerman VI, a dealer in surplus military goods. Born at Dundee, Scotland, in 1851, Bannerman immigrated to the United States while still a child in 1854, and

by 1858 had settled with his family at Brooklyn. As a youth, Francis VI is said to have demonstrated a keen resourcefulness by pulling debris from the waters of New York Harbor with a grappling hook and selling the scrap to junk merchants. Sometime around the end of the Civil War, his father started a small business buying and selling military surplus items. Then still in his teens, Francis VI assisted in the family business, which later became known as Francis Bannerman and Sons. Beginning in 1888 the company published annual military goods catalogues, whose near-encyclopedic quality made has them sought-after collector's items among weapons enthusiasts even today.[22]

Eventually Francis Bannerman VI succeeded his father in control of the business. The enterprise grew rapidly in the 1890s, and after the Spanish-American War of 1898 Bannerman and Sons managed to acquire more than 90 percent of all captured goods sold at auction by the United States government. Its inventory soon outgrew the company's Brooklyn warehouses, and with neighbors increasingly leery of such a growing stockpile of explosives so close to their homes, Bannerman began looking elsewhere to build a larger storehouse in a less residential area. In December of 1900 he purchased Pollepel Island and in the spring of 1901 began construction of a warehouse building and superintendent's house there.

Bannerman continued to develop the island until his death eighteen years later, eventually building several more warehouses, a residence for his family, and a variety of ancillary structures, some more decorative than functional. Though not trained as an architect, Bannerman designed all these structures himself. The first warehouse, which became known as the No. 1 Arsenal, was a relatively simple building that featured little architectural detail apart from crenellations atop its three-story brick walls. Later additions grew successively more "castle-like" in appearance, until they eventually became so ornate as to belie their utilitarian function.

Intensely proud of his ancestry, Bannerman modeled his buildings after castles he had seen in Scotland and elsewhere in Europe. He called the island "Craig Inch," Scots Gaelic for "rocky island." The arsenal itself took shape on the eastern half of the island, the side most visible from trains passing on the eastern shore. An arched entry gate complete with drawbridge and portcullis provided access to the buildings. In addition to a residence for the superintendent and his family, the arsenal complex grew to include of a series of large warehouses, each built more elaborately than the last. Most prominent stood a six-story stuccoed brick and fieldstone structure that Bannerman called Craig Inch Tower. Its highly detailed facade featured granite block trim and crenellated turrets at each corner. Molded into the masonry, large letters clearly visible from passing trains and steamboats identified the buildings as BANNERMAN'S ISLAND ARSENAL.

Bannerman reserved the more secluded western half of the island as

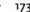
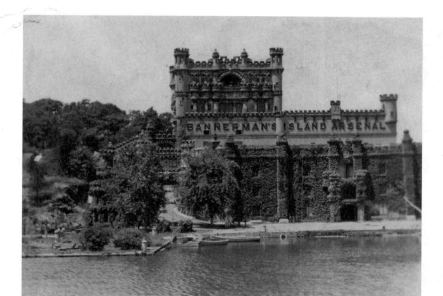

Bannerman's Island Arsenal
viewed from the east,
C. 1925. Collection of Thom
Johnson.

an estate for himself and his family. Facing south toward the Hudson River Highlands he erected a small residence, called Craig Inch Lodge. Terraced gardens surrounded the house, along with an icehouse, cistern, and springhouse. Paved paths provided circulation around the island, while markers molded into decorative gate pillars and other structures showed the way to the evocatively named "Sally Port Brae" and the "Moat Brae." Original sketches and plans show structures designed by Bannerman but not erected, including a mausoleum for his family and a monumental gated archway at the "Wee Bay," on the south side of the island. Ever the resourceful recycler, Bannerman drew plans for his buildings on hotel stationery and used Victorian bed frames as rebar.

The family crest, designed by Francis VI himself, appeared prominently on the facades of nearly every structure on the island. It took the form of a shield divided into four quarters, which featured a sailing ship; an ordinance pot for melting ammunition; a grappling hook, signifying the beginning of Bannerman's business career by hoisting refuse out of the water at navy yards; and a hand holding a banner. The latter references an old story of a paternal ancestor who rescued the clan pennant in the Battle of Bannockburn, whereupon he was presented part of the national Saint Andrew's cross banner by King Robert Bruce and pronounced a "Bannerman."

From the time of its construction, Bannerman's Island Arsenal instantly captured the popular imagination, and the complex of warehouses became known throughout the Hudson Valley simply as "Bannerman's Castle." Finally, the Hudson had a true castle of its own: "I never saw anything half so pretty on the Rhine," remarked a visitor to the island in 1911.[23] Though his "castle" was highly visible from passing steamboats

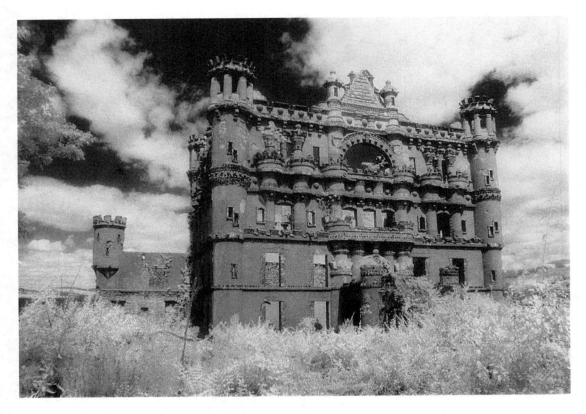

Craig Inch Tower, south front, as seen in this photograph made with black-and-white infrared film.

and trains, Bannerman kept the island strictly off limits to the public, and even to his own customers. All sales went through the company's New York City showroom, which relocated to 501 Broadway in 1905. So thorough was the arsenal's inventory that Bannerman claimed his catalogues were on file with "the office of war chiefs in nearly every nation," and that "all the great sculptors and artists" referenced the illustrations contained within them.[24]

The company did most of its business supplying weapons and other equipment to developing countries whose governments could afford to purchase only secondhand military supplies. During the Russo-Japanese War of 1904–1905, the company claimed to have sold hundreds of thousands of items to the Japanese War Department, including uniforms, saddles, rifles, and cartridges. Before America's entry into World War I Bannerman donated military supplies worth an estimated $100,000 to the British government.[25] The company also supplied a variety of less bellicose clients—uniforms and other items were sold for use as props to stage acts including Buffalo Bill Cody.

Bannerman of course had critics who decried his trade in weapons of war. Avowedly very religious, Bannerman sometimes invoked quotes from the Bible in his catalogues to justify the legitimacy of his business. The "carrying of weapons met the approval of the Prince of Peace," argued one. It was necessary to study war to end war, Bannerman said,

adding that he hoped for a day when his collection would be known as the "Museum to Lost Arts" in a time when weapons would no longer be needed to maintain law and order. But until that day came the world needed weapons to ensure peace. "Who would advise disarming the police?" asked a passage in the 1907 Bannerman catalogue.[26]

Francis VI's sons Francis VII and David took over the business after their father's death in 1918, and the island continued to stock military goods and antiques into the 1950s. The arsenal's high visibility, unusual architecture, and inaccessibility to the public incited a popular fascination with the place, and the buildings took on a perceived antiquity even before they reached twenty years of age. A *New York Times* reporter in 1920 wrote that the island had "long been used" by Bannerman for the storage of weapons.[27] As early as 1911 the Hudson River Day Line described the arsenal as an attraction in its promotional literature.[28] Over forty years later the New York Central Railroad featured the island on the cover of its annual timetable for 1954. There were widespread rumors that Bannerman and his successors had the island booby-trapped and defended by vicious guard dogs and guns set up in the turrets of Craig Inch Tower.

In 1959, the Bannerman business moved its showroom, offices, and warehouse to Blue Point, Long Island, where under different ownership it continued to operate for many years. At Pollepel Island, Francis VI's grandson Charles Bannerman had all live ammunition deactivated and removed at that time, and many items were donated to the Smithsonian

Shadows from turrets and finials of the south facade of Craig Inch Tower project onto the interior fieldstone and brick walls.

The Middle Hudson

The North Gate, as illuminated in 1998 by City Lights, under the direction of Deke Hazirjian with the Bannerman Castle Trust.

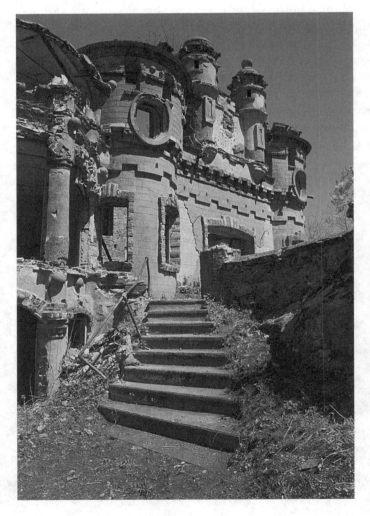

Craig Inch Lodge, south front. The staircase leads to a sitting area with unobstructed views of Breakneck and Storm King mountains.

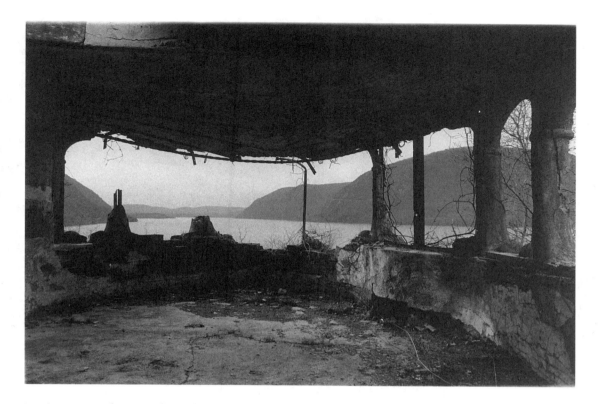

Breakneck and Storm King
viewed from Sleeping Porch,
Craig Inch Lodge.

Institution. Eight years later the Bannerman family sold the island to the Taconic State Park Commission via the Rockefeller-controlled Jackson Hole Preserve, which incorporated it into the newly formed Hudson Highlands State Park. By this time years of abandonment had left the buildings in a dilapidated state, and the Park Commission elected to keep the island closed to the public. On August 8, 1969, a fire of undetermined origin swept the entire arsenal complex, leaving only its ruined shell behind. In the decades that followed, the ruined condition of the buildings and the state's restricted access policy perpetuated the island's mystique in local lore, and the ruins of Bannerman's Island Arsenal became among the most recognized historic sites in the Hudson Valley.

In 1994, the Bannerman Castle Trust, a nonprofit friends group, began a partnership with the New York State Office of Parks, Recreation and Historic Preservation to use Bannerman's Island Arsenal as a historic, cultural, and educational resource. Using public and private funds, the trust began removing years of overgrowth, renewing lost vistas, and uncovering trails and man-made landscape features, and it has offered organized public "hard hat tours" of Pollepel Island. First conducted on only a very limited basis, the tours have grown more frequent and have provided a long-awaited opportunity for a growing number of visitors to finally get an up-close look at this long-forbidden island. While European governments have in some cases made efforts to stabilize

castle ruins to preserve them and to allow greater public access, no such attempt has been undertaken at Pollepel Island. But for the time being, Bannerman's Island Arsenal remains as firmly entrenched as ever in the cultural landscape of the Hudson River Valley.

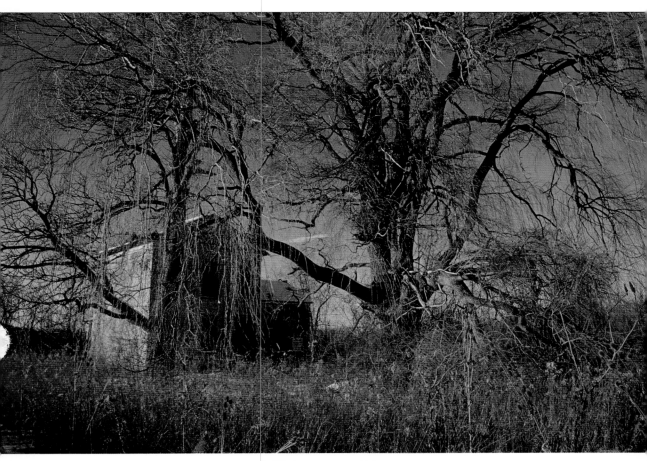

F. Sheffdecker House, Bethlehem

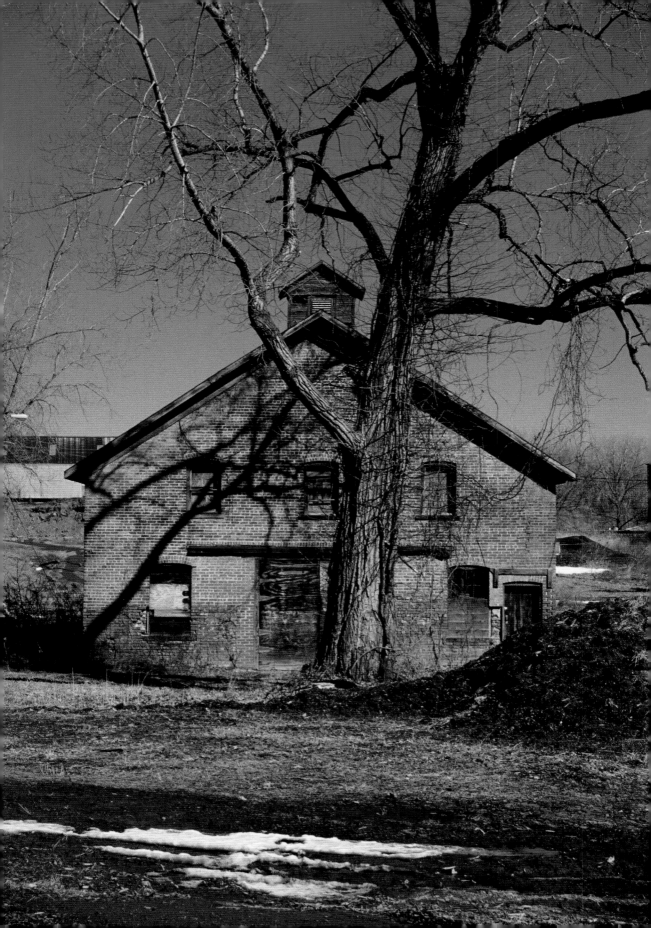

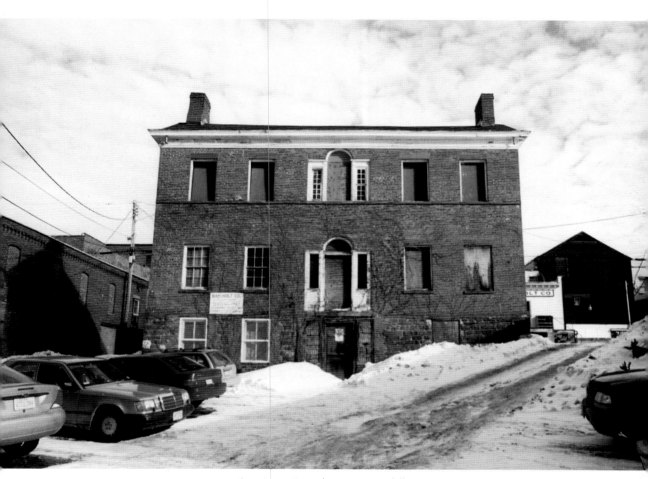

Capt. James Bogardus House, Catskill

(*Opposite*) Powell and Minnock Brick Company, Coeymans

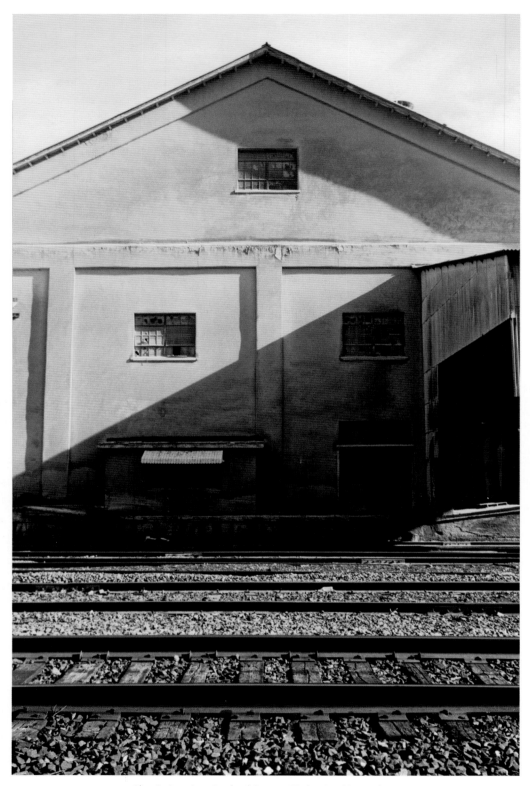

Alsen's American Portland Cement Works, Smith's Landing

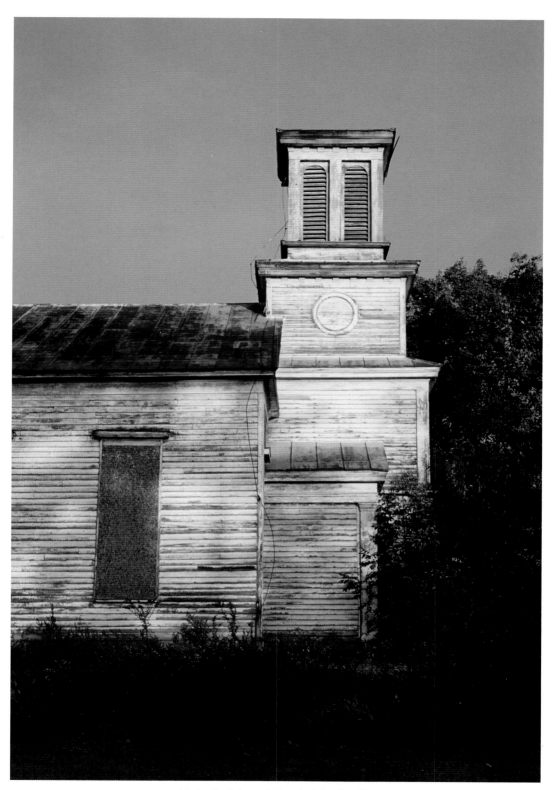

Methodist Episcopal Church, Columbiaville

New York Central Railroad Station, Stuyvesant

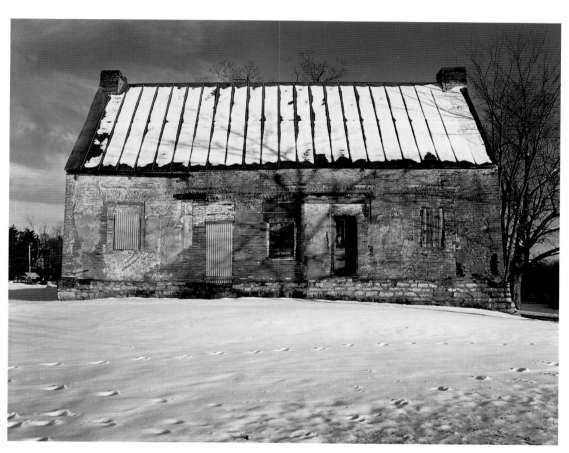

Jan van Hoesen House, Claverack

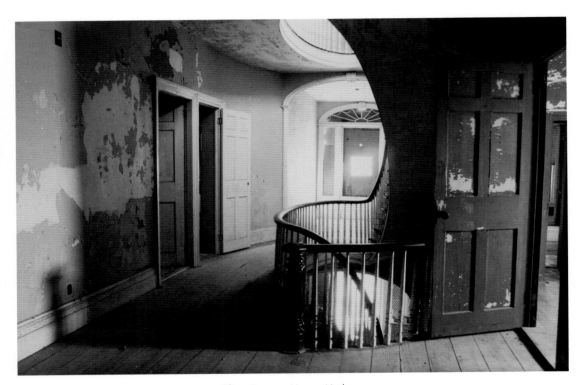

Oliver Bronson House, Hudson

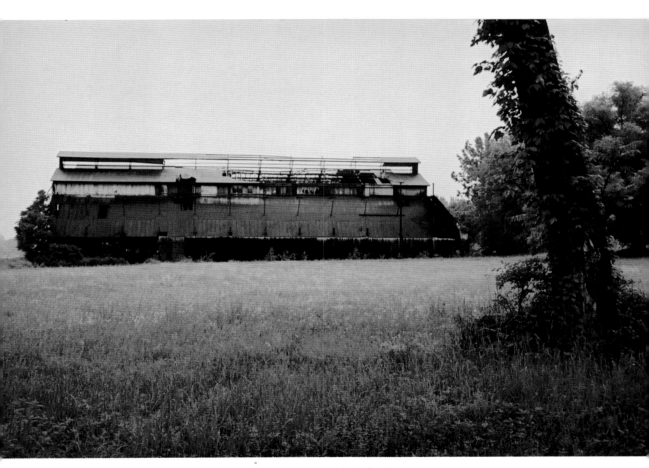

Hutton Company Brick Works, Kingston

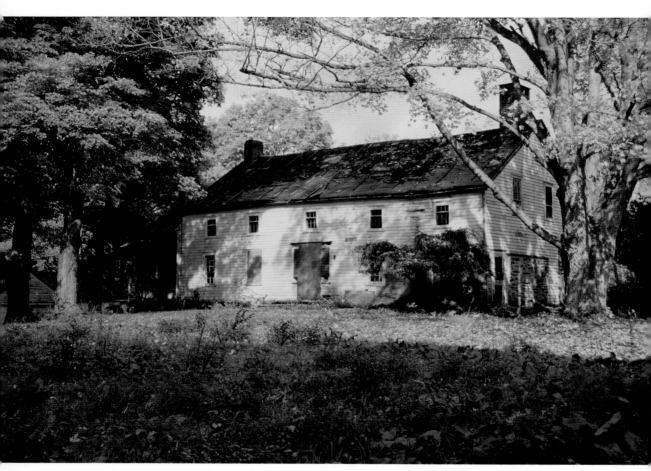

James Baird House, near Freedom Plains

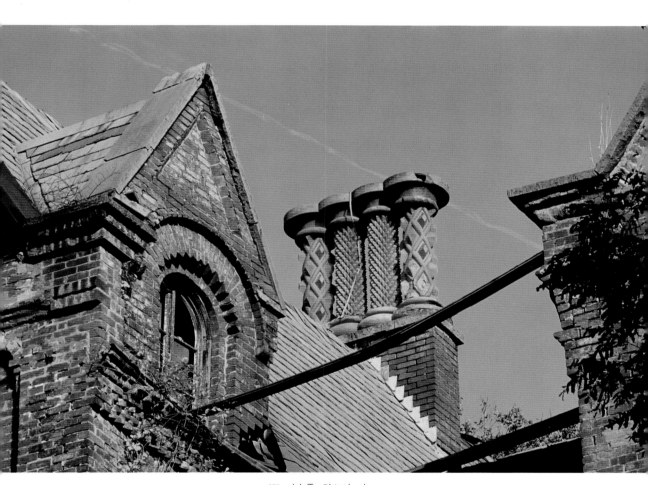

Wyndclyffe, Rhinebeck

Bannerman's Island Arsenal, Pollepel Island

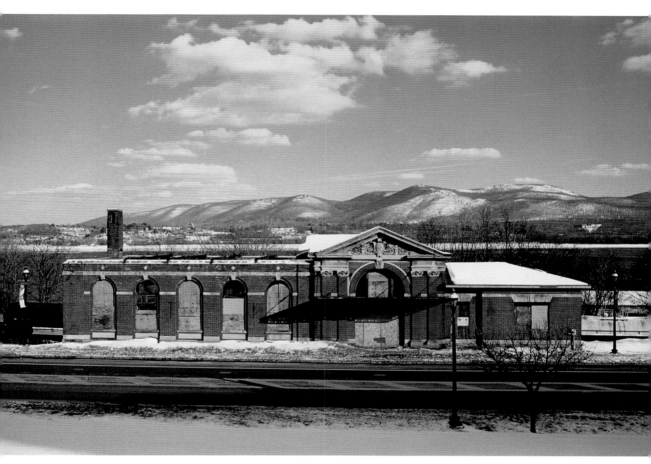

West Shore Railroad Station, Newburgh

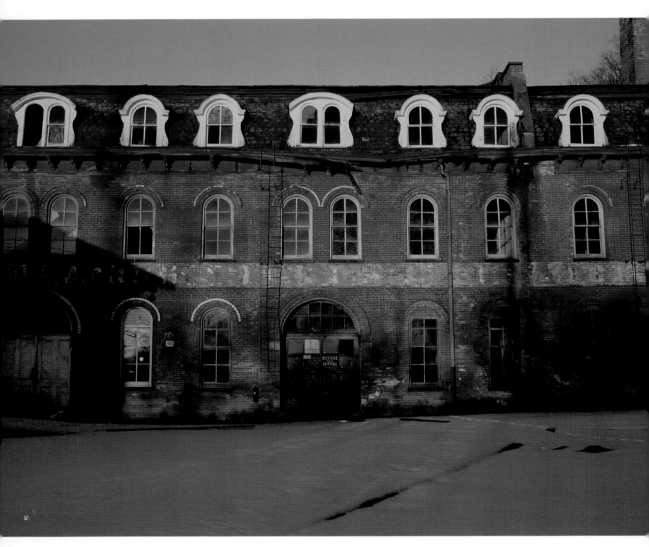

Brandreth Pill Factory, Ossining

Briarcliff Lodge, Briarcliff Manor

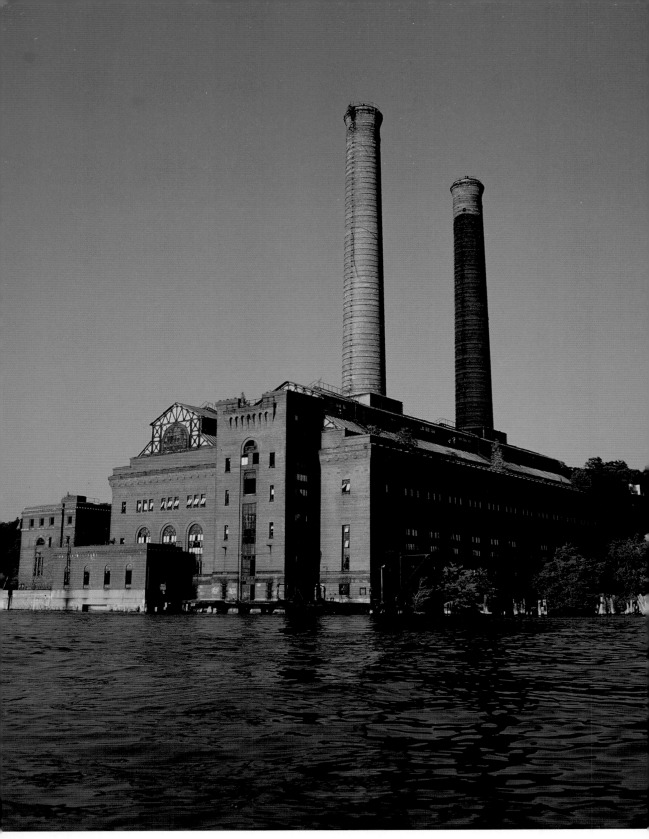

Yonkers Power Station, Yonkers

ORANGE COUNTY

ORANGE, CREATED IN 1683, is one of the twelve original counties of New York. It is named for William of Orange (1650–1702), the Dutch stadtholder who became King William III of England with the deposition of James II, his uncle and father-in-law, during the Glorious Revolution in 1689. Originally the county occupied the entire western shoreline of the Hudson River between Ulster County and the New Jersey border. But the mountains of the Hudson Highlands acted as a barrier between the southern and northern parts of this terrain, and in 1798 the southern part of the county broke off to form Rockland County.

European settlement of the Orange County riverfront came slowly. Though a member of Hudson's crew observed that it seemed "a very pleasant place to build a town on," the principal settlement on this stretch of the river, Newburgh, did not appear until the first years of the eighteenth century, when it became one of several Hudson River settlements populated by Palatine refugees who came from Germany by way of England.

By the middle 1700s, textile and paper mills developed on the Moodna and Quassaic creeks south of Newburgh, while iron mining took hold along the Popolopen Creek and further inland, especially near the present-day towns of Arden and Tuxedo. The ruins of several old iron furnaces can be found throughout the Highlands of southern Orange County.

Orange County figured prominently in the Revolutionary War. In the early part of the war the Americans built a series of fortification structures, including Forts Montgomery, Clinton, and Putnam, aimed at preventing the passage of British warships up the river. The British occupation of New York City meanwhile made Newburgh a crucial link in the chain of communication between New England and the colonies to the

Coldenham, Coldenham

Cadwallader Colden, Jr., built this stone house in 1767 on the three-thousand-acre estate outside Newburgh established by his father, Cadwallader Colden, Sr. The elder Colden was a leading political figure in colonial New York and served as the colony's lieutenant governor from 1761 to his death in 1776. After this house was abandoned, wooden interior paneling was salvaged and installed in the Metropolitan Museum of Art in New York City.

Southfields Furnace, Southfields

Abandoned iron furnaces in Orange and Rockland counties were romanticized by writers in the nineteenth century. Peter Townsend established the Southfields Furnace by the summer of 1806. Townsend, whose family also owned the nearby Sterling Ironworks, produced stamped iron and blistered steel, and, like many nearby foundries, his ironworks also made goods for government contracts. The Southfields Furnace shut down in 1887, two years after the death of Peter Townsend III. Its ruins remain standing a century later. The charging bridge that gave access to the top of the furnace from the adjacent hillside survives as well. The 490-acre site is owned by the Scenic Hudson Land Trust and is managed by the Palisades Interstate Park Commission.

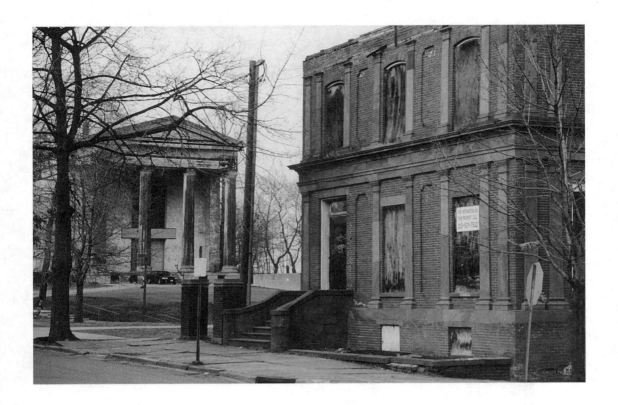

The City Club (William Culbert House), Newburgh

These ruins are two of the most architecturally significant buildings in the Hudson Valley: the Dutch Reformed Church (*left*, see pages 186–192) and the City Club (*right*). Constructed in the mid-1850s as a residence for Dr. William Culbert, the City Club represents a collaborative effort between A. J. Downing and Calvert Vaux, making this one of very few buildings even partly attributable to Downing. Vaux included the house as "Design No. 22" in his book *Villas and Cottages*. Its brick and brownstone elevations bear a notable resemblance to Vaux's Drip Rock Arch (c. 1860) in Central Park. In 1904 the Culbert house became the headquarters of the Newburgh City Club, an association of the city's leading businessmen and politicians. Additions made soon thereafter carefully matched the building's existing facades. With Newburgh's decline the City Club disbanded by the early 1970s. The building was subsequently saved from demolition only to be gutted by fire in 1981, and has stood in ruin ever since.

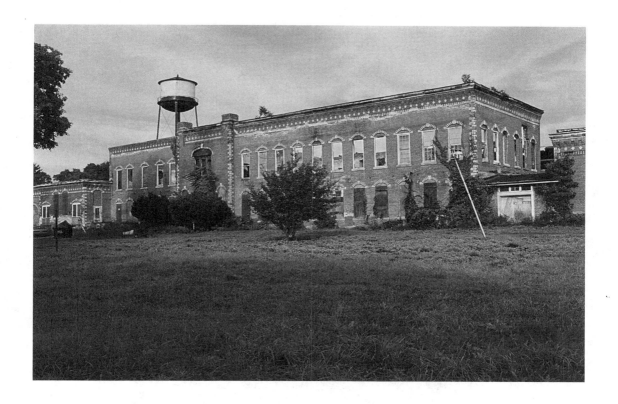

Borden Condensed Milk Company, Walden

In 1856, Gail Borden (1801–1874) patented a process for condensing milk, which involved boiling away water content in airtight vacuum pans to make a concentrated product resistant to spoiling. One year later, he formed the New York Condensed Milk Company, later renamed Borden Condensed Milk Company. Borden's son, John Gail Borden (1844–1892), established a condensery in 1881 near his family's estate at Walden, on the Orange-Ulster county border. Within a few decades Borden condenseries appeared in farm towns throughout the Hudson Valley. Today nearly all of them have vanished. But the Walden condensery survives in ruins; the office has been converted to private apartment units.

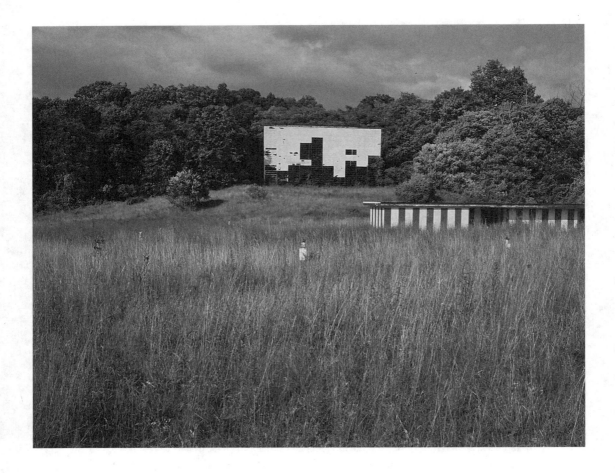

Middlehope Drive-in Theater, Middlehope

The ruins of the Middlehope Drive-In Theater stand on Route 9W north of Newburgh. Richard Hollingshead, Jr., opened the first drive-in movie theater near Camden, New Jersey, in 1933. After World War II the number of "drive-ins" grew rapidly, until by the early 1960s some 4,000 operated across the United States. Typically, drive-in theaters required small buildings to house a projector and concession stand, and installed elaborate neon signs by their main entrances. As the American landscape grew increasingly shaped by the automobile, other businesses adapted themselves accordingly, bringing the advent of drive-in and drive-thru restaurants, banks, and liquor stores.

The Middlehope Drive-In opened on Memorial Day, 1950. Though drive-ins quickly established themselves as icons of mid-century American popular culture, a variety of factors, including a reliance on fair weather and the arrival of home video technology, put most out of business by the end of the century. Closed in October 1987, the Middlehope Drive-In Theater is one of several whose ruins remain along the Hudson today. Its red-and-white striped concessions building stands before a deteriorating silver screen, surrounded by rusting metal stanchions that once held small speakers at car-window height.

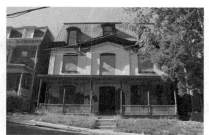

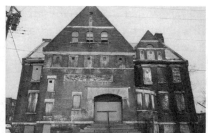

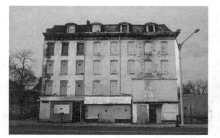

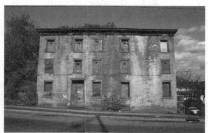

Newburgh's East End

More than three decades after urban renewal erased an appreciable part of eastern Newburgh, abandoned homes and storefronts are still appallingly profuse here. Named one of *Look* magazine's "All-America Cities" in 1952, Newburgh took a dramatic turn for the worse just a decade later. Lander Street, Liberty Street, Grand Street, Broadway: these were some of the finest addresses on the Hudson. Today they present a ghastly picture of poverty and decay. There are ruined row houses and mansions, schools, churches, and commercial buildings. The high quality of Newburgh's buildings is evident despite their poor condition, which in the 1980s and '90s led to some efforts toward gentrification. But at the beginning of the twenty-first century, as other river towns have shown signs of revival, Newburgh's East End remains a menagerie of rotting landmarks.

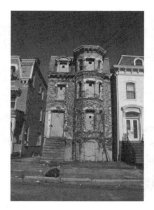

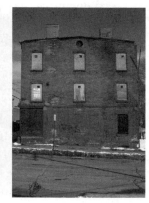

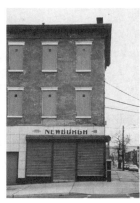

south. For the last years of the war, General Washington made his headquarters at Newburgh, while his army encamped at nearby New Windsor until peace was declared in 1783. Opened in 1802, the US Military Academy at West Point in southern Orange County was born out of the legacy of this region's role in the War for Independence.

In the nineteenth century Newburgh developed into one of the most prosperous towns on the river. The presence of nationally known figures such as the landscape designer Andrew Jackson Downing and his protégés, the architects Calvert Vaux and Frederick Withers, put Newburgh on the map by the early 1850s. Vaux and Withers graced the area with a number of fine works, including the Newburgh home of Mary Powell, namesake of the most famous steamboat ever to ply the river, and Idlewild, the home of writer Nathaniel Parker Willis, at Cornwall-on-Hudson.

Patterns of transportation and commerce changed in the twentieth century, posing great challenges to old commercial centers both on the river and inland. Downtown areas of Newburgh and Middletown suffered visibly during this period. The county's proximity to New York City spurred the development of upper-class suburbs by the beginning of the twentieth century, most notably with the appearance of Tuxedo Park. But it was the opening of the Tappan Zee Bridge and the New York State Thruway in the 1950s that brought large-scale suburban development that has significantly changed the character of this county's landscape. Today the Thruway continues to serve a wide range of Orange County institutions, including Woodbury Commons, one of the largest outlet shopping centers in the country; Stewart Airport, the area's main airfield; and the Storm King Art Center, an open-air museum of modern sculpture created in 1960.

Between the years 2000 and 2004, Orange County's population increased by 8.5 percent, making it the fastest-growing county in New York State at the beginning of the twenty-first century. Much of the mountainous scenery in the southern part of the county is part of Harriman State Park, and is thus protected from development. But elsewhere, vast swaths of agricultural land are being subdivided for residential development, as the county's population approaches a figure four times greater than what it was in 1900. Yet this growth has done little for traditional population centers, especially Newburgh, where signs of poverty and urban decay remain jarring, and where some of the county's greatest landmarks have stood abandoned for decades.

Dutch Reformed Church, Newburgh

Looking down from its perch over the river, the great columns of the old temple stand faded and forlorn, its portico worn and weathered. Yet its

towering pediment remains an imposing sight. The water below could be the Tiber or the Aegean, but of course it is the Hudson, the setting not Rome nor Athens but Newburgh, New York. The columns are those of this city's magnificent Alexander Jackson Davis–designed Dutch Reformed church, built in 1835, abandoned in the early 1970s.

The origins of the Dutch Reformed Church in the Hudson Valley go back to the arrival of the first European settlers from the Netherlands in 1614, making it perhaps the most visible vestige of the region's Dutch roots today.[1] Laymen conducted services in a New Amsterdam mill loft until an ordained minister arrived from Holland in 1628. Five years later the New Amsterdam congregation erected a purpose-built church, and from that time forward the ecclesiastical buildings of the Dutch Reformed Church were almost invariably the oldest and most impressive in nearly every town and village on the Hudson all the way up to Albany.

One river town that did not fit this pattern, however, was Newburgh, where the number of Dutch families remained scant into the nineteenth century. The first significant settlement here came in the early 1700s, when Queen Anne arranged for the relocation of several thousand Palatine refugees to the Hudson Valley from London, where they had assembled in large numbers after fleeing the war-torn Palatinate. By 1709 Newburgh was one of several important Palatine settlements on the Hudson River. In the 1730s an increasing number of English

Davis situated the massive, tetrastyle portico of Newburgh's Dutch Reformed Church facing south, into the Hudson Highlands.

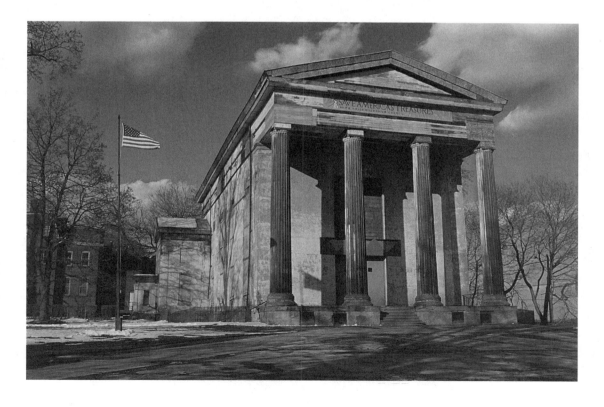

and Scottish families arrived to join them, and these newcomers quickly assumed a leading role in the town's development. By 1743 they named the town Newburgh.

In the middle 1700s Newburgh became one of the principal trading centers on the Hudson, with a ferry connection to Fishkill Landing (now Beacon) across the river and a number of mills and factories built on the Quassaic Creek. During the Revolutionary War the British occupation of New York City made the Newburgh ferry a crucial link between the New England patriots and those in the rest of the colonies. George Washington established his military headquarters here in 1782, and here he remained with his troops for the duration of the war, which ended the following August. In 1859 Washington's Newburgh headquarters became the first state historic site in the country.

Not until the 1830s did enough descendants of the Hudson River Dutch finally settle at Newburgh to warrant the construction of a Reformed church. Until then the nearest Dutch Reformed church stood across the river at Fishkill. In October of 1834, the church sent the Reverend William Cruickshank up from New York City to determine whether or not the organization of a Reformed congregation at Newburgh was needed. Cruickshank reported his findings to New York, and the decision was made to move forward with the establishment of a new church. The site chosen was at Third and Grand streets, by the edge of a plateau where the land began its steep descent to the river below. The congregation formally organized in February of 1835, after which time planning and fund-raising for the new building began in earnest. By October the church had raised enough money to begin construction. The congregation dedicated its new building just over two years later, on December 7, 1837.

When finished, Newburgh's Dutch Reformed Church was one of the largest and most impressive religious buildings in the Hudson Valley. To design the church the congregation hired one America's foremost architects, Alexander Jackson Davis (1803–1892), whose maternal grandfather had lived in New Windsor, less than three miles to the south. The new building measured fifty feet in height, fifty feet in width, and one hundred feet in length, with stuccoed walls of fieldstone more than three feet thick at the basement level. Monumental in scale and clearly visible for miles down the river, it dominated the city's skyline.

Alexander Jackson Davis began his career at New York City in the 1820s. In 1829 he formed a partnership with a well-known New York architect named Ithiel Town (1784–1844), and by the early 1830s the firm had gained a reputation for being among the most capable executors of the Greek Revival style in America—a movement whose popularity Town and Davis did much to promote. Their commissions included some of the most important Greek Revival buildings in the country, including the Federal Customs House (1833–1842) at New York City and the Indi-

ana State Capitol at Indianapolis (1831–1835). After parting ways with Town in 1835, Davis partnered briefly with an architect called Russell Warren (1783–1860) before setting off on his own the following year. At around the same time Davis's work underwent a notable and permanent shift away from the Greek Revival, and from the mid-1830s onward he became recognized as a pioneering figure in the Picturesque movement in American architecture, executing many of his finest works on the banks of the Hudson River.

It was in the midst of this period of transition that Davis, then engaged in his brief partnership with Russell Warren, gained the commission for Newburgh's Dutch Reformed Church. Davis designed the church in the Greek Revival style, which he had been so instrumental in establishing as the dominant trend in the architecture of Jacksonian America. "Owing to the descent of the ground . . . the basement line or pavement of the portico is nearly on a level with the top of the buildings between it and the river, so that the full effect of its architecture may be seen while passing the town," wrote Davis of the church, which he intended to "henceforth serve as a conspicuous and characteristic landmark, indicative of the refined taste, discrimination, and sense of classical beauty of at least a few of the inhabitants of Newburgh."[2]

He gave the building a bold portico on its main facade, supported by four massive Ionic columns of wood facing south from the hilltop toward what the Dutch had called the *wey gat*—the north gate of the Hudson River Highlands. Within the portico, a monumental main entrance stood thirty feet in height, its bold, studded doors starkly adhering to classical precedent. Inside, a handsomely detailed gallery overlooked the sanctuary and altar on three sides. A vaulted, coffered ceiling sheltered the vast space, which was lit by eight sets of thirty-foot-high windows,

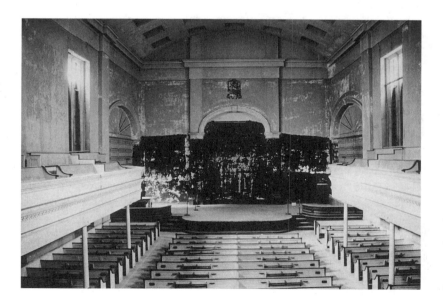

Newburgh Reformed church, view north in the sanctuary, January, 2002. Paint is peeling but this space remains remarkably intact after four decades of abandonment.

four on each side. Though Davis cited a number of ancient precedents as his basis for the church's design, the building's exterior elevations appear to have been heavily based on an earlier Davis project, the Église du Saint Esprit (French Protestant Church, 1831–1834) at Church and Franklin streets in New York City.

Like the Church of Saint Esprit, Davis's Newburgh Reformed church originally featured a great ribbed dome situated centrally over the sanctuary. But the dome placed too great a strain on the building's roof structure and was removed in the early 1840s. The only other significant alterations to Davis's original design took place from 1867 to 1868, with the extension of the nave twenty feet to the north and the completion of the east and west transepts, under the supervision of Newburgh architect George Harney (1840–1924). Harney styled the new additions with careful sensitivity toward Davis's original design. Thereafter the building remained virtually unchanged, save for the introduction of electric lighting in 1906 and the reconstruction of the portico floor using concrete in 1910. Apart from the removal of its dome and its ruined condition, the church appears today much as Davis designed it. Other Davis churches from this period (including the Église du Saint Esprit) have disappeared or been extensively altered over the years, leaving the Newburgh Reformed church, in the words of the New York State Historic Preservation Office, "the last extant Greek Revival style church directly attributable to Davis that retains design integrity consistent with the architect's original intentions."[3]

Newburgh continued to prosper throughout the nineteenth and into the twentieth centuries, and the Dutch Reformed church remained one of its greatest monuments. Davis went on to gain a number of residential commissions here,[4] and worked often in concert with the landscape designer Andrew Jackson Downing (1815–1852), a native son of Newburgh whose increasing prominence made him arguably the most influential figure in American landscape and architectural design in the 1840s. After Downing's untimely death in 1852, two of his protégées, Calvert Vaux (1824–1895) and Frederick Withers (1828–1901), maintained a practice at Newburgh for a number of years before moving to New York City. And as the achievements of Davis, Downing, Vaux, and Withers contributed to the town's reputation as a place of culture, the growth of Newburgh's shipyards and other industries led to its incorporation as a city in 1865, and ultimately made this one of the largest communities on the Hudson between Albany and New York.

After the Second World War, urban centers up and down the Hudson and across the country entered a sharp decline. Newburgh suffered more than any of the river towns during this period. Though a small city, it was just large enough to experience big-city crime: once called the "Hub of the Hudson," Newburgh soon earned a reputation for being the most dangerous city in the Hudson Valley. With the river's decreasing relevance to the lives of those who lived around it, businesses deserted

Newburgh's waterfront commercial district. In the urban renewal campaigns of the 1960s and '70s, block upon block of abandoned storefronts and row houses fell to make way for redevelopment that never came. The list of casualties included landmarks such as the Hotel Palatine, which stood adjacent to the Reformed church on Grand Street and which had been one of Newburgh's leading hotels before it closed in 1960, and Schoonmaker's, the city's principal downtown department store from 1863 until it left for a suburban shopping center in 1961.

In 1967, after 130 years, Newburgh's Dutch Reformed congregation joined the masses and fled to the suburbs, leaving its old building empty. Three years later the city's Office of Urban Development purchased the abandoned church, and like hundreds of other empty buildings it was slated for demolition. But a group of local preservationists pointed to the building's historic importance and sound condition as reasons it should be spared. In 1970 they got the church listed on the National Register of Historic Places and succeeded in convincing the city to table its demolition plans long enough for a buyer to come along. For a short time afterward the building housed services of a small Baptist congregation.

A buyer finally emerged in 1977 in the form of a group called the Hudson Valley Freedom Theater, which proposed reusing the building as a performing arts center. But as years went by and the empty church continued to deteriorate, the city sought to repossess the building, which, after a long court battle, it did in 1984. The church continued to waste away throughout the 1980s. Not until 1992 did a new movement get under way to promote its restoration, under the banner of the Newburgh Center for the Arts, which sought public funding to rehabilitate the building, again as a performing arts center. The following year the city government established a restoration fund for the church. In 2001 a group called the Dutch Reformed Church Restoration Committee succeeded the Newburgh Center for the Arts in the drive to save the building, and in November of that year the U.S. Department of the Interior designated it a National Historic Landmark.

When built, Newburgh's Dutch Reformed Church stood as an embodiment of what was then among the most progressive and prosperous regions in America, a proud expression of the high aspirations of the community for which it was built. Today it is emblematic of the problems that have faced this and other Hudson River communities over the course of the last century, and of the ways in which ill-planned responses to those problems led many towns to turn their backs on their own history and culture. Its Ionic capitals removed for safekeeping, the old portico stands tattered but still proud. Despite recent efforts to save the building it remains empty and imperiled. In 2005, the World Monuments Fund included the church on its World Monuments Watch, a biennial list of one hundred of the world's most endangered historic sites. (Ironically the same list included the first-century B.C. Temple of Portunus in Rome, a building that may have inspired Davis's design for

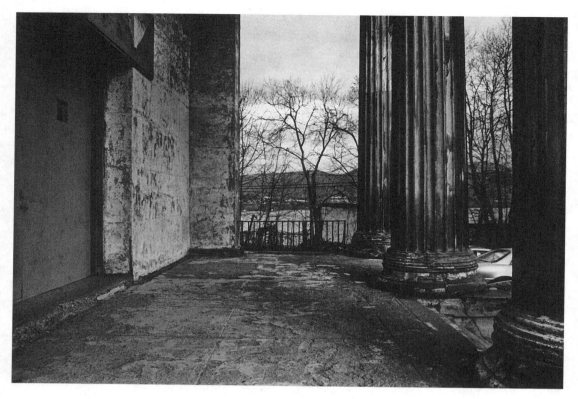

View east, toward the Hudson River, from the great portico.

the Newburgh church.) In a troubled city that has already lost an appalling number of its finest buildings, it remains unclear whether the former Dutch Reformed church will live to see its own salvation or that of the city around it.

West Shore Railroad Station, Newburgh

Once Newburgh could boast one of the busiest landings on the Hudson River between New York City and Albany. Running parallel to the river, Water Street in many ways defined the heart of the city's business district. But with the decline of America's urban centers and the displaced role of the river in the region's industrial and transportation infrastructures, Newburgh's commercial core began to disperse in the 1950s. By the following decade Water Street was a ghost town, and under the banner of urban renewal the city razed nearly all of its waterfront commercial district. Today only one building, the former West Shore Railroad Station, stands as a reminder of Water Street's heyday. It has been abandoned for more than four decades.

Newburgh grew quickly in the nineteenth century to become one of the largest towns on the Hudson below Albany. But its position on the river's western shore left it bypassed by the Hudson River Railroad,

which followed the Hudson's eastern shoreline up from Manhattan. Even before the railroad's completion in 1851, the river towns of the east bank experienced a faster rate of development than those of the west because of their greater accessibility to New York City. The railroad intensified that pattern. Largely for this reason, the vast majority of great river estates appeared on the Hudson's east bank, while the west retained the more agricultural character that had been prevalent along both shores in the previous century.

Plans for a railroad to line the river's western shore did not come about until 1867, with the formation of the Hudson River West Shore Railroad Company. But this initial attempt failed, and fifteen more years passed before a successor company finally raised enough capital to begin construction. By this time the Hudson River Railroad on the east bank had merged with the New York Central, creating one continuous line from New York City through Albany to Buffalo. The backers of the rival west shore route extended their sights as well: on February 18, 1880, the new company was incorporated as the New York West Shore and Buffalo Railway.[5]

The West Shore Railroad emerged from one of the great robber-baron power struggles of the nineteenth century. Much of the money to build it came from the Pennsylvania Railroad, which saw the West Shore's construction as an opportunity to drive Vanderbilt's New York Central—its archrival—out of business. The West Shore and Buffalo Railway was

Newburgh's West Shore Station, with Mount Beacon and Hudson River in background.

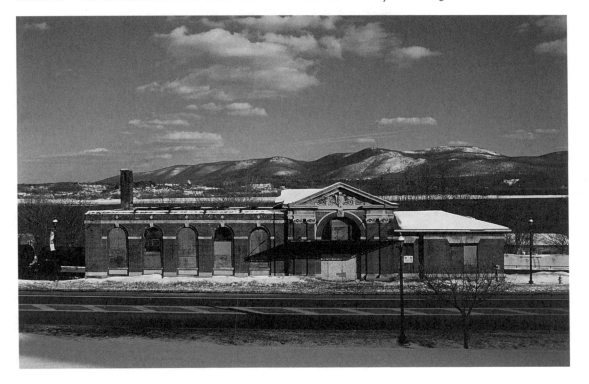

redundant by design: the idea was to use a parallel route to ruthlessly underprice the competition. Both companies would incur losses; the Pennsylvania's bet was that it could afford to lose more than the Central. If all went according to plan, this would bring the Central to its knees, allowing the Pennsylvania to gain control of its defunct competitor and making it perhaps the most powerful railroad in the country.

Work on the West Shore began in 1882, at Weehawken, New Jersey, where a ferry connection provided service to and from Manhattan. From there the railroad progressed north, and by June of the following year service had reached Newburgh. No sooner was the railroad completed to Buffalo in 1884 than the company found itself in bankruptcy; the east shore line, with its direct connection to New York City, simply proved a more viable contender. But the war between the Central and the Pennsylvania was not over yet. The Vanderbilt interests in the meantime had reciprocated, and with the backing of Andrew Carnegie had begun construction of their own line to parallel the Pennsylvania between Philadelphia and Pittsburgh. The feud eventually became so heated that J. P. Morgan summoned the dueling parties to a meeting aboard his yacht *Corsair*, in the neutral waters of the Long Island Sound. In what became known as the Corsair Agreement, the railroads called a cease-fire and withdrew to their own territories. At the end of 1885 the New York Central secured a 475-year lease on the NYWS&B, which it reorganized as the West Shore Railroad Company. The Central would act as a parent company to the new railroad, which from then on became known simply as the "West Shore."

From the beginning, Newburgh served as one of the busiest stations on the line. The city continued to grow through the turn of the century, and by the early 1900s an improved passenger station was planned. The station's design can be attributed to the firm of Warren and Wetmore, which in 1904 had been hired with Charles Reed and Allen Stem to design a new building for the New York Central's Manhattan terminus, known to the world as Grand Central Terminal (1903–1913). That Whitney Warren (1864–1943) was a cousin of New York Central chairman William K. Vanderbilt almost certainly helped his firm to gain the commission for both projects. Nonetheless, Warren and Wetmore ran a very talented partnership that had already produced the great New York Yacht Club in 1899. Their body of work later grew to include such landmarks as New York's Chelsea Piers (1910), the Ritz Carlton (1910) and Biltmore (1913) hotels among many others in New York, as well as the Mayflower Hotel (1925) in Washington, D.C.

Opened in 1909, the new station at Newburgh was part of a series of buildings designed by Warren and Wetmore for the New York Central. In addition to Grand Central these included the monumental Michigan Central Station at Detroit (1913), designed in collaboration with Reed and Stem, and a number of stations all up and down the Hudson River, including those at Yonkers (1911), Ossining (c. 1910), Beacon (c. 1918),

Poughkeepsie (1918), Hyde Park (1914), and Rhinecliff (1914). All these buildings in their own way bore a resemblance to their larger sibling in midtown Manhattan.

The Newburgh station's design followed in the tradition of the Beaux Arts movement, which took root in America following the Columbian Exposition at Chicago in 1893, and whose details were so well articulated by Warren and Wetmore (Warren himself had studied at the École des Beaux-Arts in Paris). Facing Water Street, the station's main facade was composed of six tall, arched windows, with a pedimented main entrance set at the south end. Within the pediment an elaborate stone cartouche bore the intertwined letters "NYC" (in deference to the West Shore's parent company). Its walls were wrought of red brick laid in Flemish bond, with a tile roof above—all signature details of Warren and Wetmore's Hudson River stations. Inside, passengers found a high-ceilinged waiting room, from which a central staircase descended to the tracks below.

Beaux Arts pediment detail. The cartouche with intertwined "NYC" lettering acknowledges the New York Central Railroad, which acted as parent company to the West Shore.

The waiting room's large arched windows faced out onto Water Street.

Especially in its later years, the station served mostly commuter trains running to and from Weehawken. Though the New York Central routed most of its long-distance trains along the river's eastern shore, the West Shore Railroad did offer through service to Chicago on its flagship Continental Limited until World War I. Other trains to call at Newburgh included the Buffalonian, which linked Weehawken and Buffalo, and the Storm King Limited, which ran up the river to Albany. Before the 1920s, much of the West Shore's business came from passengers bound for the resorts of the eastern Catskills, served by trains such as the Rip Van Winkle Flyer.

The Second World War brought record passenger manifests to rail-

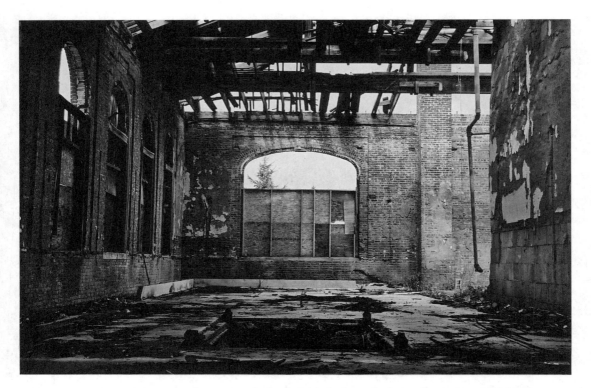

The waiting room as it appeared in the spring of 2002. A central stair led down to platforms below.

roads across the country, and stations such as Newburgh's became embarkation points for soldiers en route to battlefields in Europe and the Pacific. But after the war, the West Shore and other American railroads entered a tailspin that in a matter of twenty years led many to their demise. By this time, the West Shore had begun to serve an increasing percentage of freight trains, and passenger traffic shifted ever more to the east shore lines running out of Grand Central Terminal. In the early 1950s the New York Central began to seek approval from the Interstate Commerce Commission to discontinue passenger service on a number of its less profitable routes. In September 1956 the ICC authorized the railroad to eliminate ten of its daily scheduled trains on the West Shore. But traffic continued to fall off, and in the late 1950s the railroad cited the West Shore for losses in excess of $1.3 million annually.[6]

On Thursday, June 22, 1958, a short article in the *Newburgh News* brought the announcement that by now came as a surprise to no one: "The last passenger train out of Newburgh on the New York Central's West Shore Line will leave . . . at 8 p.m. Sunday. The passenger station on S. Water St. will close at midnight that night."[7] The building has sat empty ever since.[8]

Within a few years Newburgh's old West Shore Station was joined in abandonment by just about every building in the waterfront business district. What was once perhaps the most vibrant commercial area on the middle Hudson now stood deserted. The solution from city hall: tear it all down and start from scratch. With federal urban renewal money the

Ornate plasterwork carried
Beaux Arts detail throughout
the building's interior. Today
only fragments remain.

city government implemented the scheme in the late 1960s and early 1970s. Hundreds of buildings, entire city blocks, disappeared in a reign of physical destruction comparable to that seen in many European cities during World War II. Proposals came for new civic centers and shopping malls to replace them, but few ever materialized. Some empty lots became sites for public housing projects, but most of were simply leveled, graded, and planted with grass.

Today only vast sweeping lawns remain where much of downtown Newburgh once stood. To make the trip along Rev. Dr. Martin Luther King Jr. Boulevard (as Water Street has since been renamed), one could scarcely guess that this had been one of the busiest urban areas in the Hudson Valley. Where handsome Victorian storefronts with restaurants, shops, and apartments once lined this thoroughfare, today only the old West Shore station remains.

Somehow the old railroad station managed to escape the clutches of Newburgh's urban renewal bulldozers. After it closed, the building passed into the hands of a local real estate agent, who was unable to sell it for the rather measly asking price of $11,000 until 1980, when a new owner purchased it for redevelopment as a restaurant.[9] Citing a lack of parking as his main obstacle, the plan never took flight, and the station continued to deteriorate. Over years vandals and thieves made off with its interior fittings. Even its tile roof disappeared, leaving the waiting room exposed to the elements. The building survived a minor fire in 1992 to be purchased by another developer seven years later with new plans to open a restaurant there. In 2002 the new owner began clearing debris and installing a new roof, and for a while it seemed hopeful that a new future might await this hapless building after four decades of abandonment. But eventually work ground to a halt, and another proposal fell by the wayside.

The end of passenger service on the West Shore Railroad left doz-

ens of historic train stations abandoned. While many eventually disappeared, others found new uses and have survived. The station at West Haverstraw now houses a law office; those at Highland Falls (in Orange County) and at Highland (in Ulster) have been converted for residential use. Catskill's station now serves as a tire shop, Ravena's as the village garage.

But the old station at Newburgh still awaits new life. The tracks of the old West Shore remain in use for long freight trains, which rumble past the empty station about two dozen times each day. Nearly all of the station's Warren and Wetmore–designed counterparts on the east shore remain standing and in use for their intended purpose. While many of these have now been listed on the National Register of Historic Places, the great station at Newburgh continues to waste away without this recognition. Once an essential part of the community around it, today it stands a solitary reminder of a vanished cityscape.

III

THE MARITIME HUDSON

MARITIME RUINS

AT FIRST GLANCE it appears that nothing remains of the Hudson's age of sail and steam, that the boats have all gone for scrap. Here, where steam navigation was born in 1807, vestiges of the river's maritime past seem to have vanished entirely. Of hundreds of sloops and steamers once fixtures on the river above New York Harbor, not one authentic example has been preserved. But a closer look finds that ruins of the Hudson Valley's maritime heritage are still here to be seen. Every twelve hours, the falling tide reveals the rotting hulks of tugs, barges, ferries, day boats, and night boats, once an indispensable part of life on the river, now wasting quietly away on muddy shoals.[1]

It is important for readers to note that some of these hulks are officially designated archeological sites, making it illegal to remove artifacts from them. It must also be noted that their fragile condition has made these ruins vulnerable to damage from vandals and even from well-intentioned visitors. Those who seek them out should approach these wrecks with care to avoid hastening their deterioration.

Sloops and Schooners

For fully a century after the coming of the steamboat, merchant sailing vessels remained a common sight on the river. From the time of the first European settlement, one type of craft demonstrated a unique dexterity in maneuvering through the tight conditions of the river and meeting the needs of its merchants. This was the sloop, a traditional Dutch sailing craft easily identifiable for its single mast and mainsail. Rarely more than one hundred feet in length, sloops were just small enough to make their way through the Highlands under sail. While small schooners later

became increasingly common on the river, the sloop remained a defini-
tive Hudson River icon throughout the nineteenth century.

Today even visible hulks of these sloops are exceedingly rare. Two can
be found in the shadow of the Bear Mountain Bridge, near the mouth
of the Popolopen Creek at Fort Montgomery. Their identities are uncer-
tain; one is believed to have been called the *A. S. Parker*.[2] Both probably
date from the first half of the nineteenth century. Later in their careers
they were rerigged as two-masted schooners. Such was the fate of many
sloops that survived into the late 1800s, as a schooner's smaller sails
required fewer hands to be raised or lowered.

Both sloops and schooners managed to hold their own on the river
into the first years of the twentieth century. The *Parker* and its anony-
mous companion may have been among the last sailing vessels in com-
mercial operation on the Hudson. Photographs show them abandoned
at Fort Montgomery by 1914.[3] Today only their skeletal remains can still
be seen at low tide.

Workhorses

The most visible of the Hudson River's maritime ruins can be found
in the form of anonymous barges and scows. Today few remain in any
recognizable form, and those that do are disappearing fast. Most com-
mon among them is a type known as the covered railroad barge. Essen-
tially these served as floating boxcars, developed from simple, wood-
hulled deck scows over which stood a wooden shed with a distinctive
rounded roof.

As their name implies, covered railroad barges were built primarily
for the railroads that served New York Harbor, such as the New York
Central, and they were operated in fleets of a hundred or more. Their
owners usually assigned them numbers, not names. Somewhat larger
than canal barges, they were typically about one hundred feet in length
by thirty feet in beam, with flat bottoms and squared-off bows and sterns.
Initially of wood construction, after the 1930s many were built of steel.
The last examples appeared in the late 1950s.

Both deck scows and covered barges came fitted with small quarters
for a barge captain, who lived on board, sometimes with his family. Typi-
cally every major ice company, quarry, brickyard, and cement plant had
its own fleet of barges. From the company docks they would be picked
up by passing flotilla tows and lashed together by the dozen like freight
cars in a train. While a large towboat hauled the lumbering tow slowly
down the river, a smaller tug ran back and forth, collecting loaded barges
along the way.

By the 1960s, the decline of river industries and the advent of larger,
bulk-carrying barges made these craft obsolete. Though many sat rot-
ting away on the docks of abandoned factories, some found new use

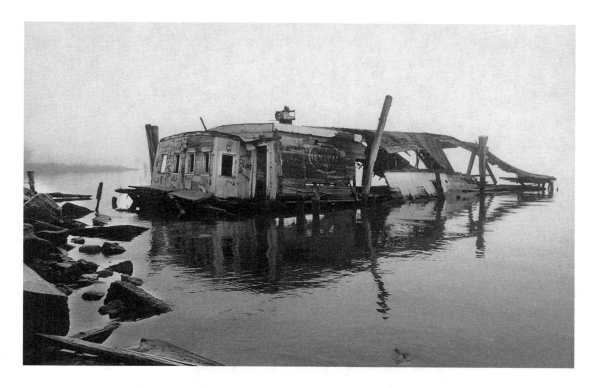

as breakwaters and clubhouses for marinas. In this capacity the barges remained a familiar sight on the river for decades after they had outlived their intended usefulness. But by the end of the twentieth century, many had fallen into disrepair and were destroyed. Once ubiquitous on the river, today only a handful of these vessels remain.

Perhaps the most dramatic hulk on the Hudson is that of another type of vessel, the schooner barge *Armistead*, which since about 1960 has served as a breakwater for a marina at Cornwall-on-Hudson, near Newburgh. Usually about three hundred feet in length, schooner barges were oceangoing vessels fitted with masts and sails to aid in maneuverability. Built to haul bulk cargoes, they can aptly be seen as predecessors to the large bulk-carrying barges common on the river today.

Built by the Maryland Shipbuilding Company at Baltimore, the *Armistead* entered service in 1919. For many years she worked out of New York and Philadelphia. Once common in harbors throughout North America, the schooner barges had all but vanished by the late 1950s. Their wood hulls offered little value to scrap merchants, and many were simply abandoned in harbor backwaters. Today the *Armistead* remains among the few intact schooner barges in existence, its stem still proudly upright, one of the most evocative maritime ruins on the river.

Farther upriver, at Coxsackie, lie the bones of another Hudson River workhorse, the freight steamer *Storm King*. The hulk struck a chord with Jack Lewis, a painter of river scenes who came across it in the early 1960s.

This former New York Central Railroad barge was used as a clubhouse for a boat club at Peekskill. It was demolished in January 2004.

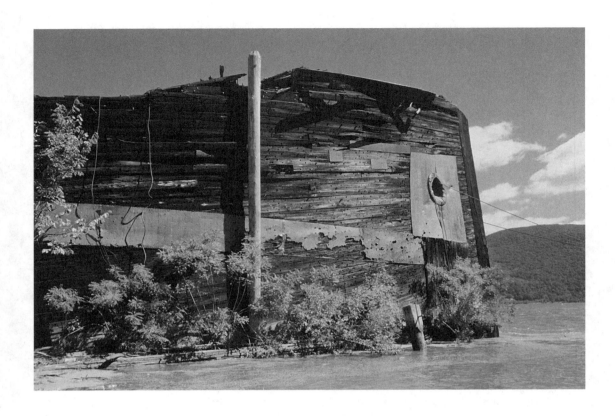

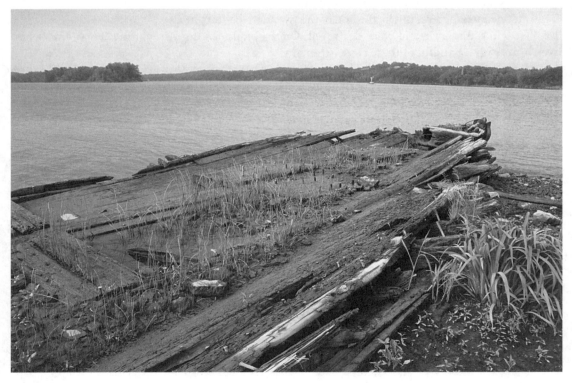

"This one-time river queen lies rotting on a river bank at Coxsackie," he wrote. "The bowsprit is the key measure. Spikes, which one time held a fine figurehead, still reach out like hairs from a balding head."[4]

The truth was less glamorous. Despite its grandiose name, the *Storm King* worked as a humble freight boat. Built at Wilmington, Delaware, it entered service in 1911 for the Catskill Evening Line. This company, once owned by the same family that ran the Catskill Mountain House, provided freight and passenger service between New York and Catskill, 115 miles upriver. By the 1910s, as the resorts of the eastern Catskills began to fade in popularity, the line's passenger traffic fell off dramatically.

After 1918 the company offered freight service only, provided by three boats—the *Storm King* and two others—which primarily served the orchards along the river's western shore. But by 1932 the cumulative effects of the Great Depression and increased competition from trucking drove the line out of business, and the *Storm King* was laid up at Coxsackie. The bottom of its old wooden hull can still be found there today, fully visible at low tide by the north end of a riverfront park.

Getting Across

The remains of the double-ended ferryboat *Garrison* lie at the village for which the boat was named. Ferries had been a fact of life on the river long before the arrival of the Dutch. Well into the twentieth century, as many as twelve upriver ferry crossings continued in service on the Hudson above New York City.

One of these ran between Garrison and West Point, in the Hudson Highlands. Chartered in 1821 by Harry Garrison, the service lasted more than a century. The last boat assigned to the run was an old side-wheel ferry called the *Garrison*. It had been built in 1887 as the *General Hancock*, for service in Boston Harbor. In 1919 it was brought to Garrison and subsequently renamed. But just five years later, in 1924, the opening of the Bear Mountain Bridge five miles below Garrison made the ferry route redundant. The company managed to hold on for four more years, until 1928, when it ceased operations and left the old *Garrison* abandoned in its slip. There its bones can be seen to this day, right where it tied up at the end of its last crossing from West Point.

Near the mouth of the Hudson, at Staten Island, the rusting hulk of the ferryboat *Beacon* is the most intact remnant of the Hudson's upriver steam ferries to survive into the twenty-first century. It was built in 1921 at the Groton Iron Works near New London, Connecticut. Like the *Garrison* it began life in Boston Harbor, where it ran as the *Lieutenant Flaherty*. In 1938 it came to the Hudson for service between Beacon and Newburgh and was renamed for this route's eastern terminus. In addition to being the busiest Hudson River ferry crossing

(Opposite, top) the schooner barge *Armistead* at Cornwall is the Hudson's most evocative maritime ruin. September 2004.

(Opposite, bottom) the *Storm King* at Coxsackie, June 2005. The ruins of the R&W Scott Ice Company power house are visible across the river.

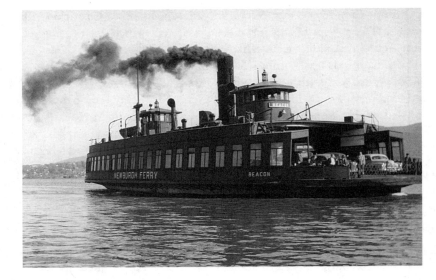

The *Beacon* is seen approaching Newburgh in the 1950s. Courtesy SSHSA Collection, University of Baltimore.

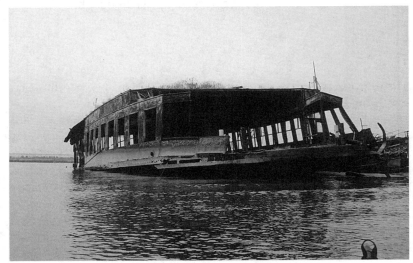

This is the ferryboat *Beacon* at Rossville, Staten Island in August 2003.

north of New York Harbor, this was also one of the oldest, its charter dating to 1743. The New York State Bridge Authority took over operation of the route in 1956, an inauspicious sign of things to come.

By the time the Bridge Authority began building the Newburgh Beacon Bridge in 1960, the *Beacon* and its older fleet mates *Dutchess* and *Orange* maintained the last surviving ferry crossing on the Hudson above New York Harbor. With the opening of the bridge on November 2, 1963, the state discontinued ferry service, bringing an end to one of the oldest institutions on the river. Sold for scrap, the *Beacon* went to the yard of the Witte Marine Equipment Company on the Arthur Kill at Rossville, Staten Island. Somehow it has managed to evade the cutter's torch, and now more than four decades after its withdrawal from service the hulk of the *Beacon* can still be seen, along with the rotting and rusting remains

of dozens of other vessels collected to form a graveyard of abandoned tugs, ferries, barges, and miscellaneous harbor craft, ending their days together in the muddy backwaters of New York Harbor.

Flagships

While freight steamers and flotilla tows plodded their way along, and ferries crossed from shore to shore, the true flagships of the Hudson River merchant marine were the fast day and night boats that ran up and down the river between New York City, Albany, and Troy. It was this service that in 1807 brought steam navigation its first commercial success with the advent of fulton's *Clermont*, and from that point until the retirement of the last Hudson River side-wheel steamer in 1971, the names and profiles of these boats remained as familiar in the valley as those of river towns themselves. Today not one of these vessels remains afloat, but their ruins can be found along with those of the old barges and ferries throughout the Hudson Valley.

As early as the 1820s the Hudson River steamboats had developed a distinctive style of their own, which would evolve steadily over the next hundred years. Unlike the bulky stern-wheelers of the Mississippi and other western rivers, the Hudson River boats were side-wheelers—longer, lower, and downright graceful by comparison. From an early time the Hudson River steamers set the design standard for nearly all coastal and inland steam-powered vessels in the eastern United States.

As elsewhere, there evolved two types of long-haul passenger steamer on the Hudson. The "night boat" functioned like a night train, casting off in the evening to finish its trip early the next day. Since there was little to see outdoors after dark, these boats offered minimal open deck space but featured grand indoor restaurants and public rooms, and were fitted with cabins where passengers could settle in after dinner to awake at their destination the next morning. Better remembered today are the "day boats," which provided their passengers vast open-deck spaces and public rooms facing out through continuous windows to capitalize on the passing scenery. Unlike the night boats, which disappeared by the 1930s after trains and automobiles replaced steamboats as a means of basic transportation, the day boats survived by adapting themselves as sightseeing and excursion vessels.

At Hastings-on-Hudson, just twenty miles north of Manhattan, lie what may be the best-preserved visible remains of all the side-wheel steamers to have plied the Hudson River. This is the hulk of the *Lancaster*, built at Sparrow's Point, Maryland, in 1892 for service on the Chesapeake Bay. Not until 1924 did it appear on the Hudson, where it ran as a night boat between New York and Troy. Its career on the Hudson proved short lived, and by 1929 it was withdrawn. With machinery and super-

structure removed, the *Lancaster*'s old steel hull eventually showed up at Hastings, where it was beached for use as a dock. Fishermen later built a shad camp on the hulk, but with the decline in commercial shad fishing on the Hudson the camp was abandoned in 1962. The *Lancaster*'s rusting hull can still be found at Hastings today, lying inconspicuously at the north end of a riverfront tennis club.

About eighty miles farther upriver, in a lonely cove north of Saugerties on the river's western shore, the falling tide reveals the remains of the *M. Martin* and the *William F. Romer*, fleet mates of the Rondout-based Romer and Tremper Steamboat Company. The *Martin* was built first, in the midst of the Civil War, at Jersey City in 1863. Assigned to the day run between Catskill and Albany, it was quickly requisitioned by the Union Army to serve as a dispatch boat on the Chesapeake, where it is said to have carried Lincoln and Grant to view the ruins of the Confederate capital at Richmond. After the War the *Martin* returned to the Hudson, running between Newburgh and Albany. The *Romer* was built as the *Mason L. Weems* at Baltimore in 1881 for Chesapeake Bay service. In 1890 the Romer and Tremper Company bought and renamed the boat, employing it as a night boat between Rondout and New York.

The *Martin* and the *Romer* continued on their assigned routes until about 1916, when the aging boats were withdrawn from service and laid up at Newburgh. There they remained until 1920, when the company sold them to a brick maker named Patrick Doherty, who planned to make docks out of their old wooden hulls. Doherty towed the old boats to a place called Eavesport, where he ran a small brickyard. Somehow he never got around to doing much with them, and the old hulks simply sat abandoned in the cove. Eventually the brickyard closed (virtually nothing remains of it today), and the land around the cove became part of a

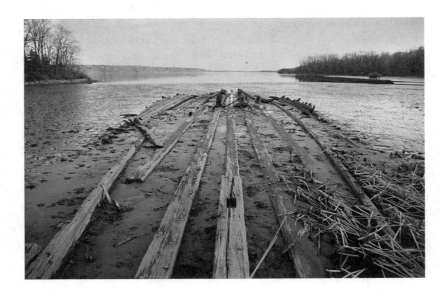

Looking aft over the hulk of the *M. Martin* at Eavesport, Ulster County, winter 2004. A duck blind visible at far right stands over the remains of the *William F. Romer*.

small state park. The hulks are still plainly visible at low tide, but there is no marker to identify them, and so they are left to fade away in peaceful anonymity.

Shortly before his death in the 1980s, Captain William O. Benson of Sleightsburgh (a landing near Rondout in Ulster County) sketched a map identifying some sixty hulks abandoned in and around the mouth of the Rondout Creek. After the Delaware and Hudson Canal opened in 1828, Rondout, marking the canal's eastern terminus and junction with the Hudson River, became the most important port on the river between New York City and Albany. But in the early part of the twentieth century, as river traffic began its long decline, Rondout became a repository for laid up old steamers. Some were scrapped here, others went on to new careers elsewhere. But dozens were abandoned where they lay, as the once-busy docks became deserted and the vibrant port became a backwater.

Today most of the hulks identified on Captain Benson's map have vanished entirely. But many remain, in varying states of decay. There are barges and scows, ferries and tugs; at Kingston Point there are even the remains of a replicated version of Fulton's *Clermont*, built for the Hudson-Fulton Celebration of 1909. A description of them all would become a book unto itself. Best known of these hulks is undoubtedly that of the side-wheeler day steamer *Mary Powell*, which over the course of a sixty-year career managed to become the favorite of all boats on the river, one of the fastest and best-proportioned steamboats ever known on the Hudson.

Built at Jersey City in 1861, the *Mary Powell* served nearly all its life on the day run between Rondout and New York. In its last years it ran for the famed Hudson River Day Line, which finally retired the steamer in 1917. In 1920 the Day Line sold the *Mary Powell* to a Rondout scrap dealer, who towed it up the creek to a point just east of the high steel viaduct of the West Shore Railroad. There it was dismantled slowly, piece by piece, over the course of the next ten years. Eventually the bottom of its wooden hull was left abandoned in the mud. Though the wreck is heavily overgrown and a number of other vessels abandoned nearby make it difficult to identify the precise spot of the *Mary Powell*'s grave, it is still possible to catch sight of an old timber or two, lying right where they were left when the scrap merchants left the old steamer to its final rest.

The decline of commercial boat traffic on the Hudson had a damaging effect on riverfront communities up and down the river. The disappearance of ferry service proved particularly disastrous for the river towns, especially Newburgh, as motor traffic now bypassed their old centers altogether. In the 1960s and '70s, urban renewal programs brought the wholesale destruction of significant portions of these towns, destroying

forever much of the traditional character of some of the river's oldest communities.

Today there are signs of revival. Near the abandoned docks and ferry slips, some of which can still be seen, historic streetscapes that did survive the hard years of the late twentieth century have become the nuclei of efforts toward revitalization. Tows, tankers, and bulkers meanwhile remain a common sight on the river, carrying bulk cargoes to and from the river's quarries and cement factories, as well as fuel for its power plants and heating oil for homes throughout the region. While small pleasure craft have largely taken the place of the sightseeing vessels that succeeded the old day boats, an increasing number of excursion boats and even some small cruise ships have begun to call at towns such as Beacon, Poughkeepsie, and Rondout. And at the dawn of the new century, almost unbelievably, upriver ferry service came back from the grave with the introduction of a pedestrian ferry between Haverstraw and the commuter train station at Ossining, aimed at relieving traffic from the Tappan Zee and Bear Mountain bridges. In the fall of 2005 a similar service opened between Newburgh and Beacon.

Meanwhile, more ruins of the river's maritime heritage can still be found in other places. At Pawcatuck, Connecticut, can be found the bones of the *Brinckerhoff*, a side-wheel ferry that crossed from Poughkeepsie to Highland for more than forty years. In New Jersey's Raritan Bay lie the remains of the *Alexander Hamilton*, the last side-wheel steamer to serve on the Hudson. And in the St. Julian's Creek at Portsmouth, Virginia, the old hull of the *Albany*, built in 1880 for the Hudson River Day Line, remains among the most captivating relics of the Hudson's age of steam. Beneath the river's murky water there are more. The New York State Historic Preservation Office is now working to identify the wrecks of more than two hundred boats revealed in sonar scans of the river bottom made in 2002. The Hudson's age of sail and steam is over. But in a very real sense the boats are still around, haunting the shallows in corners long forgotten.

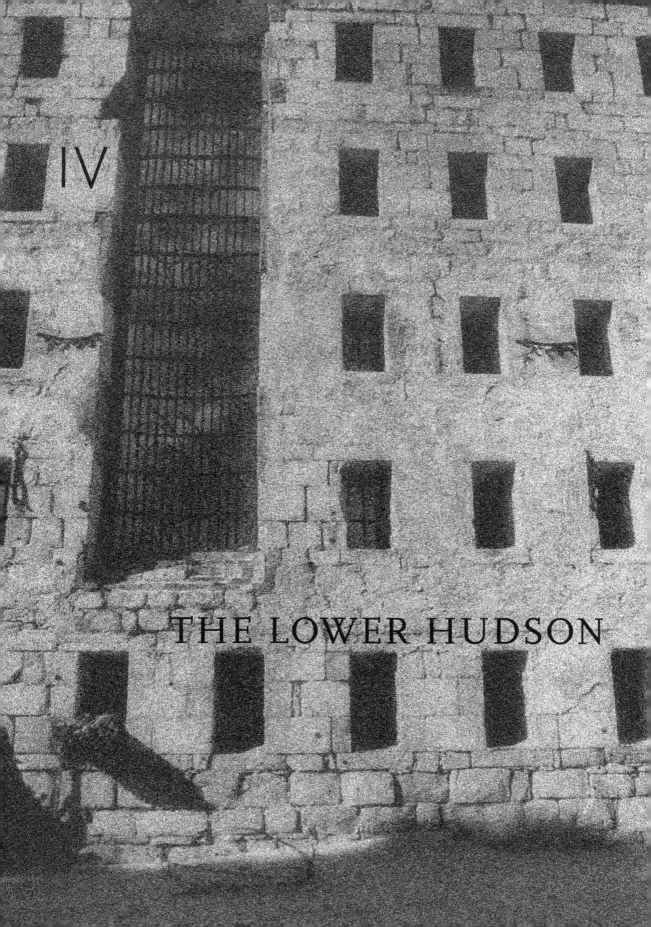

IV

THE LOWER HUDSON

PUTNAM COUNTY

PUTNAM COUNTY FORMED IN 1812, with the separation of land that had formerly belonged to Dutchess. Situated opposite southern Orange County, Putnam's Hudson River shoreline comprises the eastern half of what has long been regarded as the most visually interesting stretch of the tidal Hudson. Here, where the river and the Appalachian ridge cross paths to form the Hudson River Highlands, the banks of the river rise steeply more than a thousand feet above tidewater.

Putnam takes its name from General Israel Putnam (1718–1790), a hero of the Battle of Bunker Hill under whose command the Americans lost the Hudson Highlands to the British in 1777. But despite the loss of Forts Montgomery and Clinton, actions there delayed British advancement upriver sufficiently to help the American cause.

The mountainous character of western Putnam County stunted development of its Hudson River shoreline. Instead, settlement concentrated on the less rugged land near the Connecticut border, where towns such as Carmel, the county seat, developed in the eighteenth century. Prior to the Revolution, much of Putnam County belonged to the Philipse family, who in addition to their vast manor in Westchester County also owned land in Bergen County (New Jersey) and in Rockland, Orange, and Ulster counties. Philipstown, one of six towns in the county, is a reminder of a time when single families owned vast stretches of riverfront.

Putnam County's principal Hudson River landing is Cold Spring, whose development was stimulated by the opening of the West Point Foundry there in 1818. A smaller landing, Garrison, appeared directly across the river from the Military Academy at West Point. Otherwise western Putnam remained agricultural. But the steep terrain of the Highlands proved ill suited for farming. As early as the 1830s, a mass migration to more fertile farmland in the American west and to industrial jobs

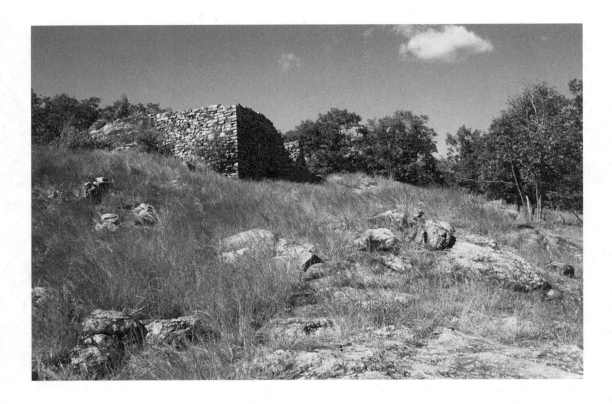

Fortification Ruins, Constitution Island

Nineteenth-century writers admired Revolutionary War–era fortification ruins for their picturesque quality as well as for their historic importance. The first military establishment at Constitution Island was named Fort Constitution. American soldiers building the fort in 1777 destroyed what was built when they were forced to flee as British troops under Sir Henry Clinton advanced upriver. In January 1778, the Americans returned and constructed a chain across the Hudson to stop advancing ships; Constitution Island was the chain's eastern terminus, protected by stone redoubts and a battery. American soldiers were stationed in barracks there until 1783. The island was later home to the Warner family from 1836 to 1915; two sisters, Susan and Anna Warner, were widely published authors and taught Bible classes at West Point Military Academy. Though Fort Putnam has been completely restored, the fortification structures on Constitution Island retain the picturesque character that drew writers and artists to muse over these ruins in the nineteenth century. Public tours of the Warner house and fortification ruins are offered on certain summer weekends.

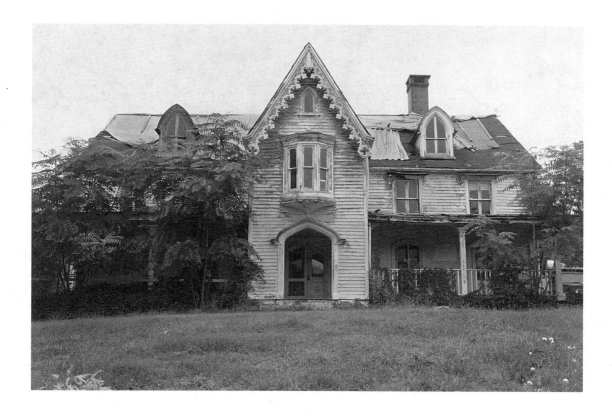

Belden House, Carmel

Thomas Belden, a land agent for the Philipse family, which owned much of present-day Putnam County, probably built the first section of this house around 1760. Descendant George Mortimer Belden acquired the house during the Civil War and added vergeboards and lancet dormer windows, making it a first-rate example of the so-called Carpenter Gothic style. The New York City Department of Environmental Protection (DEP) bought the property in 1896; it created the West Branch Reservoir by constructing a dam behind the house. For nearly a century, the DEP used the house as an office and a residence for a site custodian, until it was abandoned late in the twentieth century. Rainwater leaking through the roof has threatened the structure, which retains marble fireplaces, elaborate wood trim, and plaster finishing. In 2005, county legislators voted against funding the building's restoration despite local interest in its preservation.

Grove, Cold Spring

In 1853, Dr. Frederick Lente (1823–1883), surgeon at the West Point Foundry, built a house known as Grove on a prominent hill at the southern entrance to the village of Cold Spring. Architect Richard Upjohn (1806–1878), who lived in nearby Garrison, designed the three-story brick house with mansard roof and dormer windows.

At the turn of the twentieth century, Patrick Connick, pastor of Our Lady of Loretto Parish in Cold Spring, inherited the house. Renamed "Loretto Rest," the house became a convalescent home for priests under the direction of the Sisters of Charity. After 1918, the house was a convent for Franciscan Sisters who taught at the parish school, which closed in 1977. The house fell into disuse and was sold to a developer in 2002. Subsequently, the historic landscape of the 3.6-acre parcel was subdivided, and adjacent houses were built. The Lente house was given to the village of Cold Spring, and an anonymous donor gave $250,000 in 2005 toward restoration of the mansion for municipal purposes.

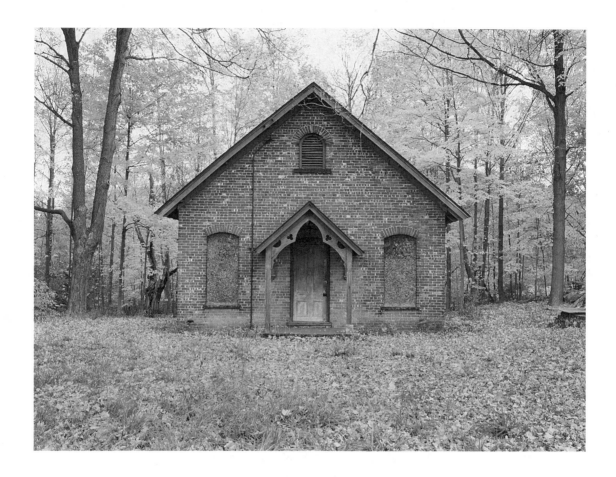

District No. 8 School, McKeel Corners

Built c. 1875, this fine example of a country schoolhouse stands about two miles east of Cold Spring, near the northeast corner of the intersection of what were once known as the Albany Post Road and the Cold Spring–Carmel Turnpike. The hilly area surrounding the school once supported active farms. Many of these were abandoned over the course of the nineteenth century as industrialization and westward migration led to a downturn in agriculture that was particularly felt in Putnam County. Schools like this continued to serve the families that remained until centralization in the twentieth century caused many of these archetypal buildings to be abandoned. In 1996 the state Office of Parks, Recreation and Historic Preservation acquired the building and the land around it. Now part of Clarence Fahnestock Memorial State Park, the schoolhouse remains empty ten years later.

in urban centers led to a decline in agriculture that was felt especially in Putnam County. As a result, the county's population dropped steadily well into the twentieth century.

Particularly after the 1850s, the availability of large tracts of under-utilized land in this scenic stretch of the valley led to the creation of numerous country estates in Putnam. It also allowed much of the area to be given over for reservoirs to serve New York City, and later for public parkland.

Only in the twentieth century did industrial development begin to encroach on the Hudson Highlands. This came first in the 1930s with large-scale quarrying at Mount Taurus near Cold Spring, and then in the 1960s with plans for two electric power stations and a gypsum wall-board plant. The potential negative impact of this development on the beauty and ecology of the river prompted a popular outcry that helped to shape the environmental movement on a national scale.

Ultimately conservation triumphed over development. Today more than twenty thousand acres of open space in Putnam is protected within the boundaries of two state parks—Clarence Fahnestock and Hudson Highlands—which together cover nearly 8 percent of the county's 246 square miles. These and other open-space preservation initiatives have caused suburban development to leapfrog over western Putnam, allow-ing this area to retain its traditionally undeveloped character and making it one of the most popular destinations in the Hudson Valley today.

Edward J. Cornish Estate, Cold Spring

The remains of the Edward Cornish estate may be the most extensive assemblage of ruins on public parkland in the Hudson Valley. Situ-ated near the village of Cold Spring amid some of the most spectacular mountain scenery on the river, they have long been a popular attraction for hikers. At one time industrial development threatened both the ruins and the land around them, helping to prompt not only the creation of vast amounts of parkland in this part of the valley but also the modern environmental movement in America. Today these ruins survive to pro-vide a glimpse of past human interaction with a landscape known for its relatively undisturbed natural beauty.

The property is known after Edward Joel Cornish (1862–1938), presi-dent of the National Lead Company, who purchased the estate in 1917 and maintained it until his death nineteen years later. But initial devel-opment of the property appears to have begun a decade earlier, when the land was acquired by a wealthy Chicagoan named Sigmund Stern. Virtually no documentation remains of the early history of the estate; the identities of its architect and landscape designer remain unknown, and there are no known photographs showing the house before it was gut-

ted by fire. A description of the 650-acre property at the time of its sale to Cornish confirms that a number of structures had already been built there, including a "large stone dwelling, garage, other outbuildings, and a swimming pool, in addition to magnificent gardens."[1]

The property lay in a vale between Mount Taurus and Breakneck Ridge, just below the north gate of the Hudson River Highlands. While early industrial development transformed the river to the north and south, the steep terrain of the Highlands kept development to a minimum throughout the nineteenth century. By the 1820s, the dramatic scenery of the Highlands was inspiring the work of Cole, Irving, and others; later it made its way into popular prints by Currier & Ives and by Bartlett.

Eventually the evocative landscapes of the Highlands led to the emergence here of what was probably the third-greatest concentration of mansions on the river (after the estate districts of southern Westchester and northern Dutchess counties). Some of the better-known estates to rise in this region included Castle Rock, built for railroad magnate William Henry Osborn; Glenclyffe, home of Hamilton Fish; and Cragston, the home of J. P. Morgan, which stood on the west bank below Highland Falls.[2]

The stone walls of the Cornish mansion are almost entirely covered by overgrowth; a small section of the west facade is visible here.

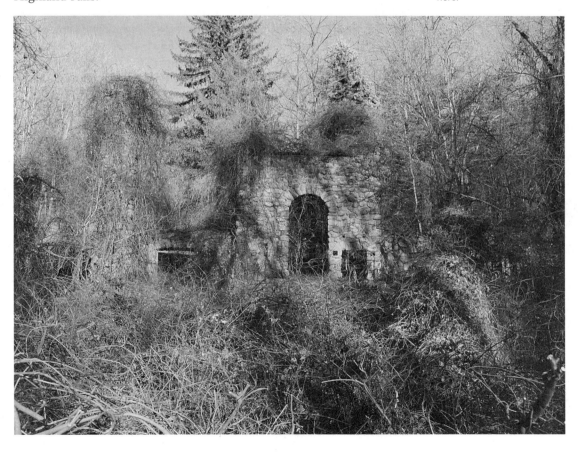

As early as the 1840s, Putnam County farmers found that they had exhausted the hilly upland soil of the county's mountainous terrain, leading to the abandonment of agricultural land throughout the region and lending the Highlands an even more picturesque appeal. The county's population declined steadily until 1920, with fewer inhabitants that year than had been recorded a century earlier. By the beginning of the twentieth century, the great availability of inexpensive land in such close proximity to New York City spurred the creation of even more estates here. It was in this context that Sigmund Stern purchased and developed his Cold Spring estate in the first decade of the twentieth century.

Edward Cornish bought the Stern estate in 1917, one year after he ascended to the presidency of the National Lead Company. With his wife, Selina, he made his primary residence at New York City, using the Cold Spring estate whenever he could to engage in the pursuits of a gentleman farmer. The mansion itself was irregular in plan, its exterior elevations composed of a lower story of stone supporting an upper facade of wood. A complex of stone and wood barns occupied the northeastern corner of the property, where Cornish raised cattle and maintained an active dairy farm.

At the time Cornish came to Cold Spring, much of Putnam County's 234 square miles remained undeveloped. Manufacturing centers had not risen in Putnam County to the extent they had elsewhere in the valley. The county's largest industrial employer of the nineteenth century, the West Point Foundry in Cold Spring, had changed hands and was in decline. But in the 1930s came an industrial revival in the Hudson River Highlands that would eventually threaten to destroy what many regarded as one of the natural wonders of the northeastern United States. The reaction to this revival culminated thirty years later in the birth of the modern environmental movement.

The 1930s saw the appearance of large-scale quarrying at Mount Taurus, between the Cornish estate and the old village of Cold Spring. Quarrying was not new to the Highlands. Almost a century before, a natural monument on Breakneck Ridge known as the "Turk's Face" was destroyed by blasting. But quarrying at Breakneck stopped in the 1850s, and the construction of the Catskill Aqueduct through the hillside in 1913 seemed to spell a permanent end for all mining operations in the area, as blasting near the aqueduct was forbidden.

Other Highlands peaks, however, remained vulnerable. Immediately adjacent to Cornish's country retreat, the opening of the Hudson River Stone Corporation's quarrying operation at Mount Taurus in 1931 brought mining at a scale unprecedented in the Highlands. Within a few years the mine had torn a very visible gash across the face of the otherwise pristine mountain. The operation extended out into the river on the peninsula known as Little Stony Point, where a crusher was fed by a tipple that stretched from Mount Taurus over what became Route 9D.

There were numerous outcries and protests against the destruction of the 1,400-foot face of Mount Taurus, and the commencement of mining operations on November 21, 1931, was closely followed by conservationists throughout the region.[3] Few lived closer to the quarry than Edward Cornish, whose neighboring estate shook with every blast. Though his own company was later to carry out extensive surface mining near the headwaters of the Hudson in the Adirondack Mountains, Cornish, then in failing health, eagerly sought to protect his land from future development by donating mining rights to the Hudson River Conservation Society, thereby preventing future quarrying on the property.

In 1936 Cornish offered the estate for sale to the Taconic State Park Commission. The state had already intervened to protect other parts of the Hudson River shoreline from quarrying, including the Palisades, Hook Mountain, and Bear Mountain, near the south gate of the Highlands. And in 1929 the commission had established the Clarence Fahnestock Memorial State Park, located only a few miles east of the Cornish estate in Putnam County. But the commission, acting under the authority of Robert Moses (then chairman of the New York State Council of Parks) declined Cornish's offer, stating that the site was "not at all adaptable for a park area" and citing potential costs associated with the upkeep of the mansion and other buildings on the property.[4] It was a decision the agency would later regret.

On May 3, 1938, Edward Cornish died at his desk at 111 Broadway in New York City.[5] His wife, Selina, passed away two weeks later. Under the absentee ownership of Cornish's heirs the property soon fell into decay. The estate continued to deteriorate throughout the 1940s, and a fire partly damaged the house in 1956.[6] Quarrying operations at neighboring Mount Taurus ceased around this time (today piles of crushed rock and the overgrown scar on the mountain remain). But a new industry had already cast a hungry eye toward the Highlands. The first major electric power plant appeared on the Hudson in 1906, with the completion of the Yonkers Power Station for the New York Central Railroad. By the 1950s, as other Hudson River industries such as brick making and textile production fell into decline, electric power generation began to emerge as one of the most prominent industrial activities on the river.

In the late 1950s, the region's two largest electric utility companies each announced plans to build large pumped-storage power-generating facilities at the famed north gate of the Hudson River Highlands. On the west shore, Consolidated Edison proposed building a plant on Storm King Mountain. At the same time, the Poughkeepsie-based Central Hudson Gas and Electric Company made plans for a similar plant across the river near Breakneck Ridge, and the company purchased the unused Cornish estate from the heirs of Edward and Selina Cornish in 1963. Both proposals became lightning rods for the budding environmental movement, directly spawning the creation of the environmental group Scenic Hudson that same year. Later followed by groups such as the

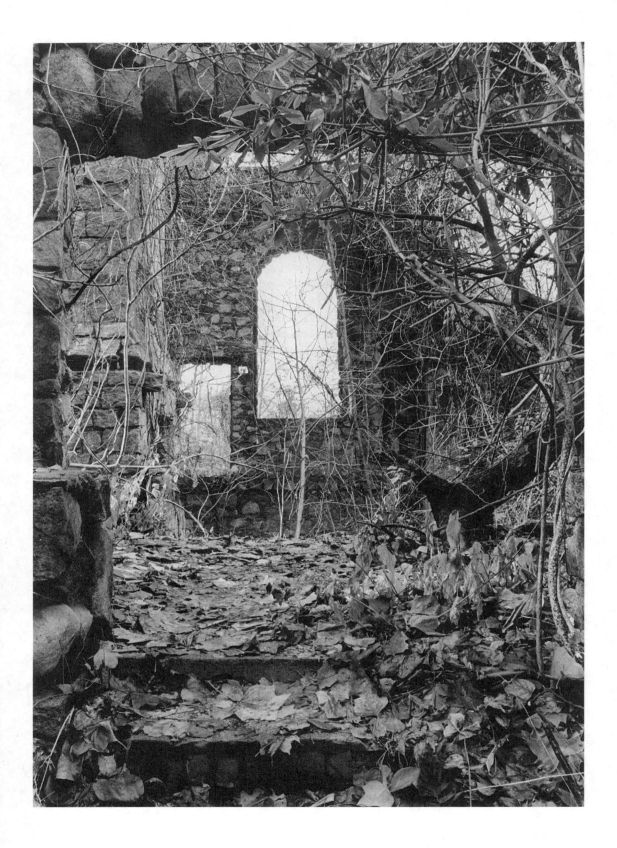

Hudson River Sloop Clearwater, Scenic Hudson is today credited with having helped to initiate the modern grassroots environmental movement in the United States, and it remains an influential force in the valley. Public reaction against the Con Ed plan eventually reached the national level, and after years of legal challenges Con Ed finally abandoned its plans for the Storm King plant in 1980.

Central Hudson did not wait as long to drop plans for its own plant, and in 1967 the company sold the Cornish property to the Taconic State Park Commission. That same year the Georgia Pacific Company canceled plans for an $8 million gypsum wallboard factory it had proposed for the former quarry site at Little Stony Point, and this parcel too became parkland.[7] Under Governor Nelson Rockefeller, the state Office of Parks and Recreation in cooperation with Laurance Rockefeller's Jackson Hole Preserve joined both properties (along with various other parcels including Pollepel Island) to form the Hudson Highlands State Park.

Thus protected from development, the Cornish estate has remained untouched since Edward Cornish's death in 1938. Within the mansion's gutted stone walls, large fireplaces stare blankly into space. Near the mansion lie the empty swimming pool and an overgrown lawn that might once have been used for tennis courts, as well as the remains of several dependencies including what may have been a cistern or icehouse and a fieldstone-fronted greenhouse with a stepped gable facade. Further east an old road parallels the Breakneck Brook, which meanders its way down through the property toward the river. By the brook stands an old pump house near a waterfall framed by carefully placed boulders. From here a path continues eastward across the Catskill Aqueduct before leading to the impressive ruins of the barn complex at the northeastern corner of the estate. Beyond the barns hikers can continue on to a large reservoir

(*Opposite*) a shaded courtyard on the east side of the mansion leads to the entrance shown here.

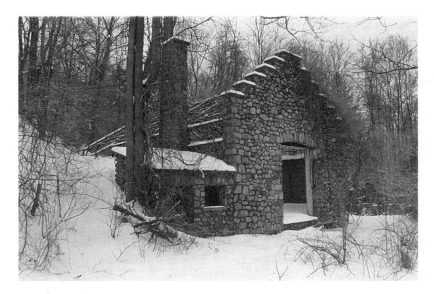

Greenhouse with stepped gable, west front.

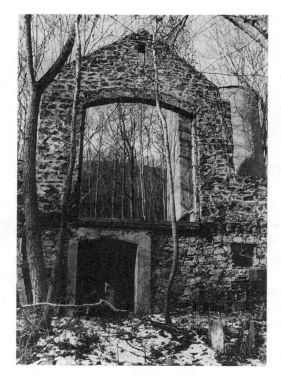

An interior view of the stone barn.

apparently built as part of the estate, or can follow marked trails south to Mount Taurus or north to Breakneck Ridge, from which a network of trails continues north to the city of Beacon via parkland administered by Scenic Hudson.

Like the Overlook Mountain House, part of the appeal of these ruins is that they are left to the elements, and not fenced off. No signs warn hikers to stay out of the buildings, nor are they defaced with graffiti. Today the Hudson Highlands State Park has grown to encompass more than six thousand acres, which include the ruins of Bannerman's Island Arsenal as well as those of the Dennings Point Brick Works near Beacon. At least one of the old brickyard buildings is to be restored as part of a new research institute called the Beacon Institute for Rivers and Estuaries, itself an outgrowth of the environmental movement born here, on the Hudson River. But for now there are no plans to maintain the standing ruins of the Cornish estate, and so the overgrown walls continue to fall back into the rocky landscape that surrounds them.

West Point Foundry, Cold Spring

In the middle of the nineteenth century, the writer Benson Lossing described a visit to West Point Foundry at Cold Spring made during the course of his great documentary journey down the Hudson River. From

the home of the painter Thomas Rossiter, situated on a bluff behind the foundry, Lossing heard the "deep breathing of furnaces, and the sullen, monotonous pulsations of trip-hammers," the sounds of an industrialized nation growing stronger by the minute.[8] A century and a half later the foundry lies in ruins, and it is hard to imagine the land beneath the old Rossiter house as anything but the peaceful wooded glen it is now. Indeed, if such an establishment were proposed in the Highlands today, it would surely raise many a hue and cry: the ruins of the West Point Foundry evoke the changes this region has known in a way few others can.

The first iron foundries appeared in the Hudson Valley by the middle of the eighteenth century, when iron mines and small foundries were established to provide colonists with basic necessities such as tools for farming and cooking. Many of these early establishments arose on the west side of the river, in Orange and Rockland counties. But for the most part these operated on a very small scale; many closed even before the beginning of the nineteenth century, and their ruins can still be found in various parts of the valley today.

After the War of 1812, President James Madison ordered the creation of four federally subsidized foundries that were to be strategically located to provide the country with heavy artillery for national defense.[9] This decree brought the formation of the West Point Foundry Association in 1818, under the direction of Governeur Kemble (1786–1875), a leading merchant and onetime United States representative, and General Joseph Swift, a graduate of the Military Academy at West Point, which stands on the river's western shore a short distance downstream of Cold Spring.

The Hudson Highlands proved an ideal location for one of Madison's new foundries. The foundry's position fifty miles up the river provided access to transportation and shelter from naval attack. Local supplies of iron ore had already been tapped for smaller foundries, and old mines in the hills of Orange and Putnam counties would continue to supply the new foundry throughout the century. The village of Cold Spring did not yet exist at the time of the foundry's inception, but as the firm prospered the town grew quickly. Soon there appeared houses and shops by the landing, located a short distance north of the foundry itself. Many of the laborers who found work at the West Point Foundry were Irish Catholics; on a rocky point facing the river, the foundry helped build the small Greek Revival–style Chapel of Our Lady for these workers in 1834. Designed by sixteen-year-old Thomas Wharton, this is thought to be the first Catholic church built in the Hudson Valley.

The foundry's great capacity made it one of the nation's principal suppliers of iron products in the early nineteenth century, rivaled on the Hudson only by the Burden Iron Works at Troy. Other modern foundries later opened at Poughkeepsie and at Hudson, but none was as well known or highly regarded as the one at Cold Spring. In addi-

tion to government contracts, the foundry undertook many prominent commercial contracts. Important early commissions included a contract with the Delaware and Hudson Canal Company in 1829 to assemble the first steam railway locomotive to operate in the United States, which had been imported from Great Britain in pieces. One year later the Mohawk and Hudson Rail Road, predecessor of the New York Central, contracted the foundry to produce the DeWitt Clinton, the first locomotive built in New York State. The foundry also made steam machinery for sugar plantations in the West Indies and architectural ornaments such as finials and railings. Other miscellaneous products included everything from lengths of ordinary pipe to decorative cast-iron furnishings, such as a pair of benches gifted by Kemble to his friend Washington Irving.

The company reached its peak during the Civil War (1861–1865), producing munitions credited with helping the Union army gain a key advantage over the Confederates. The foundry's essential role in the war allowed it to fulfill the purpose for which it was intended, though James Madison, a Virginian, could scarcely have foreseen a half century earlier that its guns would one day take aim at his own homeland.

During the war the company specialized in the production of the Parrott gun, a type of rifled cannon patented in 1861 by Robert Parrott (1804–1877). A student and later a mathematics professor at the West Point Military Academy, Parrott became superintendent of the foundry in 1836. Today the Parrott gun is still cited by Civil War historians for having played a decisive role in the Union victory. Parrott tested the guns by firing them across the river at an uninhabited Highlands peak called

The West Point Foundry office is shown here before the bell cupola was removed for roof stabilization work in the winter of 1999–2000.

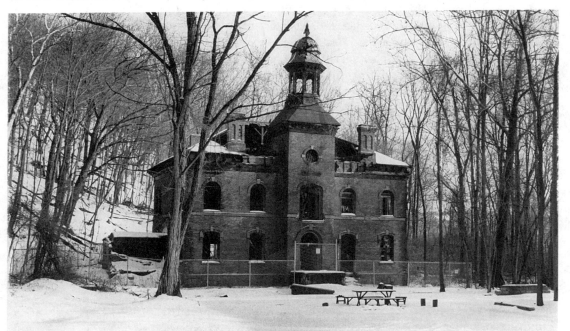

Crow's Nest. "At all hours of the day for the past four years," one visitor to the foundry wrote near the end of the war in 1865, "the firing of these guns have awakened fearful echoes among these environing heights, often times sounding like the roar of a terrible battle."[10]

At the outset of the war the foundry had grown to occupy a complex of brick and wood-framed industrial buildings that fanned out across the bottom of a clove, through which passed a stream called the Foundry Brook. Increased demand during the war drove expansion, and in 1865 the firm built a new brick office building by the creek. Italianate in style, the building stood two stories high, with a central tower and octagonal belfry projecting from the main facade. Standing figuratively as a monument to the company's great contribution toward the war effort, its completion marked the high point in the foundry's history.

Its role in the Union victory gave the foundry international recognition as one of the most important industrial institutions in America. In 1865, the same year the Civil War ended and the foundry completed its new administration building, Jules Verne (1828–1905) used the foundry as the fabricator of a rocket that sent a man into space for his novel *From Earth to the Moon*. But the most enduring image of the West Point Foundry came two years later with John Ferguson Weir's (1841–1926) painting titled *The Gun Foundry*, commissioned for Robert Parrott in 1868. A contemporary critic praised the work, not only for Weir's "rare skill in the execution of details and the management of light," but for his choice of subject matter. Weir, wrote the critic, had depicted one of "those wonderful industrial processes whereby the ore is purified and moulded into engines of destruction, of locomotion and mechanical science, and learned to realize [its] influence on civilization and national prosperity."[11]

The foundry went into a sharp decline in the decades following the Civil War. After Robert Parrott's death in 1878, the firm reorganized as Paulding, Kemble, & Company. Government contracts slowed dramatically after the war, and the firm suffered further owing to investments in an unsuccessful coal venture. By 1886 the foundry was in receivership. Its workforce, which had reached a peak of nearly 2,000 during the Civil War, dropped to only 150 that year.[12] The company remained in operation through the 1890s, satisfying military and civilian contracts. But at the end of the nineteenth century, increased competition from the modern steel mills of Pittsburgh made things even more difficult. The West Point Foundry managed to hang on, but other iron foundries on the river, such as the Poughkeepsie Iron Company and Hudson Iron Works, closed around this time.

The J. B. and J. M. Cornell Iron Company of New York purchased the site in 1897. Founded in 1828, Cornell had established itself as a leading producer of cast-iron architectural details, supplying building projects in Manhattan's SoHo district as well as most of the cast-iron bridges for

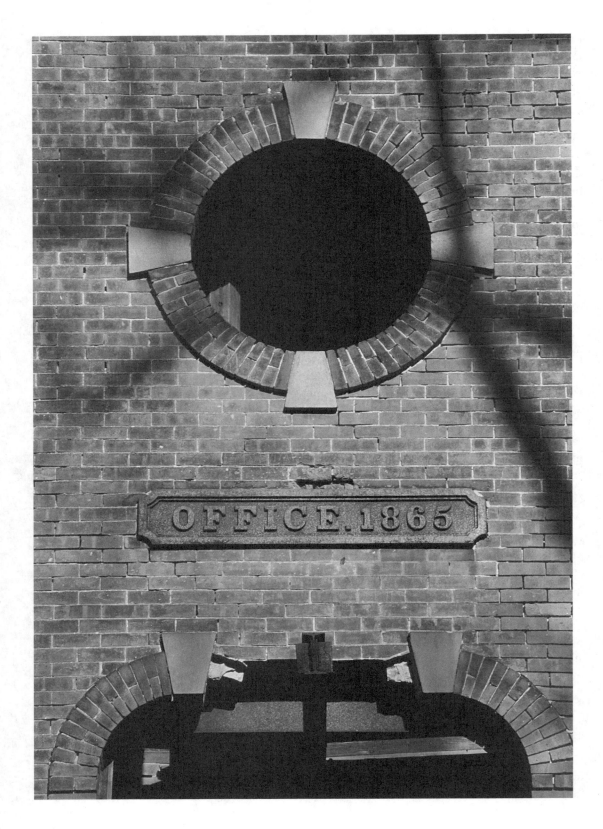

Central Park. Under Cornell the West Point Foundry continued to produce heavy ordnance and a variety of other metal products. Just one year after taking over operations at Cold Spring, the Cornell Iron Company secured a contract to supply eight thousand tons of structural steel for the Park Row Building opposite City Hall in lower Manhattan, the tallest building in the world at the time of its completion in 1899.

Cornell ceased operations at Cold Spring in 1911, after which time the plant operated sporadically for a succession of different concerns.[13] After several years of vacancy the New York City–based Astoria Silk Works acquired the property in 1920 and made significant alterations to the site, but within a few years the old buildings again found themselves empty. In 1936 the Remington Screw and Bolt Manufacturing Company purchased the property.[14] A dye works and a cotton company later occupied the site, but by the 1950s manufacturing had ceased for good.

First floor interior, March 1999. Decades of vandalism have taken their toll.

The Deuterium Corporation, a developer of Hilton resort hotels, purchased the foundry buildings in 1960 and proposed construction of a marina and hotel complex that would have destroyed nearly all that remained of the factory complex, save for the old office building. But the plan never came to fruition, and the site was left to the elements. By the early 1970s only odd bits of brick and stone walls remained of the twenty or more industrial buildings that once stood here, leaving the old administration building the lone intact structure from the foundry days. Though long forlorn, the ruins were listed on the National Register of Historic Places in 1973.

Today, the ruins of the West Point Foundry are the most visible remnants of Cold Spring's industrial heritage. After the foundry closed, the Marathon Battery Company maintained an industrial presence in Cold Spring from 1952 until 1979. Its departure left the village stuck with one of the most dangerously polluted areas on the Hudson River, necessitating a two-decade cleanup administered by the EPA, which included the demolition of the factory buildings themselves.

Since 1996, the foundry site has been owned by the nonprofit environmental group Scenic Hudson. The furnaces are gone, the boom of the trip-hammer has yielded to the sound of water flowing down through the Foundry Brook, the mass of buildings is reduced to ruins, and a young forest now stands over what once was a well-known symbol of

(*Opposite*) office, tower detail.

the nation's industrial supremacy. Scenic Hudson has undertaken stabilization work on the 1865 office building, which included the removal of its octagonal cupola for safekeeping (its bell now resides at nearby Haldane High School). Further stabilization work is planned, and restoration proposals for the building have included adaptive reuse as an educational facility. In 2001, Scenic Hudson partnered with Michigan Technological University to develop a comprehensive archeological and historical study of the entire site. Today the property is open to the public as part of Scenic Hudson's Foundry Cove Preserve. Visitors are asked to tread carefully and to respect the ongoing archeological documentation of the site.

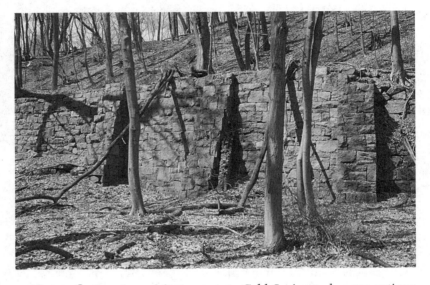

This stone retaining wall supported a tramway that ran along the edge of the workshops, providing access to the upper stories of several buildings. It also served partly as the back wall of some shops and storage spaces on the level below.

Twenty-first-century visitors come to Cold Spring to browse antique shops along Main Street or to dine at the Hudson House, which has operated here since 1832. Easily accessible by train from New York City, this former factory town is today known as one of the most popular day-trip getaways in the metropolitan area, with well-preserved nineteenth-century commercial and residential districts set immediately on the riverfront in the shadow of the spectacular scenery of the Hudson Highlands. Yet there is little to remind visitors of Cold Spring's industrial past. The old foundry school now houses a museum run by the Putnam County Historical Society, and near the river the Chapel of Our Lady stands restored after suffering more than sixty years of abandonment. Perhaps one day the West Point Foundry's old office building will also be restored to represent this town's all but forgotten industrial heritage.

ROCKLAND COUNTY

NEARLY TRIANGULAR IN SHAPE, tiny Rockland County is bordered to the northwest by Orange County, to the southwest by New Jersey, and to the east by the Hudson River. Until 1798 it belonged to Orange County. Rockland claims the distinction of being the location of the first recorded instance of a European stepping on what later became New York soil, when on September 15, 1609, Henry Hudson anchored off what is now Piermont, after previous landings in present-day New Jersey.

The first attempt at settlement occurred in 1640, when Captain David Petersen de Vries "arrived about even at Tappaen," just below modern-day Piermont. There he founded a settlement known as Vriesendael. But three years later war broke out between the Indians and the settlers under William Kieft, then director general of New Netherland. His colony in ruins, De Vries returned to Holland.

By the 1670s and '80s, parcels in present-day Rockland were acquired by Europeans, but unlike many east shore landholdings, most early purchases were made by speculators with no intention of settlement or other business. Sixteen Dutch farmers, with the intention of permanent settlement, acquired the Orangetown patent—covering parts of present-day New York and New Jersey—in 1686.

Rockland was growing by the middle of the eighteenth century, when sawmills were built along the creeks in Haverstraw, Nyack, Tappan, and Clarkstown, enabling construction activities. Early industries included iron and nickel mining, nail factories, rolling mills, and cotton mills. Sandstone quarries provided the material for iron-furnace hearths and for many of the Dutch houses in southern Rockland and northern Bergen (New Jersey) counties, which, with their gambrel roofs, are distinct from other colonial houses in the Hudson Valley.

In the nineteenth century, commercial brick making and ice harvest-

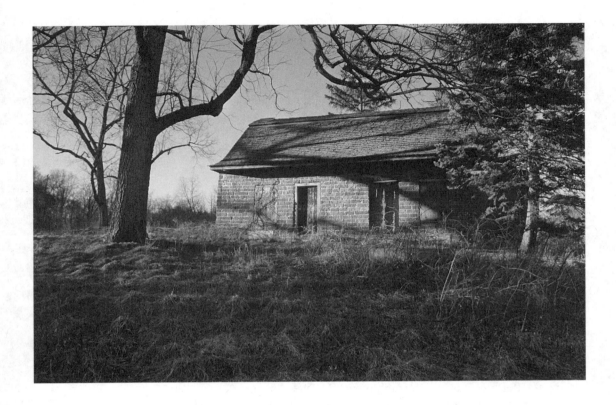

Jacob van der Bilt House, Bardonia

This house was likely built around 1730 by Jacob van der Bilt. The red sandstone construction and gambrel roof are typical of Dutch houses in Rockland County and in neighboring Bergen County, New Jersey. The gambrel roofs are not typical of the Netherlands but are adapted from English architecture; they are common on houses two rooms wide by two rooms deep with a center hall. In her book *Pre-Revolutionary Dutch Houses and Families in Northern New Jersey and Southern New York*, Rosalie Fellows Bailey noted the early construction of the house evidenced by its "irregular stonework, mud plastering, split laths, wooden locks, hand-wrought nails, small windows, [and] crude glass."

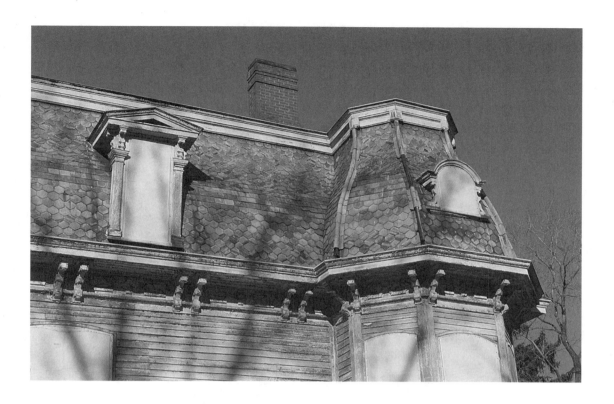

Henry M. Peck House, West Haverstraw

This French Second Empire style house was built c. 1865 by Henry M. Peck, member of a prominent family in the local brick industry. Last owned as private home in 1931, the house was sold to the adjacent children's hospital (now the Helen Hayes Hospital) for use as a superintendent's residence. It was abandoned and boarded-up in the 1970s. The hospital later planned to restore the house, which achieved designation on the National Register of Historic Places in 2000. The house was noted for its architectural details, including an S-turned mansard roof, and gabled dormer windows with pediments supported by brackets and pilasters. Before restoration was scheduled to begin, the house was destroyed in a blaze attributed to fireworks on July 3, 2002, five months after this photograph was taken.

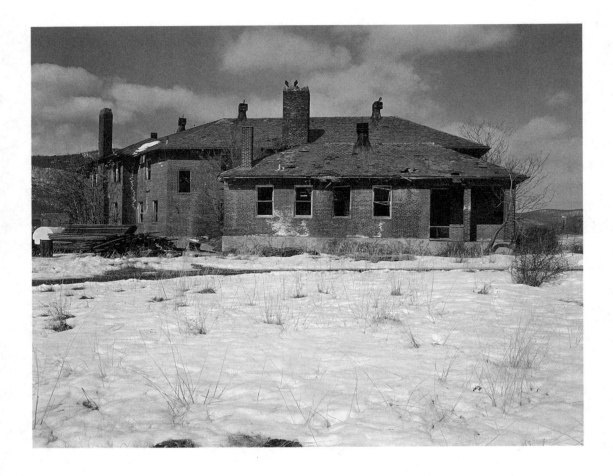

U.S. Naval Weapons Depot, Iona Island

The Department of the Navy acquired Iona Island in 1899 and constructed 146 buildings to store, assemble and test explosives and ammunition. It became one of two main ammunition depots on the east coast. With no space to expand, the Navy deactivated the site in 1947 and the Palisades Interstate Park acquired the island in 1965 build a recreational facility. Although that plan was not carried out, most of the buildings were razed two years later. Six buildings remain standing; one, the marine barracks, stands derelict while the others are used for storage. The island itself is now a protected bald eagle habitat, and is closed to the public.

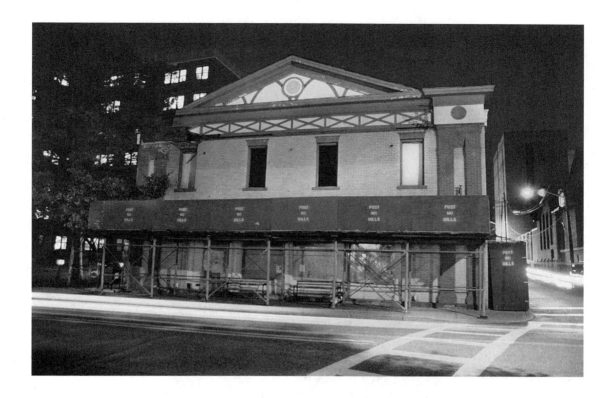

Tappan Zee Playhouse, Nyack

Known as the Broadway Theater when built in 1911, this 800-seat theater was typical of small vaude-ville theaters later converted to movie houses. The theater closed in 1931 and did not reopen until 1958, when it was renamed the Tappan Zee Playhouse. The neoclassical facade was altered then, but its survival as a largely intact example of an early-twentieth-century theater helped the building gain acceptance onto the National Register of Historic Places in 1983, eight years after a small fire closed the theater. A preservation group sought to restore the building but succeeded only in stabilizing the walls and installing a new roof after the interior was gutted. The village of Nyack acquired the theater in 1998 and sold it six years later for redevelopment; it was razed in the spring of 2004.

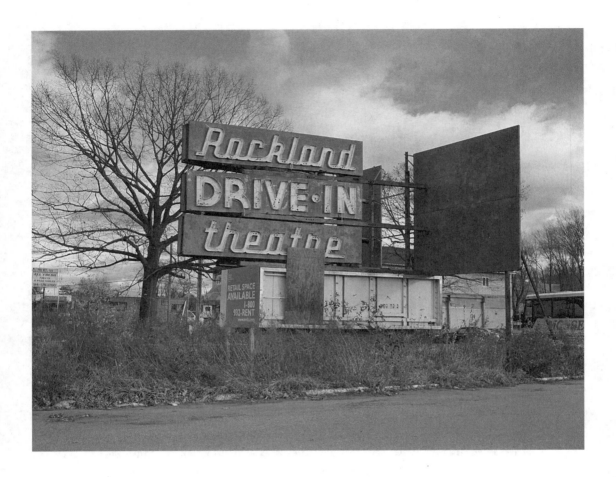

Rockland Drive-in Theatre, Monsey

The Rockland Drive-In Theatre is the most intact among the three drive-in theaters built in Rockland County; the roadside marquee and an untouched screen still stand two decades after closing. It opened in 1955, some twenty years after the outdoor movie phenomenon took root, and accommodated 1,800 cars. It may not survive much longer—Wal-Mart announced plans in 2005 for a superstore at the Monsey site. Another abandoned drive-in screen survives nearby in Blauvelt.

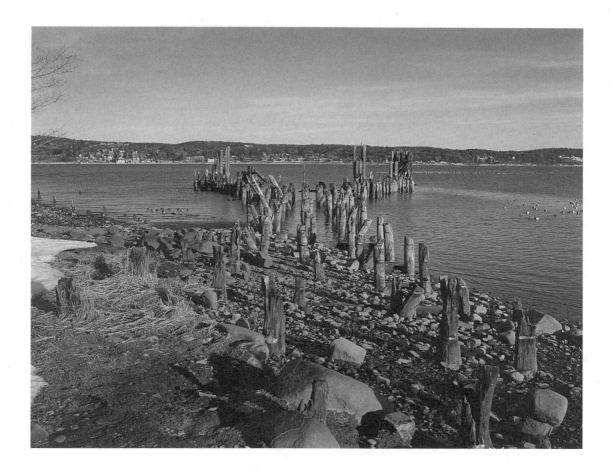

Ferry Slip, Piermont

These piles of standing timbers are among the most intact ferry slip ruins on the Hudson River. Piermont originally developed in the 1840s as the eastern terminus of the Erie Railroad, from which the company offered ferry service to New York City until it extended its tracks farther south. From 1841 to 1861 there was also a ferry between Piermont and Irvington, directly across the river. This ferry slip is thought to date from 1929, when the Irvington-Piermont Ferry Corporation revived the crossing. The company ordered new diesel ferries, the *Irvington* and *Piermont*, in 1931 and 1932. But competition from the Nyack-Tarrytown ferry just a few miles upriver drove the upstart firm out of business by the mid-1930s. A rotting hulk to the south of the slip may be that of a secondhand vessel that ran on the crossing before the arrival of the new boats. The *Irvington* and *Piermont* remain in service on Long Island in 2005.

ing began along the riverfront, particularly in the northern part of the county, and wealthy brick manufacturers built fine mansions atop the hills in Haverstraw. Stone quarrying at the turn of the twentieth century at the escarpment along the Hudson threatened the natural beauty of the riverfront, prompting the owners of estates across the river in Westchester to help form the Palisades Interstate Park Commission.

Relics of old industries can be found in parkland throughout the county. Some of the communities that developed near the old industrial sites were destroyed in the 1930s and 1940s as the parks expanded. At present large condominiums are being built along the shoreline at Haverstraw, where over forty brickyards once operated. Only scattered fragments of brick on the shore remain to mark what was one of the great brick-making centers of the world, as not one single yard in Rockland survives. Industry has not completely died out, however, as stone quarries still operate in the northeastern part of the county.

Rockland also has plateaus suitable for farming, and a few farms still exist in the early twenty-first century, but their survival is threatened by ongoing suburbanization. The suburban nature of the county increased after the opening of the Tappan Zee Bridge at the Nyack-Tarrytown crossing in 1955, enabling commuters greater access to workplaces in New York City and Westchester. Within fifteen years of the Tappan Zee Bridge's opening, the county's population more than doubled from 89,000 to 230,000. Development pressures and changing habits in shopping, entertainment, and leisure have left Rockland with a good number of ruins from the twentieth century, which stand alongside those of Dutch colonial homes and of a not-so-distant industrial past.

Dunderberg Spiral Railway, Dunderberg Mountain

High above the river opposite Peekskill can be found one of the Hudson's most obscure curiosities, ruins known to few but those who have ventured up the slopes of Dunderberg Mountain, at the south gate of the Hudson Highlands. Indeed, unmarked by any sign, the ruins are a mystery even to most who come upon them: there seems little logic to their construction. These are the remains of the unfinished Dunderberg Spiral Railway, and the fascinating story behind them, though sometimes retold in guidebooks, remains little known today.

Dunderberg Mountain's fanciful name derives from the Dutch for "Thunder Mountain." At nine hundred feet its summit provides a sweeping vista across Haverstraw Bay. From its slopes, wrote Irving, "a little bulbous-bottomed Dutch goblin" could once be heard "giving orders in Low Dutch, for the piping up of a fresh gust of wind, or the rattling off of another thunderclap."[1] As with other Highlands peaks, its rocky ter-

rain discouraged development, and by the latter part of the nineteenth century only a few small houses clung to its lower slope.

It was the Dunderberg's unmarred magnificence that in the late 1880s drew the attention of two investors from Pennsylvania, H. J. and T. L. Mumford. In 1879 the Mumford brothers had leased an abandoned mine railway in the mountains of eastern Pennsylvania, known as the Mauch Chunk Switch-back Railroad. Built in 1826, it was an engineering marvel when completed, functioning much like a similar gravity railroad built for the Delaware and Hudson Canal Company at Honesdale, Pennsylvania. The Mauch Chunk Switch-back operated for nearly fifty years before it closed in 1870.

The Mumford brothers came to Mauch Chunk with a novel idea. Industrialization in the nineteenth century gave the new working class something most Americans never had before: leisure time. Amusement parks began to spring up in cities across the country, and the Mumfords would be among the first to capitalize on an emergent trend of popular tourism. They proposed converting the old mine railway into an excursion fun ride, a "tourist attraction." Instead of coal the Switch-back would haul passengers in open cars up an incline to the top of Summit Hill. The cars would then be released to coast down the mountain, reaching speeds of fifty miles an hour. More than one of the country's first commercial amusement enterprises, the Mumfords created at Mauch Chunk what enthusiasts still recognize as the world's first roller coaster.

This stone arch was intended to carry the Dunderberg Railway's lower incline over the downgoing gravity track. Though plans called for several of these structures, only one is known to have been built.

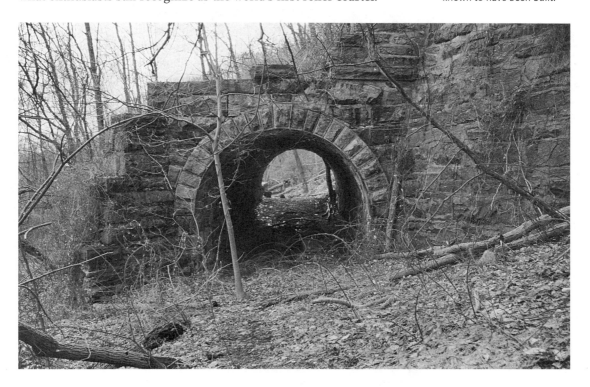

With their success in Pennsylvania, the Mumford brothers persuaded a number of New York investors to join them in forming the Dunderberg Spiral Railway, which was incorporated in November 1889. They proposed the creation of a purpose-built excursion railway and resort on the slopes of Dunderberg Mountain. Just forty miles from New York City, the Dunderberg's situation on the Hudson not only gave it views even more spectacular than those at Mauch Chunk; it also provided direct access to existing rail and boat connections from New York.

In an appeal to potential investors, the company published a prospectus in 1889 with a detailed description of its proposal accompanied by renderings of the constructed railway and a map of its route. The company chose Dunderberg for a variety of reasons, chief among them its being "the nearest to New York of any other available mountain," which they estimated placed it within three hours' journey of over six million would-be tourists.[2] Its principal market was to be the working class, the "toiling millions of people who take an outing once or oftener during the summer in search of . . . a radical change from the monotony of their daily labor." It was a market where, they noted, "within the past twenty years, the number of excursionists has probably increased by over 500 per cent."[3]

At the foot of the mountain the Mumfords proposed a "large restaurant and hotel," along with an administration building for the company, shops for its rail equipment, and a powerhouse that would generate electricity for the entire complex. There would also be facilities for the handling of passengers from the West Shore Railroad and a large, covered pier able to accommodate three Hudson River steamers at once. At the summit they proposed a grand resort hotel. In the prospectus both hotels are depicted as large, rambling structures with tall towers and mansard roofs, comparable in style and scale to the resorts of the eastern Catskills. It is not known if architects were ever consulted for the design of these buildings. The company would also supply its own water and provide housing for its employees.

The railway itself can be described in three parts: two straight inclines, which would bring passengers to the top of the mountain, and a long, winding track on which they would coast back to the bottom. Both open and closed cars would be hauled up the inclines by cable. The lower incline was to be oriented on a north-south axis and would rise about six hundred feet, about two-thirds of the way up the mountain. Here the cars would be transferred via a loop track to an upper incline track, situated on an east-west axis, which would bring them the remaining three hundred feet in elevation to the summit and the upper hotel.

From the top the cars would coast by gravity down the mountain on a winding, roughly ten-mile journey back to the river. The "down track" was graded at slightly less than 2 percent. Three stops would be made along the way to discharge and receive picnickers and hikers.

Construction got under way in the spring of 1890, and the investors

forecast the railway's completion for the summer of 1891. For the heavy work of building, the company relied primarily on newly landed Italian immigrants. In July the company was accused of inciting a riot at a nearby asphalt plant then also under construction, which the railway investors feared would discourage business.[4] But work went on. Rock was blasted, rights-of-way were piled up, at least one stone bridge was built, and a tunnel cut through the hard stone of the "Old Dunderberg."

Then, in the winter of 1890–1891, something went wrong, and work halted never to start again. Later accounts tell of unpaid workers turning violent as the company went bankrupt.[5] The cause of the railway's failure remains unclear. The Panic of 1893 was still two years off; one source suggests the company's demise may have resulted from the collapse of a bank involved in its financing.[6] Another, more colorful (if less probable) account links the project to the World's Columbian Exposition of 1893. As the story goes, one of several sites considered for the exposition was at nearby Verplanck's Point, located just south of Peekskill on the Hudson's eastern shore. After Congress awarded the exposition to Chicago, the impetus for the Dunderberg Spiral Railway was gone, and its backers walked away. This theory, while persistent—it was even recounted by the *New York Times* in the 1930s—appears to have no basis in fact.[7] Surely such a selling point would have been advertised by the builders in their prospectus, or mentioned in some of the period descriptions of the project that appeared in newspapers and engineering journals. To date, no such documentation has been found.

Soon the abandoned railway began to return to nature. Trees took root on its old rights-of-way, moss grew over stone retaining walls, as the mountain quickly healed its scars, and the remains of the Dunderberg Spiral Railway fell into ruin. In 1913 the Palisades Interstate Park Commission added parts of the Dunderberg to the newly created Bear Mountain State Park. By 1940 most of the former right-of-way had been acquired by the park and opened to the public. The realignment of Route 9W and a quarrying operation at the foot of the mountain destroyed whatever parts of the project may have been built there. Otherwise the mountain has been left undisturbed since the day the workmen walked away.

The railroad completed piled stone rights-of-way over much of the proposed route before construction halted.

Today gaps where the right-of-way was left incomplete make it difficult to hike the route in its entirety. But the finished portions of the railway remain remarkably intact, still an impressive feat of man power and engineering. In addition to rock cuts and graded rights-of-way, hikers can also visit the ruins of a stone arch that was to carry the lower incline over the down track, as well the

This loop was graded to exit the unfinished upper tunnel.

tunnel left incomplete when work was halted, but not before the men had drilled nearly one hundred feet into the side of the mountain.

Perhaps partly inspired by the Mumfords' attempt at Dunderberg, a number of similar but less ambitious projects arose elsewhere along the river. In 1892 the Otis Elevating Railway began operating to bring patrons to the famous Catskill Mountain House. Ten years later the Mount Beacon Incline Railway opened in conjunction with a midsize mountaintop resort near the north end of the Highlands, at Beacon. The year 1915 saw the opening of the Bear Mountain Inn at Bear Mountain State Park, just three miles upriver from Dunderberg, a resort similar in scale to the upper hotel proposed by the Mumford brothers three decades earlier.

One can only speculate as to what the future might have held for a completed Dunderberg Spiral Railway. In the twentieth century, changing tastes and trends led to new ideas about tourism. The Mauch Chunk Switch-back closed in 1933; its abandoned grades are now popular terrain for mountain bikers. While the Bear Mountain Inn has remained successful, most of the Hudson's grand old resorts—such as the Overlook Mountain House and Westchester's Briarcliff Lodge—could not keep pace and were forced to close. Both the Otis Elevating and the Mount

Beacon Incline railways were eventually abandoned, and today their ruins make an interesting juxtaposition with those at Dunderberg.

Gaining momentum in the early 1900s, the conservation movement shunned such commercial exploitation of nature, and mid-twentieth-century writers rejoiced at the Dunderberg Spiral Railway's demise. "Hikers today benefit from this failure," wrote one in the 1940s.[8] And in 2005, more than 115 years after the failed venture of H. J. and T. L. Mumford, a Westchester-based developer's proposal to build a cable car on High Tor Mountain, eight miles south of Dunderberg, brought the instant ire of the Rockland County Conservation Association. "It should not be turned into an amusement park ride," the association's president said of High Tor.[9] Regardless of what might have been, the ruins of the Dunderberg Spiral Railway make for one of the most interesting hikes in the Hudson Highlands today.

Rockland Lake

The rise and fall of the village of Rockland Lake is tied to three of the most influential themes in the history of the Hudson Valley. Large-scale commercial ice harvesting on the Hudson got its start at Rockland Lake; later, quarrying and the conservation movement locked horns here. Like other towns and hamlets caught in the expansion of state parkland, the village of Rockland Lake has itself largely disappeared. Today ruins of this lost community can be found standing beside those left behind by the ice harvesters, quarrymen, and park planners.

The village of Rockland Lake is situated opposite Ossining some thirty miles north of New York City, by the shore of the spring-fed lake for which it is named. Between the lake and the Hudson stands Hook Mountain, which rises more than eight hundred feet above the river. Dutch sailors who faced strong headwinds on the river here called this area Verdrietige Hoogte, or "Difficult Point." The lake itself was called Quaspeck or Snedecker's Pond before it became formally known as Rockland Lake in 1835. From its north end a clove descends to the river below, to an area once called Slaughter's Landing after John Slaughter, who settled here in 1711.

The earliest major enterprise to develop at Rockland Lake was ice harvesting. The commercial ice business in the United States began at Boston in 1805, and within a few years there arose a growing demand for ice at New York City. But the Hudson below Poughkeepsie was too brackish and polluted to provide suitable ice, so commercial ice harvesters looked to freshwater lakes near the city. With a surface area of 256 acres, and relatively easy access to a boat landing just thirty miles above Manhattan, Rockland Lake fit the bill perfectly. In 1831 Nathaniel Barmore, John Felter, and Peter Gasque sent the first ice harvest down from Slaughter's

Landing.[10] Two years later they incorporated their holdings as Barmore, Felter and Company. By 1838 they installed a wooden chute to bring harvested ice down through the clove to the landing, where it was loaded onto barges for shipment.

Soon other ice companies appeared at Rockland Lake. The village grew as demand increased. By 1842 it had its own post office. The following decades saw great competition in the ice industry, and by 1855 the three principal companies then operating at Rockland Lake merged to form the Knickerbocker Ice Company. Within the next decade, increased demand led to the appearance of more icehouses on the upper Hudson, until by the 1880s more than one hundred icehouses stood on the river above Poughkeepsie, several of them owned by Knickerbocker. But issues of pollution remained problematic for river ice, and the company marketed its Rockland Lake product as superior for its purity.

After its incorporation Knickerbocker immediately made improvements to its Rockland Lake facilities. These included the construction of an inclined railway, built between 1858 and 1860 to replace the old wooden chute. Near the lake the company built two immense new icehouses, which raised storage capacity to as much as 100,000 tons.[11] To bring such massive quantities of ice to market, the company maintained a fleet of eighty specially built ice barges.[12]

Although yearly output increased through the 1880s, the industry never truly fulfilled demand, and harvesting yields varied with the

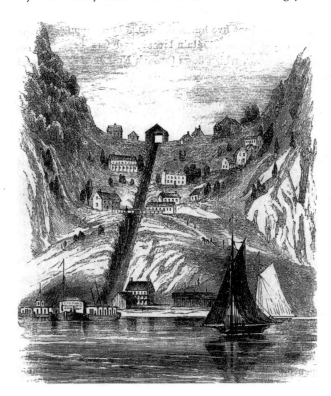

A view of the incline railway from Lossing's *The Hudson From the Wilderness to the Sea*, published in 1866.

The incline railway right-of-way in 2005. The view is east toward the river.

weather. Doubts raised by serious pollution issues at the turn of the century led to the increased popularity of machine-made ice, which quickly slowed demand for natural ice. In an effort to survive, many ice companies consolidated at this time, and the American Ice Company assumed control of the Rockland Lake icehouses in 1899. But within a few decades the introduction of electric refrigeration doomed the industry once and for all. Rockland Lake's last harvest occurred in 1924. Two years later the icehouses were demolished using dynamite, which set off a brush fire that destroyed a dozen village residences as well.[13]

As ice harvesting went into decline, another industry, traprock quarrying, arose at Rockland Lake to fill the void. Quarrying had a long history in Rockland County. Three miles south of Hook Mountain, quarries opened at Nyack in 1785, and within two decades business thrived as the New York market grew steadily larger. In the nineteenth century Rockland quarries supplied stone for everything from dock construction to architectural finishes such as windowsills, lintels, mantels, and stoops.

By the late 1830s, Jacob Voorhis owned two quarries at Hook Mountain, and Peter White ran a third operation. Together they shipped about twenty-eight thousand tons of stone annually.[14] Business declined some-

what in the 1840s but experienced a revival later in the decade supplying contracts for the Hudson River Railroad. As late as the 1890s, quarrying operations at Hook Mountain remained relatively small in scale, with most of the work done by hand, taking ten to fourteen days to load a single scow with four hundred cubic yards of stone for shipment.[15] But at the end of the nineteenth century, new machinery enabled the quarries to operate on a much larger scale. As increased road construction brought an almost insatiable demand, modern quarrying operations began to cut highly visible gashes into the Palisades and Hook Mountain.

The destruction of the Hudson River shoreline of northern New Jersey and southern Rockland County became a major issue for conservationists in the 1890s. Quarrymen made powerful enemies among wealthy estate holders, whose homes in southern Westchester looked across the river at the rugged cliffs of the Palisades. In the last years of the century a movement led by groups such as the New Jersey Federation of Women's Clubs devoted itself to stopping the quarries. Particularly instrumental in this cause was George W. Perkins, who helped form the Palisades Interstate Park Commission in 1900. With financial and political assistance from some of the most influential men in the country, including John D. Rockefeller, Sr., whose estate, Kykuit, bore daily witness to the destruction, the PIPC put a stop to quarrying on the Palisades by buying out the quarrymen and setting the land aside as the Palisades Interstate Park.

But just a few miles upriver the destruction of Hook Mountain continued. The beginnings of large-scale quarrying at Rockland Lake can be traced to 1887, with the arrival of Wilson Perkins Foss (1856–1930), an explosives manufacturer who first came to nearby Haverstraw to supply dynamite for tunnel construction on the West Shore Railroad in 1882. In 1890 Foss acquired an interest in a Hook Mountain quarrying operation run by Andrew Cosgriff. Four years later Cosgriff and Foss were joined by Jacob Conklin. Eager to modernize, Foss and Conklin urged Cosgriff to undertake improvements that would increase capacity. But Cosgriff resisted, until finally Foss and Conklin forced him out of the partnership, forming the Foss and Conklin Company in 1897. The firm immediately modernized and expanded, and by 1899 had evolved into the Rockland Lake Trap Rock Company. At around the same time two other large quarrying concerns came to Hook Mountain: the Manhattan Trap Rock Company and the Clinton Point Stone Company. In 1912 Foss's Rockland Lake Trap Rock joined the Clinton Point company to form the New York Trap Rock Company.[16]

A movement to stop the destruction of Hook Mountain gathered steam around 1900 but made little headway until 1906, when Rockefeller and others successfully lobbied for the PIPC to acquire land north of the Palisades, including Hook Mountain.[17] The quarrying interests kept the matter tied up in litigation for another decade, during which time the blasting continued. But the state ultimately prevailed, acquiring

the Manhattan Trap Rock Company's Hook Mountain property in 1911,[18] and by 1917 purchasing the land of the New York Trap Rock Company through eminent domain. The latter company retained the right to operate at Hook Mountain until 1923, and in 1918 was purchased by the New York Trap Rock Corporation, a conglomerate of Hudson River quarries that took its name from W. P. Foss's defunct Hook Mountain firm.[19] New York Trap Rock remained a major presence on the river for the duration of the twentieth century.

By 1925, both ice harvesting and quarrying at Rockland Lake came to an end, and Hook Mountain State Park was born. As early as 1873 a picnic and pleasure ground called Sylvan Grove had taken advantage of Rockland Lake's picturesque setting. In the late 1920s, the PIPC began construction of a developed recreation area at the foot of the mountain, including athletic fields, tennis courts, and a large bathhouse to service a man-made beach on the river. As it did for Bear Mountain State Park beginning in 1913, the commission provided steamboat service to ferry park patrons from New York City. Despite unfortunate attempts by certain park commissioners to racially segregate the park,[20] Hook Mountain remained popular until the 1950s, when steamboat service ceased and pollution problems forced the state to ban swimming in the Hudson.

In 1958, the PIPC acquired Rockland Lake and 225 surrounding acres that became Rockland Lake State Park. This time it was John D. Rockefeller, Jr., who helped finance the purchase, along with the Rockefeller Brothers Fund and the Jackson Hole Preserve. About one hundred people lived in the village then, including some who had worked in the ice industry at the turn of the century. Lot by lot, the state purchased

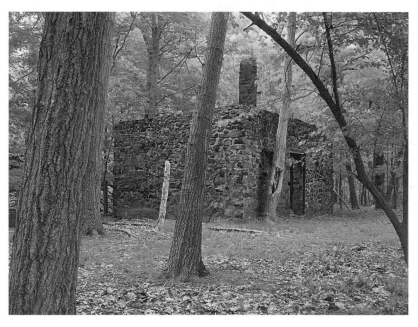

This ruined stone building atop Hook Mountain is thought to have been built to store explosives for the quarry operations.

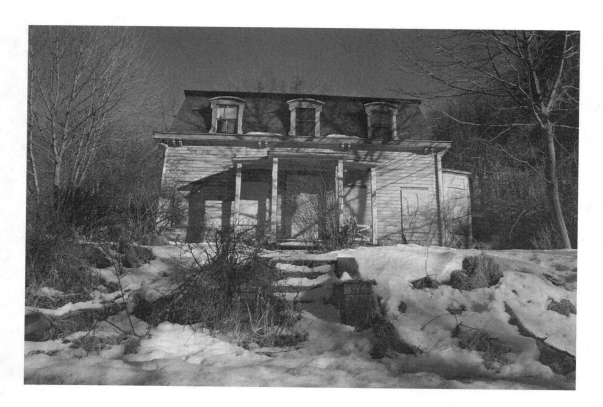

The home of Josephine
Hudson, said to be the only
woman who worked on the
ice. The house has been
empty since her death in
1993.

homes, churches, and commercial buildings around the lake, most of
which were eventually demolished as the old village faded from the map.
To replace the lost swimming facilities on the river, in 1965 the state
opened a large public swimming pool by the lake complete with a bath-
house and parking for three thousand cars. Rockland Lake's post office
closed shortly afterward.

Rockland Lake is one of several Rockland County communities that
vanished in the twentieth century in the name of conservation. The cre-
ation of public parks in this part of the Hudson Valley did not always
mean the conservation of pristine wilderness. Instead, quite a few exist-
ing villages and hamlets were condemned and erased from the land-
scape. These small towns found themselves caught between a rock and
a hard place as the conservation movement tried to reconcile the conflict
between a desire to preserve open space and an onslaught of industrial
and later suburban development.

Today only a few inhabited buildings remain at Rockland Lake. Other
communities weren't so lucky. A little more than ten miles upriver, foun-
dation ruins are all that remain of a village called Doodletown. Other
towns lie beneath artificial lakes created by the PIPC. To the west in
Harriman State Park were Sandyfields, a pre-Revolutionary settlement
whose last residents left in 1942 to make way for Lake Welch, and Johns-
town, now covered by Lake Sebago and Lake Kanawaukee. Family cem-
eteries knowingly look out across these tranquil man-made water bod-

Early-twentieth-century wallpaper in an abandoned
house in the old village of Rockland Lake.

ies, telltale signs of the lost villages below. Baileytown, Pine Meadows, Queensboro, and Woodtown are among other mountain hamlets that have disappeared.

Rockland Lake, Hook Mountain, and the adjacent Nyack Beach state parks today total 1,816 acres, throughout which remain ruins left over from the ice industry, the quarries, and even from the early development of Hook Mountain State Park. Foundations of vast icehouses large enough to cover a football field can still be seen at the northeast corner of Rockland Lake. The stone retaining walls of the incline railway survive in two sections (a paved road cuts across the ruins). Atop Hook Mountain stand the solid walls of a small stone building that may have been built as a powder house for one of the quarries. Nearby, metal stakes in the cliff face mark locations where workers climbed down to set dynamite. Below the mountain near the river stand the ruins of stone bathhouses built as part of the park, abandoned since the closing of the beach.

Near the old village center, a few odd foundation ruins can be seen not far from the top of the incline railway. A short distance above these is the Wells family cemetery, abandoned for many years but recently restored as a scout project. Just south of the village stands an abandoned house that was once the home of Josephine Hudson, said to have been the only woman to have worked on the ice, where she helped to bring ice cakes to the houses for storage.[21] The home is a simple box of a house with a mansard roof and dormer windows. After Mrs. Hudson's death in 1993 the house was deeded to Palisades Park and boarded up; it remains empty today, though the state is accepting requests for proposals for its lease and use.

Though only empty lots remain where St. Michael's Church and the village commercial district once stood, a few old homes remain inhabited. The Knickerbocker Fire Engine Company, still active, stands near what was the center of town, and the village school is now leased to the Venture Academy, a school for disabled students. Scars from the old quarries remain visible from across the river. The parks today are popular with hikers, who can climb to the top of Hook Mountain for sweeping views of the Hudson River, and visit a variety of ruins that speak for a time when three important movements in the river's industrial and cultural history crossed paths here.

WESTCHESTER COUNTY

WESTCHESTER COUNTY MAY WELL BE the most famous Hudson Valley county, prospering by virtue of its proximity to New York City and association with famous personages past and present. One of its first European settlers was Adriaen van der Donck, the only lawyer in the colony of New Netherlands, who acquired twenty-four thousand acres known as Colen Donck in 1646. His house stood near Spuyten Duyvil, opposite the northern tip of Manhattan. Van der Donck's title, *Jonkheer*, meaning "gentleman" or "squire," was corrupted to give name to the city of Yonkers.

The abundance of streams gave rise to many water-powered mills and rapid development of the surrounding area. By the end of the seventeenth century, most of Westchester's thirty-mile stretch of Hudson River shoreline belonged to two families, the Philipses and the Van Cortlandts. They built manor houses and mills at Yonkers, Sleepy Hollow, and Croton and leased their acreage to tenant farmers of European descent, while enslaved Africans operated the mills and sailed sloops carrying trade cargo to market. Westchester was bounded on the east by the Long Island Sound and by Connecticut, which contested the early boundary. The town of Westchester, situated in the present-day borough of the Bronx, was the first English settlement in the county and also the county seat until the courthouse burned and a new one was built in White Plains in 1759.

Westchester was devastated in the Revolutionary War as it was a middle ground between the British-held New York City and patriot-held lands above Peekskill, and little architecture survives from the prewar period. Although the Philipse and Van Cortlandt families were on opposite sides during the Revolution, their vast manors were both broken up into smaller parcels in the eighteenth century. The holdings of the Tory

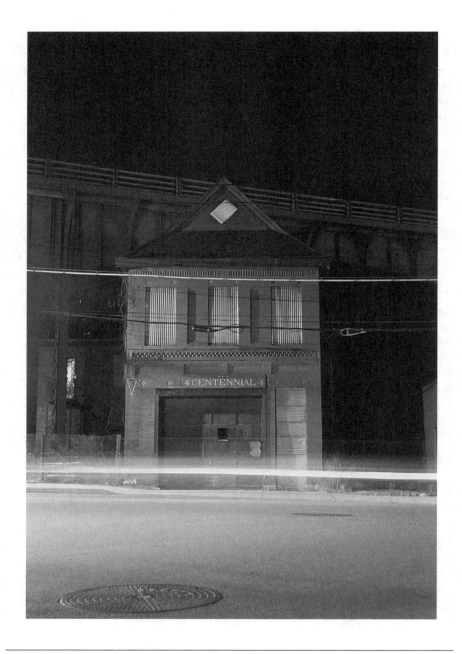

Centennial Hose Company No. 4, Peekskill

This two-story brick building was erected in 1890 and named for the nation's one hundreth anniversary, the year Company No. 4 was organized. Built to house early, small firefighting equipment such as a four-wheel side-bar carriage, it was deemed too small for modern trucks and closed in 1977. A notable original feature, a hose-drying tower, was shorn off in the mid–twentieth century when a new Route 9 overpass was built several feet above the building's roof. This area near Peekskill's waterfront is planned for redevelopment that may see a mix of adaptive reuse and demolition of historic buildings.

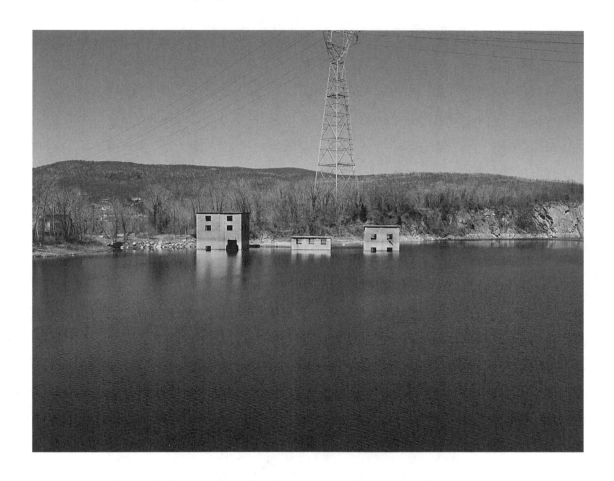

New York Trap Rock, Verplanck

The Verplanck Pulverized Limestone Company operated here in the early twentieth century and was eventually overtaken by the giant New York Trap Rock Corporation. The Verplanck quarry closed in 1956. Three years later, a marina was proposed for the flooded quarry pit, which would have been connected to the river by an artificial channel. This plan was not executed. The quarry site today includes old crusher buildings standing oddly submerged in the quarry pit. Other ruins related to the quarrying operation stand by a derelict dock on the riverfront.

FL9 Locomotive No. 2005, Harmon

Metro-North Commuter Railroad's fleet of FL9-type locomotives was built between 1956 and 1960 for the New Haven Railroad, by General Motors' Electro-Motive Division. Their iconic, streamlined styling was originally developed in the 1930s, and featured details such as porthole windows and polished stainless steel ventilation grilles. After the New Haven consolidated with the New York Central and Pennsylvania railroads to form the Penn Central in 1968, these locomotives became a familiar sight on the Hudson River, hauling passenger trains to and from Grand Central Terminal. Extraordinarily reliable, they remained in regular service until 2002. After their withdrawal, a number of these engines were brought to Harmon, just north of the large rail yard at Croton-on-Hudson, to await the scrap heap.

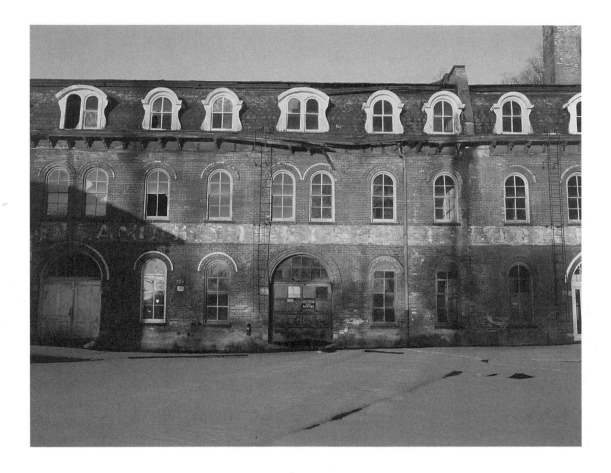

Brandreth Pill Factory, Ossining

The Brandreth Pill Factory, begun in 1836, survives as one of Westchester County's best-preserved early-nineteenth-century industrial developments. Benjamin Brandreth (1809–1880), an English immigrant who helped pioneer the use of testimonials in national advertising, manufactured popular laxative pills: the product was mentioned in Herman Melville's novel *Moby Dick*, and in Edgar Allan Poe's essay "Words With a Mummy."

The largest remaining building is this three-story brick edifice in the French Second Empire style with a mansard roof and dormer windows; it was built in 1872 for the production of Allcock's Porous Plasters. In the twentieth century, the company diversified production, and the renamed Allcock Manufacturing Company produced Havahart animal traps until it closed in 1979. In 2001, developers purchased the 1872 factory with plans to reuse it for condominiums, though the buildings remain vacant in 2006. Other surviving Brandreth buildings comprise an active industrial park, including an 1836 Greek Revival storage building.

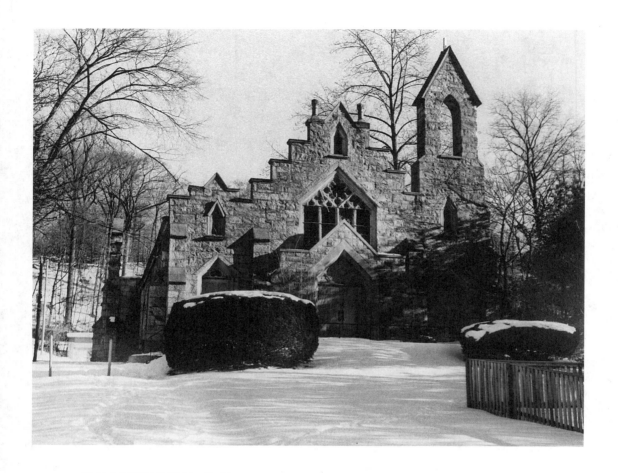

Immaculate Conception Church, Irvington

Built in 1853 by the Irvington Presbyterian congregation in just three months, this stone edifice was enlarged by the Catholic Church, which took over the building in 1873. The design of the church appears to have been inspired by plans for English Gothic Episcopal churches. The stepped gables were likely implemented as homage to Sunnyside, the nearby home of author Washington Irving, where he lived until his death in 1859; Irving's home was embellished with stepped gables to evoke a romanticized interpretation of Dutch Colonial architecture. A fire in 1970 destroyed much of the apse and chancel of the church, but the nave remained intact. The congregation erected a newer church building while the stone ruin sat abandoned for over twenty-five years. The church walls were dismantled in 1996 and the stone salvaged for reuse; surviving interior architectural details were sold for reuse at a Connecticut friary.

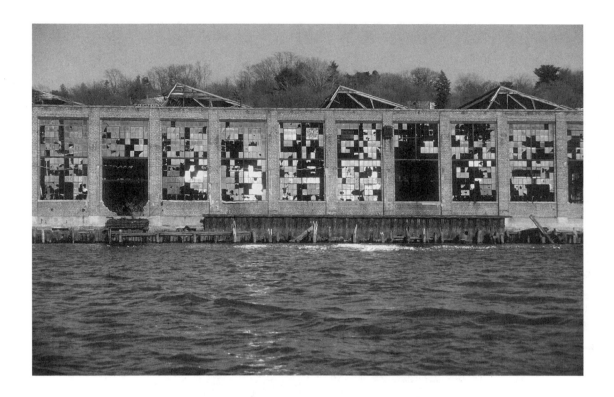

Anaconda Wire and Cable Company, Hastings-on-Hudson

The Anaconda Company, an international mining firm, produced copper wire at this Hastings plant, begun in 1898 by the National Conduit and Cable Company. Much of the site was rebuilt during an expansion c. 1912 with functionally designed low brick buildings topped with stepped gables and monitor roofs.

The Anaconda factory contributed to the notoriously polluted waters of the Hudson by leaking suspected cancer-causing pollutants known as polychlorinated biphenyls (PCBs). In 1973, Anaconda paid a $200,000 fine for violating the Refuse Act of 1899; two years earlier the U.S. attorney for the Southern District of New York had brought forth a one-hundred-count suit based on information gathered by the Hudson River Fishermen's Association and Fred Danback, a plant employee who reported pollution but was ignored by Anaconda. The site closed in 1975, and much of the complex has recently been demolished along with an adjacent dye works.

Saw Mill River Parkway Service Station, Yonkers

Straddling one of Westchester County's busiest north-south roads stand two rustic service stations, abandoned since 1980. Architect Clinton Lloyd designed the western service station, built in 1932, six years after the first section of the Saw Mill River Parkway opened. Frequent collaborator Gilmore Clarke supervised construction of the county parkways and designed the landscaping of a shaded pump station behind the building, placed out of sight of motorists.

The Westchester County Parkway system serves as a model for such roadways, and was the first of its kind to be developed. Unlike previously existing roads that grew out of old carriage paths, the parkways were designed specifically for automobiles. Built along streams or rivers, the new roads were laid out with meadows and trees planted to create a parklike atmosphere. Real estate investors also supported the parkways, as suburbs were developed nearby.

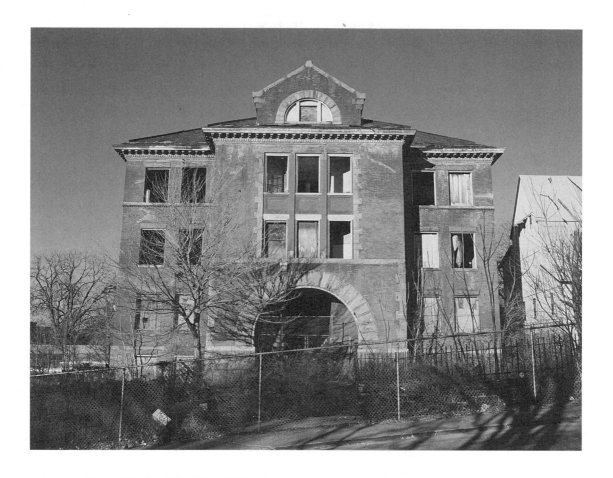

Public School 6, Yonkers

Public School 6 is one of a number of school buildings architect that C. C. Chipman designed in
Yonkers. The three-story brick building is embellished with a rough-hewn stone-arched entryway and
stone quoins. The school closed in 1986 as a result of a massive integration lawsuit, which found that
unlawful segregation by the city of Yonkers in housing and education had denied equal opportunities
to Blacks and Latinos. Elementary school students were then bused to "magnet" schools and inte-
grated into the public school system. School 6 sits within a key redevelopment zone near the Hudson
River and is threatened with demolition for commercial redevelopment.

Philipse family were confiscated and sold at auction in 1785, while the Van Cortlandt manor was subdivided by heirs.

Many of the small farms on the old manors were later sold to speculators or, beginning in the 1830s, for development as country estates. The development of estates began in earnest in the 1850s after the construction of the Hudson River Railroad. New York businessmen who called the county home included the Goulds, the Morgans, and later the Rockefellers. To design their estates they sometimes hired the country's leading architects.

Industry too flourished in Westchester. European immigrants who worked in the nearby plants, or on the large estates, inhabited handsome mixed-use buildings in village centers. Much of the historic building stock was lost in the 1960s and '70s through urban renewal, a failed effort aimed at bringing business activity to downtowns as large commercial strips and malls were built in the suburbs.

Although a few Westchester industries still operate on the Hudson, particularly in the southern and northern parts of the county, the closure of General Motors's plant at North Tarrytown in 1996 left little doubt that the Hudson's age of industry was nearing the end. Soon after, the village renamed itself Sleepy Hollow, a name made famous in the writing of Washington Irving, in hopes that tourism would be the "next big thing" on the river.

In recent years many of the last remaining great riverfront estates and former industrial sites have been targeted for high-end condominium development. Whereas earlier developments produced apartment complexes built for the middle class, communities in search of an immediate financial fix to supplant the lost tax revenues of the big factories have more recently given themselves over to developers who are charting a different course for the next hundred years, and many young people are finding it difficult to afford to live in the area where they grew up. Though some handsome old riverfront industrial buildings have been adaptively reused, others continue to disappear.

Mount Saint Florence, Peekskill

When Mount Saint Florence opened at Peekskill in the 1870s, it was among the first large Catholic institutions to appear in the Hudson Valley. By the 1930s there seemed almost too many to count: in addition to convents and reform schools such as Mount Saint Florence, the Catholic Church built colleges, seminaries, hospitals, nursing homes, retreat centers, and scores of other institutions that lined the river from New York City to Albany. Mount Saint Florence closed a century after it opened, one of several such institutions to wind up abandoned in the 1970s and '80s. Though encroaching sprawl later led to the destruction of several

historic buildings on the site, two survived to be successfully adapted for residential development.

Before the 1870s, the Mount Florence property belonged to Daniel H. Craig, who from 1861 to 1866 served as president of the Associated Press. Craig began developing the land in 1865, building a bracketed Italianate mansion, a gatehouse, and a barn and greenhouse complex. He named the property Mount Florence for his only daughter, Florence, who had tuberculosis, and he made extensive improvements to the grounds to aid her recovery. Though the identities of Craig's architect and landscape designer are unknown, a detailed map preserved at the Library of Congress shows that the estate followed in the romantic tradition promoted first in the Hudson Valley by figures such as A. J. Downing.[1]

Craig lost his fortune in the early 1870s. He devised a scheme to pay off debts by selling ownership shares in the estate. But the plan failed, and Craig's creditors foreclosed on the property, selling it to General Marshall Lefferts. For some time Mount Florence sat derelict, a fate not uncommon among the grand estates of Westchester County, which had appeared by the dozen after the opening of the Hudson River Railroad in 1849. Some residents, such as Craig, found they could no longer afford such extravagant homes; others put their properties up for sale as places like Newport and Long Island became more fashionable. A newspaper reporter who toured the property in 1874 provided a romanticized description of its path to ruin: "The shadows of evening were settling down on the grounds and pathways where decay's effacing fingers have swept the lines, but have added a charm to the beauty, rarely seen in the prosperous Northern or Western states."[2]

In 1875, the Roman Catholic Order of the Sisters of the Good Shepherd purchased the 120-acre property and established a novitiate for the purpose of training "Sisters for the work of caring for and reforming those of their own sex who have fallen from virtue."[3] Founded at Caen, France, in 1641, the Sisters of the Good Shepherd had expanded their mission to New York in 1857, setting out to reform and rehabilitate young women "regardless of race, creed, or color."[4] In 1861 they established a convent at East Ninetieth Street in Manhattan. In contrast to the punitive approach then favored for dealing with juvenile offenders, the Sisters based their educational philosophy on progressive reforms to focus on the individual, whom they believed could be helped by a caring mentor trained to observe, converse with, and learn about the person in need of help.

Easily accessible by rail from New York City, Peekskill's bucolic setting opposite Dunderberg Mountain made it an ideal location for those seeking a fresh-air retreat from urban frenzy and vice. Mount Saint Florence served also as a retreat for tuberculosis patients and a farm to supply produce for the New York convent. The Sisters retained Craig's name for the property, later adding the word "Saint" (though it remained

known variously as "Mount Florence" and "Mount Saint Florence" for as long as the Sisters remained here).

Within the next few decades a multitude of reformatory and other institutions sprang up all over the Hudson Valley, many of them built by the Catholic Church. Well into the nineteenth century, Catholics had been a distinct minority along the Hudson. The first Catholic church to appear on the river above New York is thought to be the tiny Chapel of Our Lady, built at Cold Spring in 1834 for workers at the West Point Foundry. From that point forward industrialization brought droves of Catholic immigrants from Ireland and then from southern and eastern Europe to build railroads and later to work the quarries, brickyards, and cement plants that stood along the entire course of the river.

By the 1930s Catholicism had become as prominent an institution as any, religious or secular, on the river. Like other social institutions, the church often took over old estates whose owners by choice or obligation had moved on. "The Roman Catholic Church owns more land on the shores of the Hudson than any other religious organization," wrote Carl Carmer in his 1939 book *The Hudson*.[5] At Riverdale there was Mount Saint Vincent, a convent and school built in 1855; at Poughkeepsie stood the Jesuit seminary called St. Andrew-on-Hudson, opened in 1903; across the river at West Park was the Mount Saint Alphonsus Redemptorist Seminary, built the following year. The list went on. Wrote Carmer: "From beautiful safe Maryknoll, near Ossining, the Foreign Mission Sis-

The Saint Germaine Home, south front gable with campanile-like tower.

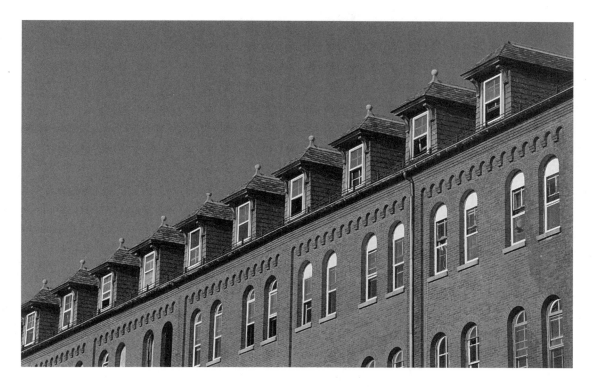

Dormer windows on west facade of the Saint Germaine Home.

ters of St. Dominic go to far and dangerous lands. At Newburgh the residents of the Oblate House of Philosophy sit deep in religious contemplation. At West Park the Sisters of the White Cross conduct an orphan asylum not far from the retreat of the Christian Brothers of Ireland. At New Hamburg are the Augustinian Fathers; at Nyack, the Sisters of Our lady of Christian Doctrine; at Beacon, Ursuline nuns. Barrytown has its St. Joseph's Normal Institute. . . ."[6]

These institutions usually preserved the character of the parklike landscapes they inherited. The Sisters of the Good Shepherd maintained the former Craig estate much as they had found it until the 1890s, when they expanded their use of the site to include a reformatory for orphaned and dependent girls. They called the school the Saint Germaine Home. In 1897 they built a large three-story brick building that provided classroom and dormitory space for the school. The new building's main gabled facade bore Romanesque details and was dominated by a tall, campanile-like tower to one side.

In 1927 the Sisters hired Frank J. Murphy, a New York architect known for his Catholic institutional work, to design two additional buildings.[7] Murphy situated these structures to complement the existing 1897 classroom and dormitory building, which required the old Craig house to be moved several hundred feet from its original site. The new buildings included a large convent for the Sisters, built to match the 1897 structure, with round-arched windows and brick corbeling along its gabled roofline. Between these near-twin structures Murphy built

A typical dormitory room at the Saint Germaine Home.

This cornerstone for the Saint Germaine school and classroom building marks the Sisters' initial expansion campaign. September 2001.

a large brick chapel, whose Renaissance-inspired facade featured a simple pediment surmounted by an octagonal, domed cupola. Later works by Murphy included buildings for the St. Agnes Hospital at White Plains (1931) as well as the St. Luke's (1936) and Frances Schervier hospitals (1937), both in the Bronx.

While Mount Saint Florence continued primarily to serve girls under the age of sixteen referred to the school by city agencies, in 1928 the Sisters of the Good Shepherd again hired Murphy to develop an adjacent property known as Villa Loretto, which they used as a school for young women between the ages of sixteen and twenty-one. In September of that year the New York convent closed, and three hundred children moved to the two Peekskill sites. The Welfare Department of New York City provided assistance with tuition. Upon reaching the ages of eighteen or twenty-one the students left the school and found work with the help of the school's Social Service Department. Some of the young women took to religious life and returned to Mount Saint Florence to become Magdalenes and live at the convent. Enrollment varied from year to year, but by 1952 over fifteen thousand children had been educated and cared for at Mount Saint Florence. Enrollment that year reached 180 students.[8]

By midcentury, the school was one of 370 of its kind run by the Sisters of the Good Shepherd throughout the world, and one of twelve in the New York–New Jersey–New England region. New educational buildings added in the 1950s were more austere in design, without the decorative elements or ornate brickwork of the earlier buildings. Other buildings on the property included a boiler house and laundry, a gymnasium, and a farm and greenhouse complex probably retained from the original devel-

opment of the estate. The Sisters of the Good Shepherd continued to use the property as a convent and school until the entire facility closed in 1978.[9]

For eight years the property lay abandoned. Then, in 1986, development began to close in. Construction began that year on a complex of town-house-style condominiums to be built in phases across the property's open lawns. Suburban development had already begun to reshape Westchester County's pastoral landscape by the 1850s, as was manifested even in the creation of the Craig estate in 1865. In the twentieth century, Westchester's population multiplied fivefold, bringing dense suburban development clear past the village of Peekskill near the county's northern border.[10] This population growth put intense pressures on underutilized historic properties such as Mount Saint Florence.

Initial plans called for the site's historic structures to be incorporated into the new development. In 1987 an attempt was made to get the buildings listed on the National Register of Historic Places. The buildings were added to the state register at that time, but concerns about the proposed condominium development effectively prevented the federal listing. Financial difficulties meanwhile caused two developers to back out after only part of the proposed condominium complex was completed. Shortly thereafter another developer, ironically calling itself Chapel Hill Development, came along with plans to raze all the convent buildings. Chapel Hill completed a second phase of condominiums but then walked away from the project after the city government insisted on preserving at least part of the historic Mount Saint Florence complex. For several years more the old buildings languished, their weathering towers and cupolas standing oddly juxtaposed to the generic prefabricated siding of the adjacent condominiums.

In 2000 the Ginsburg Development Corporation arrived to complete development of the site. Ginsburg agreed to preserve the 1897 school building and the adjacent 1927 chapel but quickly demolished the rest of the historic complex, including the old Craig house. The chapel was converted to a recreation center for residents of the adjacent homes, while twenty-eight loft-style apartments took shape within the 1897 dormitory and classroom building. Though preserved, these buildings suffered extensive alterations, such as the removal of the chapel's stained glass windows, that compromised their historic integrity (Ginsburg Development donated the windows to the Peekskill Museum).

Many Catholic institutions, such as Mount Saint Mary College at Newburgh, remain in the Hudson Valley today, but Mount Saint Florence was one of several to close or decline toward the end of the twentieth century. The neighboring Villa Loretto has similarly been incorporated into a new condominium development. At Poughkeepsie, St. Andrew's Jesuit seminary closed in 1969, later to be purchased by the Culinary Institute of America, which still operates there today. And right in the

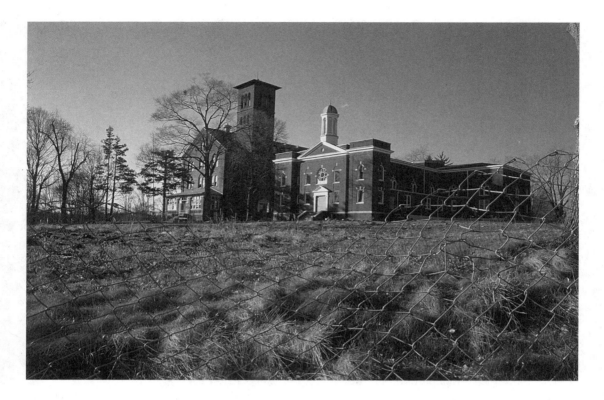

The 1927 chapel with the Saint Germaine Home in the background, shown as reconstruction began in the spring of 2002.

city of Peekskill, another Ginsburg project brought more condominiums on land formerly owned by the Franciscan Sisters. Today suburban sprawl has crept up to their very doorsteps, but the remaining buildings of Mount Saint Florence survive to recall a time when Westchester County offered a pastoral refuge from burgeoning population growth farther downriver.

Sing Sing State Prison, Ossining

One of the most historically significant ruins along the Hudson stands surrounded by high razor-wire fences and is inaccessible to the general public, though thousands of commuters pass within a few feet of its walls each day. The original 1825 cell block of Sing Sing State Prison is not closed off because of safety concerns real or imagined, as ruins generally are, but because it lies within the confines of an active maximum-security prison. Though the prison itself continues to function, a proposed museum would allow public access to the old cell block, which has gone unused since a fire left only its stone walls in 1984.

Ranked with Alcatraz and the Bastille as one of the most infamous detention houses in the world, Sing Sing is credited for being the source of expressions such as "sent up the river" and "the big house." It was

New York's third state prison, the first being Newgate at New York City, opened in 1797, the second Auburn State Prison in Cayuga County, completed in 1816. Established in 1825, Sing Sing was intended to replace Newgate, where conditions had become overcrowded and inadequate. Its role would be to house prisoners sent from Long Island, New York City, and throughout the Hudson Valley, while Auburn continued to serve the rest of the state.

For the new prison's location, the state purchased a property known as the Silver Mine Farm, situated directly on the Hudson River near the village of Sing Sing at a place called Mount Pleasant, thirty miles "up the river" from New York. The name of the prison (and the nearby village) is said to derive from a Native American word meaning "stone upon stone." As early as the seventeenth century, quarries had operated here to satisfy regional demand for stone, and the site's potential to host a quarry manned by prison labor proved the decisive factor in its selection. To oversee the prison's construction and to serve as its first warden, the state brought in Elam Lynds, warden at the Auburn prison.

Construction commenced on May 14, 1825, when one hundred prisoners arrived from Auburn to begin work. Stone quarried on-site by the prisoners provided material for the building's solid masonry walls. The massive structure took three years to build and was not completed until October 1828, one year before the opening of Philadelphia's famous Eastern State Penitentiary. Designed by local architect John Carpenter, the building stood 476 feet long by forty-four feet wide, and rose four stories in height.

Within its stone walls stood eight hundred cells built into a freestanding structure set back from the cellblock's outer walls. Each cell measured seven feet deep, three feet three inches wide, and six feet seven inches high, room enough for a prisoner to lie down, stand up, or walk three paces.[11] When completed, this was one of the largest buildings yet constructed on the Hudson River. Its basic shape resembled that of the modern textile mills then rising throughout the Northeast. But its heavy masonry walls, built of large, neatly hewn stone, remain unique to this day, with a character evocative of construction techniques used thousands of years ago.

Somewhat curiously, Sing Sing's original configuration lacked an outer wall, thus requiring guards to be especially vigilant. Alexis de Tocqueville and Gustave de Beaumont noted this unusual element of the prison's design in their 1833 work *On the Penitentiary System in the United*

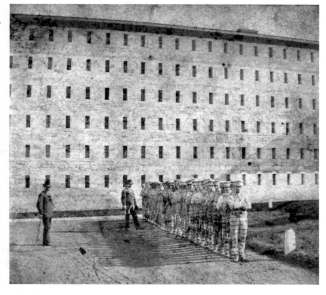

This post-1860 view shows the old cell block at Sing Sing after the construction of two additional stories.
Courtesy the Ossining Historical Society.

States, and its Application in France. The prison yard, which stood on landfill extending out into the river, was bounded by the cell block and ancillary buildings on three sides but left open to the river on the fourth. Not until 1877 did the state erect a permanent wall enclosing the entire prison.

Elam Lynds had a reputation for taking a brutally disciplinarian approach to dealing with prisoners, and historian Roger Panetta has related the cell block's design to Lynds's unsympathetic attitude toward the inmates in his charge.[12] Its unadorned facade symbolized the rigid routine of prison life. Built just a few feet above the level of the river, the cell block was constantly damp, dark, and poorly ventilated, which led to criticism from reformers including Dorothea Dix in the 1830s and '40s.

Before coming to Sing Sing, Lynds had helped to develop what was known as the Auburn system, a harsh approach to prison administration based on his belief that criminals could not be reformed. Lynds encouraged guards and keepers to mete out punishment and foster contempt within their wards, and considered flogging to be a humane form of punishment.[13] It is said that he sometimes personally administered use of a device called the "cat-o'-nine-tails," a set of leather strips attached to a wooden stick. Sing Sing continued to adhere to the Auburn system for years after Lynds's departure. Family visits were not allowed until the 1840s, and even then only on a biannual basis. Until 1912 meals consisted of hash and coffee for breakfast, bread and coffee for dinner. Prisoners could not receive letters or converse with one another or with their guards: "they must not sing, whistle, dance, run, jump, or do anything which has a tendency in the least degree to disturb the harmony or contravene the rules and regulations of the prison," quoted Sing Sing chaplain John Luckey from the prison rules in 1860.[14] Insubordination was not taken lightly. Even after the state suspended use of the "cat" in 1848, paddling, the yoke (a heavy iron restraining device), the ball and chain, solitary confinement in dark cells, and forced cold-water showers remained commonly used tools of punishment.

Prison labor continued long after the completion of the original cell block in 1828. Stone from the prison's quarry supplied a number of notable construction contracts, including the A. J. Davis–designed Lyndhurst mansion at Tarrytown, and the Smith-Robinson house at Ossining. "Sing Sing marble" is also thought to have been used in the construction of Grace Episcopal Church in Manhattan. The prison provided labor for the construction of the Croton Aqueduct (1837–1842), which ran within a short distance of its grounds, and of the Hudson River Railroad in 1848 and 1849, whose tracks still pass through the prison just a short distance from the eastern wall of the old cell block.

In a controversial practice that prevailed until 1896, the state allowed private contractors to employ inmates in shops erected on the prison grounds, where they made a variety of items including furniture, carpets, hardware, clothing, shoes, barrels, and cast-iron products. After 1896

prison labor continued under the auspices of the state, and the village of Sing Sing was renamed Ossining in 1901 at the urging of local businessmen to avoid association with goods manufactured by inmates.

Though progressive reform in the handling of prisoners began to appear in the early 1840s, change was slow in coming. A library and Sunday school appeared in 1840 only to be disbanded three years later. But gradually, the state moved away from the punitive methodology of Lynds's Auburn system and toward a philosophy aimed at reforming criminals so that they might leave the prison ready to become productive members of society.

Ultimately Sing Sing may be remembered for its association with the electric chair, whose initial development came in the 1880s under the direction of the Edison Company. In 1888 New York State became the first in the nation to adopt the chair as a form of execution. The first execution by electric chair took place at Auburn in 1890; Sing Sing administered its first electrocution the following year, and from 1914 onward it was the only prison in New York to perform capital punishment. Some of the more sensational electrocutions at Sing Sing included those of

Prisoner Charles E. Chapin, the "Rose Man," transformed the barren prison yard in front of the cell block into a small park with shrubbery and a fountain in the 1920s. Chapin also raised funds to build an aviary in the prison yard in 1929, which no longer exists.

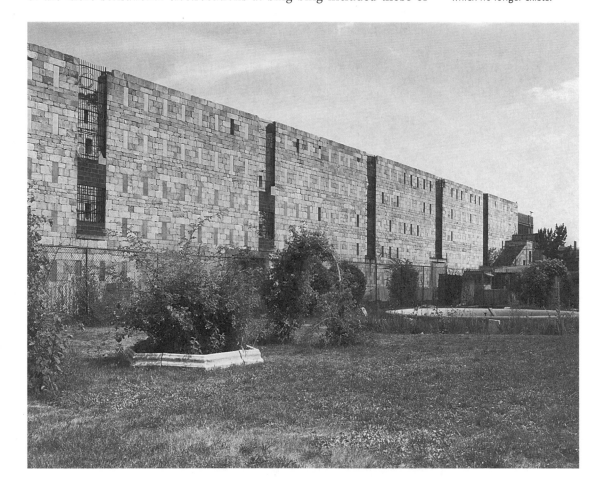

Ruth Snyder and Henry Gray, executed in 1928 for the murder of Snyder's husband. In 1953, the executions of Julius and Ethel Rosenberg, found guilty of spying for the Soviet Union, spurred global controversy. The last of 614 executions at Sing Sing took place in 1963.

Despite repeated expansions, Sing Sing remained notoriously overcrowded through most of its history. The prison added a fifth story to the old cell block in 1831 and a sixth thirty years later, bringing the total number of cells to 1,200. But by the turn of the century, conditions in the aging cell block had become so deplorable that the state made plans to close Sing Sing altogether and build a new prison about fifteen miles upriver at Bear Mountain. Land was acquired, and construction began on the new prison in 1908. But two years later the state gave the site over to the Palisades Interstate Park Commission to become Bear Mountain State Park, in response to demands for more parkland. In 1911 construction began at an alternate site, at Wingdale in eastern Dutchess County. But bureaucratic indecision halted work shortly afterward (the Wingdale property later became the site of Harlem Valley State Hospital, itself now closed), and eventually the state decided simply to make improvements to the existing prison at Sing Sing.

In 1916 state lawmakers called for the demolition of the old cell block

Cell block interior, looking north.

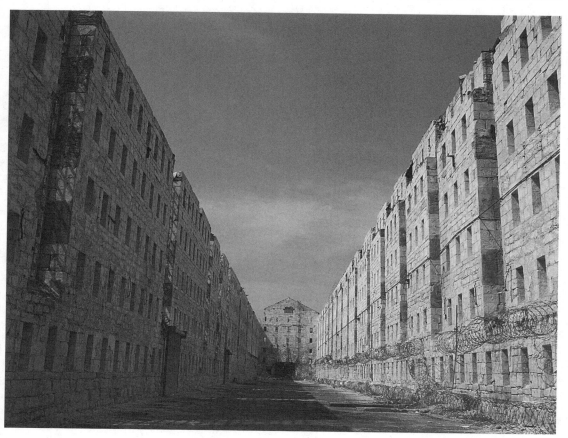

and its replacement with a new facility. Within the building, prisoners dismantled three hundred cells from 1917 to 1918. But demolition halted as overcrowding pressed the old building into continued service for nearly three more decades. Under the direction of Lewis Lawes, appointed warden in 1920, a massive expansion campaign brought the completion of new brick cell blocks on the hill to the east of the old prison. Lawes's term also saw great strides in progressive reform at Sing Sing. He arranged for celebrity guests and athletes to entertain at the prison, including Jack Dempsey, Harry Houdini, and Edward G. Robinson. At the same time, a number of big-budget films were produced on location at Sing Sing, including *The Big House* (1930), *20,000 Years in Sing Sing* (1940), and *Castle on the Hudson* (1940), which entrenched the prison's place in the popular imagination in America and throughout the world.

By the 1930s, the completion of the new cell blocks and the opening of new state prisons such as Attica and Woodbourne began to ease overcrowding at Sing Sing. But the old cell block remained in use throughout the decade. Apart from the addition of two floors, the only significant improvements made to the building since it opened were the installation of electric lighting in 1897 and the creation of large openings cut into its facade for added light and ventilation in 1902. The last prisoners were not removed until 1943, 115 years after it had opened. Thereafter the prison removed the cells and used the old building for storage space and workshops, until finally in 1984 the old building was completely gutted by fire, leaving it in its present state of ruin.

Ironically, the village that once distanced itself from the prison by changing its name is now seeking to capitalize on its presence. Local shops sell T-shirts bearing the slogan "Ossining: Home of The Grand Slammer," and since the mid-1980s, village officials have endorsed plans for a museum to be created on the little-used western half of the prison grounds, which includes the original cell block. Over the years there have been calls for the outright closure of the prison by groups and individuals citing the potential tax revenue that could be generated by commercial or residential development of the seventy-acre property. But for now Sing Sing remains open for business, after nearly two centuries one of the oldest institutions on the river.

At the beginning of the twenty-first century, county officials have revived talk of a Sing Sing museum. Under the plan, the prison's long-vacant former power plant would be made into a

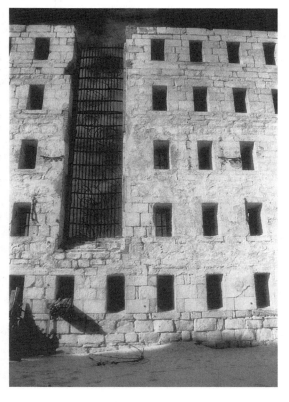

Cell block interior wall showing grating installed in 1902 for ventilation and light. This photograph was made with infrared film.

visitor center, and the old cell block would be partially restored to house re-creations of some of the original cells. Unlike other prisons-turned-museums, such as Alcatraz in San Francisco and the Eastern State Penitentiary in Philadelphia, Sing Sing is still an active correctional facility, holding over 1,700 men within its walls, and opponents of the proposed museum are wary of a return to the days when nineteenth-century tourists paid twenty-five cents to spy on inmates.[15] Those in favor of the museum, however, see not only a chance to capitalize on its world-famous name but an opportunity to encourage a sophisticated view of the role of prisons in society.[16] As talk continues about future plans, the old cell block that would be the center of it all stands silently awaiting its fate, one of the most storied ruins on the course of the river.

Briarcliff Lodge, Briarcliff Manor

From its vantage point high above the river, Briarcliff Lodge looked over a panorama of abandoned buildings. Its heyday spanned two eras, first as a glamorous resort, then as an educational institution. Situated in a neighborhood of exclusive estates, it became in abandonment one of many neglected historic sites threatened by development. After neighboring residents challenged adaptive reuse plans in the 1990s, in 2003 the once-grand hotel met the same fiery end shared by the old Catskill Mountain resorts of eras past.

Built by former carpet industry executive Walter William Law (1837–1924), Briarcliff Lodge opened on June 26, 1902. Known as the "Laird of Briarcliff Manor," Law at one time owned over five thousand acres in central Westchester County, where he built dairy barns and greenhouses. Born in England, Law immigrated to the United States in 1858, and came to Yonkers. There he found employment with the W&J Sloane Company, a carpet purveyor, serving first as a salesman and later as director.

In the 1890s, he began a gradual retirement from the carpet industry and started purchasing land near a community just east of present-day Ossining called Whitson's Corners. His first acquisition was the 232-acre Briar Cliff Farms, on Pleasantville Road. In 1902, one square mile of his real estate holdings was incorporated into an independent village, called Briarcliff Manor, which was served by the Putnam Division of the New York Central Railroad. Walter Law, said a period journalist, took "a keen interest in municipal improvement and, it is said, will spend much money to make Briarcliff Manor a model village."[17] A century later, that model village would lose its greatest landmark, Law's Briarcliff Lodge.

Just outside the village Law embarked on a new venture, the development of a resort hotel to be called Briarcliff Lodge. To design the hotel he hired Guy King (1863–1925), a Philadelphia architect who specialized in

resort and residential architecture but whose commissions also included a range of projects such as hospitals, banks, stores, and factories, primarily in Pennsylvania, New Jersey, and New York. Promotional literature for Law's new hotel called it the first of a new generation of resort hotels, one that felt less like a hotel and more like a private estate. Hotel brochures claimed it was the first such establishment in or near New York to provide its guests with long-distance telephone service; patrons would enjoy "every convenience, and every device which modern luxury demands. Without, it was to be a dream of architectural beauty; within an illustration of the refined and artistic era in which we live."[18]

King's design called for Tudor-style facades set above a main floor of brick with accents of Indiana limestone and a rubblework foundation. Foundation stones were selected from nearby hillsides and set in place with care so as to not injure their weathered, mossy appearance.[19] Red tiles sheathed the broad, dormered roof. A pergola stood off the southern end of the lodge for outdoor dining and dancing.

The original wood-frame, four-story structure contained 75 guest rooms. Law added a north wing five years later, and he again retained King to design a seven-story rear wing in 1909, which increased the number of rooms to about 220. Unlike the original section, both additions were built using concrete and framed with steel in an attempt to make them fireproof. In one of the more unusual aspects of the hotel's design, King built the taller 1909 addition to function as what was said to be the world's first "mooring pier for dirigibles," intended to facilitate the arrival and departure of guests via airship, though there is no documentation to suggest that an attempt was ever made to use the structure for this purpose.[20]

Pergola and porte cochere, main entrance to Briarcliff Lodge. Author's collection.

The property also included a variety of ancillary structures for guests and hotel staff, including a staff dormitory, the shingle-style Amusement Building that contained a bowling alley and indoor pool, and the Briarcliff Garage (similar in design to the hotel, it contained a horse stable and blacksmith shop), all built during the initial development phase in 1902. A power plant was constructed in 1907 to generate heat for the hotel as well as for sterilizing water for drinking and cooking.

Well-appointed public rooms on the first floor included the Great Hall, or main lobby, with its two stone fireplaces; two dining rooms; and the smaller Dutch Room, where guests found rich "Rembrandt effects and a veritable treasure room of rare china."[21] An adjoining foyer with Italian marble walls led to the ballroom, located in the 1909 addition; it

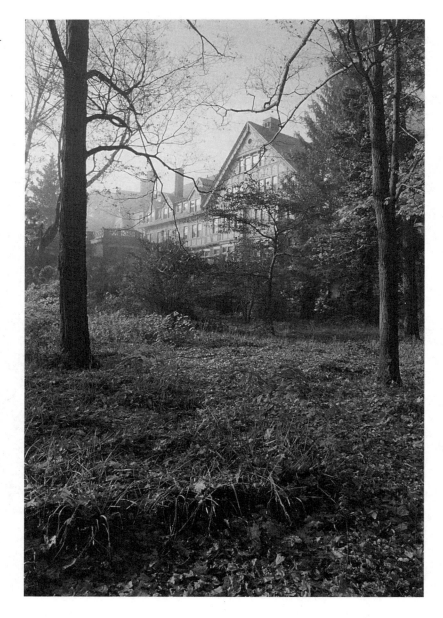

The north wing of Briarcliff Lodge as seen in the fall of 2001. This part of the Lodge was built to be fireproof and survived the arson in 2003 but was subsequently demolished along with all other lodge buildings.

featured fluted Ionic columns and large windows that opened out to a wraparound porch on three sides. A flight of marble stairs led down to the Mirror Room, whose mirrored columns cast brilliant rays of sunlight in diagonal patterns across the floor at sunset.

To landscape the extensive grounds around the hotel, Law hired the prolific Olmsted Brothers firm. Formed in 1898, the firm's principals were John C. Olmsted (1852–1920) and his younger half brother, Frederick Law Olmsted, Jr. (1870–1957). From its inception the firm inherited the immense reputation of the younger partner's father, Frederick Law Olmsted, Sr. (1822–1903), who will always be remembered for his

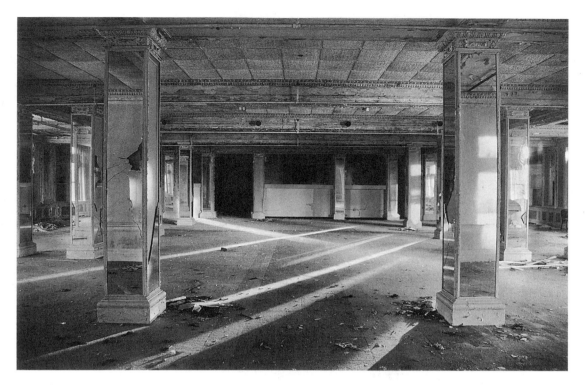

codesign of New York's Central Park. The Olmsted firm's almost innumerable commissions included designs for a number of estates in Westchester County as well as for parks and institutional campuses throughout the country. The younger Olmsted was particularly influential in the development of the McMillan Plan, which established the design for the National Mall in Washington, D.C.

The Olmsted firm's plan for Briarcliff Lodge wrought a parklike landscape from what previously had been farmland. The lodge, which stood six hundred feet above the Hudson, afforded views in all directions; from its upper floors guests could clearly make out the rising towers of Manhattan, thirty miles to the south. And directly across the river, much to the discontent of the Olmsteds, the quarries of Hook Mountain were also plainly visible. The Olmsteds advised Law to avoid opening views to the west, "where there is unfortunately a disagreeably conspicuous and very large scar made by quarrying trap rock on the slopes of the great hill along the west bank of the Hudson."[22] The grounds supported numerous recreation activities, such as tennis and horseback riding.

The lodge catered primarily to a wealthy clientele; many of its guests rented rooms for the entire season. After the death of Walter Law, his son Henry and later his grandson Theodore Law continued to manage the various enterprises he had begun. Perhaps the greatest period of fame for Briarcliff Lodge came in the years 1923–1933, when under the management of Chauncey Depew Steele the resort hosted a series of grand events that drew some of the country's best-known celebrities and pro-

The columns of the mirror room reflected sunlight at the right time of day and year when the sun was low in the sky, as in this late winter image. Although vandals broke mirrors and windows after the lodge was closed, most damage to the hotel was superficial.

fessional athletes. Luminaries who visited the lodge during this period included politicians such as Franklin Roosevelt, Al Smith, and Jimmy Walker; early screen stars such as Tallulah Bankhead and "Tarzan" star Johnny Weissmuller, and athletes including Babe Ruth. Eleanor Roosevelt spoke to women's Democratic voting groups here.

The U.S. Olympic Swimming Team used the lodge's six-million-gallon outdoor pool for exhibitions throughout the 1920s. In 1924, the lodge constructed a ski jump for exhibitions by the U.S. Olympic Ski Team. Guests were offered the use of not one but two golf courses, including an eighteen-hole championship course laid out by Devereux Emmet, a well-known designer of golf courses in the United States. The lodge hired Gene Sarazen, 1922 U.S. Open and PGA champion, as the club professional.

Despite its growing reputation as a premier resort hotel, Briarcliff Lodge was not just an exclusive enclave for wealthy out-of-towners. Its grand public rooms were always open to residents of the surrounding community for wedding receptions and other memorable events. The accessibility of the lodge as a hotel and later as an educational institution made it a community asset in many ways. But beginning in the middle years of the twentieth century, some neighbors grew opposed to the intrusion of such a large public institution in their otherwise quiet community.

The hotel's business declined during the Great Depression. Increased use of automobiles meant the lodge could rely less on seasonal guests, while intensifying suburban development in Westchester County diminished its appeal as a fresh-air retreat. In 1936, the lodge was leased during the winter months to Edgewood Park School for young women, founded by Dr. Matthew H. Reaser; the nonaccredited junior college offered college preparatory and two-year programs "designed to prepare high school graduates for semiprofessional occupations without neglecting general culture."[23] Edgewood Park bought the property outright the following year, but the lodge continued to operate as a hotel in the summer months through 1939. The Edgewood Park School, wrote Mary Cheever in her history of Briarcliff Manor and Scarborough, "also served the community by acting as host to performers and lecturers to whom most residents would not otherwise have been exposed."[24]

Edgewood Park continued to operate at Briarcliff until 1954, when it could no longer make its mortgage payments, and Theodore Law foreclosed on it. The school never reopened. Two businessmen, Frank Moroze and Emanuel Shapiro, soon appeared with a proposal to purchase the property and restore the lodge as a resort and country club. But a group of neighboring residents opposed the proposal, filing a lawsuit to stop the plan in its tracks. A judge rejected their opposition; however, it deterred Moroze and Shapiro's backers, and the proposal was dropped.

The King's College, a Christian liberal arts school, acquired the prop-

The original dining room had windows facing out to the east, south, and west. Although adapted to other uses by the Edgewood Park School and The King's College, the main public rooms of the lodge retained their original architectural integrity.

erty in 1955. Founded in New Jersey in 1938, the school relocated to Delaware three years later. But encroaching oil refineries pushed its administration to seek out a more suitable campus, which they found at the former Briarcliff Lodge. The school prospered and continued to grow at Briarcliff, until enrollment peaked at 870 in 1980. It built a new library wing off the south end of the lodge, and over the years added a number of structures to the property, including gymnasium, dormitory, and classroom buildings.

The first floor and basement of Briarcliff Lodge housed classrooms and offices, while the upper floors served as dormitory space, with women housed in the older portions of the former hotel and men in the 1909 addition. The building adapted well to its new use, and despite some modernizations, the old hotel's public rooms remained virtually unchanged. The elegant Mirror Room became a cafeteria, and the dining rooms on the main floor were outfitted with library stacks, but these changes had only a minimal impact on the architectural integrity of these spaces.

But there were signs that the school could not last forever in Briarcliff. By the 1970s, The King's College found that it could no longer expand its campus or upgrade facilities to draw students, owing in part to zoning restrictions. In the late 1980s, relations soured between the college and its neighbors. College president Robert Cook passed away, and his successor, Dr. Friedhelm Radant, began considering relocation. Radant pointed to the need for major overhauls to the school's infrastructure brought on by years of insufficient and deferred maintenance as further justification to relocate. Decreased enrollment and growing debt led the college to lose its accreditation, and it closed in December 1994. After nearly one hundred years the lodge shut its doors for the last time.

The school's administration made efforts to sell the property, but pro-

Even after years of abandonment, the tiled fireplace in the great hall survived intact.

posed new uses for the lodge faced vocal opposition from the surrounding community. In the meantime the building began to fall into decay. Before The King's College closed it had entered into an agreement with Tara Circle, a nonprofit educational institution, to purchase the site for use as an Irish cultural center. But a group of local residents, steadfast in their opposition to what they said would be a magnet for "traffic, noise and congestion," organized as the Briarcliff Manor Residents Association and effectively blocked the deal from going through.[25]

After nearly being forced out of existence while it struggled to sell the property, the school traded the Briarcliff campus for an office complex

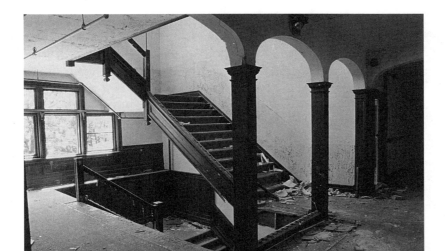
The balustrade along the staircase from the great hall, at the second-floor landing shown here, was stolen along with fireplace mantels and other architectural finishes.

in Tuxedo, in Orange County. Then in 1997, The King's College merged with Campus Crusade for Christ and Northeastern Bible College and relocated to New York City. In the late 1990s, a development and management firm called Barrington Venture proposed to demolish the lodge and all historic structures on the site and to build in their place a large senior assisted-living facility. Village officials, some of whom stated their views that the old hotel was now a derelict eyesore, approved the proposal in the spring of 2003.

On September 20, 2003, four days before hazardous materials abatement was set to begin in preparation for demolition, the lodge's original wood-frame section burned to the ground. An inquiry ruled the fire arson, but no culprit was ever found. The ruins were subsequently demolished along with all other buildings on the property. So ended the long and varied career of another grand Hudson River resort, 101 years after the lodge had first opened. Barrington Venture later backed out of the project, leaving the property vacant for several years more while plans for its reuse continued to stir. A number of buildings from Walter Law's development of Briarcliff Manor still stand in the village today, but Law's greatest monument is gone forever.

Graystone and Pinkstone, Tarrytown

By the middle of the twentieth century, dense suburban development had marched north from New York City, redefining the traditional appeal of the lower Hudson Valley as the sprawl worked its way upriver. Signs of Westchester's suburban transformation began a century earlier, when the opening of the Hudson River Railroad in 1849 gave rise to dozens of

grand river estates. In the twentieth century, the coming of the automobile and the completion of the Tappan Zee Bridge in 1955 opened both Westchester and Rockland counties to exponential population growth. Ironically this growth resulted in the destruction of many of the great estates whose coming had heralded the birth of this new era. At Tarrytown, the ruins of the Graystone and Pinkstone estates survived into the 1990s as picturesque evidence of the changes that continue to reshape the valley today.

By 1860 two estate districts had risen on the banks of the Hudson River. To the north lay Rhinebeck's "River Row," where successful businessmen had joined descendants of old-money landholders in building fine estates with views of the Catskill Mountains. The riverfront of southern Westchester meanwhile became home to an even more dense concentration of grand mansions, whose proximity to New York allowed their owners to commute to and from the city on a daily basis. Writing of Tarrytown's "South End" and neighboring Irvington in 1910, Ernest Ingersoll stated in his *Handy Guide to the Hudson River and Catskill Mountains* that "at no point along the Hudson are there more evidences of wealth and refinement, and this locality . . . is noted as one of the most aristocratic suburbs of the great metropolis."[26]

The development of country estates here began even before the railroad made daily commuting a practical reality. Tarrytown's South End, within twenty-five miles of Manhattan, became fashionable as a place for country seats as early as the 1830s. Those wealthy enough to build such estates found at Tarrytown or places nearby a storied, pastoral landscape that offered views out toward the expanse of the Tappan Zee and the steep cliffs of the Palisades.

Previously this land had been used for farming. Well into the nineteenth century, a large tract below Tarrytown belonged to the Requa farmstead, settled in 1729 by a French Huguenot named Claude Equier who leased the land from the vast manor of the Philipse family. English-speaking neighbors and mapmakers spelled his name phonetically, and he became known as "Glode Requa." After the Revolutionary War Requa's descendants acquired the farm as a freehold. Over the course of the following century most of the farm was given over for the development of three estates: Lyndhurst, Graystone, and Pinkstone.

Oldest of the three is Lyndhurst. Its development began in the late 1830s, when the Requa family sold part of the farm to former New York City mayor William Paulding, who hired architect Alexander Jackson Davis to develop the property as an estate called Knoll. Later it passed to railroad magnate

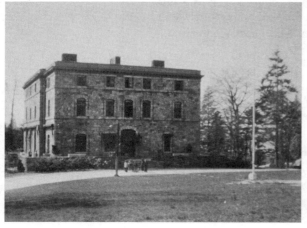

Graystone, east front, c. 1950, when it was part of Bernarr McFadden's Tarrytown School. From the collection of Kathryn Jolowicz.

Jay Gould and became known as Lyndhurst. In the twentieth century, while Lyndhurst was opened to the public and preserved as one of the best-known historic sites in the Hudson Valley, Graystone and Pinkstone suffered a more ignominious fate that became sadly typical among the grand homes of the lower estate district.

At about the same time that the Hudson River Railroad opened in 1849, one David Stebbins purchased the eastern half of the old Requa farm to develop another estate here, which he called Graystone.[27] The property lay to the east of what is today known as Broadway, the old post road from New York City to Albany. The designers associated with the property's initial development are unknown, and the rapid succession of ownership complicates a study of how the property evolved as an estate.

Although there are no known photographs showing the house before twentieth-century alterations substantially changed its appearance, a number of outbuildings survived in their original form long enough to be documented. These included several Picturesque-style wood-frame cottages that probably housed gardeners or grounds-keepers. Some distance from the mansion stood a magnificent Gothic Revival stone stable and carriage house, which featured a crenellated clock tower, ornamental chimney pots, and lancet-arched dormer windows. Later additions to the estate included a large brick barn complex designed c. 1896 by noted architect Robert Henderson Robertson (1849–1919).

Pinkstone, east front, c. 1886. Engraving from *History of Westchester County, New York, 1886.*

The stone stable of the Graystone estate, shown here viewed from the southwest, served later as a dormitory for the Tarrytown School.

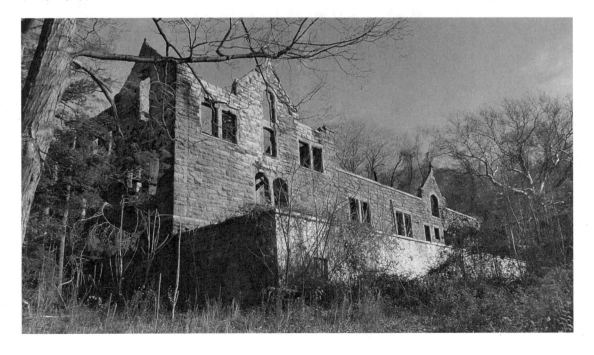

Following its initial development the estate changed hands repeatedly. Subsequent owners included Walter S. Gurnee, a former mayor of Chicago. The northern portion of the property, including the Robertson-designed barns, was sold off around the turn of the century (the barns were later adapted for residential use and survive today). In 1909 the estate passed to Robert B. Dula, a vice president of the American Tobacco Company, who renamed it "Hibriton." Dula sold the property in 1915, and for a short time it became a dance school run by Elizabeth Duncan, sister of the celebrated dancer Isadora Duncan.

Five years later the property returned to residential use under the ownership of Dr. and Mrs. Joseph Blake, who owned the house from 1920 to 1925 and renamed it "Fortoiseau." Following a major fire in 1920 the Blakes rebuilt the mansion as a three-story structure, with simple, squared-off elevations that bore neoclassical and Mediterranean influences, indicative of popular trends of the period. Again the architect remains unknown. After 1925 the estate changed hands several more times before being sold permanently for institutional use in 1942.

Pinkstone arose some nine years after Graystone, in 1859, when John Terry (1822–1913) of New York acquired twenty-three acres of the Recqua farm, including the old farmhouse, situated directly north of Lyndhurst. An "enterprising and most successful business man," Terry served as a financial adviser to such prominent figures as New York governor (and later U.S. senator) Edwin D. Morgan and Jay Gould, who later purchased the neighboring Lyndhurst estate.[28] Shortly after his purchase Terry built a mansion near the old post road, which ran along the property's eastern boundary.

Although Terry's architect has not been identified, early images of the house show a two-and-a-half-story Italianate mansion, which like so many others bore the influence of the Picturesque ideals popularized by the likes of Davis and Downing. Its stone walls were capped by a dormered mansard roof and surrounded by a covered veranda, which afforded views out to the river. To the northeast of the mansion Terry built a bracketed stone carriage house. He retained the old Requa farmhouse for use as a caretaker's residence.

Unlike Graystone, which changed hands as though out of habit, Pinkstone remained the home of John Terry for more than fifty years, until his death in 1913. The Reverend Alfred Duane Pell owned the estate for a few years after Terry's death, until the property passed to Harold M. Lehman, a nephew of New York governor Herbert H. Lehman, in 1916.

This Picturesque cottage may have dated to the Graystone estate's inception c. 1850. The intact cottage was demolished in the spring of 1996, along with three other cottages and various ancillary buildings from different periods.

(*Opposite*) the clock tower of the Graystone stable as viewed through a window on the west wing of the building several months after the arson of March 3, 1995.

The Pinkstone carriage house, demolished in November of 1995, was the last surviving building of the John Terry estate, established in 1859.

Lehman renamed the estate "Willow Pond" and undertook alterations to the mansion including a brick veneer facade and new wings to its north and south ends. He also added dependencies including a gambrel-roofed gardener's cottage and adjacent greenhouses. The estate's formal gardens are thought to have appeared around the same time.

In the frenzy of mansion building that came after the opening of the railroad, many of the Hudson River estates were simply overbuilt. Some of their owners encountered financial difficulties and could no longer afford the costly upkeep of such extravagant properties. Others built new homes at Newport or on Long Island as those places became more fashionable later in the nineteenth century. By the 1870s and '80s, a number of southern Westchester estates had fallen into ruin, a phenomenon noted frequently by period writers who likened the abandoned estates of Westchester to ruined castles on the Rhine. Near Graystone and Pinkstone stood Malkasten, the Jacob Wrey Mould–designed home of painter Albert Bierstadt. The house burned in 1882 after six or eight years of disuse and deterioration. Ernest Ingersoll noted its "still stately ruins" in his guidebook nearly three decades later.[29]

Depressed land values allowed some of these properties to be purchased for use by educational or religious institutions. When modern suburban development began to drive up real estate prices in the twentieth century, it became increasingly common to find these old estates subdivided for single-family housing developments or for commercial office parks. Sometimes the grand old mansions survived on reduced acreage or were adapted for new uses. A few—including Lyndhurst—were preserved as museums. But more often they fell victim to fire or to the bulldozers of indifferent developers, and vanished entirely.

· · ·

Graystone's institutional phase began in 1942, when it was sold to physical culturist Bernarr McFadden to become the Tarrytown School, a private military academy for children aged eight to fourteen years. McFadden ran other boarding schools at nearby Scarborough and at Dansville in central New York. The Tarrytown School adapted the Graystone grounds for horseback riding and athletic fields and reconfigured the stone stable to house classroom and dormitory space.

The Tarrytown School closed in 1954. Two years later the Jewish Federation of Yonkers acquired part of the property for use as the Pinsly Day Camp, a summer retreat for six hundred children. More portions of the property were subdivided and sold off, and by 1965 the camp was operating on the twenty-six-acre core of what had once been a ninety-nine-acre estate. The stone mansion burned on January 2, 1972, after which time the camp continued to use outbuildings, including the cottages and the former stable, until it closed in 1984. For the next decade the property sat abandoned, its old buildings falling slowly to ruin. Arson gutted the stable in March of 1995, leaving only its empty stone walls behind, until all remaining buildings on the former estate were bulldozed in the spring of 1996. The property has since been subdivided in preparation for residential development.

Pinkstone remained in the Lehman family until 1975, when it was sold to the General Foods Company for use as a corporate office campus. Despite the efforts of local preservationists, General Foods demolished the old mansion in 1976, and the old Requa house, abandoned for years, had disappeared by 1982. Other structures survived longer. The old greenhouses stood abandoned for another eight years, faded ribbons from prizewinning entries in flower shows still on display until the buildings disappeared along with the gambrel-roofed gardener's cottage around 1990. John Terry's bracketed carriage house, built in 1859, remained standing until it too was razed in 1995.

Remnants of the estate's formal gardens and designed landscape have survived into the twenty-first century in corners of the property long forgotten. Brick-lined paths lead past an ornamental reflecting pool to the shattered remains of an old stone bench. Not far away a brick staircase leads to a tree-lined walk that descends to the river.

The same process of destruction and new development repeated itself all through the twentieth century, claiming more and more of the old estates, such as the c. 1850 Tarrytown mansion of Moses Hicks Grinnell, which burned in 1963. Its gutted stone walls stood in ruins until they were demolished fifteen years later. Though the crush of development continues to consume these properties, remnants of other estates remain scattered on odd patches of undeveloped land throughout southern

This garden bench fragment is all that remains of a now-overgrown sitting area at Pinkstone that once overlooked the Hudson River.

Westchester. In 2002, the Westchester County government purchased thirty-seven acres of such land, throughout which can be found evidence of the old estates and their importance in the history of the region. This land, which adjoins the Old Croton Aqueduct trailway and the preserved estates of Lyndhurst and Sunnyside, is to be preserved as passive recreation parkland, which will be jointly administered by Historic Hudson Valley and the National Trust for Historic Preservation, with a conservation easement held by Scenic Hudson. That it took three nonprofit organizations working in cooperation with the county government to achieve such a truce between opposing forces is a statement of the high value of this land both to developers and preservationists.

Yonkers Power Station, Yonkers

I look at this, and this tells me that we're really at a junction, a transition, between the old industrial Hudson and a different kind of Hudson. . . . The question is: What's going to happen here in the future? What new future are we going to see?

— Roger Panetta on the Yonkers Power Station, in Bill Moyers, The Hudson, *2002*

❧

Standing opposite the Palisades less than five miles above Manhattan, the massive Yonkers Power Station may be the most remarkable ruin on the Hudson River. Built in 1906 for the New York Central and Hudson River Railroad, this was the prototype for the last traditional industry to establish a presence in the valley: electric power generation. As other Hudson River industries began to decline, the power plants proliferated, eventually growing so intrusive that they became a menace to the quality of life on the river. Unlike later plants, the Yonkers Power Station was carefully designed to complement its surroundings. While the successful reuse of similar structures has demonstrated the potential of historic industrial buildings, today this landmark continues to face an uncertain future.

In January 1902, the collision of two passenger trains in the Park Avenue tunnel in New York City resulted in fifteen deaths and numerous injuries. It was the most serious of several accidents caused by smoke and soot from steam locomotives that obscured signal lights in the tunnel, which had been built to eliminate grade-level crossings on the tracks leading into and out of Grand Central Station. Newspaper editors and an outraged public held top railroad officials accountable for the disaster, and in May 1903 the New York State legislature outlawed steam locomotives south of the Harlem River five years thenceforth.

Hopelessly overcrowded conditions at Grand Central had already led executives of the New York Central and Hudson River Railroad to begin planning the station's complete reconstruction. Opened in 1871, the depot had been expanded continually through the years. By the turn of the century, the sprawling rail yard behind it took up the better part of eight city blocks, and with the increasing value of midtown real estate there was no room for further expansion. The only solution was to put the tracks underground: even before the legislature issued its mandate,

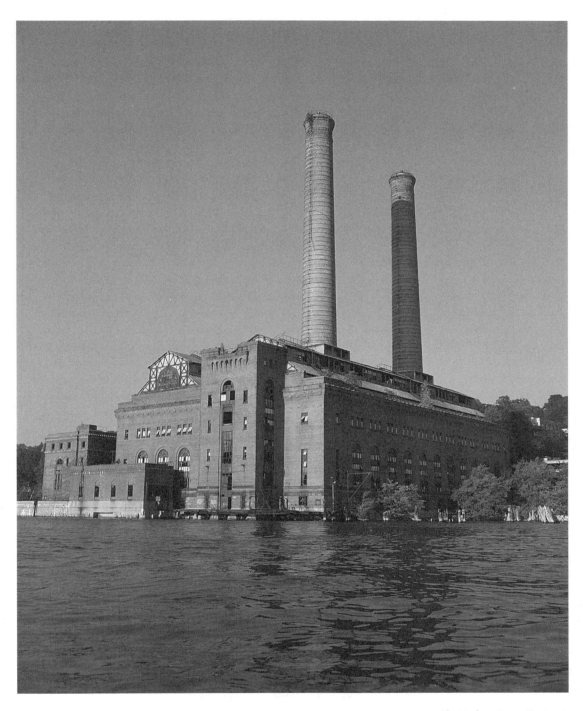

The Yonkers Power Station is
a visual landmark known to
many who have traveled on
the lower Hudson River.

the railroad knew it had no choice but to convert all its trains serving metropolitan New York to electric power.

But there remained the problem of where this power would come from. Just two decades after Thomas Edison had built his first power station in Manhattan in 1882, electric power remained a very limited commodity. New York's largest electric utility, the Edison Electric Illuminating Company (later Consolidated Edison), could produce nowhere near the amount of power the New York Central's electrification program required. Faced with the same problem, the Interboro Rapid Transit (IRT) Company—then building the city's first subway line—decided to generate its own power. The Central would have to do the same.

Work began in 1903, under the direction of William Wilgus, the railroad's chief engineer. The project took more than ten years to complete. Its centerpiece was to be a new Grand Central Terminal, served by two enormous power plants, one in the Port Morris section of the Bronx, the other on the Hudson River at Yonkers. Together these three buildings comprised the principal architectural elements of the railroad's monumental undertaking. To design all three, the Central hired the St. Paul, Minnesota-based firm of Reed and Stem in 1903.

A native of Scarsdale in Westchester County, Charles Reed (1858–1911) had entered into partnership with Allen Stem (1856–1931) in 1891, and within a few years the duo earned a reputation for being one of the leading architectural firms in the Midwest. Reed and Stem's later commissions included a number of notable railroad stations, such as the Michigan Central Station at Detroit (1913, designed with Warren and Wetmore) and Union Station at Tacoma, Washington (1911), as well as numerous civic buildings in the Midwest and Pacific Coast.

Nonetheless, Reed and Stem seemed a rather unlikely choice for one of the most important architectural commissions in New York. That Reed was William Wilgus's brother-in-law probably played no small role in his firm's being selected over some of the leading architects in the country, including McKim, Mead, and White, Daniel Burnham, and others. But Reed wasn't the only architect with friends in high places: in 1904 Whitney Warren, a partner in the firm of Warren and Wetmore and a distant cousin of New York Central chairman William K. Vanderbilt, succeeded in having his firm hired to work in partnership with Reed and Stem in the design of the new Grand Central Terminal. Though the finished building included many key concepts of Reed and Stem's plan, Warren in 1912 used his influence to oust the Minnesota firm from the Grand Central contract, a breach of ethics that later led to his expulsion from the American Institute of Architects.

While controversy haunted the design of Grand Central, Reed and Stem retained free rein over the two power stations, which have remained among the firm's largest and most important works. Like the IRT subway plant, completed in 1904 according to plans by McKim, Mead, and White, these were to be masterpieces of both architecture and engineer-

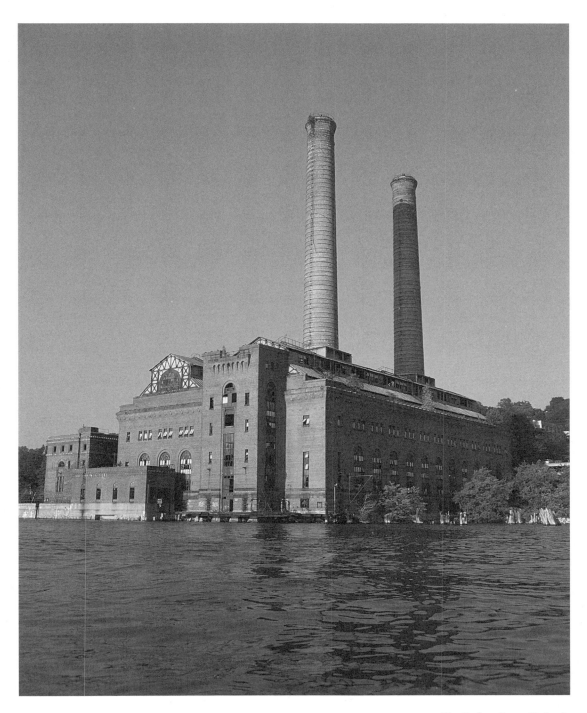

The Yonkers Power Station is
a visual landmark known to
many who have traveled on
the lower Hudson River.

the railroad knew it had no choice but to convert all its trains serving metropolitan New York to electric power.

But there remained the problem of where this power would come from. Just two decades after Thomas Edison had built his first power station in Manhattan in 1882, electric power remained a very limited commodity. New York's largest electric utility, the Edison Electric Illuminating Company (later Consolidated Edison), could produce nowhere near the amount of power the New York Central's electrification program required. Faced with the same problem, the Interboro Rapid Transit (IRT) Company—then building the city's first subway line—decided to generate its own power. The Central would have to do the same.

Work began in 1903, under the direction of William Wilgus, the railroad's chief engineer. The project took more than ten years to complete. Its centerpiece was to be a new Grand Central Terminal, served by two enormous power plants, one in the Port Morris section of the Bronx, the other on the Hudson River at Yonkers. Together these three buildings comprised the principal architectural elements of the railroad's monumental undertaking. To design all three, the Central hired the St. Paul, Minnesota-based firm of Reed and Stem in 1903.

A native of Scarsdale in Westchester County, Charles Reed (1858–1911) had entered into partnership with Allen Stem (1856–1931) in 1891, and within a few years the duo earned a reputation for being one of the leading architectural firms in the Midwest. Reed and Stem's later commissions included a number of notable railroad stations, such as the Michigan Central Station at Detroit (1913, designed with Warren and Wetmore) and Union Station at Tacoma, Washington (1911), as well as numerous civic buildings in the Midwest and Pacific Coast.

Nonetheless, Reed and Stem seemed a rather unlikely choice for one of the most important architectural commissions in New York. That Reed was William Wilgus's brother-in-law probably played no small role in his firm's being selected over some of the leading architects in the country, including McKim, Mead, and White, Daniel Burnham, and others. But Reed wasn't the only architect with friends in high places: in 1904 Whitney Warren, a partner in the firm of Warren and Wetmore and a distant cousin of New York Central chairman William K. Vanderbilt, succeeded in having his firm hired to work in partnership with Reed and Stem in the design of the new Grand Central Terminal. Though the finished building included many key concepts of Reed and Stem's plan, Warren in 1912 used his influence to oust the Minnesota firm from the Grand Central contract, a breach of ethics that later led to his expulsion from the American Institute of Architects.

While controversy haunted the design of Grand Central, Reed and Stem retained free rein over the two power stations, which have remained among the firm's largest and most important works. Like the IRT subway plant, completed in 1904 according to plans by McKim, Mead, and White, these were to be masterpieces of both architecture and engineer-

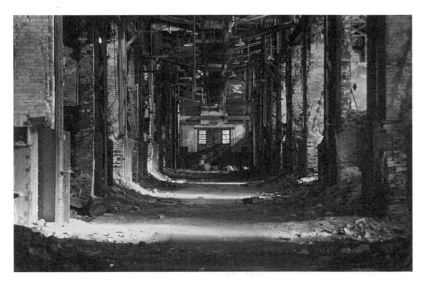

Afternoon sunlight filters into the boiler room through voids left when the boilers themselves were removed for scrap.

ing. Begun in 1904 and ready for operation in late 1906, the near-twin power plants were built at a cost of more than $2 million each. Wilgus intended the Port Morris facility to power both the Hudson and Harlem lines, with the Yonkers plant designed to provide backup but likewise built with capacity to power both lines.

The Yonkers Power Station included an adjacent switch house and substation housed in a separate building. The plant had its own rail

The turbine room, looking west.

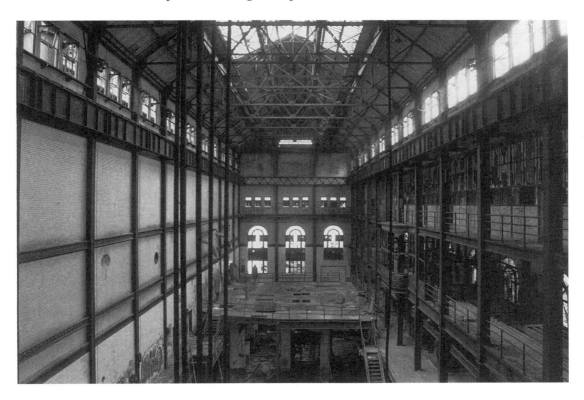

This terra-cotta door surround on the substation provides Beaux Arts detail evocative of Reed and Stem's proposal for Grand Central Terminal.

siding and dock to facilitate coal deliveries by train or barge. Built of brick, the main power plant occupied a square plan, which was divided into two main interior spaces, each surmounted by separate gable roof structures. The southern half of the plant housed the boiler room, which accommodated twenty-four boilers beneath two 3,500-ton-capacity coal bunkers; a pair of enormous smokestacks towered above. The plant's northern half housed the turbine room, with space for six five-thousand-kilowatt, thirty-five-foot-tall Curtis turbogenerators (though only four were initially installed). The initial output of twenty thousand kilowatts was sufficient to power the entire electrified zone of the Hudson and Harlem lines, should there have been a need to shut down the Port Morris plant.[30]

The exterior of the powerhouse remains aesthetically appealing; rows of tall, arched windows characterize its north and south facades. Though the building was executed of brick, the massing of its elevations echoes the Beaux Arts spirit that guided both Reed and Stem and Warren and Wetmore in their proposals for Grand Central. The powerhouse's corbeled cornice is crowned by exposed metal roof trusses embedded in concrete, which quite intentionally create a Tudor-style half-timber pattern. Reed and Stem acknowledged that the powerhouse was highly visible not only from the two main transportation avenues of the time—the river and the railroad—but also from a number of estates in the Glen-

wood section of Yonkers, where the plant stood. The architects therefore took pains to make the building stand in harmony with its surroundings. "Special attention was given to the design of the windows," wrote the *Street Railway Journal* in a summation of the building's design, "not only to obtain a well-lighted interior, but also to present a striking and attractive appearance from the exterior at night."[31] For the plant's construction the railroad contracted the American Bridge Company, a subsidiary of the massive U.S. Steel Corporation.

When completed, the New York Central's electrification program was the largest of its kind; the railroad went further than called for by the new law, electrifying the Hudson division thirty-four miles upriver to Croton and the Harlem division twenty-four miles north to North White Plains. Because alternating current could be distributed across greater distances, it had become favored over direct current for domestic use. But direct current proved better suited for railroad use, allowing locomotives to accelerate faster. To address this dilemma the railroad built a series of substations throughout the electrified zone, all designed by Reed and Stem, which converted the 11,000-volt alternating current generated in the power stations to 688-volt direct current for distribution via the third rail.

The Yonkers Power Station continued to operate under the ownership of the railroad until 1936, when the New York Central sold the plant to the Yonkers Electric Light and Power Company, a subsidiary of Consolidated Edison. By then, rapidly increasing demand had forced Con Ed and other electric utilities to construct plants significantly larger than those built for the railroads at the turn of the century. The railroads that had built their own plants, including the IRT subway and the Pennsylvania Railroad in addition to the New York Central, soon found it less expensive simply to buy their power from ConEd than to produce it themselves. No longer needed, the Central's old Port Morris Power Station was later demolished.

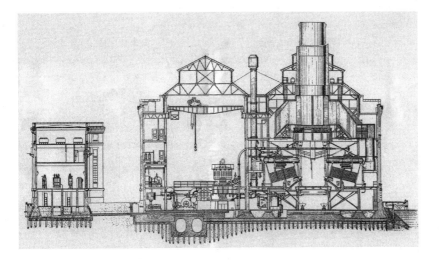

This section drawing, showing substation at left, powerhouse at right, was published in the November 11, 1905, edition of the *Street Railway Journal*.

With "capacity sufficient to care for the needs of a considerable part of the county," the Yonkers Power Station was still, in 1950, one of three sources of electricity for the rapidly growing city.[32] But age soon got the better of it. Improved technology enabled modern plants to generate power with ever-greater efficiency. With plans being developed for a new $8 million substation along the Grassy Sprain Reservoir in Yonkers, the old Yonkers Power Station was put on standby until it closed permanently in 1963.[33]

By the 1950s, demand for electricity had grown far beyond early-twentieth-century forecasts. Once again, the Hudson Valley's proximity to New York City and its value as a transportation corridor gave rise to yet another chapter in the region's industrial experience, as new power plants began to appear along the length of the river. In the 1960s and '70s, as the river's brickyards, cement factories, and textile mills disappeared, proposals for more power plants kept coming.

Soon electric power generation emerged as the final apogee of three centuries of industrial development on the Hudson River. Above Newburgh, Central Hudson Gas and Electric opened its Danskammer plant in 1952. Con Ed opened one of the world's first large nuclear power plants at Indian Point, just below Peekskill, in 1963. Across the river construction began on new plants at Tomkins Cove in 1967, and at Bowline Point a few years later. A second plant appeared north of Newburgh in 1973. The utilitarian design of these new plants lacked the architectural frills of older industrial buildings such as the Yonkers Power Station, and in sheer size they dwarfed their prototype. Con Ed's Indian Point facility, opened the year of the Yonkers plant's closing, was designed to produce 275,000 kilowatts—nearly ten times the older Yonkers plant's intended 30,000-kilowatt maximum capacity.[34]

Clashes between industry and those concerned with the cultural value of the Hudson's scenic beauty were not new. But the power plants upped the ante, growing so large and intrusive that they threatened to destroy the environmental health of the river as well as its scenic beauty. With new plants proposed at Storm King Mountain and Breakneck Ridge, at Cruger's Island in northern Dutchess County, and at Cementon below Catskill, the growing threat prompted a backlash in public sentiment that in the 1960s spawned the creation of organizations such as Scenic Hudson. The successful fight to stop the Storm King plant in particular is cited for having set legal and organizational precedents that became foundations for the modern environmental movement in the United States.

As environmental groups and electric utilities waged war over power plant construction upriver, the old Yonkers Power Station began to fall into decay. In 1974 the city of Yonkers declined an option to buy the power station for one dollar, citing a desire to keep the property on the

tax rolls. Its boilers and turbines sold for scrap, the derelict plant continued to languish. Three years later it was sold to a private party who recognized the investment value of the land.[35]

Three decades later the Yonkers Power Station remains abandoned. Still plainly visible from passing trains, in abandonment it has captivated the popular imagination. Its ruins have been likened to *Desolation*, the final painting in Thomas Cole's series *The Course of Empire*.[36] Some pictorial works on the Hudson River have used the power station to illustrate the twentieth-century downfall of river industries. With the Port Morris plant now gone and industrial ruins on the lower Hudson continuing to disappear, the significance of this place as both a ruin and a historic structure in its own right has become more pronounced.

A conveyor belt dropped coal into bins over the boilers in the southern half of the generating building.

Examples of power plants that have been successfully reclaimed for new cultural, residential, and commercial use can be found all over the planet. In the heart of London, the former Bankside Power Station has been converted by architects Herzog and de Meuron to house the Tate Modern, one of the most important galleries of modern art in the world (the project helped its architects win the prestigious Pritzker Architecture Prize in 2001). In Rome, the Centrale Montemartini power station is now home to a museum of antique sculpture. Closer to home, in Baltimore's inner harbor, another turn-of-the-century power plant has been made into a commercial center complete with such consumer icons as a Barnes & Noble bookstore and a Hard Rock Cafe. Long Island City's McKim, Mead, and White–designed Pennsylvania Railroad power station, built in 1909, is to be outfitted with apartments after decades of abandonment. And right on the Yonkers waterfront stands Scrimshaw House, a former Yonkers Light & Power plant converted into condominiums in 1987. In some cases these restoration projects have gained international recognition and anchored successful community revitalization initiatives.

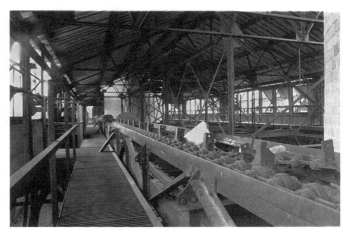

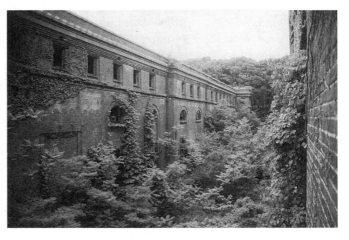

View of the substation and transformer building adjacent to the generating building.

But the future of the Yonkers Power Station remains unclear. Local preservationists have acted to protect the power station by seeking land-

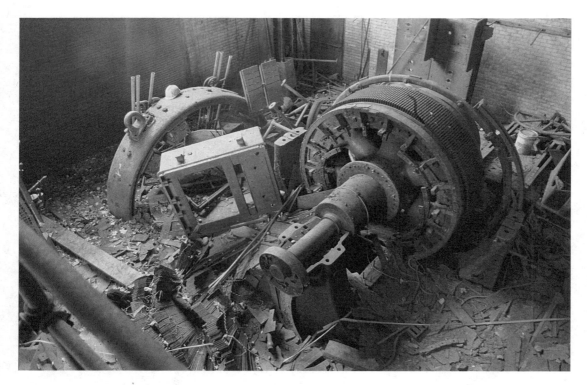

Immediately north of the power plant stands one of several substations built in conjunction with the power stations. These buildings housed massive rotary converters, such as the one pictured here, that converted AC electric power to DC.

mark status. For the time being it continues to decay without recognition on local, state, or federal landmark listings. Conveyors remain motionless above the partly filled coal bunkers. Its generators removed, the turbine room is quiet now. Old switchboards and rusted gauges look out on the nave-like space from a silent control room. In the spring, overgrowth that has worked its way over the building's brick facades comes brilliantly to life. It is a scene moving enough to have inspired Cole or Irving, perhaps even John Ruskin himself.

One can hope for the day when this ruin will be reborn, when an incandescent glow might once again cast a reflection over the river from within its great arched windows. Speaking in an interview with Bill Moyers for a television special titled *The Hudson: America's First River*, historian Roger Panetta pointed to the Yonkers Power Station to demonstrate that the Hudson is now in a state of transition, and that decisions made today will have a lasting impact. Though newer power plants continue to operate, the age of the industrial Hudson has passed, and after decades of quiescence the riverfront now faces development pressures as intense as any it has ever known. The fate of the Yonkers Power Station and the scores of other ruins along the Hudson will affect the quality of life on the river for generations to come.

Some Ruins on Public Land

Selected ruins that can be visited by the public in the Hudson Valley. Access to some is limited.

Name of Ruin. Owner or Managing Agency / Name of Park or Property. Location

RENSSELEAR COUNTY

Miller & Whitbeck Ice Co. chimney. NYS OPRHP / Schodack Island State Park (Seasonal). Schodack Island.

COLUMBIA COUNTY

R&W Scott Ice Co. NYS DEC / Nutten Hook State Unique Area. Newton Hook.
Copake Iron Furnace. NYS OPRHP / Taconic State Park. Copake Falls.
Arryl House ruins. NYS OPRHP / Clermont State Historic Site. Clermont.

ULSTER COUNTY

Overlook Mountain House. NYS DEC / Catskill Forest Preserve. Woodstock.
D&H Canal (High Falls). D&H Canal Museum (limited access). High Falls.
Century Cement Co. ruins. Century House Historical Society. Rosendale.
Robinson Estate ruins. Scenic Hudson / Franny Reese Preserve. Highland.
Minnewaska Power House ruins. NYS OPRHP / Minnewaska State Park Preserve. Kerhonkson.

DUTCHESS COUNTY

Crugers Island ruins. NYS DEC / Tivoli Bays State Unique Area. Crugers Island.
"The Point" (Lydig Hoyt Estate). NYS OPRHP / Mills and Norrie State Parks. Staatsburg.
James Baird House. NYS OPRHP / James Baird State Park. LaGrangeville.
Mt. Beacon Incline Railway. Scenic Hudson / Mt. Beacon Park. Beacon.
Dennings Point Brick Works & Durisol Co. Plant. NYS OPRHP / Hudson Highlands State Park. Beacon.
Bannerman's Island Arsenal. NYS OPRHP / Hudson Highlands State Park (Guided Tours Only, Reservations Required). Pollepel Island.

PUTNAM COUNTY

McKeel Corners School. NYS OPRHP / Clarence Fahnestock Mem. State Park. Near Cold Spring.

Edward J. Cornish Estate. NYS OPRHP / Hudson Highlands State Park. Cold Spring.

West Point Foundry. Scenic Hudson / West Point Foundry Preserve. Cold Spring.

Fort Constitution. United States Military Academy / Constitution Island (Seasonal, Reservations Required). Cold Spring.

Arden Point ruins. NYS OPRHP / Hudson Highlands State Park. Garrison.

Livingston Estate ruins. Scenic Hudson / Open Space Institute / Manitou Point Preserve. Manitou.

ORANGE COUNTY

D&H Canal (Cuddebackville). Orange County Dept. of Parks, Recreation and Conservation / D&H Canal Park. Cuddebackville.

Orange Powder Mills. Orange County Dept. of Parks, Recreation and Conservation / Algonquin Park. Newburgh.

Fort Clinton and Fort Montgomery. NYS OPRHP / PIPC / Bear Mountain State Park. Fort Montgomery.

Clove Furnace. Orange County Historical Society. Arden.

Southfields Furnace. Scenic Hudson / PIPC / Indian Hill-Southfields Furnace Park. Southfields.

ROCKLAND COUNTY

Doodletown ruins. NYS OPRHP / PIPC / Bear Mountain State Park. Doodletown.

Dunderberg Spiral Railway. NYS OPRHP / PIPC / Bear Mountain State Park. Dunderberg Mountain.

ORAK Estate. NYS OPRHP / PIPC / Harriman State Park. Haverstraw.

Ice Harvesting and Quarry Industry ruins. NYS ORPHP / PIPC / Rockland Lake and Hook Mountain State Parks. Rockland Lake.

Bluefields Rifle Range. NYS OPRHP / Clausland Mountain State Park. Orangetown.

WESTCHESTER COUNTY

Reusen's Farms. Westchester County Dept. of Parks / Oscawana Park. Oscawana.

Note: NYS OPRHP = New York State Office of Parks, Recreation, and Historic Preservation;
 NYS DEC = New York State Department of Environmental Conservation;
 PIPC = Palisades Interstate Park Commission.

Hudson Valley Ruins Recognized as National Historic Places and Landmarks

Ruins in this book that have been listed by the United States Department of the Interior on the National Register of Historic Places. Note that this list is limited to historic sites pictured within this book. Asterisk denotes a site also recognized as a National Historic Landmark.

RENNESLEAR COUNTY

Dutch Reformed Church (Church St. Hist. Dist.). Nassau. (destroyed)

GREENE COUNTY

Captain James Bogardus House (East Side Hist. Dist.). Catskill.
Hop-O-Nose Knitting Mill. Catskill. (partially destroyed)

COLUMBIA COUNTY

Albany & Hudson Power Co. Power Station (Stuyvesant Falls Mill Dist.). Stuyvesant Falls.
New York Central Railroad Station. Stuyvesant.
R&W Scott Ice Co. Newton Hook.
Jan van Hoesen House. Claverack.
* **Oliver Bronson House.** Hudson.

ULSTER COUNTY

Peter Corneliessen Louw House (Kingston Stockade Hist. Dist.). Kingston.
City Hall. Kingston.
* **Delaware & Hudson Canal.** Eddyville and West.
Snyder Estate Natural Cement Historic District. Rosendale.

DUTCHESS COUNTY

Sipperly-Lown Dutch Barn. Rhinebeck.
Poughkeepsie Railroad Bridge. Poughkeepsie.
Mount Beacon Incline Railway and Powerhouse. Beacon.
Tioronda Bridge. Beacon.
* **Wyndclyffe.** Rhinebeck. National Historic Landmark Dist.

* **The Point.** Staatsburg. National Historic Landmark Dist.
* **Hudson River State Hospital.** Poughkeepsie. National Historic Landmark
Luckey Platt & Co. Department Store. Poughkeepsie.
Bannerman's Island Arsenal. Fishkill.

ORANGE COUNTY

Southfield Furnace Ruin. Monroe.
City Club (William Culbert House, East End Hist. Dist.). Newburgh.
* **Dutch Reformed Church.** Newburgh. National Historic Landmark

PUTNAM COUNTY

West Point Foundry. Cold Spring, Putnam Co.

ROCKLAND COUNTY

Henry M. Peck House. Haverstraw. (destroyed)
Tappan Zee Playhouse. Nyack. (destroyed)

WESTCHESTER COUNTY

Brandreth Pill Factory. Ossining.

NOTES

Introduction (pages 1–21)

1. Cole, *American Monthly Magazine*, Jan. 1836.
2. Hoffman, 59.
3. "Hudson River," *New York Times*, 10 Sept. 1852.
4. Lossing, 67.
5. Irving, *Sketch Book*, 10–11.
6. Downing, *Treatise*, 55.
7. The other is referenced in Carl Carmer's *The Hudson* as being on the Clewes estate at Hyde Park. For more on Cruger's ruin folly, see Clyne, 103–109.
8. Cole, *American Monthly Magazine*, Jan. 1836.
9. Asher B. Durand, Introduction in *American Landscape No. 1*, 1830, 11–12.
10. Cooper, 126.
11. From Frances Anne Butler (Kemble), *Journal*, reprinted in Van Zandt, *Chronicles*, 199.
12. Bryant, 10.
13. Richardson, 162.
14. Smith, 17.
15. Richardson, 163.
16. Wall text, from exhibition titled The Hudson River School at the New-York Historical Society: Nature and the American Vision, The New-York Historical Society, 17 May 2005–5 Feb. 2006.
17. U.S. Census data.
18. "Ruins," *New York Times*, 16 July 1882.
19. "Suburban Walk," *New York Times*, 21 Apr. 1878.
20. "Ruins," *New York Times*, 16 July 1882.
21. Gurstein, 32–37.
22. Ruskin, 207.
23. Ibid, xvii.
24. Russell Sturgis, introduction in Ruskin.
25. Lossing, 225.
26. Reynolds, 34.
27. Ibid., 184.
28. Franklin D. Roosevelt, introduction in Reynolds.
29. *Landmarks . . . 2004*.
30. *White Plains Journal News*, 28 June 2005.
31. *Poughkeepsie Journal*, 23 Mar. 2005.
32. *Hudson Register Star*, 24 Mar. 2005.
33. *Opportunities*, 1.
34. Kunstler, *The Geography of Nowhere*, 124.

Albany and Rensselaer Counties (pages 25–45)

1. For a thorough history of the Hudson River brick industry, see Hutton, *The Great Hudson River Brick Industry*, and deNoyelles, *Within These Gates*.
2. Hutton, 69.
3. "Albany Troops," "Call State Troops," "Coeymans Rioters," and "Soldiers," *Albany Evening Journal*, May 16–19, 1906.
4. The introduction of coal to the mix reduced firing time by half and was the invention of Haverstraw brickmaker James Wood.
5. Hutton, 109, 134.
6. Carmer, 331
7. Other Hudson River yards had considered switching to shale, but only Powell and Minnock managed to secure access to a reliable supply of what elsewhere had become a popular alternative to clay.
8. Adams, *The Hudson through the Years*, 261.
9. Sylvester, 413.
10. "54 Men," *New York Times*, 8 Jan. 1910.
11. Bird, *New York Times*, 23 Dec. 1971.
12. "Mill Closures & Curtailments from 1989 until 2003," http://www.property rightsresearch.org/articles4/mill_closures.htm.
13. Riley, *The Independent*, 11 June 2004, 1 Oct. 2004, 3 Dec. 2004.

Greene County (pages 46–59)

1. Van Orden (Barbara and Elsie), "Smith's Landing."
2. "Rossoff Coup," *New York Times*, 13 Apr. 1925.
3. Hammer, *New York Times*, 18 Sept. 1955.
4. Wilcke, *New York Times*, 31 Oct. 1965.
5. Faber, *New York Times*, 8 Dec. 1985.
6. The Department of State's decision was summarized in a letter from Commissioner Randy A. Daniels to David Loomes of St. Lawrence Cement, dated 19 Apr. 2005.
7. Kirby, *Kingston Daily Freeman*, 19 July 2005. At the time of writing a citizens' group called Friends of Kingston Waterfront has organized in response to the proposed development.

Columbia County (pages 60–99)

1. A thorough history of the Hudson River Railroad can be found in Harlow, 138–165.
2. Harlow, 143, quoting from report of John B. Jervis, 12 Jan. 1848, in John B. Jervis Papers, New York Public Library.
3. From Walt Whitman, *Specimen Days and Collect*, reprinted in Marranca, 373.
4. Martin and Kwacz, *The Independent*, 31 July 2001.
5. "R&W Scott," National Register Nomination Form.
6. Stott, 314.
7. Hamilton, 74.

8. Stott, 314.
9. "R&W Scott," National Register Nomination Form.
10. Ellis, 348.
11. Gordon, 411.
12. The village is shown as "Stottsville" on George Snyder's 1848 map of the proposed Hudson River Railroad.
13. "W. L. Strong," *New York Times*, 15 Nov. 1900.
14. "Jan van Hoesen House," National Register Nomination Form.
15. For a detailed description on construction techniques in New Netherland, see Meeske, *The Hudson Valley Dutch and Their Houses*.
16. "Jan van Hoesen House," National Register Nomination Form.
17. Ibid.
18. *Albany Evening Journal*, 17 May 1906.
19. Reynolds, 337, 124, 184.
20. "Hudson's First," *Chatham Courier*, 26 Jan. 1961.
21. "Bronson," National Historic Landmark Nomination.
22. For a monograph of Davis's works, see Peck, *Alexander Jackson Davis*.
23. "Bronson," National Historic Landmark Nomination.
24. Downing, *Architecture*, 28–29
25. Krattinger, *Hudson River Valley Review*, Autumn, 2004.
26. Eberlein and Hubbard, 124.

Ulster County (pages 103–135)

1. Evers, 249–250. A thorough history of the Overlook Mountain House can be found in Evers, *Woodstock*.
2. Evers, *Woodstock*, 256.
3. Ibid, 279–281.
4. "President Grant," *New York Times*, 31 July 1873.
5. Evers, *Catskills*, 478.
6. Evers, *Woodstock*, 488–489.
7. Van Zandt, *Catskill Mountain House*, vii.
8. "Overlook Mountain . . . Management Plan Draft."
9. "Kingston City Hall," Historic American Buildings Survey.
10. "Building Kingston's Future."
11. Hu, *New York Times*, 23 Jan. 2002.
12. For more information on the history of the D&H Canal, see Wakefield, *Coal Boats to Tidewater*, and Osterberg, *The Delaware and Hudson Canal and the Gravity Railroad*.
13. Gilchrist, 68.
14. Ibid., 81.
15. McDermott, 5.
16. Gilchrist, 84. Different sources provide conflicting dates for when the eastern portion of the canal finally ceased operation. A date of 1913 was provided for historian Ann LeFevre Gilchrist in the 1970s by Earl Mack, whose father and grandfather worked as lock tenders. Certainly the canal closed no later than 1915, when the Rosendale Consolidated Cement Company itself ceased operations.
17. James S. McEntee, an assistant engineer for the D&H Canal, is the man

most often credited with this discovery. His son, the painter Jervis McEntee, later became one of the leading figures of the Hudson River School.

18. "Snyder Estate," National Register Registration Form.
19. Ibid.
20. U.S. Census data.

Dutchess County (pages 136–178)

1. Zukowsky and Stimson, 180.
2. "Wyndclyffe (Linden Grove)." Altered, the building still stands as the Good Shepherd Roman Catholic Church.
3. "Wyndclyffe (Linden Grove)."
4. Wharton, 27–28.
5. Downing, *Treatise*, 555.
6. For more on Downing and Vaux, see Schuyler, *Apostle of Taste*, and Kowsky, *Country, Park & City*.
7. Kowsky, *Country, Park & City*, 60.
8. Vaux, 306–307.
9. It is possible that R. P. Huntington has been confused for Franklin B. Huntington, a partner in Hoppin and Koen in the early 1900s.
10. *Mills-Norrie State Park: Master Plan* (Staatsburg, N.Y.: Taconic State Park Commission, 1968).
11. Draft Environmental Impact Statement, 25, quoting from Kowsky, "Architecture."
12. Kowsky, *Architecture of Frederick Clarke Withers*, 74.
13. Draft Environmental Impact Statement, 26.
14. Myers, *Poughkeepsie Sunday New Yorker*, 31 Dec. 1944.
15. Auster, *Poughkeepsie Journal*, 22 Aug. 1993.
16. For an academic history of the rise of department stores in America, see William Leach, *Land of Desire: Merchants, Power and the Rise of a New American Culture* (New York: Pantheon, 1993).
17. "Luckey, Platt," *Dutchess County Historical Society Yearbook*, 1969. The firm reorganized as Luckey, Platt & Company in 1872.
18. Other Percival Lloyd buildings at Poughkeepsie included the First Presbyterian Church (1905–1908), the Poughkeepsie Trust Company (1906), the Lady Washington Hose Company (1908), the Niagara Hose Company (1909), and a factory building for FIAT of America (c. 1919). All but the last remain standing.
19. Bernstein, *Poughkeepsie Journal*, 3 July 1981.
20. U.S. Census data.
21. Vizard, *New York Times*, 29 Dec. 1991.
22. A detailed history of the Bannerman family and of the Bannerman company's formation can be found accompanying most editions of Bannerman's military goods catalogues.
23. "Bannerman's," *Hudson River Day Line Magazine*, Aug. 1911.
24. *Catalogue of Military Goods* (1927), 4.
25. "F. Bannerman," *New York Times*, 28 Nov. 1918.
26. *Catalogue of Military Goods* (1927), 3.
27. *New York Times*, 16 Aug. 1920.

28. "Bannerman's," *Hudson River Day Line Magazine*, Aug. 1911.

Orange County (pages 179–198)

1. For a detailed history on the origins of the Dutch Reformed Church in America, see Brouwer, *Reformed Church Roots*, and De Jong, *The Dutch Reformed Church in the American Colonies*.
2. "Dutch reformed Church," National Historic Landmark Nomination Form, 4, quoting from Day Book of A. J. Davis, 172, in Alexander Jackson Davis Collection, New York Public Library.
3. Ibid, 11.
4. Ibid, 20. Davis's Newburgh commissions included a remodeling of A. J. Downing's home for Charles C. Alger after Downing's death and a Norman-style gatehouse for Amos G. Hull. Both buildings have been demolished.
5. A thorough history of the West Shore Railroad can be found in Harlow, 319–340.
6. "Last Whistle," *Newburgh News*, 22 June 1958.
7. Ibid.
8. The West Shore continued to provide commuter service between West Haverstraw and Weehawken for a little more than a year before passenger service on the West Shore finally came to an end on December 10, 1959. Adams, *The Hudson through the Years*, 214–215.
9. Eshbacher, *Middletown Times Herald-Record*, 16 Aug. 1995.

Maritime Ruins (pages 201–210)

1. For a more thorough treatment of this subject, see Rinaldi, "The Hudson's Lost Steam Fleet."
2. Peckham, *Sea History*, Spring 1996.
3. Ibid.
4. Lewis, 142.

Putnam County (pages 213–230)

1. "Real Estate," *New York Times*, 19 Apr. 1917.
2. An overview of estate development in the Hudson River Highlands can be found in Dunwell, *The Hudson River Highlands*.
3. "First Blast," *New York Times*, 22 Nov. 1931.
4. Letter, F. R. Masters to R. Moses, 21 Sept. 1937, New York State Office of Parks, Recreation and Historic Preservation, Taconic Region.
5. "Edward J. Cornish Dies," *New York Times*, 4 May 1938.
6. Dykeman, *Poughkeepsie Journal*, 24 Oct. 1982.
7. *New York Times*, 13 Jan. 1967. Georgia Pacific later built the plant near the site of another Hudson River quarry, at Buchanan in Westchester County, where it remains in operation nearly forty years later.
8. Lossing, 246.

9. The other three foundries were planned for Richmond, Virginia, Pittsburgh, Pennsylvania, and Georgetown in the District of Columbia.

10. "West Point Foundry," *New York Times*, 2 July 1865.

11. *New York Times*, 11 May 1868.

12. "West Point Foundry," *New York Times*, 14 Aug. 1886.

13. Cornell continued to operate at New York City until 1965, when it relocated to Mountaintop, Pennsylvania, where it remains in business in 2005.

14. "Manufacturers," *New York Times*, 25 Mar. 1936.

Rockland County (pages 231–250)

1. Irving, *Bracebridge Hall*, 343.

2. *Prospectus of the Dunderberg Spiral Railway*, 6.

3. Ibid, 8. All information in this and the following paragraph is taken from the *Prospectus of the Dunderberg Spiral Railway*.

4. "Conspiracy," *New York Times*, 22 July 1890.

5. *In The Hudson Highlands*, 201.

6. Goldwaithe, *Appalachia*, Nov. 1935.

7. "Engineers' Task," *New York Times*, 4 May 1930.

8. *In The Hudson Highlands*, 201.

9. Incaltcaterra, *White Plains Journal News*, 23 Feb. 2005.

10. Stott, "Knickerbocker Ice Company," 9.

11. Ibid.

12. Ibid, 13.

13. "Fire," *New York Times*, 21 Apr. 1926.

14. Green, 166.

15. "Wilson Perkins Foss," 10.

16. Ibid., 16–17.

17. Binnewies, 27, 33.

18. Ibid., 72, 88.

19. "Wilson Perkins Foss," 16–17.

20. Binnewies, 208, 232.

21. Maroni, *White Plains Journal News*, 19 May 1985.

Westchester County (pages 251–294)

1. *The Mount Florence Property at Peekskill*, c. 1872.

2. "A Decaying Paradise: The Mount Florence Story." *New York Sun*, clipping dated 1874, from the Collection of the Peekskill Museum.

3. Scharf, 398.

4. "Party," *New York Times*, 30 Apr. 1939.

5. Carmer, 400.

6. Ibid.

7. "Mount Florence," National Register Nomination Form.

8. Smith, *Peekskill*, 145.

9. "Mount Florence," National Register Nomination Form.

10. U.S. Census data.

11. Panetta, 39.

12. Ibid., 41.
13. *Sing Sing Prison*, 3.
14. Luckey, 16.
15. Marchant, *White Plains Journal News*, 13 Mar. 2005.
16. Moore, *USA Today*, 8 Feb. 2005.
17. Cheever, 43.
18. *Briarcliff Outlook*, 15 June 1902. The *Briarcliff Outlook*, and later the *Briarcliff Once-a-Week*, were promotional newspapers published in the early 1900s and contain many detailed accounts of the Briarcliff Lodge Association, Briarcliff Realty Company, and the Briarcliff Farms, the three incorporated companies set up by Walter Law to oversee his hotel, real estate, and farming ventures.
19. *Briarcliff Outlook*, June 1903.
20. "Guy King," *Philadelphia Evening Times*, 23 Sept. 1909.
21. *Briarcliff Outlook*, 15 June 1902.
22. Olmsted Brothers to W. Law, 18 July 1900.
23. Cheever, 73.
24. Ibid, 74.
25. Vizard, *New York Times*, 4 Feb. 1996.
26. Ingersoll, 49.
27. The popularity of this name, sometimes spelled "Greystone," is evidenced in its having been chosen for at least two other Hudson River estates, the best known of which was that of Samuel J. Tilden at Yonkers.
28. Scharf, 243. Terry has permanent residence next to another former South End resident: he is buried in Sleepy Hollow Cemetery next to the family plot of Washington Irving.
29. Ingersoll, 51.
30. *New York Times*, 16 Aug. 1908.
31. "Power Stations," *Street Railway Journal*, 11 Nov. 1905.
32. Walton, 152.
33. Dentzer, *Gannet Suburban Newspapers*, 15 Aug. 1995.
34. Smith, *New York Times*, 3 Aug. 1962.
35. Dentzer, *Gannet Suburban Newspapers*, 15 Aug. 1995.
36. Moyers, *The Hudson*.

BIBLIOGRAPHY

General

Adams, Arthur G. *The Hudson River Guidebook*. New York: Fordham University Press, 1996.

Adams, Arthur G. *The Hudson through the Years*. New York: Fordham University Press, 1996.

Bailey, Rosalie Fellows. *Pre-Revolutionary Dutch Houses and Families in Northern New Jersey and Southern New York*. New York: Dover Publications, 1968.

Binnewies, Robert O. *Palisades: 100,000 Acres in 100 Years*. New York: Fordham University Press and Palisades Interstate Park Commission, 2001.

Blackburn, Roderic H., and Ruth Piwonka, eds. *Remembrance of Patria: Dutch Arts and Culture in Colonial America, 1609–1776*. New York: Produced for the Albany Institute of History and Art, 1988.

Boyle, Robert H. *The Hudson River: A Natural and Unnatural History*. New York: W. W. Norton & Company, 1969.

Bruegel, Martin. *Farm, Shop, Landing*. Durham, N.C.: Duke University Press, 2002.

Buxton, Wally, and Jeff Canning. *History of the Tarrytowns*. Harrison, N.Y.: Harbor Hill Books, 1975.

Carmer, Carl. *The Hudson*. New York: Farrar & Rinehart, 1939.

Clyne, Patricia Edwards. *Hudson Valley Tales and Trails*. Woodstock, N.Y.: Overlook Press, 1990.

Cronin, John, and Robert F. Kennedy, Jr. *The Riverkeepers*. New York: Scribner, 1997.

deNoyelles, Daniel. *Within These Gates*. Thiells, N.Y.: Daniel deNoyelles, 1982.

Downing, Andrew Jackson. *The Architecture of Country Houses*. New York: Dover Publications, 1960. Reprint of 1850 edition by D. Appleton, New York.

Downing, Andrew Jackson. *Treatise on the Theory and Practice of Landscape Gardening*. New York: O. Judd, 1865.

Dunwell, Frances F. *The Hudson River Highlands*. New York: Columbia University Press, 1991.

Dwyer, Michael Middleton, ed. *Great Houses of the Hudson River*. Boston: Little Brown and Company, 2001.

Eberlein, Harold Donaldson, and Cortlandt van Dyke Hubbard. *Historic Houses of the Hudson Valley*. New York: Bonanza Books, 1942.

Evers, Alf. *The Catskills from Wilderness to Woodstock*. Garden City, N.Y.: Doubleday Publishing, 1972.

Evers, Alf. *Woodstock: History of an American Town*. Woodstock, N.Y.: Overlook Press, 1987.

Gross, Geoffrey, Susan Piatt, Roderic H. Blackburn, and Harrison Frederick

Meeske. *Dutch Colonial Homes in America*. New York: Rizzoli International Publications, 2002.

Harlow, Alvin F. *The Road of the Century: The Story of the New York Central*. New York: Creative Age Press, 1947.

Hoffman, Edward Fenno, ed. *The Poems of Charles Fenno Hoffman*. Philadelphia: Porter & Coates, 1873.

Hutton, George V. *The Great Hudson River Brick Industry*. Fleischmanns, N.Y.: Purple Mountain Press, 2003.

In the Hudson Highlands. New York: Creative Age Press, 1945.

Ingersoll, Ernest. *The Handy Guide to the Hudson River and Catskill Mountains*. New York: Ernest Ingersoll, 1910. Reprinted by J. C. & A. L. Fawcett, Astoria, N.Y., 1989.

Irving, Washington. *A History of New-York*. New York: G. P. Putnam, 1859.

Keller, Allan. *Life along the Hudson*. Tarrytown, N.Y.: Sleepy Hollow Restorations, 1976.

Lossing, Benson J. *The Hudson, from the Wilderness to the Sea*. Troy, N.Y.: H. B. Nims & Co., 1866. Reprinted by Black Dome Press, Hensonville, N.Y., 2000.

Murphy, Robert J., and Denise Doring van Buren. *Historic Beacon*. Charleston, S.C.: Arcadia Publishing, 1998.

New York Walk Book, sixth ed. New York: New York–New Jersey Trail Conference, 1998.

Pelletreau, William S. *History of Putnam County, New York*. Philadelphia: W. W. Preston & Co., 1886.

Ransom, James M. *Vanishing Ironworks of the Ramapos*. New Brunswick, N.J.: Rutgers University Press, 1966.

Reynolds, Helen Wilkinson. *Dutch Houses in the Hudson Valley before 1776*. New York: Dover Publications, 1965.

Rhoads, William B. *Kingston, New York: The Architectural Guide*. Hensonville, N.Y.: Black Dome Press, 2003.

Richardson, Judith. *Possessions: The History and Uses of Hauntings in the Hudson Valley*. Cambridge, Mass.: Harvard University Press, 2003.

Rogers, Elizabeth Barlow. *Landscape Design: A Cultural and Architectural History*. New York: Harry N. Abrams, 2001.

Ruskin, John. *The Seven Lamps of Architecture*. New York: D. Appleton & Company, 1901.

Sanchis, Frank E. *American Architecture, Westchester County, New York: Colonial to Contemporary*. Croton-on-Hudson, N.Y.: North River Press, 1977.

Scharf, J. Thomas. *History of Westchester County, New York*. Philadelphia: L. E. Preston & Co., 1886.

Schuyler, David. *Apostle of Taste: Andrew Jackson Downing, 1815–1852*. Baltimore: Johns Hopkins University Press, 1996.

Van Zandt, Roland. *The Catskill Mountain House*. Hensonville, N.Y.: Black Dome Press, 1991.

Wilstach, Paul. *Hudson River Landings*. New York: Tudor Publishing Co., 1933.

Woodward, Christopher. *In Ruins*. New York: Pantheon Books, 2001.

Zukowsky, John, and Robbe Pierce Stimson. *Hudson River Villas*. New York: Rizzoli International Publications, 1985.

The American Landscape No. 1. New York: E. Bliss, 1830.

Bryant, William Cullen, ed. *Picturesque America, or The Land We Live In.* Vol. 2. New York: D. Appleton, c. 1874.

Cole, Thomas. "Essay on American Scenery." *American Monthly Magazine,* Jan. 1836, pp. 1–12.

Cooper, James Fenimore. *The Last of the Mohicans: A Narrative of 1757.* New York: Charles Scribner's Sons, 1952.

Effman, Elsie. "Thomas Cole's *View of Fort Putnam.*" *The Magazine Antiques,* Nov. 2004, 155–159.

Gurstein, Rochelle. "Pleasing Decay." *New Republic,* 23 Feb. 2004, pp. 32–37.

"The Hudson River." *New York Times,* 10 Sept. 1852, p. 2.

Irving, Washington. *The Sketch Book of Geoffrey Crayon, Gentn.* Facsimile edition by Tarrytown, N.Y.: Sleepy Hollow Press, 1981. Reprint of 1852 edition by George P. Putnam, New York.

Kunstler, James Howard. *The Geography of Nowhere: The Rise and Decline of America's Man-Made Landscape.* New York: Touchstone, 1994.

Landmarks in Threatened, Emergency and Lost Status, 2004. Washington, D.C.: National Park Service, 2004.

Macaulay, Rose. *The Pleasure of Ruins.* London: Weidenfeld and Nicolson, 1953.

Opportunities Waiting to Happen: Redeveloping Abandoned Buildings and Sites to Revitalize Communities. Albany: New York State Department of State—Division of Coastal Resources, 2004.

Richardson, Judith. *Possessions: The History and Uses of Haunting in the Hudson Valley.* Cambridge, Mass.: Harvard University Press, 2003.

"Ruins Along the Hudson: Many Deserted Mansions On Historic Spots." *New York Times,* 16 July 1882, p. 10.

Smith, E. Oakes, ed. *The Salamander.* New York: George P. Putnam, 1849.

"A Suburban Walk: From Spuyten Duyvel to Tarrytown." *New York Times,* 21 Apr. 1878, p. 4.

Van Zandt, Roland. *Hudson River Chronicles: Three Centuries of Travel and Adventure.* Hendersonville, N.Y.: Black Dome Press, 1992.

Woodward, Christopher. *In Ruins.* New York: Pantheon Books, 2001.

Albany and Rensselaer Counties

Powell and Minnock Brick Company, Coeymans

"Albany Troops Go to Coeymans." *Albany Evening Journal,* 16 May 1906, p. 1

"Call State Troops for Brick Yard Riots." *New York Times,* 17 May 1906, p. 4

Carmer, Carl. *The Hudson.* New York: Farrar & Rinehart, 1939.

"Coeymans Rioters Bailed." *Albany Evening Journal,* 19 May 1906, p. 1.

deNoyelles, Daniel. *Within These Gates.* Thiells, N.Y.: Daniel deNoyelles, 1982.

Giddings, Edward D. *Coeymans and the Past.* Rensselaer, N.Y.: Tri-Centennial Committee of the Town of Coeymans, 1973.

Hutton, George V. *The Great Hudson River Brick Industry.* Fleischmanns, N.Y.: Purple Mountain Press, 2003.

Powell & Minnock Brick Works. http://www.pmbrick.com/page647668.htm, printed 17 June 2002.

"Soldiers after the Rioters." *Albany Evening Journal*, 17 May 1906, p. 1.

Tuthill, William. "Managers Try to Save State's Last Brick Works." *The Business Review Serving New York's Capital Region*, 19 Oct. 2001.

Fort Orange Paper Company, Castleton-on-Hudson

Bird, David. "Two Paper Companies in State Get Federal Pollution Mandate." *New York Times*, 23 Dec. 1971, p. 49.

"54 Men Indicted in Paper Pool Case." *New York Times*, 8 Jan. 1920, p. 1.

"Mill Closures & Curtailments from 1989 until 2003," http://www.property rightsresearch.org/articles4/mill_closures.htm.

Riley, David. "County Feels Plant Headache." *The Independent*, 3 Dec. 2004.

Riley, David. "EPA Joins in Plant Cleanup." *The Independent*, 11 June 2004

Riley, David. "EPA Lacks Funding for Castleton Plant Cleanup." *The Independent*, 1 Oct. 2004.

Riley, David. "Spitzer Investigates Old Castleton Paper Facility." *The Independent*, 8 Aug. 2003.

Sylvester, N. B. *History of Rensselaer County*. Philadelphia: Everts & Peck, 1880.

Walsh, Alice. "The Hudson River Ice Industry." *Chatham Courier*, 3 Mar. 1983, p. 6.

Greene County

Alsen's American Portland Cement Works, Smith's Landing

100 Jahre Alsen. Hamburg: Alsen'sche Portland Cement-Fabriken KG, 1963.

Beecher, Raymond. *Notes on Cement Industry*, 28 Mar. 2002.

"Cement Firm Drops Proposal." *Kingston Daily Freeman*, 25 Apr. 2005, p. A1.

"Cord Meyer Fails." *New York Times*, 8 Feb. 1922, p. 33.

Faber, Harold. "Coal Trade to Make a Comeback on Hudson River." *New York Times*, 8 Dec. 1985, p. 62.

"Geschichte der Holcim (Deutschland) AG." http://www-cms.holcim.com, printed 7 July 2005.

Hammer, Alexander R. "U.S. Cement Industry Suffers Growing Pains." *New York Times*, 18 Sept. 1955, p. F1.

"History of Local Cement Plant Traced in Article." *Catskill Mountain Star*, 7 Jan. 1955.

Jensis, Annabar. "A Blast From the Past: Cementon Asks to Be 'Smith's Landing' Again." *Catskill Daily Mail*, 3 Mar. 1993, p. 1.

Kirby, Paul. "City Accepts The Landing's Draft Impact Statement." *Kingston Daily Freeman*, 19 July 2005, p. 1.

"Lehigh Cement Company History." http://www.lehighcement.com/a_hist.asp, printed 2 Feb. 2002.

Pavlack, Joseph M. *Alsen, New York: A Cement Plant, a Railroad Station, a School, a Post Office, a Community*. Cementon, 1991.

R. A. Daniels to D. Loomes. 19 Apr. 2005. Vedder Memorial Library, Greene County Historical Society, Coxsackie, N.Y.

"Reorganized by Palmer." *New York Times*, 26 Mar. 1918, p. 11.

"Rossoff Coup Makes Hudson Penn. Rival." *New York Times*, 13 Apr. 1925, p. 36.

Shapley, Dan. "State Says No to Plant." *Poughkeepsie Journal*, 20 Apr. 2005, p. A1.

"Three Shot in Fight." *New York Times*, 20 June 1910, p. 3.

Unsigned to F. N. Curtis, 18 Feb. 1922. Smith's Landing file, Greene County Historical Society.

Van Orden, Barbara, and Elsie Van Orden. "Smith's Landing—Now Cementon." *The Quarterly Journal (A Publication of the Greene County Historical Society, Inc.)*, Spring 1979, pp. 1, 3–9.

Wilcke, Gerd. "New Methods Helping Ailing Cement Industry." *New York Times*, 31 Oct. 1965, p. F1.

Columbia County

New York Central Railroad Station, Stuyvesant

Eyre, Jim. "The Stuyvesant Railroad Station." *Columbia County History and Heritage*, Summer 2001, pp. 30–31.

Hammer, Alexander R. "Court Here Lets Railroads Consolidate Tomorrow." *New York Times*, 31 Jan. 1968, p. 51.

Harlow, Alvin F. *The Road of the Century: The Story of the New York Central*. New York: Creative Age Press, 1947.

Marranca, Bonnie. *Hudson Valley Lives*. Woodstock, N.Y.: Overlook Press, 1991.

Martin, Virginia, and Kwacz, Kristina. "Stuyvesant Restoration Draws Many." *The Independent*, 31 July 2000.

Pellnat, Christopher. "Stuyvesant Railroad Station a Forgotten Remnant." *Chatham Courier*, 31 Jan. 1991, p. B4.

"Stuyvesant Railroad Station." National Register of Historic Places Registration Form, 21 Sept. 1998.

Van Zandt, Roland. *Hudson River Chronicles: Three Centuries of Travel and Adventure*. Hendersonville, N.Y.: Black Dome Press, 1992.

R&W Scott Ice Company, Newton Hook

Faherty-Sansaricq, Mary. "A Call for the Conservation of Nutten Hook." *Columbia County History and Heritage*, Summer 2004, pp. 20–21.

Hall, Henry. *The Ice Industry of the United States, With a Brief Sketch of its History*. Washington, D.C.: Government Printing Office, 1888.

Hamilton, John G. *Hudson River Pilot: From Steamboats to Super Tankers*. Hendersonville, N.Y.: Black Dome Press, 2001.

Harris, Wendy Elizabeth, and Arnold Pickman. *Slip-Slidin' Away: Archaeology and the Reconstruction of the Hudson River Ice Industry*. Oct. 1998. Paper presented at the annual meeting and conference of the Council for Northeast Historical Archaeology, Montreal, Quebec.

"R&W Scott Ice Company Powerhouse and Ice House Site." National Register of Historic Places Nomination Form, Oct. 1984.

Stott, Peter H. *Finding Work: Industrial Archeology in Columbia County, New York*. Kinderhook, N.Y.: Columbia County Historical Society, 2005.

Walsh, Alice. "The Hudson River Ice Industry." *Chatham Courier*, 3 Mar. 1983, p. 6, and 10 Mar. 1983, p. 1.

Stott Woolen Mills, Stottville

Beersiap, Frank. *Stottville or Springville*. In "Stottville" file, Columbia County Historian's Office.
Calvin, Jim. "$51,000 Demolition Pact Approved for Stottville Mill." *Hudson Register Star*, 11 May 1978.
Ellis, Franklin. *History of Columbia County, New York*. Philadelphia: Everts and Ensign, 1880.
"Fire Razes Old Mill." *Hudson Register Star*, 4 Aug. 1994, p. A1.
Gordon, Thomas Francis. *Gazetteer of the State of New York*. Philadelphia: T. K. and P. G. Collins, 1836.
Miller, Martin. "Smoke Still Blankets Stottville Air." *The Independent*, 8 Aug. 1994.
Philip, J. Van Ness, Jr. *The Stotts of Stottville*. In "Stottville" file, Columbia County Historian's Office.
"Report on Failure of W. L. Strong & Co." *New York Times*, 21 Jan. 1901, p. 3.
Smith, H. P., ed. *Columbia County at the End of the Century*. Hudson, N.Y.: Record Printing and Publishing Co., 1900.
Stott, Peter H. *Finding Work: Industrial Archeology in Columbia County, New York*. Kinderhook, N.Y.: Columbia County Historical Society, 2005.
"Stottville Mill Wall Collapses." *Hudson Register Star*, 16 Apr. 1976, p. 1.
"W. L. Strong Indorsed Notes for Large Sums." *New York Times*, 15 Nov. 1900, p. 2.

Jan van Hoesen House, Claverack

Dwyer, Michael Middleton, ed. *Great Houses of the Hudson River*. Boston: Little Brown and Company, 2001.
Gross, Geoffrey, Susan Piatt, Roderic H. Blackburn, and Harrison Frederick Meeske. *Dutch Colonial Homes in America*. New York: Rizzoli International Publications, 2002.
"Hudson's First Citizen." *Chatham Courier*, 26 Jan. 1961, p. 7.
"Jan van Hoesen House." National Register of Historic Places Inventory—Nomination Form. New York State Division for Historic Preservation, Parks and Recreation, 23 Mar. 1979.
Meeske, Harrison Frederick. *The Hudson Valley Dutch and Their Houses*. Fleischmanns, N.Y.: Purple Mountain Press, 1998.
Reynolds, Helen Wilkinson. *Dutch Houses in the Hudson Valley before 1776*. New York: Dover Publications, 1965. Originally published by the Holland Society of New York, 1929.

Oliver Bronson House, Hudson

"Bronson, Dr. Oliver, House and Estate." National Historic Landmark Nomination, July 2001 (revisions 14 Aug. 2001).
Cummings, Kelliann. "Gem of House 'Imprisoned.'" *Hudson Register Star*, 12 Aug. 1997.

Downing, Andrew Jackson. *The Architecture of Country Houses; Including Designs for Cottages, Farm-Houses, and Villas.* New York: D. Appleton & Co., 1861.

Eberlein, Harold Donaldson, and Cortlandt van Dyke Hubbard. *Historic Houses of the Hudson Valley.* New York: Bonanza Books, 1942.

Krattinger, William. "Conspicuous but Endangered Landmarks." *The Hudson River Valley Review,* Autumn 2004, pp. 12–37.

Peck, Amelia, ed. *Alexander Jackson Davis: American Architect, 1803–1892.* New York: Rizzoli International Publications, 1992.

"Plumb Bronson to Have Open House." *Hudson Register Star,* 7 May 1999.

Zukowsky, John, and Robbe Pierce Stimson. *Hudson River Villas.* New York: Rizzoli International Publications, 1985.

Ulster County

Overlook Mountain House, Woodstock

"Catskill Hotel Burns." *New York Times,* 1 Nov. 1923, p. 14.

Evers, Alf. *The Catskills from Wilderness to Woodstock.* Garden City, N.Y.: Doubleday Publishing, 1972.

Evers, Alf. *Woodstock: History of an American Town.* Woodstock, N.Y.: Overlook Press, 1987.

"Overlook Mountain Wild Forest Unit Management Plan Draft." New York State Department of Environmental Conservation, Oct. 1998.

"President Grant." *New York Times,* 31 July 1873, p. 1.

"Red Scheming Here Began on Mountain." *New York Times,* 14 Sept. 1923, p. 24.

Kingston City Hall, Kingston

"Cities Remaking Themselves to Restore Life in Downtowns." *Middletown Times Herald-Record,* 22 Nov. 1999.

Fishman, David, Thomas Mellins, and Robert Stern. *New York, 1880: Architecture and Urbanism in the Gilded Age.* New York: Monacelli Press, 1999.

"Gallo Talks about Revitalization Prospectus." *Kingston Daily Freeman,* 19 May 2000, p. 24.

Hu, Winnie. "Kingston Mourns Loss of Mayor Who Breathed Life into City." *New York Times,* 23 Jan. 2002, p. B5.

"Kingston City Hall." National Register of Historic Places Inventory—Nomination Form, Nov. 1971.

"Kingston City Hall." Historic American Buildings Survey, Summer 1972.

"Building Kingston's Future," Press Kit, City of Kingston, N.Y., 1999.

Rhoads, William B. *Kingston, New York: The Architectural Guide.* Hensonville, N.Y.: Black Dome Press, 2003.

Rowe, Claudia. "Fixing a Building, Building a Career." *New York Times,* 17 Dec. 1999.

White, Norval, and Elliot Willensky. "AIA Guide to New York City." New York: Three Rivers Press, 2000.

Bibliography

Delaware and Hudson Canal, Eddyville and West

Booth, Malcolm A. "Roebling's Sixth Bridge, 'Neversink.'" *Journal of the Rutgers University Library*, Dec. 1966, pp. 12–15.

Clyne, Patricia Edwards. *Hudson Valley Tales and Trails*. Woodstock, N.Y.: Overlook Press, 1990.

Gilchrist, Ann LeFevre. *Footsteps across Cement: A History of the Township of Rosendale, New York*. N.p.: [?], 1976.

McDermott, John D. *Delaware and Hudson Canal, Pennsylvania and New York*. Washington, D.C.: National Park Service, 1968.

Osterberg, Matthew M. *The Delaware and Hudson Canal and the Gravity Railroad*. Charleston, S.C.: Arcadia Publishing, 2002.

Wakefield, Manville B. *Coal Boats to Tidewater: The Story of the Delaware and Hudson Canal*. Fallsburg, N.Y.: Steingart Associates, 1965.

Rosendale Natural Cement Industry, Rosendale and Vicinity

Gilchrist, Ann LeFevre. *Footsteps across Cement: A History of the Township of Rosendale, New York*. N.p.: [?], 1976.

Gillmore, Q. A. *Report of the Cement Manufactory of F. O. Norton*. New York: D. van Nostrand, Publisher, 1878.

"125 Years of Construction Industry Is Paced by Rosendale Natural Cement." *New York Times*, 23 Oct. 1955, p. R4.

"Snyder Estate Natural Cement Historic District." National Register of Historic Places Registration Form, Jan. 1992.

Dutchess County

Wyndclyffe, Rhinebeck

Downing, Andrew Jackson. *A Treatise on the Theory and Practice of Landscape Gardening*, sixth ed. New York: A. O. Moore & Co., 1859.

Dunwell, Frances F. *The Hudson River Highlands*. New York: Columbia University Press, 1991.

Kelly, Nancy V. *A Brief History of Rhinebeck*. New York: Wise Family Trust, 2001.

Smith, Edward M. *History of Rhinebeck*. Rhinebeck: Edward M. Smith, 1881.

Tiltsen, Sari B. *Rhinebeck: Portrait of a Town*. Rhinebeck, N.Y.: Phanter Press, c. 1990.

Wharton, Edith. *A Backward Glance*. New York: D. Appleton-Century Company, 1934.

"Wyndclyffe." *Historic Preservation*, Oct./Dec. 1978, pp. 8–9.

"Wyndclyffe (Linden Grove)." *Historic American Buildings Survey*. Washington, D.C.: National Park Service, 1974.

Zukowsky, John, and Robbe Pierce Stimson. *Hudson River Villas*. New York: Rizzoli International Publications, 1985.

The Point, Staatsburg

Alex, William. *Calvert Vaux: Architect & Planner*. New York: Ink, 1994.

Fullam, Anne. "Wasting Away: The State's Focus on Land Acquisition Is Leaving Historic Buildings Neglected." *Empire State Report*, online edition, Sept. 1999.

Havas, Valerie. "Landmark in Limbo." *Hudson Valley*, Apr. 2003, pp. 42–44.

"Hoyt, Lydig M. and Geraldine L., House and Estate." National Historic Landmark Nomination, 15 Jun. 2005.

Kowsky, Francis R. *Country, Park & City: The Architecture and Life of Calvert Vaux.* New York: Oxford University Press, 1998.

"Report on the L. M. Hoyt Estate, Staatsburgh, Dutchess County, New York." New York State Historic Trust, Oct. 1969.

Schuyler, David. *Apostle of Taste: Andrew Jackson Downing, 1815–1852.* Baltimore: Johns Hopkins University Press, 1996.

Vaux, Calvert. *Villas and Cottages.* New York: Dover Publications, 1970. Reprint of 1864 edition by Harper and Brothers, New York.

Zukowsky, John, and Robbe Pierce Stimson. *Hudson River Villas.* New York: Rizzoli International Publications, 1985.

Hudson River State Hospital, Poughkeepsie

Auster, Harvey. "Fate of Psychiatric Center Buidling Costly in Any Case." *Poughkeepsie Journal*, 22 Aug. 1993.

Burns, Mark. "Best Restoration Opportunity: Hudson River Psychiatric Center, Poughkeepsie." *Hudson Valley*, Nov. 2003, pp. 38–39.

Censer, Jane Turner, and David Schuyler. *The Papers of Frederick Law Olmsted, Volume VI: The Years of Vaux, Olmsted & Company.* Baltimore: Johns Hopkins University Press, 1992.

"Demolition of the North and South Wings; Building 51, Hudson River Psychiatric Center, Poughkeepsie, New York." Draft Environmental Impact Statement prepared for the New York State Office of Mental Health, May 1990.

Fishman, David, Thomas Mellins, and Robert Stern. *New York, 1880: Architecture and Urbanism in the Gilded Age.* New York: Monacelli Press, 1999.

Hall, Lee. *Olmsted's America: An 'Unpractical' Man and His Vision of Civilization.* Boston: Little, Brown & Co., 1995.

"The Hudson River State Hospital for the Insane." *New York Times*, 26 Dec. 1872, p. 2.

"Hudson River State Hospital, Main Building." National Register of Historic Places Registration Form, c. 1989.

Kowsky, Francis S. "Architecture, Nature and Humanitarian Reform: The Buffalo State Hospital for the Insane." in B. Campagna, M. Feurerstein, and L. Schneeklogh, *Changing Places: Remaking Institutional Buildings.* Fredonia, N.Y.: White Pine Press, 1992.

Kowsky, Francis S. *The Architecture of Frederick Clarke Withers.* Middletown, Conn.: Weslyan University Press, 1980.

Mares, Franklin D. *Springwood.* Hyde Park, N.Y.: Hyde Park Historical Association, 1993.

Myers, Helen. "Hard Bargaining Brought HRSH Here." *Poughkeepsie Sunday New Yorker*, 31 Dec. 1944.

O'Gorman, James F. *Three American Architects.* Chicago: University of Chicago Press, 1991.

Rowe, Claudia. "Modern Efficiency Displaces Historic Psychiatric Hospital." *New York Times*, 30 May 2001.

Rozhon, Tracie. "A Fight to Preserve Old and Abandoned Asylums." *New York Times*, 18 Nov. 1998, p. B1.

Valkys, Michael. "Psychiatric Center Deal Finally Closes." *Poughkeepsie Journal*, 16 Mar. 2005, p. A1.

Luckey Platt & Company, Poughkeepsie

Berger, Joseph. "Poughkeepsie, in a Long Tailspin, Now Copes with a Clouded Image." *New York Times*, 5 Oct. 1998.

Bernstein, George. "Luckey Platt Store Closes Quietly in City." *Poughkeepsie Journal*, 3 July 1981.

Bernstein, George. "Luckey Platt to Close City Store." *Poughkeepsie Journal*, 10 June 1981, p. 5.

Haviland, James C. "Historic Poughkeepsie Hotel Bought by Dutchess County." *Albany Times-Union*, 16 Nov. 1969, p. B8.

"Hudson Landmark: A Switch to Offices." *New York Times*, 11 Jan. 1987, p. R1.

"Luckey, Platt & Company: 100 Years of Service." *Dutchess County Historical Society Yearbook*, 1969, pp. 39–42.

"Luckey, Platt & Company Department Store." National Register of Historic Places Building-Structure Inventory Form, 8 Aug. 1980.

Seetoo, Rob. "Artist Sees Center of Arts, Commerce." *Poughkeepsie Journal*, 5 Apr. 2002, p. A1.

Seetoo, Rob. "Luckey Concept Greeted Warmly." *Poughkeepsie Journal*, 11 Nov. 1999.

Vizard, Mary McAleer. "Cars Trickle Back to Pedestrian Malls." *New York Times*, 29 Dec. 1991.

"Wallaces to Close City Store." *Poughkeepsie Journal*, 29 Apr. 1975, p. 1.

Zappe, John. "Wallaces Closing Focuses Attention on City's Central Business District." *Poughkeepsie Journal*, 4 May 1975.

Bannerman's Island Arsenal, Pollepel Island

Bannerman, Charles S. *The Story of Bannerman Island*. New York: Francis Bannerman Sons, 1962. Reprinted by the Bannerman Castle Trust, Beacon, N.Y., 1995.

"Bannerman's Island Arsenal." *Hudson River Day Line Magazine*, Aug. 1911, p. 22.

"Bannerman's Island Arsenal." National Register of Historic Places Building-Structure Inventory Form, 8 Mar. 1982.

1907 *Catalogue of Military Goods from Government Auction for Sale by Francis Bannerman*. New York: Francis Bannerman, 1907.

Dunwell, Frances F. *The Hudson River Highlands*. New York: Columbia University Press, 1991.

"F. Bannerman, Arms Dealer, Dies." *New York Times*, 28 Nov. 1918, p. 17.

"Fire Destroys Famous Bannerman's Castle." *New York Times*, 9 Aug. 1969, p. 17.

Haviland, James C. "A Chunk of Scotland on the Hudson." *New York Times*, 17 Nov. 1968, p. XX17.

Lossing, Benson J. *The Hudson, from the Wilderness to the Sea.* Troy, N.Y.: H. B. Nims & Co., 1866. Reprinted by Black Dome Press, Hensonville, N.Y., 2000.

Zukowsky, John, and Robbe Pierce Stimson. *Hudson River Villas.* New York: Rizzoli International Publications, 1985.

Orange County

Dutch Reformed Church, Newburgh

Armario, Christine. "Buildings of Distinction." *Poughkeepsie Journal,* 26 July 2003, p. 1A.

Belden, Maureen. "Savior at Last: A Newburgh Group Has Big Plans to Restore a Landmark Church." *Hudson Valley,* Feb. 2002, pp. 21–23.

A Brief History. Newburgh, N.Y.: American Reformed Church, 1910.

Brouwer, Arie R. *Reformed Church Roots: Thirty-Five Formative Events.* New York: Reformed Church Press, 1977.

Brown, Patricia Leigh. "Partners in Saving a Legacy." *New York Times,* 23 July 1998.

Brugnard, Bond. "Restoring Dutch Church Urged." *Poughkeepsie Journal,* 24 Nov. 2002.

De Jong, Gerald F. *The Dutch Reformed Church in the American Colonies.* Grand Rapids, Mich.: William B. Eerdmans Co., 1978.

"Dutch Reformed Church." *Historic American Buildings Survey.* Washington, D.C.: National Park Service, June, 1984.

"Dutch Reformed Church." National Historic Landmark Nomination, 2001.

"Dutch Reformed Church." National Register of Historic Places Inventory— Nomination Form, 4 Sept. 1970.

Herron, Don. "Concerned Citizens Seek to Save Landmark." *Middletown Times Herald-Record,* 14 June 2001, p. HV33.

Peck, Amelia, ed. *Alexander Jackson Davis: American Architect, 1803–1892.* New York: Rizzoli International Publications, 1992.

Randall, Michael. "A First Lady and a Church." *Middletown Times Herald-Record,* 20 May 1999, p. 3.

Ruttenber, E. M. *History of the Town of Newburgh.* Newburgh, N.Y.: E. M. Ruttenber & Co., 1859.

West Shore Railroad Station, Newburgh

Adams, Arthur G. *The Hudson through the Years.* New York: Fordham University Press, 1996.

Bigart, Homer. "West Shore Line Asks to End Runs." *New York Times,* 31 Mar. 1959, p. 19.

"Contracts for New West Shore Station." *Newburgh Daily News,* 29 Mar. 1909.

Eshbacher, Karen. "Trains Serving Western Shore May Return." *Middletown Times Herald-Record,* 9 Aug. 1999.

Gill, Bo. "Railroad Station Was Once Grand." *Middletown Times Herald-Record,* 16 Aug. 1995.

Harlow, Alvin F. *The Road of the Century: The Story of the New York Central*. New York: Creative Age Press, 1947.

Jannotti, Rose, and Ed Shanahan. "Fire Damages Closed Rail Station." *Times Herald-Record*, 17 Nov. 1992, p. 5.

"Last Whistle Blows Sunday on West Shore." *Newburgh News*, 22 June 1958.

Stern, Robert A. M., Gregory Gilmartin, and John Massengale. *New York, 1900: Metropolitan Architecture and Urbanism 1890–1915*. New York: Rizzoli International Publications, 1995.

Maritime Ruins

Burgess, Robert H., and H. Graham Wood. *Steamboats out of Baltimore*. Cambridge, Md.: Tidewater Publishers, 1968.

Eisele, Peter T. "Hopes for the Hamilton." *Steamboat Bill*, Fall 1979, pp. 21–24.

Hamilton, John G. *Hudson River Pilot*. Hensonville, N.Y.: Black Dome Press, 2001.

Johnson, Kirk. "Hudson Shipwrecks Found, but No Loose Lips." *New York Times*, 18 Dec. 2002, p. B1.

Jones, Harry. "A Centennial Salute to Albany." *Steamboat Bill*, Winter 1979, pp. 215–226.

Lewis, Jack. *The Hudson River*. N.p.: [?], 1964.

Moffett, Glendon L. *To Poughkeepsie and Back*. Fleishmanns, N.Y.: Purple Mountain Press, 1994.

Morris, Paul C. *Schooners and Schooner Barges*. Orleans, Mass.: Lower Cape Publishing, 1984.

Murray, Stuart. *Thomas Cornell and the Cornell Steamboat Company*. Fleishmanns, N.Y.: Purple Mountain Press, 2001.

"New Ferry Boats for Boston Harbor." *Marine Engineering*, Nov. 1921, pp. 827–830.

Peckham, Mark. "Remnants of Working Sail on the Hudson." *Sea History*, Spring 1996, pp. 27–30.

Rinaldi, Thomas E. "The Hudson's Lost Steam Fleet." *Steamboat Bill*, Fall 2003, pp. 173–192.

Ringwald, Donald C. "Central Hudson Steamboat Co." *Steamboat Bill*, Winter 1982, pp. 231–257.

Ringwald, Donald C. *Hudson River Day Line*. Berkeley, Calif.: Howell-North Books, 1965.

Ringwald, Donald C. *Mary Powell*. Berkeley, Calif.: Howell-North Books, 1972.

Ringwald, Donald C. *Steamboats for Rondout*. Providence, R.I.: Steamship Historical Society of America, 1981.

Putnam County

Edward J. Cornish Estate, Cold Spring

"Adds to Tract on Hudson." *New York Times*, 28 May 1931, p. 52.

Buttlar, Richard. "A Crumbling Legacy." *Hudson Valley*, Apr. 2004, pp. 19–23.

Dunwell, Frances F. *The Hudson River Highlands*. New York: Columbia University Press, 1991.

Dykeman, Nathan. "Breakneck Is for Curious Hikers." *Poughkeepsie Journal*, 24 Oct. 1982, p. 20B.

"Edward J. Cornish Dies at Desk Here." *New York Times*, 4 May 1938, p. 23.

"First Blast Inflicts Scar on Mount Taurus." *New York Times*, 22 Nov. 1931, p. 52.

New York Walk Book, sixth ed. New York: New York–New Jersey Trail Conference, 1998.

"Plans to Give Cattle to Aid Flood Victims." *New York Times*, 2 June 1927, p. 11.

"Putnam County Farms Giving Way to Country Estates." *New York Times*, 7 Oct. 1928, p. RE2.

"The Real Estate Field." *New York Times*, 19 Apr. 1917, p. 21.

West Point Foundry, Cold Spring

Dunwell, Frances F. *The Hudson River Highlands*. New York: Columbia University Press, 1991.

"Foundry for Silk Making." *New York Times*, 22 Aug. 1920, p. W1.

Greenhouses, Linda. "Student Environmentalist Is Honored." *New York Times*, 31 Oct. 1972, p. 49.

Lossing, Benson J. *The Hudson, from the Wilderness to the Sea*. Troy, N.Y.: H. B. Nims & Co., 1866. Reprinted by Black Dome Press, Hensonville, N.Y., 2000.

Lyons, Richard D. "3 Fish Caught Near a Battery Factory on the Hudson Contain up to 1,000 Times Normal Cadmium." *New York Times*, 13 June 1971, p. 23.

"Manufacturers to Open Old Cold Spring Plant." *New York Times*, 25 Mar. 1936, p. 41.

Nackman, Barbara Livingston. "A Blast from the Past." *White Plains Journal News*, 30 Mar. 2001, p. 1A.

"No Profit in Cannons." *New York Times*, 19 Aug. 1884, p. 1.

Rowe, Claudia. "Seeking What Lies Beneath: Cold Spring Foundry Site Yields Clues to the Past." *New York Times*, 8 Sept. 2002, p. WE8.

"West Point Foundry." National Register of Historic Places Inventory—Nomination Form, 11 Apr. 1973.

"The West Point Foundry." *New York Times*, 2 Jul. 1865, p. 3.

"The West Point Foundry." *New York Times*, 14 Aug. 1886, p. 2.

"West Point Foundry Sold." *New York Times*, 10 Aug. 1920, p. 11.

Rockland County

Dunderberg Spiral Railway, Dunderberg Mountain

Collier, Barbara, and Jonathan Paul. "On the Way Up." *Washington Post*, 13 Oct. 1999.

"A Conspiracy to Ruin the Business of an Asphalt Company." *New York Times*, 22 July 1890, p. 8.

"The Dunderberg Mountain Gravity Railway." *Engineering News*, 21 Dec. 1889.

"Engineers' Task Never Completed." *New York Times*, 4 May 1930, p. RE15.

Goldwaithe, George E. "The Dunderberg Scenic Railroad." *Appalachia*, Nov. 1935, pp. 380–387.

In the Hudson Highlands. New York: Walking News, 1945.

Incaltcaterra, Laura. "Cable Car Proposed for High Tor Mountain." *White Plains Journal News*, 23 Feb. 2005.

Irving, Washington. *Bracebridge Hall; Tales of a Traveller; The Alhambra*. New York: Library of America, 1991. Texts copyright 1977, 1987, and 1983 by G. K. Hall & Co.

Prospectus of the Dunderberg Spiral Railway. New York, N.Y.: [?], 1889.

"A Road on Old Dunderberg." *New York Times*, 10 Nov. 1889, p. 3.

Rockland Lake, Rockland Lake

Binnewies, Robert O. *Palisades: 100,000 Acres in 100 Years*. New York: Fordham University Press and Palisades Interstate Park Commission, 2001.

"Fire and Explosion Imperil a Town." *New York Times*, 21 Apr. 1926, p. 1.

Green, Frank Bertangue, M.D. *History of Rockland County*. Reprinted by Historical Society of Rockland County, New City, N.Y., 1989.

"Hook Mountain: A Part Owner on What Has Been Done to Save It." *New York Times*, 1 Oct. 1909, p. 8.

Maroni, Peter. "Growing Up at Rockland Lake." *Rockland Journal News*, 19 May 1985.

"Reclaim Quarry Sites to Add Playground." *New York Times*, 16 Dec. 1928, p. N6.

"A State Highlands Park." *New York Times*, 6 Jan. 1910, p. 8.

Stott, Peter. "The Knickerbocker Ice Company and Inclined Railway at Rockland Lake, New York." *Journal of the Society for Industrial Archaeology*, vol. 5, no. 1, 1979.

"To Save Hook Mountain." *New York Times*, 14 Oct. 1906, p. 24.

"Trap Rock Magnate Passes." *Rockland County Times*, 27 Sept. 1930.

"Wilson P. Foss Dead: Ex-Billiard Champion." *New York Times*, 22 Sept. 1930, p. 15.

"Wilson Perkins Foss." Undated anonymous manuscript in collection of Ned Foss, Delmar, N.Y.

Westchester County

Mount Saint Florence, Peekskill

"The Boston Courier on the Associated Press." *New York Times*, 12 July, 1859, p. 12.

Carmer, Carl. *The Hudson*. New York: Farrar & Rinehart, 1939.

"A Decaying Paradise: The Mount Florence Story." *New York Sun*, clipping dated 1874, from the collection of the Peeksill Museum.

"Mount Florence." National Register of Historic Places Inventory—Nomination Form, 30 Dec. 1987.

"Party on Friday Will Help Sisters." *New York Times*, 30 Apr. 1939, p. 50.

Rhames, Marilyn Anderson. "Board Awaits Builder's Move." *White Plains Journal News*, 3 Aug. 2001, p. 1B

Dunwell, Frances F. *The Hudson River Highlands*. New York: Columbia University Press, 1991.

Dykeman, Nathan. "Breakneck Is for Curious Hikers." *Poughkeepsie Journal*, 24 Oct. 1982, p. 20B.

"Edward J. Cornish Dies at Desk Here." *New York Times*, 4 May 1938, p. 23.

"First Blast Inflicts Scar on Mount Taurus." *New York Times*, 22 Nov. 1931, p. 52.

New York Walk Book, sixth ed. New York: New York–New Jersey Trail Conference, 1998.

"Plans to Give Cattle to Aid Flood Victims." *New York Times*, 2 June 1927, p. 11.

"Putnam County Farms Giving Way to Country Estates." *New York Times*, 7 Oct. 1928, p. RE2.

"The Real Estate Field." *New York Times*, 19 Apr. 1917, p. 21.

West Point Foundry, Cold Spring

Dunwell, Frances F. *The Hudson River Highlands*. New York: Columbia University Press, 1991.

"Foundry for Silk Making." *New York Times*, 22 Aug. 1920, p. W1.

Greenhouses, Linda. "Student Environmentalist Is Honored." *New York Times*, 31 Oct. 1972, p. 49.

Lossing, Benson J. *The Hudson, from the Wilderness to the Sea*. Troy, N.Y.: H. B. Nims & Co., 1866. Reprinted by Black Dome Press, Hensonville, N.Y., 2000.

Lyons, Richard D. "3 Fish Caught Near a Battery Factory on the Hudson Contain up to 1,000 Times Normal Cadmium." *New York Times*, 13 June 1971, p. 23.

"Manufacturers to Open Old Cold Spring Plant." *New York Times*, 25 Mar. 1936, p. 41.

Nackman, Barbara Livingston. "A Blast from the Past." *White Plains Journal News*, 30 Mar. 2001, p. 1A.

"No Profit in Cannons." *New York Times*, 19 Aug. 1884, p. 1.

Rowe, Claudia. "Seeking What Lies Beneath: Cold Spring Foundry Site Yields Clues to the Past." *New York Times*, 8 Sept. 2002, p. WE8.

"West Point Foundry." National Register of Historic Places Inventory — Nomination Form, 11 Apr. 1973.

"The West Point Foundry." *New York Times*, 2 Jul. 1865, p. 3.

"The West Point Foundry." *New York Times*, 14 Aug. 1886, p. 2.

"West Point Foundry Sold." *New York Times*, 10 Aug. 1920, p. 11.

Rockland County

Dunderberg Spiral Railway, Dunderberg Mountain

Collier, Barbara, and Jonathan Paul. "On the Way Up." *Washington Post*, 13 Oct. 1999.

"A Conspiracy to Ruin the Business of an Asphalt Company." *New York Times*, 22 July 1890, p. 8.

"The Dunderberg Mountain Gravity Railway." *Engineering News*, 21 Dec. 1889.

"Engineers' Task Never Completed." *New York Times*, 4 May 1930, p. RE15.

Goldwaithe, George E. "The Dunderberg Scenic Railroad." *Appalachia*, Nov. 1935, pp. 380–387.

In the Hudson Highlands. New York: Walking News, 1945.

Incaltcaterra, Laura. "Cable Car Proposed for High Tor Mountain." *White Plains Journal News*, 23 Feb. 2005.

Irving, Washington. *Bracebridge Hall; Tales of a Traveller; The Alhambra*. New York: Library of America, 1991. Texts copyright 1977, 1987, and 1983 by G. K. Hall & Co.

Prospectus of the Dunderberg Spiral Railway. New York, N.Y.: [?], 1889.

"A Road on Old Dunderberg." *New York Times*, 10 Nov. 1889, p. 3.

Rockland Lake, Rockland Lake

Binnewies, Robert O. *Palisades: 100,000 Acres in 100 Years*. New York: Fordham University Press and Palisades Interstate Park Commission, 2001.

"Fire and Explosion Imperil a Town." *New York Times*, 21 Apr. 1926, p. 1.

Green, Frank Bertangue, M.D. *History of Rockland County*. Reprinted by Historical Society of Rockland County, New City, N.Y., 1989.

"Hook Mountain: A Part Owner on What Has Been Done to Save It." *New York Times*, 1 Oct. 1909, p. 8.

Maroni, Peter. "Growing Up at Rockland Lake." *Rockland Journal News*, 19 May 1985.

"Reclaim Quarry Sites to Add Playground." *New York Times*, 16 Dec. 1928, p. N6.

"A State Highlands Park." *New York Times*, 6 Jan. 1910, p. 8.

Stott, Peter. "The Knickerbocker Ice Company and Inclined Railway at Rockland Lake, New York." *Journal of the Society for Industrial Archaeology*, vol. 5, no. 1, 1979.

"To Save Hook Mountain." *New York Times*, 14 Oct. 1906, p. 24.

"Trap Rock Magnate Passes." *Rockland County Times*, 27 Sept. 1930.

"Wilson P. Foss Dead: Ex-Billiard Champion." *New York Times*, 22 Sept. 1930, p. 15.

"Wilson Perkins Foss." Undated anonymous manuscript in collection of Ned Foss, Delmar, N.Y.

Westchester County

Mount Saint Florence, Peekskill

"The Boston Courier on the Associated Press." *New York Times*, 12 July, 1859, p. 12.

Carmer, Carl. *The Hudson*. New York: Farrar & Rinehart, 1939.

"A Decaying Paradise: The Mount Florence Story." *New York Sun*, clipping dated 1874, from the collection of the Peeksill Museum.

"Mount Florence." National Register of Historic Places Inventory—Nomination Form, 30 Dec. 1987.

"Party on Friday Will Help Sisters." *New York Times*, 30 Apr. 1939, p. 50.

Rhames, Marilyn Anderson. "Board Awaits Builder's Move." *White Plains Journal News*, 3 Aug. 2001, p. 1B

Scharf, J. Thomas. *History of Westchester County, New York*. Philadelphia: L. E. Preston & Co., 1886.

Seebacher, Noreen. "Picking Up the Pieces . . . Again." *White Plains Journal News*, 10 Feb. 2002, p. 1H.

Smith, Chester A. *Peekskill, a Friendly Town: Its Historic Sites and Shrines*. Peekskill, N.Y.: Friendly Town Association, c. 1952.

Sing Sing, Ossining

"Babe Ruth Gets Big Reception from Prisoners." Anonymous news clipping dated 6 Sept. 1929, Ossining Public Library.

Beaumont, Gustave de, and Alexis de Tocqueville. *On the Penitentiary System in the United States, and Its Application in France*. Philadelphia: Carey, Lea and Blanchard, 1833.

Luckey, John. *Life in Sing Sing State Prison*. New York: N. Tibbals, 1860.

Marchant, Robert. "Foes Slam Prison Museum Idea." *White Plains Journal News*, 13 Mar. 2005.

Moore, Martha T. "Town Wants to Open Sing Sing to Public." *USA Today*, 8 Feb. 2005.

Panetta, Roger. "The Design and Construction of Sing Sing Prison, 1825–1828." *Westchester Historian*, vol. 62, no. 20, Spring 1986.

"Prison Group Asks 3D Degree Inquiry." *New York Times*, 22 Jan. 1935, p. 3.

Sing Sing Prison, Ossining, N.Y. New York State Department of Correction, 1959.

Smith, Edward H. "Old Sing Sing Cells Round Out a Century." *New York Times*, 21 Aug. 1927, p. XXII.

Briarcliff Lodge, Briarcliff Manor

Briarcliff Manor—Scarborough Historical Society. *A Village between Two Rivers: Briarcliff Manor*. White Plains, N.Y.: Monarch Publishing, Inc., 1977.

Cheever, Mary. *The Changing Landscape: A History of Briarcliff Manor–Scarbororugh*. West Kennebunk, Maine: Phoenix Publishing, 1990.

"Guy King Architect Plans Aerial Wharf for Airships." *Philadelphia Evening Times*, 23 Sept. 1909.

Olmsted Brothers to W. Law, 18 July 1900. Frederick Law Olmsted Papers, Library of Congress, Washington, D.C.

Vizard, Mary McAleer. "Another Hurdle Cleared toward an Irish Center." *New York Times*, 4 Feb. 1996.

Yasinsac, Robert. *Images of America: Briarcliff Lodge*. Portsmouth, N.H.: Arcadia Publishing, 2004.

Graystone and Pinkstone, Tarrytown

Ingersoll, Ernest. *The Handy Guide to the Hudson River and Catskill Mountains*. New York: Ernest Ingersoll, 1910. Reprinted by J. C. & A. L. Fawcett, Astoria, N.Y., 1989.

Ross, Barbara. "General Foods Buys 35 Acres from Lehmans." *Tarrytown Daily News*, 3 Jan. 1975, p. A3.

Scharf, J. Thomas. *History of Westchester County, New York*. Philadelphia: L. E. Preston & Co., 1886.

Wehle, Eleanor. "General Foods Razing Lehman-Meyer Mansion." *Tarrytown Daily News*, 1 Mar. 1976, p. A3.

Yonkers Power Station, Yonkers

The Central Hudson Century, 1900–1999: With a Forward-Looking Introduction to Our 21st Century Future. Poughkeepsie, N.Y.: CH Energy Group, 2000.

Dentzer, Bill. "Future Looks Dim for Power Station." *Gannet Suburban Newspapers*, 15 Aug. 1995.

"Glenwood Plant: The Spark Is Gone." *Yonkers Herald Statesman*, 20 Sept. 1963.

Middleton, William D. *Grand Central: The World's Greatest Railway Terminal*. San Marino, Calif.: Golden West Books, 1977.

Moyers, Bill. *The Hudson: America's First River*. PBS televised documentary film aired 19 April 2002.

"Northwest Architectural Archives, University of Minnesota." http://special.lib .umn.edu/findaid/html/mss/nwaa0087.html.

Payne, Christopher. *New York's Forgotten Substations: The Power behind the Subway*. New York: Princeton Architectural Press, 2002.

"Power Stations of the Electric Zone of the New York Central & Hudson River Railroad." *Street Railway Journal*, 11 Nov. 1905. vol. 26, no. 20, pp. 872–878.

Sanchis, Frank E. *American Architecture, Westchester County, New York: Colonial to Contemporary*. New York: North River Press, 1977.

Schlichting, Kurt C. *Grand Central Terminal: Railroads, Engineering and Architecture in New York City*. Baltimore: Johns Hopkins University Press, 2001.

Smith, Gene. "ConEdison Atomic Power Plant in Westchester Goes 'Critical.'" *New York Times*, 3 Aug. 1962, p. 27.

Walton, Frank L. *Pillars of Yonkers*. New York: Stratford House, 1951.

"Tacoma Union Station—The Architects: Reed and Stem." http://www.north west.gsa.gov/heritage/tacoma/architects.html.

INDEX

Page numbers for illustrations appear in **bold**.

PHOTOGRAPH CREDITS

Photographs on the following pages by and copyright Thomas E. Rinaldi:

9, 20 (right), 21, 29, 30, 32, 35, 38, 42, 43, 47, 48, 49, 50, 54, 61, 62, 63, 69, 70, 73, 76, 82, 84, 85 (bottom), 88, 89 (all), 96 (all), 97, 104, 105, 119, 121, 122, 125, 128, 130, 131 (all), 135, 138, 139, 140, 141, 142, 143 (center left, center right, bottom middle), 150, 153, 155 (bottom), 160 (all), 161 (bottom), 163, 165, 166, 167, 168, 169 (left), 170, 180, 182, 185 (all), 189, 192, 195 (bottom), 196, 199, 203, 204 (all), 206 (bottom), 208, 214, 229, 232, 239, 241, 252, 254, 257, 264 (bottom), 290, 294

Photographs on the following pages by and copyright Robert J. Yasinsac:

ii, 26, 27, 28, 51, 55, 57 (bottom), 64, 65, 67, 74, 77, 83, 85 (top), 86, 87, 95, 106, 107, 108, 109, 115 (all), 116, 117, 123, 134, 137, 143 (top right, center middle, bottom left, bottom right), 145, 148, 149, 151 (top), 155 (top), 156, 161 (top), 169 (right), 174, 175, 176 (all), 177, 181, 183, 184, 187, 193, 195 (top), 197, 211, 215, 216, 217, 219, 222, 223, 224, 226, 228, 230, 233, 234, 235, 236, 237, 242, 245, 247, 248, 249, 253, 255, 256, 258, 259, 262, 263, 264 (top), 266, 269, 270, 271, 274, 275, 277, 278, 279, 281, 282, 283, 284, 285, 287, 289 (bottom), 293 (top)